Peter Stanford

50 Schlüsselideen

Religion

Aus dem Englischen übersetzt von Sebastian Vogel

Inhalt

Einleitung

Über Religion hat jeder eine Meinung. Diese kann positiv oder negativ sein, neutral ist sie selten. Der deutsche Philosoph Friedrich Nietzsche verkündete in den 1880er Jahren voller Selbstvertrauen, Gott sei tot – er wäre überrascht darüber, dass die Religion auch heute, 120 Jahre später, auf der Weltbühne noch ein höchst lebendiges, weithin diskutiertes Dasein führt.

Dieses Buch unternimmt den Versuch, zu den Grundlagen zurückzukehren und ein ausgewogenes Bild davon zu zeichnen, was Religion ist und was sie nicht ist, von ihren Ursprüngen durch ihre gesamte Geschichte mit ihren Höhen und Tiefen bis zu ihrer Bedeutung in der Welt von heute. Nach Ansicht von Polemikern wie Richard Dawkins, der mit seinem 2007 erschienenen Buch *The God Delusion* (dt. *Der Gotteswahn*) viele religionsfeindliche Vorurteile genährt und gestärkt hat, ist eine ganz und gar objektive Darstellung der Religion unmöglich. Damit mag er recht haben, aber ich habe mich auf den folgenden Seiten stets darum bemüht, meine eigenen Gefühle und meine Konfessionszugehörigkeit beiseite zu lassen, um so ein möglichst abgerundetes Bild zu präsentieren.

Wenn es eine Aussage über die Religion gibt, die man immer und immer wieder aussprechen muss, dann diese: Ihre verschiedenen Ausprägungsformen auf der ganzen Welt haben mehr Gemeinsamkeiten als Trennendes. Auf diese gemeinsame Grundlage habe ich mich am Anfang und Ende des vorliegenden Buches konzentriert. Die Abschnitte zwischen den Eingangs- und Schlussüberlegungen beschreiben das Spektrum der Religionen auf der ganzen Welt. Jede Glaubensrichtung wird in ähnlicher Weise vorgestellt: Wir verfolgen ihre Geschichte und Entwicklung, dann betrachten wir die wesentlichen Aussagen ihrer Lehre und fragen, was diese für das Alltagsleben bedeuten. Ich hoffe, die folgenden Seiten werden zu einer faszinierenden Entdeckungsreise werden, ganz gleich, ob Sie noch nichts über Religion wissen oder ob Sie sich mit manchen der beschriebenen Glaubensrichtungen bereits beschäftigt und in einer davon (oder sogar in mehreren) Wurzeln geschlagen haben.

Nur wenn man mehr über diese wichtige Kraft, die unsere Welt auch heute noch prägt, weiß, kann man die Klischees überwinden, die so viele Diskussionen über Religion belasten. Es ist nicht mein Ziel, dass irgendjemand am Ende unserer Reise bekehrt ist, aber Sie sollten nach der Lektüre besser dafür gerüstet sein, sich an der nach wie vor laufenden Debatte zu beteiligen.

Peter Stanford

01 Das gottförmige Vakuum

Im Allgemeinen wird der französische Philosoph Blaise Pascal als Urheber der Idee von einem „gottförmigen Vakuum" genannt. In seinen im 17. Jahrhundert erschienenen *Pensées* beschreibt er einen im Inneren jedes Menschen vorhandenen grenzenlosen Abgrund, eine Leere, die danach strebt, gefüllt zu werden. Das Konzept reicht aber viel weiter in die Vergangenheit, nämlich bis zu den Ursprüngen des Lebens auf der Erde. Nach Ansicht vieler Menschen ging die Entstehung des religiösen Impulses – jenes mächtigen Bedürfnisses, im Dasein einen tieferen Sinn zu finden – Hand in Hand mit der Entstehung der Menschheit.

Ernsthafte Gläubige behaupten natürlich, Gott sei zuerst dagewesen und habe Männer und Frauen geschaffen, damit sie die Erde bevölkern. „Am Anfang war das Wort, und das Wort war bei Gott, und Gott war das Wort" – so beginnt das Johannesevangelium im Neuen Testament. In den Upanischaden, dem heiligen Text des Hinduismus, enthielt der Hiranyagarbha, der goldene Mutterleib, die Ursprünge des Universums und des hinduistischen Schöpfergottes Brahman.

Andere behaupten jedoch, dass die Entwicklung genau umgekehrt verlaufen sei. Über die Entstehung der Religionen gibt es viele Theorien. Einig sind sich alle darin, dass die Menschen sich immer Götter erschaffen haben. Als die ersten Männer und Frauen sich mit dem Zufallscharakter ihres Schicksals auseinandersetzen mussten – das Krankheit und Leiden ebenso bereithalten kann wie Freude und Gesundheit –, suchten und fanden sie eine Erklärung für diese ansonsten unerklärlichen Wendungen des Schicksals: Man führte sie auf die Handlungen einer fernen Gottheit zurück.

Einen genaueren Ausgangspunkt für die Vorstellung eines von Menschen geschaffenen Gottes finden wir vor 14.000 Jahren im Nahen Osten. Dort stießen Historiker und Archäologen auf Indi-

> **Du hast uns zu dir hin geschaffen, oh Herr, und unruhig ist unser Herz, bis es ruht in dir.**
> Augustinus, 354–430

Zeitleiste

vor 2 Millionen Jahren

erste Menschen; Entstehung der Vorstellung vom Himmelsgott

zien dafür, dass die Naturkräfte – Wind, Sonne, Sterne –, aber auch weniger greifbare, jedoch trotzdem genau spürbare, vermeintlich in der Landschaft vorhandene Gebilde oder Geister personalisiert und als Götter mit menschlichen Eigenschaften angebetet wurden.

In ein neues Stadium trat diese Entwicklung zwischen 800 und 300 vor unserer Zeitrechnung (v. u. Z.) ein, eine Zeit, die in der Geschichte als Achsenzeit bezeichnet wird. Während dieser Phase wurde die Suche nach dem Sinn des Lebens zu einer Kernfrage für Persönlichkeiten wie Buddha, Sokrates, Konfuzius und Jeremia; ihnen allen gemeinsam war die Vorstellung, dass es eine transzendente oder spirituelle Dimension des Daseins gebe, und sie versuchten erstmals, solche Gedanken zu formulieren. Damit wurde die primitive Vorstellung von einer Gottheit genauer umrissen und weiterentwickelt.

Solche Versuche, eine göttliche Oberherrschaft zu definieren, führten schließlich zu den verschiedenen Konfessionen und Glaubensrichtungen, aus denen die Welt der Religion heute besteht. Ihr Gegenstand ist immer der gleiche: ethisches Verhalten und die Frage, wie die Menschen zueinander in Beziehung treten sollten. In der Frage, wie das geschehen sollte – oder in ihrer Doktrin, wie man die jeweilige Lehre auch nennen könnte – unterscheiden sie sich. Christentum Judentum und Islam sind beispielsweise mo-

Die Entstehung des Gottesbegriffs

Viele Historiker und Theologen haben zu beweisen versucht, dass der Gottesbegriff seinen Ursprung im Geist des Menschen hat. Einer der einflussreichsten Autoren in diesem Bereich war der deutsche Anthropologe, Ethnologe und katholische Geistliche Wilhelm Schmidt (1868–1954), dessen zwölfbändiges Werk *Der Ursprung der Gottesidee* 1912 erstmals erschien. Nach seiner Theorie des „primitiven Monotheismus" erdachten die Menschen der Frühzeit einen wohlwollenden Schöpfergott. Dieser wurde häufig als „Himmelsgott" bezeichnet, da man ihn oberhalb der Erde in einer Region ansiedelte, die als „Himmel" bezeichnet wurde. Damit fanden die Menschen für sich eine Erklärung für ansonsten unerklärbare Dinge, gute wie schlechte, die auf der Erde geschahen. Der Himmelsgott war von den Problemen des menschlichen Lebens so weit entfernt, dass es als zwecklos erschien, sich ein Bild von ihm zu machen oder ihm in Ritualen, die von heiligen Männern und Frauen geleitet wurden, zu huldigen. Da diese Vorstellung von Distanz die Menschen befremdete, wandten sie sich näherliegenden Gottheiten zu, die nach dem Bild der Menschen geformt waren. Nach Schmidts Ansicht hielt sich der Kult des Himmelsgottes nur in isolierten Bevölkerungsgruppen, so bei einigen afrikanischen und lateinamerikanischen Stämmen und bei den australischen Ureinwohnern.

notheistische Religionen: Ihre Anhänger glauben an einen einzigen, allmächtigen Gott. Im Hinduismus und den anderen östlichen Glaubensrichtungen dagegen gibt es eine Vielzahl von Göttern.

❯ Wenn ich ihn kennen würde, wäre ich er. ❮
Rabbi Josef Albo, **1380–1445**

Schattengestalten In der Achsenzeit wurden die verschiedenen religiösen Traditionen in heiligen Büchern niedergeschrieben. Daneben wurden immer mehr theologische Studien betrieben, und es wurden Verhaltensregeln festgelegt, die für die Mitglieder einer bestimmten Glaubensrichtung galten. Die Gottheit selbst hingegen, ihre genaue Natur, bleibt bis heute in den meisten Glaubensrichtungen schattenhaft. In manchen Fällen, so im Taoismus und Konfuzianismus, ist das so gewollt: Der Schwerpunkt soll auf einer ethischen Lebensführung im Glauben liegen und nicht auf theologischen Spekulationen. Oft ist jedoch allgemein anerkannt, dass die Gottheit sich der gewöhnlichen Sprache entzieht. Der *Penny Catechism* der katholischen Kirche, eine beliebte Zusammenfassung der wesentlichen Regeln und Überzeugungen dieser Konfession, die in England bis in die 1960er Jahre allgemein in Gebrauch war, bestand aus einer Reihe von Fragen und Antworten. Auf die Frage „Was ist Gott?" antwortete er mit den undurchsichtigen Worten „Gott ist der Höchste Geist, Der allein aus Sich selbst heraus existiert und in allen Vollkommenheiten unendlich ist."

Jede Definition des Göttlichen bleibt in Abstraktionen und Tabus gehüllt. Juden ist es verboten, den heiligen Namen Gottes auszusprechen, und Muslime dürfen das Göttliche nicht in Bildern darstellen. Gerade dieses Geheimnis scheint aber den Reiz der Religion als Weg, Ordnung in eine ansonsten undurchsichtige Welt zu bringen, nur zu steigern.

Eine ständig sich verändernde Gottheit Mit der Weiterentwicklung der Welt haben sich die Bedürfnisse und Wünsche der Menschen geändert, und sie wandeln sich weiterhin, indem der Planet und seine Bewohner ständig vor neuen Herausforderungen stehen. Ebenso entwickeln und verändern sich die Vorstellungen vom Göttlichen – die meisten Religionen nehmen das aber nicht zur Kenntnis: Sie stellen sich als unerschütterlich dar, sowohl in ihren grundlegenden Glaubenssätzen als auch in ihren Regeln, die die Praxis in den Institutionen bestimmen.

Fest verdrahtet im Gottesglauben?

In jüngster Zeit haben Wissenschaftler zu zeigen versucht, dass das Gehirn des Menschen für den Gottesglauben prädisponiert oder fest verdrahtet ist. Nach Ansicht von Forschern an der Universität im britischen Bristol sind die Menschen dazu programmiert, an Gott zu glauben, weil ihnen der Glaube bessere Überlebensaussichten verschafft. Bruce Hood, Professor für Entwicklungspsychologie, veröffentlichte 2009 eine Studie über die Gehirnentwicklung bei Kindern; seine Befunde legen die Vermutung nahe, dass Menschen mit religiösen Neigungen im Laufe der Evolution von ihrem Glauben profitierten – möglicherweise, weil sie in Gruppen zusammenarbeiteten und damit die Zukunft ihrer Gemeinschaft sicherten. Deshalb wurde der „Glaube an Übernatürliches" in unserem Gehirn von Geburt an fest verdrahtet, so dass wir aufgeschlossen für die Behauptungen religiöser Organisationen sind. Wie Hoods Forschungsergebnisse zeigen, „haben Kinder eine natürliche, intuitive Denkweise, durch die sie zu allen möglichen Vorstellungen von der übernatürlichen Funktionsweise der Welt gelangen. Mit dem Heranwachsen werden solche Überzeugungen von stärker rationalen Ansätzen überlagert, aber die Neigung zum Glauben an unlogische, übernatürliche Dinge bleibt in Form der Religion bestehen." In diesen Schlussfolgerungen hallen auch andere Befunde wider, insbesondere die einer Arbeitsgruppe am Centre for the Science of Mind der Universität Oxford, die 2008 veröffentlicht wurden; danach weisen verschiedene Indizien auf einen Zusammenhang zwischen religiösen Gefühlen und bestimmten Gehirnarealen hin. Gläubige Katholiken, denen man ein Bild der Jungfrau Maria zeigte, hatten bei einem elektrischen Schlag weniger Schmerzen als Ungläubige, weil die Aktivität im rechten ventrolateralen Bereich des frontalen Cortex stärker zurückging.

Der Gottesbegriff bleibt also erstaunlich wandelbar, und gerade wegen dieser Flexibilität konnte er nach Ansicht mancher Fachleute so lange erhalten bleiben. Eine solche Vermutung unterstellt den Religionsführern ein gewisses Maß an Berechnung – sie hätten also ihre Darstellung auf die jeweiligen Bedürfnisse in bestimmten Epochen zugeschnitten. Dass man Gott letztlich nicht kennen kann, wird aber von allen Glaubensrichtungen ausdrücklich betont: Sie lehren, dass wir in unserem Bestreben, Gott oder die Götter zu kennen, letztlich Werte und Sinn im Leben suchen und hoffentlich auch finden.

Worum es geht
Götter erklären das Unerklärliche

02 Heilige Texte

Als die Religionen den Begriff einer Gottheit prägten, als Erklärung für den ansonsten unerklärlichen Wechsel zwischen Freude und Qual im individuellen Leben, destillierten sie aus einer ursprünglich meist mündlichen Überlieferung heilige Texte. Diese bilden für die Gläubigen durch die Geschichte hindurch einen roten Faden der Kontinuität und der zeitlosen Weisheit.

Bei allem Geschriebenen gibt es eine Beziehung zwischen dem Leser und dem Wort auf dem Papier, aber bei den heiligen Texten erreicht diese Beziehung für die Gläubigen eine höhere Ebene. Manche erzählen, ihr heiliges Buch habe sich vor ihnen rein zufällig auf einer Seite geöffnet, die eine eindeutige Antwort genau auf die Notlage enthielt, der sie sich gerade gegenübersahen. Andere beziehen aus der täglichen Lektüre religiöser Texte eine Anleitung für ihr Alltagsleben. Religiöse Texte sind Zeile für Zeile mit Glauben durchtränkt und werden zum praktischen, spirituellen und ethischen Maßstab, zur letzten Autorität für die Beurteilung von Verhaltensweisen. Im Folgenden erörtern wir drei der bekanntesten heiligen Werke; von anderen wird später die Rede sein.

Die Bibel Die Bibel, das heilige Buch der Christen, gliedert sich in zwei große Teile: das Alte und das Neue Testament. Das Alte Testament, das ungefähr zwischen 1200 und 200 v. u. Z. niedergeschrieben wurde, beginnt mit der Erschaffung der Welt. Es enthält auch Prophezeiungen über den Messias, der kommen soll, endet aber vor der Geburt Jesu. Das Neue Testament stammt aus den Jahren 40 bis 160 u.Z. und behandelt das Leben, die Lehren, den Tod und die Auferstehung Jesu; es endet (in den meisten Versionen) mit einem Blick auf das Ende der Welt und das Jüngste Gericht. Allein in den letzten 200 Jahren wurden nach Schätzungen sechs Milliarden Exemplare der Bibel verkauft.

Noch heute halten manche Christen den Bericht über die Erschaffung der Welt im Ersten Buch Mose am Anfang des Alten Testaments wortwörtlich für wahr. Da-

Zeitleiste

ca. 700 v. u. Z.

Entstehung der ersten von
13 hinduistischen Upanischaden

ca. 586 v. u. Z.

Vertreibung der Juden aus Jerusalem
gibt Anlass zur Entstehung der Thora

nach schuf Gott die Erde in sechs Tagen und ruhte am siebten. Andere erkennen an, dass dies den Erkenntnissen der Wissenschaft widerspricht. Überall in der Bibel finden sich zahlreiche widersprüchliche Details und Aussagen, die meisten Christen halten aber an der Überzeugung fest, dass die Bibel trotz solcher Widersprüche eine letzte Wahrheit enthält. Für manche, insbesondere in der protestantischen Tradition, ist sie der oberste Schiedsrichter in religiösen Fragen.

Sind die Evangelien wahr?

Die vier Evangelien („Evangelium" bedeutet „gute Nachricht") im Neuen Testament sind für Christen die entscheidenden Quellen, die über das Leben Jesu berichten. Aber keines von ihnen ist ein Bericht aus erster Hand. Sie sind, um das Wort in seiner heute üblichen Bedeutung zu gebrauchen, kein Evangelium – das heißt, sie sind nicht in jeder Hinsicht unfehlbar. Zunächst einmal wurden sie erst Jahrzehnte nach dem Tod Jesu geschrieben; die ältesten heute noch existierenden Manuskripte stammen aus dem dritten Jahrhundert. Außerdem bieten sie oft auffallend unterschiedliche Berichte über Einzelheiten aus dem Leben Jesu.

Nach Überzeugung der meisten Christen sind die Evangelien das Ergebnis einer komplizierten Entstehungsgeschichte, die sie zu weit mehr als nur zu einfachen historischen Chroniken machen. Sie sind zum Teil Reportage, zum Teil halten sie auch in schriftlicher Form ältere mündliche Überlieferungen fest, die sich bis in die Zeit zurückerstrecken, als Jesus lebte. Zum Teil sind es Predigten, zum Teil nehmen sie Bezug auf alttestamentarische Prophezeiungen, es finden sich Kommentare zu politischen Ereignissen aus der Zeit ihrer Entstehung, und teilweise sind sie auch Werke der Literatur und der Fantasie. Welchen genauen Anteil diese Elemente jeweils am Ganzen haben, ist heftig umstritten.

> **Die Autorität, die die Bibel für Christen hat, ist dadurch begründet, dass sie eine besondere Beziehung zu ihr haben, die wie die Beziehung zwischen Eltern und Kind nie verändert werden kann.**
>
> **Diarmaid MacCulloch, Professor für Kirchengeschichte, Universität Oxford, 2009**

ca. **100** v. u. Z.	ca. **40** u. Z.	ca. **635** u. Z.
Niederschrift der buddhistischen Schriften	Paulus schreibt die ersten Abschnitte des Neuen Testaments	Entstehung des Korans nach Mohammeds Tod

Die Thora Der Begriff Thora bezeichnet sowohl die hebräische Bibel (die sich mit dem Alten Testament überschneidet, aber nicht sein genaues Spiegelbild ist) als auch die Lehren der Rabbiner, die sich in den ersten sechs Jahrhunderten unserer Zeitrechnung entwickelten. Meist meint man damit jedoch die ersten fünf Bücher der Bibel – die „Bücher Mose" Genesis, Exodus, Levitikus, Numeri und Deuteronomium. Nach dem jüdischen Glauben diktierte Gott Moses die Thora auf dem Berg Sinai, 50 Tage nachdem das Volk der ägyptischen Sklaverei entkommen war – dies kann jedoch nur für bestimmte Abschnitte der fünf Bücher stimmen, die manchmal auch als „Mündliche Thora" bezeichnet werden. Nach der jüdischen Lehre zeigt die Thora, wie die Menschen nach Gottes Willen leben sollen – dies ist in 613 Geboten festgeschrieben. Darüber hinaus verbindet die fünf Bücher auch, dass sie alle von Gottes Sorge um sein „auserwähltes" Volk Israel handeln.

Die Schriftrolle der Thora ist in einer jüdischen Synagoge der heiligste Gegenstand. Sie wird meist in einer „Lade" – einem Schrank – aufbewahrt und zum Höhepunkt der Liturgie gezeigt. Dann wird sie feierlich durch die Gemeinde der Gläubigen getragen, und diese zeigen ihre Verehrung, indem sie mit den Fransen ihrer Gebetsschals über die Rolle streichen.

Buddha und die Schriften

Buddha (Siddhartha Gautama) kämpfte während seines ganzen Lebens gegen den Personenkult und bemühte sich darum, die Aufmerksamkeit seiner Jünger von sich selbst abzulenken. Sein Leben, so erklärte er, sei nicht wichtig. Entscheidend sei die von ihm entdeckte Wahrheit, die ihre Wurzeln im tiefsten Geflecht des Daseins habe – *Dharma*, ein grundlegendes Lebensgesetz, das für Götter, Menschen und Tiere gleichermaßen gelte. Darin unterscheiden sich die buddhistischen Schriften stark von anderen heiligen Büchern: Sie berichten nur sehr wenig über Buddha selbst. Deshalb hatten einige abendländische Gelehrte im 19. Jahrhundert sogar Zweifel daran, dass es ihn überhaupt gab. Die Schriften füllen viele Bände in verschiedenen asiatischen Sprachen, und ihre Authentizität ist Gegenstand umfangreicher wissenschaftlicher Diskussionen. Vermutlich wurden sie erst im ersten Jahrhundert v. u. Z. niedergeschrieben, ungefähr 400 Jahre nach Buddhas Tod.

Der Koran Nach dem muslimischen Glauben wurde der Koran dem Propheten Mohammed im Laufe von 23 Jahren Stück für Stück offenbart. Er enthält, so der Glaube, die genauen Worte Allahs; menschliche Autoren waren also an ihm, anders als bei den heiligen Büchern anderer Glaubensrichtungen, nicht beteiligt. Die Lehren Mohammeds stehen im *Hadith*, einer Sammlung mündlicher Überlieferungen, die von Worten und Taten des Propheten handeln. Erstmals niedergeschrieben wurde der Koran kurze Zeit nach dem Tod des Propheten im Jahr 632 von Mohammeds Sekretär und Jünger Zaid ibn Thabit. Er besteht aus 114 Kapiteln, die nicht chronologisch geordnet sind. Der Islam verbietet bildliche Darstellungen, aber durch die Schönschrift bzw. Kalligrafie in manchen alten Exemplaren gehören diese zu den größten Kunstschätzen der Welt.

> **Lass immer heilige Lektüre zugegen sein.**
> Hl. Hieronymus, **ca. 410**

Die Lektüre des Koran ist mit einem genau festgelegten Ritual verbunden. Muslime müssen dazu „ihr Herz vorbereiten" und sich die Hände waschen. Frauen bedecken in der Regel den Kopf – wie für ein Gebet. Man nimmt eine besondere – disziplinierte und aufmerksame – Sitzhaltung auf dem Fußboden ein, und der Koran liegt auf einem Pult oder *Kursi* vor dem Leser.

Die Worte des Korans sind zwar unveränderlich, unterschiedliche Übersetzungen und Interpretationen messen ihnen aber voneinander abweichende Bedeutungen bei. In jüngster Zeit versuchten beispielsweise manche Muslime, grausame Gewalttaten mit dem *Dschihad*, oder Kampf, zu rechtfertigen. Dabei stellen sie den Begriff in einen militärischen Zusammenhang, obwohl Mohammed im Islam nicht als Mann der Gewalt dargestellt wird.

Die Bedeutung all dieser heiligen Bücher geht über den direkten oder indirekten Zusammenhang mit der Gottheit hinaus. Man schreibt ihnen die Macht zu, besser als jeder andere Text die Hoffnungen der Menschheit in sich zu vereinigen und auf einzigartige, greifbare, stärkende Weise unmittelbar zu den Gläubigen zu sprechen.

Worum es geht
Religionen verehren heilige Bücher

03 Gut und Böse

Nachdem die Vorstellung von einem Himmelsgott sich zu der Vorstellung von einer Gottheit weiterentwickelt hatte, die vom Himmel aus die Welt und ihr Schicksal lenkt, stellte sich die Frage: Warum lässt eine solche Gottheit es zu, dass die Menschen leiden? Auf dieses Dilemma geben die Religionen nach Ansicht vieler Menschen bis heute keine zufriedenstellende Antwort. Ein Ausweg bestand für die Religionen darin, die Schuld abzuschieben: Was in der Welt und im Leben des Einzelnen falschläuft, ist demnach nicht auf einen allmächtigen Gott zurückzuführen, sondern auf einen bösen Geist.

In dieser Vorstellung ist die Erde das apokalyptische Schlachtfeld für einen kosmischen Konflikt zwischen guten und bösen Göttern, wobei die Menschheit das Kanonenfutter darstellt. Sehr alte Belege für den Glauben an einen bösen, gehörnten Geist, der halb Mensch und halb Tier ist, finden sich in den 9000 Jahre alten Höhlenmalereien der Caverne des Trois Frères im französischen Ariège. Zur Götterwelt der alten Ägypter gehörten im vierten Jahrhundert v. u. Z. mehrere doppelgesichtige Gottheiten mit einem wohlwollenden und einem bedrohlichen Profil. In der bekanntesten derartigen Gestalt verbindet sich der falkenköpfige Himmelsgott Horus mit Seth, der als Schlange oder Schwein dargestellt wird und das Böse verkörpert. In heiligen Legenden aus dem alten Ägypten sind beide in einem ewigen, tödlichen Kampf gefangen.

Der feindselige Geist Ein Höhepunkt dieses Glaubens an gleich starke, einander entgegengesetzte göttliche Kräfte, die um die Weltherrschaft kämpfen, war im 12. Jahrhundert v. u. Z. im antiken Persien erreicht. Die heiligen Texte des Zoroastrismus, die Gathas, erzählen die Geschichte vom Machtkampf zwischen dem guten Gott Ahura Masda, der über Weisheit und Gerechtigkeit herrscht, und dem feindseligen Geist Angra Mainyu, der in die Welt eingedrungen ist und sie mit Gewalt, Hinterlist, Schmutz, Staub, Krankheiten, Tod und Zerfall durchtränkt.

Zeitleiste

ca. **1200** v. u. Z.

Zoroasters apokalyptische
Visionen

ca. **585** v. u. Z.

Die Juden lernen in Babylon
den Zoroastrismus kennen

Der Zoroastrismus

Der Zoroastrismus hat heute rund 479.000 Anhänger, die meisten von ihnen in Indien im Volk der Parsi. Die Glaubensrichtung hatte großen Einfluss auf die Entwicklung anderer Religionen, denn diese übernahmen viele Erkenntnisse ihres Begründers und wandelten sie ab. Zoroaster (Zarathustra), der vermutlich um 1200 v. u. Z. lebte, betrübten die Leiden seines eigenen Volkes im heutigen Irak und Iran. In den Gathas – 17 Hymnen, die ihm zugeschrieben werden – grübelt er über die Verletzlichkeit und Ohnmacht der Menschen nach. Diese führt er nicht einfach auf einen Schöpfergott zurück, sondern auch auf seinen ebenso starken Gegner – „zwei Urgeister, Zwillinge, die dazu bestimmt sind, in Konflikt zueinander zu stehen". Vermutlich führte er als Erster eine solche apokalyptische Vision in die Religion ein.

Das Gute war vom Bösen getrennt, das Reine vom Unreinen. Mit einer solchen Vorstellung von gegensätzlichen göttlichen Prinzipien, Dualismus genannt, liebäugelten viele Religionen im Laufe der Geschichte.

Im sechsten Jahrhundert v. u. Z. zum Beispiel, während des jüdischen Exils in Babylon, wurden die Juden mit der Vorstellung vom zoroastrischen Dualismus so vertraut, dass einige von ihnen – nach ihrer Niederlage gegen die babylonischen Streitkräfte und der Zerstörung des Tempels in Jerusalem – glaubten, ihr Scheitern sei nicht auf Jahwe zurückzuführen, sondern auf einen eingedrungenen, bösen Geist, der sich zwischen die Israeliten und ihren Gott gestellt habe.

> **Sine diabolo, nullus dominus.**
> („Ohne das Böse gibt es keinen Herrn") Traditionelles Sprichwort

ca. **30** u. Z.

Jesus kämpft den Evangelien zufolge mit dem Teufel

ca. **1200** u. Z.

Die christliche Inquisition verfolgt Teufelsanbeter

Das Gesicht des Bösen Der Dualismus wurde seinerseits vom Christentum übernommen. Im Neuen Testament gibt es einen wichtigen Handlungsstrang, der das Dasein der Menschen unter dem Gesichtspunkt des Konflikts zwischen Jesus und dem Teufel darstellt, insbesondere während der 40 Tage und 40 Nächte, die Jesus in der Wildnis verbringt: Dort lockt ihn der Teufel mit allen Reichtümern der Welt. Die Offenbarung enthält einen Bericht über das Ende der Zeiten, wenn der Teufel und seine Anhänger von Gott endgültig besiegt werden, aber weiterhin Beute unter leichtgläubigen Menschen machen können, bis das Jüngste Gericht heraufdämmert; auf diese Weise wird die Erde mit Sünde und Leid vergiftet.

Exorzismus

In der katholischen Kirche spielt der Teufel heute zwar nicht mehr eine so große Rolle wie im Mittelalter, die Praxis des Exorzismus gibt es aber immer noch. Der Vatikan unterhält ein weltweites Netz von Exorzistenpriestern und glaubt nach wie vor, dass Menschen in seltenen Fällen von Dämonen besessen sein können. Im März 1982 berichtete Kardinal Jacques Martin, der Vorsteher des päpstlichen Haushalts, Papst Johannes Paul II. habe persönlich an einer jungen Frau, die angeblich vom Teufel besessen war, einen Exorzismus vorgenommen. Die Austreibungsriten der katholischen Kirche gehen auf die Dämonenaustreibungen durch Jesus in den Evangelien zurück. Das Ritual hat sich seit 1614 kaum verändert und beinhaltet Gebete, Handauflegen, das Schlagen des Kreuzes und das Versprengen von Weihwasser. Kleinere Austreibungsriten gibt es auch im Wortlaut des Taufgottesdienstes oder wenn ein Priester ein neues Haus segnet.

Das Christentum ist zwar offiziell eine monotheistische Religion, für die es nur einen Gott als Quelle aller Dinge in der Welt gibt, in der Praxis wurde diese Theorie aber lange durch eine gewisse Dosis von Dualismus verwässert. Im Vergleich dazu sind sowohl das Judentum als auch der Islam in ihrem Monotheismus viel puristischer. Kleinere teufelsähnliche Gestalten, die Schaitan und Iblis, gibt es zwar auch im Koran, sie sind aber mehr oder weniger machtlos. „Ich habe keine Macht über euch", sagt Schaitan, „es sei denn, ich rufe euch und ihr gehorcht. Deshalb gebt die Schuld nicht mir, sondern euch selbst." Im Judentum spricht man lieber nicht über böse Geister, sondern über böse Neigungen – *Yetzer Hara* – in jedem Menschen.

Das Christentum stellte den Teufel als Gesicht des Bösen dar. Im Mittelalter lehrte die Kirche, der Teufel lauere an jeder Ecke, um die Gläubigen von Gott und dem Weg der Rechtschaffenheit weg zur Sünde und letztlich zur Verdammnis der Hölle

zu locken. Selbst die protestantischen Reformer machten sich diese Sichtweise zu eigen. Martin Luther war völlig davon überzeugt, dass es den Teufel gebe, und er glaubte sogar, seine Darmbeschwerden seien auf die Besessenheit durch einen Dämon zurückzuführen.

In jüngerer Zeit spricht die Hauptrichtung des Christentums nur noch widerwillig vom Bösen. Beliebter ist die Figur des Teufels in stärker evangelikalen Kirchen, in denen Schwäche oder Krankheit manchmal damit begründet werden, dass man diesem nachgegeben hat. Für Besessene werden Exorzismus-Zeremonien vollzogen. Im allgemeineren Sinne wird jede Form von Störung auf eine äußere Realität – das heißt auf den Teufel – zurückgeführt und nicht auf psychische, gesellschaftliche oder emotionale Faktoren, die einen Menschen beeinflussen. Auch wenn die etablierte Kirche den Teufel ins Abseits gedrängt hat, hat die Vorstellung von gegensätzlichen göttlichen Prinzipien bei vielen Gläubigen nach wie vor starkes Gewicht.

Worum es geht

In uns liegen Gut und Böse im Krieg

04 Leben und Tod

Religion will nicht nur in dieser Welt moralische und ethische Maßstäbe setzen, sondern sie verspricht auch ein Leben nach dem Tod. Es kann sich in einem Paradies wie dem christlichen Himmel oder dem muslimischen *Dschanna* abspielen, aber auch als Teil eines Kreislaufs aus Tod und Wiedergeburt, bei welcher der Geist sich unterschiedlich manifestieren kann – die hinduistischen Upanischaden sprechen von *Samsara*.

Alle Religionen verbinden mit dem Tod ein Element des Gerichts: das Verhalten auf Erden steht in Zusammenhang mit Belohnung oder Bestrafung im Jenseits. Dieser Gedanke geht auf die alten Ägypter zurück, deren Hochkultur vom vierten Jahrtausend v. u. Z. bis zur griechischen und römischen Antike am Nil und in seinem Delta gedieh. Dass die Ägypter an ein Leben nach dem Tod glaubten, machen die Mumien und Grabbeigaben in den Grabkammern der Pyramiden mehr als deutlich. Im Reich des Totengottes Osiris wurde das *Ka* – der Verstand und Geist jedes Einzelnen – in eine Waagschale gelegt und eine Straußenfeder in die andere. Gutes Verhalten galt als leicht. Neigte die Waage sich in die falsche Richtung, bedeutete dies die Verbannung in eine Unterwelt voller Ungeheuer. Die Urteile wurden von Osiris' Sohn Thot aufgezeichnet; dies ist der Ursprung des üppig illustrierten Totenbuches, das aus dem alten Ägypten erhalten geblieben ist.

Gericht nach dem Tod Obwohl die Israeliten in Ägypten im Exil lebten, übernahmen sie diese Vorstellung eines Gerichtes nach dem Tod nicht, als sie um 1200 v. u. Z. im Heiligen Land ihr eigenes Königreich gründeten. Die hebräischen Schriften und die ältesten Bücher des Alten Testaments sprechen vom *Scheol*, einem unterirdischen Ort der Ruhe, an den alle Menschen unabhängig von ihren irdischen Verdiensten gelangen. Nur eine Handvoll außergewöhnlicher Menschen, beispielsweise der Prophet Elias, fahren nach dieser Beschreibung in den Himmel zu Gott auf. Ungefähr im achten Jahrhundert v. u. Z. jedoch wurde dann das Element eines Gerichts am Ende des Lebens in die jüdische Lehre aufgenommen und später an die christliche Religion weitergegeben.

Zeitleiste

ca. 4000 v. u. Z.
Im alten Ägypten werden die Seelen der Verstorbenen gewogen

ca. 800 v. u. Z.
Im Judentum wird die Verurteilung im Totenreich *Scheol* eingeführt

Nach der traditionellen christlichen Lehre erhalten diejenigen, die Jesu Lehren befolgen, im Himmel das ewige Leben, während diejenigen, die sie ablehnen, Höllenqualen erleiden. Irgendwo dazwischen liegt das Fegefeuer; dieses Wartezimmer für den Himmel wird in theologischen Diskussionen um 1170 erstmals erwähnt und wurde 1254 von einem Papst ausdrücklich benannt. Es steht in enger Verbindung mit dem 2. November, dem Feiertag Allerseelen des christlichen Kalenders, an dem die Gläubigen beten, dass Freunde und Angehörige aus dem Fegefeuer befreit werden und in den Himmel und in die ewige Freude eingehen.

Endgültige Erleuchtung Die Upanischaden, die zwischen 700 und 300 v. u. Z. entstandenen heiligen Schriften des Hinduismus, beschreiben das *Samsara* sehr genau. Wer in einem Leben Getreide gestohlen hat, wird im nächsten eine Ratte. Wer einen Priester tötet, wird als Schwein wiedergeboren. Die *Mokscha*, die Befreiung der Seele von der Last des Körpers und damit die endgültige Erleuchtung, ist nach dem hinduistischen Glauben ein lange dauernder Prozess. An seinem Ende findet man weniger einen Ort als vielmehr einen Seelenzustand, der in den Upanischaden als Selbstaufgabe beschrieben wird.

Abendländische Christen betrachten die Wiedergeburt manchmal als attraktive Möglichkeit im Vergleich zur Endgültigkeit des Todes, für Hindus ist aber der Kreislauf des *Samsara* nicht nur eine Gelegenheit zu spirituellem Wachstum, sondern auch eine Bestrafung: Es bedeutet, dass der Gläubige noch nicht die endgültige Erleuchtung erlangt hat.

Ein hinduistischer Himmel

Im Hinduismus werden detaillierte Beschreibungen des Jenseits in der Regel vermieden – in der Kausitaki-Upanischade gibt es jedoch eine Schilderung der Landschaft, in der diejenigen, die aus dem *Samsara* hervorgegangen sind, sich der Vereinigung mit dem unendlichen Geist Brahman erfreuen. „Zuerst kommt er an den See Ara. Er überquert ihn mit seinem Geist, aber jene, die ohne vollständiges Wissen hineingehen, ertrinken darin. Dann kommt er in der Nähe der Wächter, Muhurta, aber sie flüchten vor ihm. Dann kommt er zum Fluss Vijara, den er nur mit seinem Geist überquert. Dort schüttelt er seine guten und schlechten Taten ab, welche auf seine Angehörigen fallen – die guten Taten auf diejenigen, die er liebt, die schlechten auf jene, die er nicht mag ... So von guten und schlechten Taten befreit, geht dieser Mann, der die Kenntnis von Brahman hat, zu Brahman."

❝ **Ein Ding, zu gewaltig, als dass die Zunge es erzählen oder die Fantasie es ausmalen könnte.** ❞

As-Sujathi, 1445-1505, über das *Dschanna*

Der Paradiesgarten In vielen Religionen bleibt unklar, wie das Jenseits im Einzelnen aussieht. Die östlichen Religionen sagen darüber fast nichts, Schintoismus und Taoismus beinhalten allerdings Elemente der Ahnenverehrung. Nach islamischer Lehre ist das *Dschanna* ein Paradiesgarten, wo, dem Koran zufolge, die feinsten kulinarischen Genüsse warten; weitere theologische Spekulationen über die ansonsten abstrakte Idee werden aber als *Zannah* – selbstgerechte Verschrobenheit – abgelehnt. Augustinus, der vermutlich einflussreichste Schreiber und Denker der christlichen Kirchengeschichte, bezeichnete den Himmel im fünften Jahrhundert als unbeschreiblich – als jenseits der Worte.

Obwohl also ein solches Bündnis mächtiger Stimmen vor dem Versuch warnt, sich das Jenseits vorzustellen, hat es eine lange Reihe von Theologen, Mystikern, Künstlern und Autoren fasziniert und inspiriert. Der italienische Dichter Dante Alig-

Das Schlaraffenland

Im Mittelalter berichteten abendländische Reisende, die aus islamischen Ländern zurückkehrten, der Koran verspreche muslimischen Märtyrern, dass sie im *Dschanna* von wunderschönen Jungfrauen empfangen würden. Der Koran selbst macht in dieser Frage keine genauen Aussagen – je nach Übersetzung kann die Beschreibung alles Mögliche meinen, von „Gefährten" bis zu „vollbusigen Mädchen". Die Hadithe – Aussprüche, die mit unterschiedlicher Glaubwürdigkeit Mohammed zugeschrieben werden – versprechen (wiederum in verschiedenen Versionen): „Die geringste [Belohnung] für die Völker des Himmels besteht in 80.000 Dienern und 72 Ehefrauen, über denen eine Kuppel aus Perlen, Aquamarinen und Rubinen steht." Solche

Texte ermutigten die abendländische Literatur jener Zeit, sich in Übertreibungen über das erotische Element des *Dschanna* zu ergehen – eine Haltung, die bis heute anzutreffen ist. Das *Liber Scalae* („Buch der Leiter") von 1264 beschreibt das *Dschanna* als Ort mit rubinenbesetzten Mauern, wo Jungfrauen liegen und darauf warten, Neuankömmlinge unter Baldachinen aus Smaragden und Perlen zu erfreuen, umgeben von Obstbäumen und Tischen voller Speisen und Getränke. Solche Beschreibungen gaben vermutlich ihrerseits den Anlass zu Erzählungen über das fiktive Schlaraffenland, ein irdisches Paradies des Überflusses, das in vielen mittelalterlichen europäischen Schriften und Abbildungen vorkommt.

> **Der Himmel hat keine Lieblinge.
> Er ist immer bei den guten Menschen.**
>
> Laotse, 6. Jahrhundert v. u. Z.

hieri schuf im 14. Jahrhundert in seiner *Göttlichen Komödie* ein denkwürdiges Bild des Paradieses, aber auch er scheute sich, den innersten Kern des Himmels zu beschreiben. Seine Beschreibung der Hölle – das Inferno – als Reihe von Ebenen in immer größeren Tiefen der Erde entspricht der des Jainismus, einer altindischen Religion, nach deren Lehre das Universum zwei Himmelsebenen oberhalb der Erde und zwei Höllenebenen darunter enthält.

Mehrere abendländische Künstler übernahmen Darstellungen des Lebens nach dem Tode von dem römischen Dichter Vergil: Dieser beschrieb im ersten Jahrhundert v. u. Z. die elysischen Felder, die man symbolisch durch ein Tor betritt. Mittelalterliche christliche Mystiker, viele von ihnen keusche Nonnen, bevorzugten das Bild eines Christus, der im Himmel auf die Seelen der Gläubigen wartet wie ein Bräutigam auf seine Braut.

Die vielen unterschiedlichen Versuche, sich das Leben nach dem Tod vorzustellen, lassen sich also in zwei Denkschulen einteilen: Nach der einen ist es eine gereinigte Version des irdischen Lebens, die andere behauptet wie Augustinus, die Seelen könnten nur dann in Ewigkeit zufrieden sein, wenn dieses Leben außerhalb unserer Vorstellung liege und nur in Metaphern zu beschreiben sei.

Worum es geht
Der Tod ist nicht das Ende

05 Die Goldene Regel

Das ethische Kernstück aller Religionen bildet ein einfaches Gebot, das häufig als „Goldene Regel" bezeichnet wird. Sie hat in den einzelnen Religionen einen unterschiedlichen Wortlaut, ihre Bedeutung ist aber im Wesentlichen immer die gleiche. In der abendländischen Gesellschaft lässt sie sich am besten mit einem bekannten Sprichwort zusammenfassen: „Was du nicht willst, das man dir tu, das füg auch keinem andern zu."

Im Konfuzianismus ist diese Verhaltensregel als *Shu* („Rücksicht") bekannt: Man nimmt Rücksicht auf andere, weil man den eigenen Schmerz, die eigene Hoffnung oder Zufriedenheit nicht von denen anderer trennen kann. Die Buddhisten sprechen von einer lebenslangen Annäherung an diese Regel. Sie ist in einer Formulierung von Buddha zusammengefasst, die im *Samyutta Nikaya* (wörtlich „Zusammenge-stellte Sammlung") niedergeschrieben wurde: „Wer das Ich liebt, sollte das Ich anderer nicht schädigen." Etwas Ähnliches sagte Jesus nach der christlichen Lehre seinen Jüngern; im Matthäusevangelium heißt es: „Alles nun, was ihr wollt, dass euch die Leute tun sollen, das tut ihnen auch! Das ist das Gesetz und die Prophe-ten." Und man könnte mit Fug und Recht hinzufügen: Es ist auch der Sinn des Neuen Testaments.

Die Juden erklären die Regel in Form einer Geschichte. Zu dem berühmten Ge-lehrten Rabbi Hillel (80 v. u. Z. bis 30 u. Z.) kommt ein Heide und verspricht, er werde zum Judentum konvertieren, wenn Hillel ihm die Thora lehren könne, wäh-rend er selbst auf einem Bein stehe. „Was dir selbst verhasst ist, tu nicht deinem Mitmenschen an", erwidert der Rabbi, während der Heide auf einem Bein steht. „Das ist die ganze Thora, alles andere sind nur Kommentare. Geh hin und lerne es."

Zeitleiste

ca. **530** v. u. Z.

Konfuzius formuliert erstmals
die Goldene Regel

ca. **480** u. u. Z.

Buddha fordert Nächstenliebe
statt Selbstliebe

Der Erste, der die Goldene Regel formulierte

Der erste Religionsführer, der die Goldene Regel formulierte, war wahrscheinlich Konfuzius im sechsten Jahrhundert v. u. Z. Diese Goldene Regel erwuchs aus seiner tiefen Überzeugung, dass Heiligkeit und Altruismus nicht zu trennen seien und dass alles darauf hinauslaufe, andere stets mit Respekt zu behandeln. Einer seiner Schüler sagte: „Der Weg unseres Meisters ist einfach nur dieser: sein Bestes für andere zu tun [im Konfuzianismus *Zhong*] und Rücksicht [*Shu*] zu nehmen." Konfuzius entwickelte viele seiner Erkenntnisse in Gesprächen mit seinen Anhängern, die er um sich gesammelt hatte. In den *Analekten*, der wichtigsten Quelle von Berichten über sein Leben und seine Lehren, diskutiert er unablässig mit ihnen. Zigong, einer aus der Gruppe, fragt: „Gibt es einen einzelnen Ausspruch, nach dem man sich an jedem Tag richten kann?" Darauf erwidert Konfuzius: „Vielleicht den Ausspruch über die Rücksicht."

Ein gemeinsames Ideal Natürlich gibt es in den religiösen Traditionen gegensätzliche Kräfte. In den Büchern des Alten Testaments, die sowohl den Juden als auch den Christen heilig sind, befiehlt Jahwe den Israeliten, die anderen Bewohner des Gelobten Landes mit dem Schwert zu vertreiben, und er gestattet sogar Vergewaltigungen und den Mord an Frauen. Wollte man aber einen Gedankengang finden, der alle Religionen verbindet, so ist es ihr Festhalten an der Goldenen Regel.

Die Goldene Regel hat deshalb so großes Gewicht, weil ihr Inhalt den kulturellen Traditionen und der Intuition der Menschen zutiefst widerspricht: Sie besagt, dass wir nicht vorrangig uns selbst und unsere eigenen Bedürfnisse sehen sollen. Dies mag ein instinktiver Impuls sein, aber alle Religionen lehren, dass er unmoralisch ist und selbstzerstörerisch wirken kann.

> **Füge niemandem Schmerzen zu, damit niemand dir Schmerzen zufügt.**
>
> **Mohammed, 632 u. Z.**

ca. **30** u. Z.

Rabbi Hillel definiert
die Goldene Regel

ca. **60** u. Z.

Die Goldene Regel fließt
in die Evangelien ein

Rabbi Hillel und die Goldene Regel

Die christliche Bibel rückt die Pharisäer im Zusammenhang mit den Ereignissen rund um Jesu Kreuzigung in ein unvorteilhaftes Licht. Den historischen Befunden zufolge waren sie aber in Wirklichkeit im Judentum des ersten Jahrhunderts u. Z. die fortschrittlichste, am stärksten Einheit stiftende Kraft. Die Heimat der Juden war damals von den Römern besetzt, die einen Aufstand mit großer Brutalität niederschlugen und den Tempel in Jerusalem zerstörten. Einer der führenden Pharisäer war Rabbi Hillel. Er erklärte, jeder Mensch könne Gott überall erleben, dies sei nicht einer Elite vorbehalten, die im Tempel komplizierte Rituale vollziehe. Das wichtigste Bestreben der Menschen sollte nach seiner Überzeugung die Nächstenliebe sein, und deshalb setzte er sich für die Goldene Regel ein. Entscheidend war für ihn der Geist des jüdischen Gesetzes, nicht aber sein Buchstabe. Dies vermittelt auch eine andere Geschichte aus dem Talmud. Darin betrachten zwei Juden die Ruinen des Tempels. Der eine sagt: „Weh uns, dass dieser Ort, an dem die Sünden Israels gesühnt wurden, in Trümmern liegt." Darauf der andere: „Gräme dich nicht. Wir haben eine andere Form der Sühne, die dem Tempel gleichkommt: liebevolle Taten."

Eine vernünftige Definition von Religion könnte so lauten: Sie ist die Suche nach dem Weg, auf dem Menschen friedlich zusammenleben können, Gesellschaften gerecht, umfassend und gleichberechtigt funktionieren und verschiedene Gesellschaften und Volksgruppen ihre eigenen Bedürfnisse befriedigen können, während sie mit anderen auf der Erde gemeinsam existieren. Das oberste Prinzip, das diesen verschiedenen Zielen dient, ist die Goldene Regel.

Eine radikale Herausforderung Die Goldene Regel vertritt in vielerlei Hinsicht eine radikale Vorstellung: Wenn wir anderen Priorität einräumen, zeigen wir entgegen einer in der westlich-säkularen Gesellschaft verbreiteten Vorstellung keine Schwäche, sondern moralische Stärke. Ausdrücklich oder unausgesprochen verbindet sich damit auch der Gedanke, dass wir uns letztlich selbst nützen, wenn wir andere gut behandeln: Wenn wir mit unserem eigenen Verhalten Maßstäbe setzen, werden sich auch andere in ihrem Umgang mit uns daran halten, und davon profitieren alle.

Die Goldene Regel berührt noch einen anderen Aspekt: Religion ist nicht nur einfacher Glaube, sondern beinhaltet auch das Handeln. Mitgefühl, Besorgnis und Mitleid zu zeigen, nachzugeben statt zu richten: Solche Lehren werden in den heiligen Schriften betont, doch treten sie häufig zugunsten von Dogmen, Doktrinen, Regeln und Ritualen in den Hintergrund.

Worum es geht
Behandle andere so,
wie du behandelt werden möchtest

06 Riten und Rituale

Alle Religionen haben ihre Zeremonien und Übergangsriten. Diese haben den Zweck, eine Verbindung zwischen Menschen und Göttern herzustellen, ein Forum für spirituelle Erfahrungen zu bieten und die einzelnen Gläubigen daran zu erinnern, dass sie sowohl in ihrer eigenen Zeit als auch in der Geschichte Teil eines größeren Ganzen sind.

Für viele Gläubige prägen die Riten und Rituale ihrer Religion ihr ganzes Leben. Die christlichen Sakramente beispielsweise begleiten die wichtigsten Stationen eines Lebens von der Geburt über das Erwachsenenalter bis zum Tod. Von Muslimen wird verlangt, dass sie fünfmal am Tag beten – der Ruf zum Gebet ist Teil der *Schahada*, der ersten der „Fünf Säulen" der islamischen Glaubenspraxis. Und Buddha lehrte vor 2500 Jahren, regelmäßige Meditation sei der Weg zur Erleuchtung. Deshalb bildet die Meditation noch heute für Buddhisten das Kernstück des Lebens.

Die einzelnen Religionen haben aber zu ihren Riten und Ritualen unterschiedliche Einstellungen. Der Islam beispielsweise lehrt, dass man jedes Gebäude zu einer Moschee machen kann; demnach sind die traditionellen Merkmale großer Moscheen keineswegs zwingend notwendig. Hindus versammeln sich zur Anbetung in Tempeln, aber dazu besteht keine Verpflichtung. Die Riten können ebenso gut zuhause vor einem privaten Schrein vollzogen werden.

Im Christentum bevorzugt die Hauskirchenbewegung einfache Gottesdienste, die im Haus der Gläubigen in Alltagssprache abgehalten werden. Am anderen Ende des Spektrums stehen im Christentum die ausgefeilten Hochämter: Sie werden in alten, verzierten Gebäuden von Geistlichen in prächtigen Gewändern abgehalten und folgen einem strengen, jahrhundertealten Muster; manchmal bedient man sich dabei sogar noch der „toten" lateinischen Sprache.

Die christlichen Sakramente

Viele christliche Konfessionen kennen eine Reihe von Sakramenten, die bei einschneidenden Ereignissen im Leben der Gläubigen gespendet werden. Im Katholizismus beispielsweise ist das Leben von sieben Sakramenten begleitet; diese sind die Taufe (offizielle Aufnahme in die Kirche), meist im Säuglingsalter; die Beichte und Erstkommunion (Empfang von Brot und Wein als Leib und Blut Jesu), ungefähr mit acht Jahren; die Firmung (Glaubensbekenntnis als Erwachsener) im Teenageralter; die Eheschließung als Erwachsener; die Priesterweihe, ebenfalls als Erwachsener; und schließlich das Sterbesakrament, in der Regel kurz vor dem Tod.

Höhere Symbolik Riten und Rituale sind stark mit Symbolen befrachtet. Diese gehören zu den Dingen, mit denen die Religion versucht, den Blick der Gläubigen vom irdischen Alltag auf die spirituelle Ebene zu erheben. Im christlichen Mittelalter galten selbst die Zinnen und Türme der Kathedralen nicht einfach nur als äußerliche Statussymbole oder als Orientierungsmarken für die Gläubigen, sondern sie sollten fast buchstäblich bis in den Himmel reichen. Im Taoismus, der alten religiösen und philosophischen Tradition, die in China im sechsten Jahrhundert v. u. Z. von Laotse begründet wurde, sind die Reinigungs- und Meditationsrituale mit Gesängen, dem Spiel von Instrumenten und Tänzen häufig so kompliziert und hoch entwickelt, dass man sie den Priestern überlässt; die Gemeinde spielt dabei kaum eine Rolle. Da man den Ritualen so große Bedeutung beimisst, besteht die Gefahr, dass sie zum Selbstzweck werden. Altbewährte Worte oder Sätze, die von Glaubensgenossen in einem vertrauten Umfeld häufig wiederholt werden, gelten irgendwann ebenso viel wie die eigentliche Theologie oder die Erkenntnisse der Religionen. Guru Nanak, der im 16. Jahrhundert in Indien den Sikhismus begründete,

> **Denn wo zwei oder drei versammelt sind in meinem Namen, da bin ich mitten unter ihnen.**
> **Matthäus 18, 20**

warnte insbesondere vor dem Gedanken, man könne Gott nur durch Rituale nahe kommen. Die Zeit, die man im Gebet verbringt, sollte man nach seiner Ansicht mit der Zeit in Gesellschaft eines Freundes vergleichen. Im Gegensatz zu den Angehörigen manch anderer Religionen verehren die Sikhs deshalb Gott in seiner abstrakten Form, ohne Zuhilfenahme von Bildern oder Statuen. Sie versammeln sich aber zur gemeinsamen Anbetung in ihren Tempeln, den *Gurdwaras*.

Die Riten der islamischen *Haddsch*

Jeder Muslim, der es sich leisten kann und gesund genug ist, hat die Pflicht, einmal im Leben nach Mekka zu pilgern, dem geistlichen Zentrum des Islam. Diese Reise nennt man *Haddsch* – wörtlich bedeutet das „sich zu einem bestimmten Zweck auf den Weg machen". Das *Haddsch*-Ritual besteht aus vier Teilen: 1. Ihram – man trägt besondere Kleidung und versetzt sich in einen spirituellen oder heiligen Geisteszustand; 2. Tawaf – man umkreist siebenmal im Gegenuhrzeigersinn die Kaaba, den heiligen Schrein in Mekka, und berührt möglichst den darin enthaltenen schwarzen Stein (al-Hajar al-Aswad), der vom Himmel auf die Erde gesandt worden sein soll; 3. Wuquf – man begibt sich in die Ebene von Arafat 24 Kilometer östlich von Mekka und betet vor Allah oder in der Nähe des Berges der Vergebung; und 4. man umkreist nach der Rückkehr von Arafat noch einmal die Kaaba. Erst jetzt kann der Pilger sich als *Haddschi* (männlicher Pilger) oder *Haddscha* (Pilgerin) bezeichnen.

Alle Glaubensrichtungen betonen, dass Rituale eine Verbindung zwischen dem spirituellen und dem materiellen Bereich herstellten. In der taoistischen Zeremonie des *Chiao* (oder *Jiao*), in der es um kosmische Erneuerung geht, bringt jeder Haushalt eines Dorfes den örtlichen Gottheiten ein Opfer dar. Ein Priester weiht dann die Opfergaben im Namen der spendenden Familien, stellt mittels eines Rituals die Ordnung im Universum wieder her und bittet die Götter, dem Dorf Frieden und Wohlstand zu bringen.

Aufgrund ihrer Symbolik und des Vertrauens, das die Gläubigen in sie setzen, haben sich die religiösen Rituale im Laufe der Jahrhunderte kaum verändert. Dies liegt größtenteils in ihrem Wesen: Sie verschaffen den heutigen Gläubigen in einer sich schnell wandelnden Welt das Gefühl, auf den Spuren früherer Generationen zu wandeln, die ihren Glauben teilten. Wenn Christen beispielsweise das Vaterunser beten, sprechen sie – meist allerdings in ihrer eigenen Sprache – die gleichen Worte, die in den Evangelien vor 2000 Jahren niedergeschrieben wurden.

Trotz der vielen Unterschiede gibt es aber in den Riten und Ritualen der verschiedenen Glaubensrichtungen auch Überschneidungen und einen Austausch. Manchmal liegt es daran, dass sie einen gemeinsamen Ursprung haben, es kann aber auch eine Absicht dahinterstecken. Als das Christentum im ersten Jahrtausend u. Z. in weiten Teilen Europas an die Stelle der heidnischen Religionen trat, übernahm es bewusst Elemente aus deren Ritualen: So wurden die Festtage für Geburt und Tod Jesu auf die heidnischen Festtage der Wintersonnenwende und der Frühjahrs-Tagundnachtgleiche gelegt.

> **Durch Gebete könnt ihr in eurem Geist einen Altar Gottes bauen.**
>
> **Hl. Johannes Chrysostomus, ca. 390**

Worte und Bedeutungen Religiöse Riten und Rituale sollen auch belehren. Das laute Vorlesen aus heiligen Büchern geht auf eine Zeit zurück, in der die Mehrheit der Gemeinde nicht lesen konnte; es trägt dazu bei, dass die Gläubigen sich auf die wesentlichen Inhalte ihres Glaubens konzentrieren. Muslime werden schon in jungen Jahren dazu angehalten, Passagen aus dem Koran auswendig zu lernen, so dass sie sie ohne Rückgriff auf den gedruckten Text aufsagen können. Und wenn Christen das Nizänische Glaubensbekenntnis sprechen, wiederholen und verinnerlichen sie in komprimierter Form die wesentlichen Lehren ihrer Kirche. Dieser Vorgang wurde in der Kirchengeschichte mit dem lateinischen Ausdruck *Lex orandi, lex credendi* bezeichnet – „das Gesetz des Gebets ist das Gesetz des Glaubens". Oder einfacher gesagt: Was man während eines Ritus oder Rituals ausspricht, glaubt man auch im Herzen.

Worum es geht
Privater Glaube hat eine öffentliche Dimension

07 Das Leben Jesu

Die vier Evangelien im Neuen Testament der Bibel erzählen die Geschichte eines jüdischen Zimmermannssohnes, der im ersten Jahrhundert in Palästina gekreuzigt wurde und dann auf wundersame Weise von den Toten auferstanden sei. Diese Berichte über Taten und Lehre Jesu Christi sind das Fundament des Christentums und haben noch heute große Auswirkungen auf das Leben von schätzungsweise 2,1 Milliarden Christen auf der ganzen Welt, oder, mit anderen Worten, auf ein knappes Drittel der Weltbevölkerung.

Nach der christlichen Lehre war Jesus der Sohn Gottes, der zum Menschen wurde, um die Sünden der Welt zu sühnen. Die Berichte der Evangelisten Markus und Johannes setzen ein, als Jesus bereits erwachsen ist und von seinem Vetter Johannes getauft wird. Die beiden anderen, Matthäus und Lukas, beginnen mit der bekannten Geschichte, die von den Christen jedes Jahr zu Weihnachten erzählt wird: Sie handelt von Jesu Mutter Maria, der jungfräulichen Geburt (Marias Ehemann, der Zimmermann Josef, war demnach nicht Jesu wirklicher Vater) und dem Kind, das im Stall von Bethlehem zuerst von den Hirten besucht wird, später von drei Königen aus dem Morgenland, die von einem Stern an diesen Ort geführt wurden.

Der Schwerpunkt liegt jedoch in allen vier Evangelien auf den drei letzten der 33 Jahre, die Jesus dem christlichen Glauben zufolge auf Erden verbrachte. In dieser Zeit verließ er seine Heimat in Nazareth und wanderte durch das Heilige Land, wie es heute genannt wird. Anfangs predigte er in Synagogen, später bei großen Versammlungen unter freiem Himmel. Gleichzeitig sammelte er eine Gruppe von zwölf Aposteln unter Führung des Fischers Simon, dem er den Namen Petrus gab, und eine weitere große Anhängerschaft um sich.

Zeitleiste

1 u. Z.

30 u. Z.

Jesus wird in Bethlehem geboren

erste öffentliche Predigten

Die vier Evangelien

Die Evangelien überschneiden sich zwar in manchen Berichten, jedes von ihnen enthält aber auch Einzelheiten, die in keinem anderen zu finden sind, und jedes hat seinen eigenen Stil. Am kürzesten ist das Markusevangelium; es bezeichnet Jesus als Mann der Tat und beinhaltet nur wenige sprachliche Ausschmückungen. Es entstand nach heutiger Kenntnis um 70 u. Z. und ist damit auch das älteste Evangelium. Das Matthäusevangelium dagegen wurde gegen Ende des ersten Jahrhunderts verfasst und widmet der Erklärung von Jesu Taten, die bei Markus nur aufgezählt werden, mehr Raum. Es richtete sich anfangs an ein jüdisches Publikum und stellt Jesus in den Zusammenhang der Propheten, Könige und Patriarchen Israels. Das Lukasevangelium, das längste der vier, hat einen poetischen Tonfall. Es enthält viel mehr Geschichten und Bilder; es entstand nach heutiger Kenntnis zwischen Ende des ersten und Anfang des zweiten Jahrhunderts. Der Text des Johannes enthält ganze Abschnitte, zu denen es in den drei anderen keine Entsprechung gibt; in diesen langen Passagen erklärt Jesus, wer er ist und warum er in die Welt gekommen ist. Das Johannesevangelium ist vermutlich das Werk mehrerer Autoren und wurde auf die Zeit zwischen 100 und 125 u. Z. datiert.

Gleichnisse und Wunder In den Evangelien verwendet Jesus vor allem zweierlei Lehrmethoden: Gleichnisse und Wunder. Seine Gleichnisse sind denkwürdige Geschichten, die auf das bäuerliche Alltagsleben zurückgreifen, das seinem Publikum vertraut war, gleichzeitig aber auch umfassendere ethische Aussagen enthalten. Auf diese Weise vermittelte er seine Botschaft einer Bevölkerung, die größtenteils ungebildet war und deshalb abstrakte theologische Ausführungen nicht verstanden hätte.

> **Ohne Jesus Christus wissen wir weder, was unser Leben, noch, was unser Tod ist.**
> Blaise Pascal, 1662

Die Wunder Jesu – die Heilung von Kranken und Sterbenden sowie in mindestens zwei Fällen die Erweckung von den Toten, aber auch das Gehen auf dem Wasser, die Austreibung von Dämonen und die Speisung von 5000 Menschen mit wenigen Broten und Fischen – zeigten, dass er größere Kräfte hatte als ein normaler Mensch. Das war für die, die diese Wunder sahen, der greifbare Beweis, dass er tatsächlich der Sohn Gottes war. Seine Taten erinnern an die vielen Geschichten aus dem Alten Testament – bei den Juden als hebräische Schriften bekannt – über Wunderheilungen durch göttliche Eingriffe.

Die Bergpredigt Welche Botschaft Jesus den Gläubigen im Einzelnen vermitteln wollte, wird in den verschiedenen Zweigen der Christengemeinschaft kontrovers diskutiert. Einige Kernelemente sind jedoch unumstritten. In seinen Gleichnissen beschreibt er, wie die Welt sein sollte: Liebe, Teilen, Fürsorge und Mitleid sollten einen höheren Wert genießen. Von diesen Werten spricht er immer wieder, insbesondere in der Bergpredigt, die im Matthäusevangelium drei der 28 Kapitel beansprucht. Sie enthält die Worte des Vaterunser, das regelmäßig von allen Christen gebetet wird, und Jesu Version der Goldenen Regel, wonach man andere so behandeln solle, wie man selbst behandelt werden möchte. Es finden sich dort auch seine Anweisung „Richtet nicht, auf dass ihr nicht gerichtet werdet" und die Seligpreisungen, deren erste lautet: „Selig sind, die da geistlich arm sind, denn das Himmelreich ist ihrer." Mit diesen Worten identifiziert sich Jesus ausdrücklich mit den Randgruppen und Besitzlosen. Der gleiche Eindruck verstärkt sich später in den

Unabhängige Berichte über Jesus

Neben den Evangelien gibt es drei unabhängige historische Quellen, die über Jesu Leben und Tod berichten. Gegen Ende des ersten und Anfang des zweiten Jahrhunderts beschrieben ihn die römischen Historiker Tacitus und Plinius sowie der jüdische Chronist Josephus als religiösen Lehrer, der in Palästina lebte. Unmittelbar im Anschluss an seine Schilderung des großen Feuers in Rom, das sich 64 u. Z. während der Herrschaft des Kaisers Nero ereignete, berichtete Tacitus: „Nero schob die Schuld der Brandstiftung auf eine Klasse, die wegen ihrer Gräuel verhasst war und beim einfachen Volk Christen hieß, und fügte ihnen die raffiniertesten Foltern zu. Christus, von dem der Name herstammt, erhielt die höchste Strafe während der Herrschaftszeit des Tiberius [14–37 u. Z.] von der Hand unseres Procurators Pontius Pilatus."

> **In jedem Wunder steckt ein heimlicher Tadel an der Welt.**
> John Donne, 1649

Evangelien, wo er einem reichen jungen Mann sagt: „Gehe hin, verkaufe, was du hast, und gib's den Armen, so wirst du einen Schatz im Himmel haben."

Leiden und Tod Jesu Lehren und seine zunehmende Popularität beunruhigten viele zeitgenössische Angehörige des jüdischen Establishments. Sie sahen in ihm eine Bedrohung für ihre Autorität und taten sich mit der römischen Kolonialmacht zusammen, um ihn zum Tode zu verurteilen. Die letzte Woche seines Lebens verbrachte er den Evangelien zufolge in Jerusalem. Sie begann mit seinem triumphalen Einzug in die Stadt, bei dem die Menschen ihn als Befreier von der Fremdherrschaft feierten. Am Ende standen seine Verurteilung und der Tod am Kreuz – ein Martyrium, das im Christentum als Passion bezeichnet wird.

Die Evangelien berichten, Jesus sei drei Tage nach seinem Tod, am Ostersonntag, von den Toten auferstanden. Durch Tod und Auferstehung, so die Lehre, habe er die Sünden der Menschheit auf sich genommen, und nachdem er seinen Auftrag auf Erden an die Apostel übertragen hatte, die zu den ersten Führern der christlichen Kirche werden sollten, fuhr er in Herrlichkeit gen Himmel und kehrte zurück zu seinem Vater.

Worum es geht
Jesus Christus ist der Sohn Gottes

08 Gott und Mammon

Obwohl Jesus sich in seinen Lehren immer wieder für die Armen, die an den Rand Gedrängten und die Besitzlosen einsetzte, wurde die in seinem Namen gegründete christliche Kirche später zu einer der reichsten und mächtigsten Institutionen der Welt. In vielerlei Hinsicht kann man sie als den ersten multinationalen Konzern betrachten. In der gesamten Geschichte der Christenheit war die Beziehung zwischen Gott und Mammon – das in der Bibel verwendete Wort stammt von dem hebräischen Begriff für „Geld" – immer problematisch.

In ihrer Frühzeit existierte die christliche Kirche an den Rändern der Gesellschaft. Vielfach bestand sie aus Untergrundgruppen, die insbesondere im römischen Reich einer ständigen, blutigen Verfolgung ausgesetzt waren. Strukturen gab es nur in Ansätzen, und ihre Mittel waren knapp. Im Jahr 312 wurde das Christentum dann vom römischen Kaiser Konstantin offiziell als Staatsreligion anerkannt. Damit erhielt die Kirche Zugang zu beträchtlichen Mitteln, was in Rom und anderswo zu einer großen Welle des Kirchenbaus führte.

Im vierten und fünften Jahrhundert zerfiel der westliche Teil des römischen Reiches. In dem Chaos, das darauf folgte, gelang es der christlichen Kirche, Macht und Einfluss nicht nur zu behalten, sondern sogar zu erweitern. Dazu schlüpfte sie ins Gewand der weltlichen wie auch der geistlichen Autorität. Unter der Herrschaft geschickter, ehrgeiziger Kirchenführer, etwa unter Papst Gregor dem Großen am Ende des sechsten Jahrhunderts, bekehrte sie viele Heiden, die zuvor zur Zerstörung des alten Reiches beigetragen hatten. Damit legte sie die Grundlage für ein ganz neues politisches System, dessen Mittelpunkt die Kirche bildete. Um das Jahr 800 hatte der Frankenkönig Karl der Große seine Herrschaft über Westeuropa gefestigt; am Weihnachtstag jenes Jahres reiste er nach Rom, kniete vor Papst Leo III. nieder und ließ sich zum Heiligen Römischen Kaiser krönen. Damit stand die christliche Kirche unverkennbar im Mittelpunkt der Weltpolitik.

Zeitleiste

ca. 64

Petrus, der erste Papst, wird
von den Römern hingerichtet

312

Friedensschluss zwischen Kirche
und Römischem Reich

Seither gab es in der Beziehung zwischen Kirche und Staat viele Hochs und Tiefs, insgesamt aber spielt das Christentum bis heute auch in weltlichen Angelegenheiten eine akzeptierte und manchmal auch offiziell anerkannte Rolle. Dies führte unter anderem dazu, dass die Kirche große Reichtümer anhäufte; unter ihrer Schirmherrschaft wurden viele außergewöhnliche Bau- und Kunstwerke geschaffen, darunter Michelangelos gewaltiges Fresko *Das Jüngste Gericht* (1537–1541) in der Sixtinischen Kapelle, die zum Komplex des Papstpalastes im Vatikan gehörte.

> **Der Papst! Wie viele Divisionen hat er?**
> Josef Stalin, 1935

Eine Quelle des Widerspruchs Die Beziehung zwischen Kirche und Mammon war nie einfach. Lange Zeit wurde darüber diskutiert, wer das Recht haben sollte, Bischöfe zu ernennen: der lokale Herrscher oder der Papst in Rom. Und die Praxis des Ablasshandels (siehe unten) veranlasste den deutschen Mönch Martin Luther im Jahr 1517, mit dem Katholizismus zu brechen, was letztlich zur protestantischen Reformation führte.

Der Ablasshandel

Im Jahr 1517 bot Papst Leo X. jenen Christen, die Geld für den Neubau des Petersdoms in Rom gespendet hatten, den Ablass an, das heißt die Vergebung ihrer Sünden. Der aggressive Verkauf dieser Vergebung machte den Augustinermönch und Lehrer Martin Luther (1483–1546) so wütend, dass er die Praxis in seinen 95 Thesen angriff: Das darin formulierte Reformprogramm nagelte er der Legende zufolge im Oktober 1517 an die Tür der Schlosskirche zu Wittenberg. In der These 28 zog Luther gegen eine bestimmte Formulierung zu Felde, die beim Verkauf der Ablässe verwendet wurde: „Wenn das Geld im Kasten klingt, die Seele aus dem Fegefeuer springt." Das Einzige, was der Ablasshandel garantiere, hielt Luther dagegen, sei eine Zunahme von Profit und Habgier; die Vergebung jedoch sei allein die Sache Gottes.

800
Karl der Große wird vom Papst gekrönt

1517
Luther wendet sich gegen den Ablasshandel

1787
Trennung von Kirche und Staat in der Verfassung der Vereinigten Staaten

Theologie der Befreiung

Das Konzept der Befreiungstheologie entwickelte sich in den 1960er Jahren in Lateinamerika und Asien als wissenschaftliche und praktische Ausdrucksform des katholischen Christentums. Die Kirche wurde aufgefordert, dem Beispiel Jesu zu folgen und „sich bevorzugt für die Armen einzusetzen". Einer ihrer bekanntesten Vertreter, der brasilianische Geistliche Leonardo Boff, schrieb: „Wie können wir in einer Welt der Zerstörung und der Ungerechtigkeiten noch Christen sein? Wir sind nur dann Nachfolger Jesu, wenn wir gemeinsame Sache mit den Armen machen und das Evangelium der Befreiung verkünden."

Diese Botschaft löste heftige Kontroversen aus. Boff wurde in den 1980er Jahren vom Papst mundtot gemacht und legte später sein Priesteramt nieder. Nach Ansicht der Kirchenführung im Vatikan ist die Befreiungstheologie ein zu politisches Evangelium und birgt die Gefahr in sich, das Christentum mit dem Marxismus zu infizieren. Papst Johannes Paul II. bekräftigte 1986 das Ziel, sich für die Armen einzusetzen, betonte aber, dies dürfe nicht mit politischen Mitteln geschehen, sondern indem man jedem Einzelnen helfe, zu einem sündenfreien Leben zu finden.

In manchen Ländern, beispielsweise in Großbritannien, ist die Kirche nach wie vor ein Verfassungsorgan und erhält staatliche Mittel. In den letzten Jahrhunderten wurden aber die offiziellen Verbindungen zwischen Kirche und Staat in mehreren, zuvor offiziell christlichen Staaten – insbesondere in Frankreich – gelockert; in anderen, so in den Vereinigten Staaten, ist die Trennung zwischen beiden in der Verfassung festgeschrieben. Anderswo schränken Regierungen die Tätigkeit der Kirche ein. In China zum Beispiel gründeten die kommunistischen Behörden eine staatlich kontrollierte Chinesische Katholische Patriotische Vereinigung, um damit den „Einfluss von außen" der Kirche in Rom auf ihre Bevölkerung zu verringern.

❞ Ich betrachte die ganze Welt als meine Pfarrei. ❝

John Wesley, ca. 1780

Ein himmlischer Funke Welch großen politischen Einfluss das Christentum nach wie vor hat, wurde während der Amtszeit von Papst Johannes Paul II. (1978–2005) besonders deutlich. Viele Menschen meinten, von ihm sei der „himmlische Funke" ausgegangen, der seit 1989 in Osteuropa einschließlich seiner polnischen Heimat die Revolutionen zur Abschaffung des Kommunismus in Gang setzte. Berichten zufolge arbeitete er zur Erreichung dieses Ziels eng mit der US-Regierung zusammen. In anderen Bereichen jedoch war Johannes Pauls gesellschaftlicher und politischer Einfluss umstritten. So beharrte er beispielsweise darauf, dass die Lehre der Kirche den Gebrauch von Kondomen zur Verhütung von AIDS verbot; dies hatte nach Ansicht vieler Gesundheitsorganisationen große Auswirkungen auf die Bemühungen der Regierungen und der internationalen Gemeinschaft, die Pandemie insbesondere in Afrika einzudämmen. Die Beziehung zwischen Kirche und Staat ist bis heute Gegenstand von Kontroversen und Diskussionen.

Worum es geht
Religion ist politisch

09 Reformation

Während der ersten 1000 Jahre ihrer Existenz erfüllte die christliche Kirche das Versprechen des apostolischen Glaubensbekenntnisses, „eine einzige, heilige, katholische und apostolische" Kirche zu sein. Zwischen ihren verschiedenen Teilen gab es aber auch zu dieser Zeit schon Meinungsverschiedenheiten über Doktrin und Organisation. Das 11. Jahrhundert brachte den Bruch zwischen abendländischen und östlichen (orthodoxen) Christen. Zu Beginn des 16. Jahrhunderts setzte der deutsche Mönch Martin Luther die Reformation in Gang, die zu einer bis heute andauernden Trennung führte.

Ende des 15. Jahrhunderts wirkte das Papsttum mächtiger als je zuvor. Die Zurschaustellung von Reichtum, die Aufträge für große Kunstwerke und der pompöse Lebensstil einiger Päpste schienen Zeichen für die robuste Gesundheit der Institution zu sein. Hinter der Fassade jedoch befand sich das Christentum in moralischem und spirituellem Verfall. Aus Verzweiflung über das Verhalten der Päpste – Alexander VI. (1492–1503) wurde beispielsweise als Papst eingesetzt, während seine Kinder aus verschiedenen illegitimen Beziehungen unverfroren zusahen – setzte sich eine Reihe oftmals kleiner lokaler Reformbewegungen für eine spirituelle Erneuerung und die Wiederbelebung der hohen moralischen Ideale in Theorie und Praxis der Kirche ein. Eine davon war die „Gemeinschaft der göttlichen Liebe", eine mildtätige Institution, die 1497 in Genua von Ettore Vernazza gegründet wurde und auch in Rom, Neapel und Bologna aktiv war. Aber keine davon erlangte genügend Einfluss, um das Papsttum ernsthaft infrage zu stellen.

Martin Luther Als Martin Luther Anfang des 16. Jahrhunderts öffentlich die kirchliche Korruption anprangerte, sprach er für viele enttäuschte Gläubige. Die theologischen Grundlagen seines Aufbegehrens stehen in den berühmten 95 Thesen, die er im Jahr 1517 an die Tür einer Kirche in Wittenberg nagelte. Er lehnte die in

Zeitleiste

ca. 1490er Jahre	1517
Gründung reformorientierter Bruderschaften	Luther nagelt seine 95 Thesen an die Kirchentür

der katholischen Christenheit damals wie heute zentrale Vorstellung ab, man könne mit guten Taten dazu beitragen, sich nach dem Tod einen Platz im Himmel zu sichern. Die Erlösung, so Luther, hänge ausschließlich vom Glauben an Gott ab. Was zähle, sei nicht das Verhalten des Einzelnen, sondern Gottes Liebe.

Die Bibel in Umgangssprache

Die oberste Instanz christlicher Autorität waren für Luther nicht die Aussprüche des Papstes oder die traditionellen Praktiken der Kirche, sondern die Bibel. 1521 tobte der Konflikt zwischen deutschen Fürsten, die ihn verteidigten, und der Kirche, die ihn zum Schweigen bringen wollte. In diesem Jahr machte Luther sich daran, das Neue Testament ins Deutsche zu übersetzen. Schon früher hatte es Bemühungen gegeben, die Bibel in der Sprache des Volkes, anstelle des Kirchenlateins, zugänglich zu machen. Luthers Arbeit glänzte durch ihre Wissenschaftlichkeit:

Er hielt sich an die griechische Urfassung, um die wahre Bedeutung der Bibel zu verstehen – und er bediente sich der deutschen Sprache, wie sie von einfachen Menschen gesprochen wurde. Er wollte die Bibel für alle verständlich machen. Sein Neues Testament erschien 1522, die vollständige deutsche Bibel 1534. Anderswo erschienen eine niederländische Bibel (1526), eine französische Bibel (1528) und eine Züricher Bibel (1531). Diese Projekte wurden zur Anregung für andere, und 1611 erschien die King James Bible, eine Übersetzung ins Englische.

Luther profitierte bei seinen Angriffen von seinen rhetorischen Fähigkeiten, und er nutzte den neu erfundenen Buchdruck, um seine Botschaft in Büchern und auf Flugblättern zu verbreiten. Außerdem kam es ihm gelegen, dass man ihn in Rom als unwichtig abtat, statt ihn als ebenbürtigen Gegner mit einer wachsenden Unterstützergemeinde anzuerkennen. Als die deutschen Fürsten mit seiner Hilfe versuchten, dem Papst den Zugriff auf ihre Ländereien zu verwehren, erkannte er, dass er mächtige politische Fürsprecher hatte. Sie sorgen dafür, dass er der Verhaftung und Bestrafung durch die Kirche sowie 1521 auf dem Reichstag zu Worms auch der Verurteilung durch den Heiligen Römischen Kaiser Karl V. entgehen konnte.

1532
Heinrich VIII. bricht mit Rom

1541
Luther lehnt in Regensburg einen Kompromiss ab

1545
Konzil von Trient

Zwingli und Calvin

Ulrich Zwingli (1484–1531) reagierte ähnlich wie Luther auf den moralischen und spirituellen Verfall der römischen Kirche, er lebte aber in dem ganz anders gearteten politischen Umfeld des Stadtstaates Zürich in der nahezu unabhängigen schweizerischen Eidgenossenschaft. Erstmals machte er 1522 auf sich aufmerksam, als er die Tradition des Fastens in der Zeit vor Ostern anprangerte. Später griff er die Korruption innerhalb des Klerus an, setzte sich für die Eheschließung von Priestern ein und lehnte den Gebrauch von Bildern im Gottesdienst ab – Kirchen sollten für ihn so einfach wie möglich aussehen. Die Bibel zog er als Autorität den Päpsten vor, die Sakramente lehnte er ab, und er hoffte auf eine von Gott gelenkte Regierung. Der Zwinglianismus gewann zwar großen Einfluss, überlebte aber als eigenständige Bewegung nur in der Schweiz. Der Franzose Johannes Calvin (1509–1564) dagegen gilt als einer der wichtigsten Begründer der modernen Reformierten Kirche. Er lebte in Genf, sagte sich 1530 von Rom los, reformierte die Liturgie und pries die Beziehung jedes einzelnen Menschen zu Gott. Eine von ihm neu geschaffene Verwaltungsstruktur der Kirche trat an die Stelle des autoritären Papsttums.

Daraufhin wurde Luther immer kühner. Er lehnte fünf der sieben kirchlichen Sakramente ab, griff die Autorität des Papstes an und setzte sich dafür ein, Gottesdienste in der Landessprache statt in Latein abzuhalten. Die Kluft wurde tiefer. Beim Regensburger Kirchengespräch von 1541 wuchsen die Hoffnungen auf eine Versöhnung, aber Luthers Forderungen – für die Erlaubnis für Priester zu heiraten, für eine lokale Unabhängigkeit vom Papst – erwiesen sich als zu weitreichend.

> **❞ Die Erfindung des Buchdrucks und die Reformation sind und bleiben die beiden herausragenden Dienste, die Mitteleuropa der Menschheit erwiesen hat. ❞**
> Thomas Mann, 1924

Die Kirche von England (Church of England)
Mittlerweile hatten Luthers Gedanken sich in Europa verbreitet und spornten andere an, darunter Ulrich Zwingli und Johannes Calvin in der Schweiz. In England nutzte Heinrich VIII. (1491–1547) den neuen protestantischen Geist, um einen Streit mit dem Papst um die Scheidung von seiner ersten Frau beizulegen, die ihm keinen männlichen Erben geschenkt hatte. Spätere englische Herrscher schwankten zwischen einem extremen

Protestantismus (Edward VI., 1537–1553) und einem aggressiven Katholizismus (Maria I., 1516–1558); Heinrichs zweite Tochter Elisabeth (1533–1603) erreichte schließlich einen Konsens, der zu einer gemäßigten Form des Protestantismus – der Kirche von England – führte.

Gegenreformation Nach der Reformation war der katholischen Kirche klar, dass sie nur mit Veränderungen überleben und sich neu ordnen konnte. Über die Gegenmaßnahmen wurde auf dem Konzil von Trient entschieden, das zwischen 1545 und 1563 mehrmals zusammentrat. Es überprüfte umstrittene Doktrinen, beharrte aber auf dem Priesterzölibat, behielt die sieben Sakramente bei und bekräftigte die Autorität des Papstes. Es erkannte aber auch an, dass manche alten Missbrauchspraktiken aufhören mussten. In einigen Ländern, in denen der Katholizismus an Einfluss verloren hatte – in Frankreich, Polen, den südlichen Niederlanden und Teilen Deutschlands – wurde seine Macht wiederhergestellt, die religiöse Teilung gehörte aber seither immer zum Gesicht Europas.

> **Die Kirche von England, jene schöne Blüte, welche die geniale Kompromissfähigkeit unserer Insel hervorgebracht hat.**
> Robert Bolt, **1960**

Worum es geht
Römisches Fehlverhalten löste einen Aufstand aus

10 Das Papsttum

Die katholische Kirche unterscheidet sich in vielen Aspekten von den anderen christlichen Religionen. Einer davon ist das Festhalten am Papsttum. Nach der katholischen Lehre steht der Papst in Rom in einer ununterbrochenen Reihe, die sich bis auf den Apostel Petrus zurückverfolgen lässt, und er verfügt über eine beispiellose Autorität in geistlichen und dogmatischen Fragen. Die Äußerungen des Papstes in bestimmten Angelegenheiten des Glaubens und der Moral gelten als unfehlbar – das heißt, er kann sich nicht irren.

Das hierarchische System der Kirchenleitung im Christentum wurde um 160 u. Z. eingerichtet. Zuvor genossen die verschiedenen christlichen Gemeinschaften eine beträchtliche Selbstständigkeit. Eine eindeutige Führung fehlte, und deshalb kam es häufig zu Diskussionen über die wahre Lehre. Um diesem Missstand abzuhelfen, bildete sich in der Frühzeit der Kirche ein System mit mehreren Hierarchieebenen (Erzbischöfe, Bischöfe, Priester und Diakone) mit dem Papst an der Spitze. Diese Geistlichen übten ihrerseits Autorität über die einfachen, als Laien bezeichneten Menschen aus.

Theorie und Praxis In der Anfangszeit des Christentums war die Autorität des Papstes eher theoretischer als praktischer Natur. Erst Mitte des fünften Jahrhunderts, während der Amtszeit von Papst Leo dem Großen, machte sich der Einfluss des Papstes als Bischof von Rom und Nachfolger von Petrus in Europa in nennenswerten Umfang bemerkbar. Leo verschaffte sich diese Autorität durch persönliches Engagement und durch sein Vorbild in Verbindung mit einer erfolgreichen Missionstätigkeit sowie durch Bündnisse mit mächtigen Königen und Prinzen.

Zeitleiste

ca. 64 u. Z.	160
Petrus wird hingerichtet	Anfänge der Hierarchie

Papst Leo der Große

Leo (440–461) ist einer von nur zwei Päpsten in der Geschichte, die den Beinamen „der Große" erhielten. Er wurde vor allem dadurch bekannt, dass er für den Papst die höchste Autorität in der Kirche einforderte. „Er machte ein für alle Mal klar, dass das Papsttum mit Petrus identisch ist", schrieb der Kirchenhistoriker Eamon Duffy, der in Cambridge lehrte. „Leo hatte ein fast mythisches Gespür für diese Identität. Er bezeichnete sich zwar als 'unwürdiger Erbe', erbte von Petrus aber alle Privilegien." Leo setzte seine Vorstellung vom Papsttum energisch und rücksichtslos durch und verwandelte die Kirche damit von einem System mehr oder weniger selbstständiger Prälaten und Bischöfe, die sich über das Gebiet des alten Römischen Reiches verteilten, in einen hierarchischen Apparat mit dem Papst an der Spitze. Er war nicht nur ein geschickter Redner und Diplomat, sondern auch ein sehr mutiger Mann. Im Jahr 452 stellte er sich dem Hunnen Attila entgegen, der Norditalien in Schutt und Asche gelegt hatte und nun weiter nach Süden in Richtung Rom vordringen wollte; er konnte den Eindringling überreden, sich zurückzuziehen.

Danach erlebte das Papsttum Blütephasen mit höchster Macht, aber auch Zeiten – beispielsweise im neunten Jahrhundert –, in denen Rom und das Papsttum im Chaos versanken. Die katholische Kirche hält zwar auch heute noch an der Vorstellung einer apostolischen Nachfolge fest, durch die jeder einzelne der mehr als 260 Nachfolger Petri durch diesen mit Jesus verbunden ist, in Wirklichkeit hatten aber auch Wüstlinge, Betrüger und der Legende zufolge sogar eine als Mann verkleidete Frau das Amt inne. Die kirchliche Lehre besagt aber, dass das Versagen einzelner Päpste die Autorität des Amtes nicht ins Wanken bringen kann. Außerdem sollte man nicht vergessen, dass viele Päpste Männer mit großen geistigen Fähigkeiten, Demut, Spiritualität und ethischem Mut waren, die das Gewand Petri durchaus zu Recht trugen.

> **Du bist Petrus, und auf diesen Felsen will ich bauen meine Gemeinde.**
> Matthäus 16, 18

440
Leo der Große erweitert seinen Herrschaftsbereich

1870
Der Papst wird für unfehlbar erklärt

> **Das Papsttum ist nichts anderes
> als der Geist des verstorbenen
> Römischen Reiches.**
>
> Thomas Hobbes, **1651**

Papstwahlen Im ersten Jahrtausend der Kirchengeschichte wurden Päpste häufig durch Abstimmung der Geistlichen in ihrem Umfeld oder auch der Bevölkerung Roms gewählt. Auch weltliche Herrscher spielten manchmal eine Rolle, da die Beziehung zwischen Kirche und Staat von großer Bedeutung war. Seit 1059 bildete sich langsam das bis heute bestehende System heraus. Jetzt wählten die Kardinäle den Papst in einer Reihe geheimer Abstimmungen aus ihrer Mitte. Ungefähr 80 Prozent der Männer, die bisher auf dem Stuhl Petri saßen, waren Italiener, und 38 Prozent stammten aus Rom. Nachdem aber heute ein immer größerer Anteil der wahlberechtigten Kardinäle aus Entwicklungsländern stammt, wird es wohl nur eine Frage der Zeit sein, bis einer von ihnen auch Papst und damit ein Symbol der heute weltweit verbreiteten Kirche wird.

Unfehlbarkeit Der Anspruch auf eine oberste, von Gott verliehene Autorität wurde von den Päpsten aller Zeiten erhoben und bildet ein Kernstück des Katholizismus. Kein Mitglied der Kirche darf demnach den Lehren des Papstes widersprechen oder sie missachten. Die Tradition, dass der Papst die Wahrheit der Apostel weiterträgt, wurde erstmals 519 in der Formel von Hormisdas festgeschrieben; diese ist nach dem Papst benannt, der sie gemeinsam mit dem römischen Kaiser Justinian durchsetzte.

Im Laufe der folgenden Jahrhunderte gab es innerhalb der Kirche immer wieder langwierige Diskussionen über die Unfehlbarkeit des Papstes. Aber erst im 19. Jahrhundert – also gerade zu einer Zeit, als die weltliche Macht des Papstes, mit den Bestrebungen zur Vereinigung Italiens und dem damit verbundenen Verlust des Kirchenstaates im Jahr 1870, einen Tiefpunkt erreicht hatte – wurde der Anspruch des Papstes, in manchen geistlichen Fragen unfehlbare Lehren zu verkünden, bei einem Treffen der Kardinäle in Rom festgeschrieben. Seit jener Zeit wurde aber nur eine einzige päpstliche Äußerung – die Erklärung im Jahr 1950, wonach Maria, die Mutter Jesu, mit Leib und Seele in den Himmel aufgefahren sei (Mariä Himmelfahrt) – als unfehlbar eingestuft.

Exkommunikation

Im Mittelalter, als die Inquisition auf ihrem Höhepunkt wütete und ihre Vertreter die päpstliche Lehre häufig mit Folter und Todesstrafe durchsetzten, wurden abweichende Meinungen oft mit der Exkommunikation bestraft. Nach der Reformation bemühte sich das Konzil von Trient, solche Exzesse zurückzudrängen: Es ordnete an, die Exkommunikation nur mit „Ernsthaftigkeit und großer Umsicht" zu verhängen. Der Kodex des Kanonischen Rechts, das Gesetzbuch der katholischen Kirche, nennt als Sünden, die mit Exkommunikation bestraft werden dürfen: Abfall vom Glauben, Ketzerei, Kirchenspaltung, Entweihung der Eucharistie, körperliche Gewalt gegen den Papst und die Schaffung der Gelegenheit zur Abtreibung.

Mit seinem Beamtenapparat im Vatikan (der Kurie), dem weltweiten Netz der lokalen Erzbischöfe und Bischöfe sowie den Geistlichen in den Kirchengemeinden hat der Papst noch heute die Macht, einzelne Katholiken zu disziplinieren – entweder durch Ausschluss von den Sakramenten oder in seltenen Fällen durch Exkommunikation, den Ausschluss aus der Kirche. Dabei wird aber betont, dass ja nur derjenige aus der Kirche ausgeschlossen werden kann, der vorher durch die Taufe ihr Mitglied geworden ist; daher bleibt nach der Exkommunikation die Tür für Buße und Wiederaufnahme immer offen.

Worum es geht

Der Papst ist das Oberhaupt der katholischen Kirche

11 Schuld und Frauenfeindlichkeit

In den vier Evangelien des Neuen Testaments geht es Jesus vor allem um die Sozialethik, wie man sie nennen könnte – um die Frage, wie Einzelne und Gesellschaft einander gerecht und liebevoll gegenübertreten können. Über Geschlechter oder Sexualmoral sagt er sehr wenig. Die christliche Kirche wurde während ihrer Geschichte ausschließlich von Männern geleitet, und manche Konfessionen lassen Frauen bis heute nicht als Geistliche zu. Außerdem wird ihre radikale soziale Botschaft häufig durch konservative Einstellungen zu Empfängnisverhütung, Abtreibung, Sexualität vor der Ehe und Homosexualität überschattet.

Im Laufe der Jahrhunderte wurden viele traditionelle abendländische Einstellungen zur Sexualmoral und zu der Rolle von Männern und Frauen in der Gesellschaft durch das Christentum geprägt. Während aber unsere zunehmend säkulare Gesellschaft toleranter geworden ist, halten die Kirchen an ihren althergebrachten Lehren fest, die häufig als sexualfeindlich und als vorurteilsbeladen gegenüber Frauen gelten.

Nach Ansicht der Kritiker ist Religion für Männer eine Methode des Machterhalts. Viele ehrlich Gläubige entwickeln wegen der immer breiter werdenden Kluft zwischen den Idealvorstellungen ihrer Religion von Sexualität und Geschlechterrollen auf der einen Seite und der Realität ihres Alltagslebens auf der anderen Seite Ängste und Schuldgefühle; dies zeigt sich beispielsweise in den Romanen von Autoren wie Graham Greene, Edna O'Brien, Antonia White und David Lodge.

Zeitleiste

4. Jahrhundert v. u. Z.

Platon betrachtet Leib und Seele als getrennte Gebilde

5. Jahrhundert u. Z.

Augustinus warnt vor den Gefahren der Sexualität

Frauen in Islam und Judentum

Im Islam gibt es in Bezug auf Frauen einen Widerspruch zwischen Lehre und Praxis. Der Koran betont die Gleichberechtigung von Männern und Frauen, die von einer einzigen Seele abstammten. Historiker weisen darauf hin, dass Mohammed sich von seinen Frauen beraten ließ und ihnen mehr Rechte einräumte, als es der späteren Tradition entsprach. In manchen muslimischen Ländern haben Frauen bis heute kaum Rechte und Freiheiten; umstritten ist aber, ob dies auf ihrer eigenen Entscheidung oder auf den Vorurteilen der Männer beruht. Als etwa die Taliban-Fundamentalisten in Afghanistan herrschten, verweigerten sie Frauen den Schulbesuch und bestanden darauf, dass sie Körper und Gesicht in der Öffentlichkeit bedeckten.

In Saudi-Arabien dürfen Frauen nicht Auto fahren. Im Irak dagegen ist der Frauenanteil im Parlament einer der höchsten der Welt. Auch im Judentum gibt es gegenüber Frauen unterschiedliche Einstellungen, je nachdem, welche Form des Glaubens praktiziert wird. In manchen liberalen jüdischen Gemeinden gibt es weibliche Rabbiner. Orthodoxe Gruppen dagegen verlangen, dass Frauen in der Synagoge in einem abgegrenzten Bereich sitzen, und in ultraorthodoxen Kreisen wird von Frauen erwartet, dass sie rituelle Reinheitsgesetze befolgen; dazu gehören das Verbot der ehelichen Sexualität während der Menstruation und das Bedecken der Haare in der Öffentlichkeit.

Erst seit ungefähr 100 Jahren lassen die meisten christlichen Konfessionen auch Frauen als Priester und Geistliche zu. Antoinette Brown wurde 1853 die erste freikirchliche Pastorin, 1886 folgten Helenor Alter Davisson bei den Methodisten und 1942 Florence Li Tim-Oi bei den Anglikanern. Die Kirche von England selbst ordinierte erst 1992 zum ersten Mal Frauen. In den anglikanischen Bezirken der Verei-

> **Meine wichtigsten Probleme mit der Kirche drehen sich um ihre Einstellung zur Sexualität. Man könnte also durchaus behaupten, dass die Kirche eine Alternative zum Sexualleben ist.**
> **Antonia White, 1899-1980**

nigten Staaten und Neuseeland gibt es seit 1989 Bischöfinnen, aber manche Teile dieser Konfession verweigern noch heute, ebenso wie die katholische Kirche, den Frauen das Priesteramt. Dafür werden dreierlei Argumente angeführt: Jesus habe nur männliche Apostel gewählt; der Geistliche stehe anstelle Jesu am Altar und müsse deshalb wie er ein Mann sein; und die Tradition der Kirche schließe Frauen als Priester aus, auch wenn dies nicht ausdrücklich in den Evangelien steht.

Die katholische Kirche besteht auch auf dem Zölibat für die Priester (in seltenen Fällen wurden allerdings Ausnahmen zugelassen). In der Frühzeit der Kirche war dies nicht üblich; bis zum Konzil von Trient gab es verheiratete Geistliche. Die Regel wurde erlassen, weil man glaubte, die zölibatär lebenden Mönche in den Klöstern seien für die Gläubigen ein besseres Vorbild als ein Gemeindepriester mit Ehefrau und Kindern. In der katholischen Hierarchie glaubte man, Angehörige würden einen Geistlichen von seinem Amt ablenken; in anderen Kirchen stellte man allerdings fest, dass sich die Rollen als Vater und Pater durchaus miteinander vereinbaren lassen.

Augustinus und Thomas von Aquin

Augustinus (354–430) wurde christlich getauft, entfernte sich aber während seiner ausschweifenden, weltlichen Jugendjahre von der Kirche. Mit 33 Jahren kehrte er, von seiner Mutter, der heiligen Monika, ermutigt, in die Gemeinde zurück und war während seines restlichen Lebens in Nordafrika ein angesehener Bischof und Lehrer. Seine Schriften, insbesondere die *Bekenntnisse* und der *Gottesstaat*, haben in katholischen Kreisen bis heute überdauert. Augustinus beschäftigte sich mit Blick auf sein eigenes früheres Leben ausführlich mit dem sündigen menschlichen Fleisch und mit den Gefahren der Sexualität für den Geist. Thomas von Aquin (1225–1274), der wie Augustinus noch heute häufig von Päpsten und Bischöfen zitiert wird, konstruierte im Rückgriff auf die griechischen Philosophen ein rationales Verständnis von Gott als Schöpfer und Quell allen Seins, aller Güte und Wahrheit. In seiner *Summa Theologia* beschreibt er ein Naturgesetz, das heißt, ein vorgegebenes moralisches Verhaltensmuster, das man bei Tieren beobachten könne, das aber auch bei Menschen vorhanden sei. Dies prägte seine Schriften über die Sexualität der Menschen. „Der Zustand der Jungfräulichkeit", behauptete er, „ist sogar dem einer dauerhaften Ehe vorzuziehen."

> ❞ Ich erkläre, dass die Kirche keinerlei Autorität besitzt,
> die Priesterweihe an Frauen zu erteilen, und dass dieses Urteil
> von allen Gläubigen der Kirche eindeutig mitgetragen
> werden muss. ❝
>
> Papst Johannes Paul II., 1994

Gefahren der Sexualität Das Christentum war nicht die erste Religion, die sexuelles Vergnügen für gefährlich hielt. Der griechische Philosoph Platon (424–348 v. u. Z.) lehrte, der menschliche Körper sei böse, weil er den Geist vom Streben nach der Wahrheit ablenke. Sexualität war für ihn ausschließlich eine körperliche Funktion. Sein Schüler Aristoteles (384–322 v. u. Z.) teilte diese Ansicht; Frauen waren in seinen Augen minderwertig und lenkten die Männer von geistigen Beschäftigungen ab. Aristoteles und Platon trugen entscheidend zu der pessimistischen Einstellung bei, die die meisten christlichen Aussagen zur Sexualmoral bestimmt. Insbesondere Augustinus und Thomas von Aquin nutzten im fünften beziehungsweise 13. Jahrhundert die Schriften dieser Philosophen als Grundlage für ihre eigenen einflussreichen Beiträge zu dem Thema.

Noch heute lehren die meisten christlichen Kirchen, dass Homosexualität eine Sünde ist – obwohl Jesus sie in den Evangelien nicht erwähnt. Ebenso halten sie an seiner ausdrücklichen Verurteilung der Ehescheidung fest – eine der wenigen Stellen, an denen sich Jesus zu einem Thema der Sexualmoral äußert –, und die meisten plädieren auch für sexuelle Enthaltsamkeit vor der Ehe. Die katholische Kirche wendet sich gegen die so genannte „künstliche Empfängnisverhütung" – die Pille, Kondome, Intrauterinpessare –, weil diese nach ihrer Überzeugung die „Übertragung menschlichen Lebens" behinderten, die der wichtigste Zweck der Sexualität sei. Die unauflösliche Verbindung zwischen Sexualität und der Schaffung neuen Lebens ist auch der Grund, warum die katholische Kirche gegenüber der Homosexualität so feindselig eingestellt ist.

Worum es geht
Frauen und Sex sind gefährlich

12 Der Heilige Geist

Die Hauptrichtung des Christentums lehrt, dass Gott in drei Personen ein Einziger ist: Gott Vater, Gott Sohn und Gott Heiliger Geist. Gemeinsam werden sie als Dreifaltigkeit bezeichnet. Alle drei sind gleich und haben die gleiche „Essenz", aber jede spielt eine besondere Rolle. In der modernen Pfingstbewegung ist der Geist das herausragende Element der Dreifaltigkeit, und den „Gaben des Geistes" schreibt man die Fähigkeit zu, ein Leben umzugestalten. Für viele Christen bleibt der Heilige Geist jedoch ein schwer fassbarer Begriff.

In der Heiligen Schrift wird die Dreifaltigkeit nicht ausdrücklich erwähnt. Die Lehre bildete sich erst in der Frühzeit der Kirche allmählich heraus, und im dritten Jahrhundert u. Z. war man sich einig, dass Vater, Sohn und Heiliger Geist nicht nur verbunden oder verwandt sind, sondern das gleiche Wesen darstellen. Im nizänischen Glaubensbekenntnis, das im vierten Jahrhundert formuliert wurde und viele christliche Richtungen verbindet, wird die genaue Beziehung zwischen den Elementen der Dreifaltigkeit dargelegt. In der Version, die noch heute in der katholischen Messe gesprochen wird, heißt es beispielsweise: „Wir glauben an den Heiligen Geist, der Herr ist und lebendig macht, der aus dem Vater und dem Sohn hervorgeht, der mit dem Vater und dem Sohn angebetet und verherrlicht wird."

Ketzerei und Streitigkeiten Die Formel der Dreifaltigkeit war in der Kirchengeschichte umstritten. Der Priester Arius aus Alexandria lehrte im vierten Jahrhundert, Jesus sei übernatürlich gewesen, aber nicht dem Gottvater gleich. Die daraus erwachsene „Arianische Häresie" spaltete die Kirche. Im neunten Jahrhundert entschieden sich die Christen im Osten, die Worte „und dem Sohn" (lateinisch *filioque*) aus dem Bekenntnis zu streichen und darauf zu beharren, dass der Geist ausschließlich vom Vater käme. Diese Haltung trug 1054 zur Spaltung zwischen Ost- und Westkirche bei. In jüngerer Zeit lehnen manche christliche Gruppen, beispiels-

Pfingsten

Nach dem Johannesevangelium trat Jesus am Abend des Tages, an dem er von den Toten auferstanden war, unter seine Jünger, die sich seit seiner Kreuzigung versteckt hielten, und sagte zu ihnen: „Nehmt hin den Heiligen Geist. Welchen ihr die Sünden erlasst, denen sind sie erlassen; und welchen ihr sie behaltet, denen sind sie behalten." Ein ähnliches Ereignis beschreibt die Apostelgeschichte, die im Neuen Testament im Anschluss an die Evangelien über die ersten Jahre der christlichen Kirche berichtet: Nachdem Jesus gen Himmel aufgefahren war, versammelten sich die Apostel in einem Zimmer;

„Und es geschah plötzlich ein Brausen vom Himmel wie von einem gewaltigen Wind und erfüllte das ganze Haus, in dem sie saßen. Und es erschienen ihnen Zungen zerteilt, wie von Feuer ..." Sie wurden vom Heiligen Geist erfüllt und konnten nun Sprachen sprechen, die sie nie gelernt hatten. Dieses Ereignis wird von Christen jedes Jahr sieben Wochen nach dem Ostersonntag als Pfingsten gefeiert und gab der Pfingstbewegung ihren Namen: deren Anhänger glauben, dass alle Gläubigen die gleichen Gaben des Geistes erlangen können. Der Pfingstsonntag gilt manchmal als der Geburtstag der Kirche.

weise die Mormonen, die Dreifaltigkeit völlig ab und sehen in Vater, Sohn und Geist drei getrennte Personen, die sich in ihrem Zweck einig sind, nicht aber in ihrem Wesen.

Im Aramäischen – der Sprache, die Jesus sprach – und auch im Hebräischen ist das Wort für „Geist" weiblich. Deshalb hielten viele christliche Denker im Laufe der Geschichte den Heiligen Geist für den weiblichen Aspekt der Gottheit.

Feuerzungen In der christlichen Kunst wurde der Heilige Geist auf unterschiedliche Weise dargestellt. Glaubt man den biblischen Berichten über die Taufe Jesu im Jordan durch seinen Vetter Johannes, so fuhr der Geist als Taube auf ihn herab. Das gleiche Symbol taucht auch in Darstellungen auf, in denen Maria von dem Engel erfährt, dass sie mit Gottes Sohn schwanger sei. In der Apostelgeschichte zeigt sich der Geist den Aposteln als Wind oder als Feuerzungen, die von den Künstlern häufig als Flammen dargestellt werden.

Zungenreden

Zu den Gaben des Heiligen Geistes, von denen das Neue Testament berichtet, gehört auch die „Zungenrede" oder Glossolalie. Wer diese Gabe hat, kann in einer Sprache sprechen, die für die Zuhörer unverständlich ist. Darin spiegelt sich nach der christlichen Lehre das Erlebnis der Apostel wider, als der Geist über sie kam. Eine viel kleinere Zahl von Gläubigen, so heißt es weiter, erhalte vom Geist noch eine zweite Gabe: diese Gläubigen könnten die Äußerungen deuten. Das Zungenreden gilt bei Christen der Pfingstbewegung, die im 20. Jahrhundert ihren Aufschwung erlebte, als authentisches Kennzeichen für die Taufe im Geiste. Die Anhänger der Pfingstbewegung beschreiben die Äußerungen derer, die in der Lage sind, in Zungen zu reden, als Himmelssprache, Sprache der Engel oder Sprache des Heiligen Geistes. Wissenschaftliche Bemühungen, sie zu entschlüsseln, lieferten bisher kaum Ergebnisse; in Studien wird jedoch darauf hingewiesen, dass die Betroffenen sich dabei in einem emotional erregten Zustand befänden. In früheren Jahrhunderten war das Zungenreden in der christlichen Kirche kaum bekannt: Augustinus vermutete, die Gabe beschränke sich auf die ursprünglichen Apostel. Manche christlichen Heiligen und Mystiker jedoch – beispielsweise Patrick, der Schutzheilige Irlands, der im vierten Jahrhundert lebte – beschrieben, dass sie ihr Zwiegespräch mit dem Geist in einer Sprache geführt hätten, die sie verstehen konnten, während sie für andere Zuhörer unverständlich gewesen sei.

> Komm, Heiliger Geist, erfülle unsere Seelen
> und erleuchte sie mit himmlischem Feuer.
> Du, der du uns im Geiste salbst,
> und siebenfach Geschenke gabst.
>
> Book of Common Prayer, 1662

> Ich glaube ganz aufrichtig, dass jeder,
> der mit der Macht des Heiligen Geistes
> eine einfache frohe Botschaft predigt,
> mit Ergebnissen rechnen kann,
> wenn er zu nicht bekehrten Menschen spricht.
>
> Billy Graham, geb. 1918

Die Gaben des Heiligen Geistes In der Hauptrichtung des Christentums ist man weiterhin überzeugt, dass der Heilige Geist auf einzigartige Weise dazu beiträgt, Menschen zu bekehren, die heiligen Schriften zu prägen (daher der Bezug auf die Propheten im Glaubensbekenntnis) und den Gläubigen zu helfen, anderen mit den richtigen Worten von ihrem Glauben zu berichten. Nach der katholischen Lehre greift der Heilige Geist vor allem in das Leben der Kirche ein, um ihre Entscheidungen zu beeinflussen. Wenn sich beispielsweise die Kardinäle zur Wahl eines neuen Papstes versammeln, geben sie ihre Stimme angeblich unter der Führung des Heiligen Geistes ab. Auch im Protestantismus hat der Heilige Geist eine Funktion für die Institutionen, hier glaubt man aber eher an seine unmittelbare Beziehung zu den einzelnen Gläubigen.

Im ersten Korintherbrief, der ungefähr im Jahr 50 u. Z. entstand, beschreibt Paulus die Gaben, die der Heilige Geist dem einzelnen verleiht: „Dem einen wird durch den Geist gegeben, von der Weisheit zu reden; dem andern wird gegeben, von der Erkenntnis zu reden, nach demselben Geist; einem andern Glaube, in demselben Geist; ... einem andern die Kraft, Wunder zu tun; ... einem andern mancherlei Zungenrede; einem andern die Gabe, sie auszulegen. Dies alles aber wirkt derselbe eine Geist und teilt einem jedem das Seine zu, wie er will."

Worum es geht
Gott ist drei in einem

13 Heilige und Sünder

In vielen Religionen dienen heilige Männer und Frauen aus früheren Zeiten als Vorbild, das die heutigen Gläubigen zu einem guten, moralischen Leben anleiten und anregen soll. In der christlichen Kirche werden solche Vorbilder als Heilige bezeichnet, und insbesondere im Katholizismus sorgt ein offizielles System bis heute dafür, dass ihre Zahl von Jahr zu Jahr wächst.

Schätzungsweise 10.000 Heilige sind bereits offiziell anerkannt: An sie können sich die Gläubigen im Gebet wenden, wenn sie in schwierigen Zeiten Inspiration, Kraft und Hilfe suchen. Manche Heilige haben besondere Aufgaben: Josef, der Ehemann der Jungfrau Maria, ist der Schutzheilige der Zimmerleute, die Heilige Cäcilia beschützt Musiker, und zum Heiligen Judas beten jene, die sich in verzweifelten Situationen befinden. In der Kirche gibt es seit ihren Anfängen die Vorstellung von einer „Gemeinschaft der Heiligen", die im Himmel wiedergeboren werden und durch ihren Heiligenschein (in traditionellen Darstellungen ein Lichtring um den Kopf) gekennzeichnet sind. Sie dienen als Vermittler zwischen Menschen und Gott. Deshalb erhalten Menschen den Namen eines Heiligen, wenn sie durch die Taufe offiziell in die Kirche aufgenommen werden, und in manchen christlichen Gruppen wählen sie später einen Heiligen als Patron für das Sakrament der Firmung.

Bis 1234 wurden Heilige im Christentum durch Volksabstimmung ernannt. Man glaubte, durch die Lebensgeschichte eines sehr geschätzten Menschen könne man einen Blick darauf erhaschen, wie Gott ist. Besonders glaubte man dies bei jenen, die in der Frühzeit des Christentums für ihren Glauben als Märtyrer starben. Der bekehrte Jude Stephanus wurde nach dem Bericht der Apostelgeschichte wegen seiner Missionstätigkeit gesteinigt. Er gilt in der christlichen Kirche als der erste Heilige, und seine Fähigkeiten als Prediger und Wundertäter können als Vorbild für alle späteren Heiligen gelten.

Zeitleiste

ca. 35 u. Z.
Tod des Stephanus, des ersten Heiligen

4. Jahrhundert
In der christlichen Kunst tauchen Heiligenscheine auf

Der Heiligenschein

Der Heiligenschein in der religiösen Kunst ist älter als das Christentum. Schon in altägyptischen und asiatischen Darstellungen kennzeichnet ein Lichtring um den Kopf eine Gottheit, und das Gleiche gilt für Abbildungen griechischer und römischer Götter. Im Christentum wurde die Praxis erstmals im vierten Jahrhundert aufgegriffen, anfangs nur für Bilder von Jesus. Später verbreitete sie sich schnell. In der christlichen Kunst gibt es eine Hierarchie der Heiligenscheine: dreieckige sind der Dreifaltigkeit – Vater, Sohn und Heiliger Geist – vorbehalten. Runde Heiligenscheine in Weiß, Gold oder Gelb kennzeichnen Heilige. Die Jungfrau Maria trägt einen Sternenkranz, manche Künstler schmücken sie aber auch mit der Mandorla, einem Ganzkörper-Heiligenschein. Ein quadratischer Heiligenschein wurde zur Darstellung eines noch lebenden, aber heiligen Menschen verwendet, beispielsweise auf Gemälden verschiedener Päpste. Judas trägt traditionell einen schwarzen Heiligenschein. Die Praxis, Heilige mit einem Heiligenschein darzustellen, verschwand in der Renaissance allmählich.

Dieses demokratische System war manchmal chaotisch. Häufig wurden Geschichten über verschiedene Personen durcheinandergebracht. In der Frühzeit gab es beispielsweise einige weibliche Heilige (Pelagia, Apollinaris, Euphrosyne, Eugenia, Marina), die sich als Männer verkleideten und ein asketisches Leben führten; ihre Geschichten sind sich bemerkenswert ähnlich. Manche Heilige aus der Frühzeit – darunter der bei Autofahrern beliebte Christophorus oder Valentin, der Schirmherr der Verliebten – haben nach heutiger Kenntnis überhaupt nicht existiert. Ihre Lebensgeschichten gingen auf frühere heidnische Götter zurück, die von der frühen christlichen Kirche vereinnahmt wurden.

Als die Kirchenführung immer stärker in das Leben der Gläubigen eingriff, wurde die Ernennung von Heiligen institutionalisiert. Papst Gregor IX. erklärte 1234, das Recht, Menschen heilig zu sprechen, stehe ausschließlich dem „Bischof von Rom" zu, also dem Papst. Von nun an wurde das Spektrum der Kandidaten, die in den Heiligenstand erhoben wurden, enger; vor der Heiligsprechung wurde ein Beweis für ein tugendhaftes Leben und wundersame Eingriffe nach ihrem Tod verlangt.

1234
Rom übernimmt die Heiligsprechungen

2005
Johannes Paul II. hat bis zu seinem Tod fast 500 Menschen heiliggesprochen

Heilige heute

Die in Albanien geborene katholische Nonne Mutter Theresa von Kalkutta (1910–1997) wurde aufgrund ihrer Arbeit mit den Armen, Besitzlosen und Sterbenden in Indien berühmt. Sie gründete den florierenden religiösen Orden der „Missionarinnen der Nächstenliebe"; die Ordensfrauen tragen ihren charakteristischen weißen Umhang mit blauem Rand. 1979 erhielt sie den Friedensnobelpreis, rund sechs Jahre nach ihrem Tod wurde sie von Papst Johannes Paul II. seliggesprochen. Der Spanier Monsignore Josemaria Escriva (1902–1975) gründete innerhalb der katholischen Kirche die Bewegung „Opus Dei", die wegen ihrer konservativen Haltung und ihrer Neigung zur Geheimniskrämerei höchst umstritten ist (unter anderem in Dan Browns Roman *Sakrileg*). Dennoch wurde Escriva 2002, nur 27 Jahre nach seinem Tod, heiliggesprochen. Der Erzbischof Oscar Romero (1917–1980) dagegen galt zwar in seiner mittelamerikanischen Heimat vielfach als Heiliger, ist aber bis heute nicht offiziell anerkannt. Nach seiner freimütigen Verurteilung der Menschenrechtsverletzungen durch die Militärregierung in El Salvador wurde er von Soldaten während der Messe vor dem Altar erschossen. Das war im März 1980. Sein Martyrium reichte in den Augen der katholischen Kirche nicht aus, um die Heiligsprechung zu beschleunigen; man nimmt an, dass Rom eine politische Interpretation seiner Taten fürchtete.

> **Die Heiligen waren in den schwierigsten Augenblicken der Kirchengeschichte stets der Quell und Ursprung der Erneuerung.**
> Katechismus der katholischen Kirche, **1994**

Heiligsprechung heute Heute wendet vor allem die katholische Kirche große Energie für Heiligsprechungen auf. In der orthodoxen Kirche dagegen gelten Heilige nicht als moralische Vorbilder, sondern nur als Menschen, die jetzt im Himmel sind. Man respektiert, dass sie als Ausnahmegestalten in Erinnerung bleiben, fällt aber kein Urteil über sie. Die anglikanische Kirche und andere protestantische Konfessionen erkennen die wichtigsten Gestalten der Kirchengeschichte als Heilige an, deren Zahl wird aber nicht durch einen institutionalisierten Prozess vermehrt. Der Methodismus lehnt die Heiligenverehrung völlig ab.

In der katholischen Kirche setzt die Heiligsprechung zwingend ein Wunder voraus. Damit jemand heiliggesprochen wird, muss zur Zufriedenheit der Kirchenbehörden nachgewiesen sein, dass diese Person nach ihrem Tod die Gebete der Gläubigen erhört hat. Am einfachsten ist dieser Beweis, wenn jemand zu dem potenziellen Heiligen gebetet hat und dann auf wundersame Weise von einer Krankheit geheilt wird. Nach dem derzeitigen System reicht der Beweis eines Wunders für die Seligsprechung aus, und nach zwei Wundern kann jemand heiliggesprochen werden.

Zwischen 1234 und 1978 gab es knapp 300 erfolgreiche Kandidaten für die Heiligsprechung. Es war die Gewohnheit der Kirche, lange und intensiv über Entscheidungen nachzudenken – Bis ein Urteil gefällt war, vergingen oft über 100 Jahre, und nur besonders tugendhafte Menschen wurden heiliggesprochen. Papst Johannes Paul II. (1978–2005) verfolgte einen anderen Ansatz. Er nahm insgesamt 476 Heilig- und 1315 Seligsprechungen vor.

> **Für die meisten Menschen, auch die guten, ist Gott ein Glaube. Für die Heiligen ist er eine Umarmung.**
>
> Francis Thompson, **1859–1907**

Worum es geht
Ein gutes Vorbild kann nicht übertroffen werden

14 Orthodoxie

In den Gebeten der orthodoxen Liturgie findet sich die Formulierung „war, ist und wird sein". Sie fasst die Überzeugung dieser bedeutenden Richtung des Christentums zusammen, dass sie allein die alten Strukturen der Urkirche und den Glauben der Apostel bewahrt hat. „Orthodox" bedeutet „richtige Lehre". Theologie, Entscheidungsprozesse und vor allem die Liturgie haben sich im Laufe der letzten zwei Jahrtausende nicht verändert; das jedenfalls behaupten die drei wichtigsten orthodoxen Kirchen – die griechische, die russische und die verschiedenen Richtungen auf dem Balkan.

Mit weltweit rund 250 Millionen Anhängern ist die Orthodoxe Kirche die zweitgrößte christliche Gruppe nach den Katholiken. Die Spaltung zwischen östlichem und westlichem Christentum hat ihre Wurzeln in der Aufteilung des alten Römischen Reiches. Dessen Westteil mit seinem Mittelpunkt Rom zerfiel im fünften Jahrhundert; der östliche Teil mit Konstantinopel als Hauptstadt blieb in wechselnder Form bis 1453 erhalten, erst dann wurde er von den Osmanen erobert. Diese politische Teilung spiegelte sich in der christlichen Kirche wider: In Konstantinopel residierte ein Patriarch, der sich als gleichberechtigt mit dem Bischof von Rom bezeichnete und sich dem Anspruch des Papsttums auf Autorität über alle Christen widersetzte. Die Ostkirche versuchte sogar, den Anspruch Roms auf die direkte Linie über Petrus bis zu Jesus zu übertrumpfen: Sie erklärte, sie sei von Andreas gegründet worden, dem ersten von Jesus ernannten Apostel.

Die Spaltung von 1054 Vor diesem Hintergrund spielten sich die verschiedenen theologischen Dispute ab, die 1054 zur Spaltung zwischen Ost und West führten. Zu den Themen, bei denen die beiden Seiten verschiedener Meinung waren, gehörten die Einstellung zur Dreifaltigkeit (siehe Seite 49) und das Festhalten der Ostkirche an den Ikonen; außerdem gab es Diskussionen über Eucharistie und liturgi-

Zeitleiste

381
Das Konzil von Konstantinopel setzt einen Stadt-Patriarchen ein

540
Wiederaufbau der Hagia Sophia („Heilige Weisheit"), der Mutterkirche des orthodoxen Christentums (heute eine Moschee)

Die Heiligen Kyrill und Methodius

Kyrill (ca. 827–869) und Methodius (ca. 815–885) sind in der slawischen Kirche als Apostel bekannt; sie waren Brüder, sprachen Griechisch und verbreiteten das Christentum in der Bevölkerung Osteuropas, des Balkans und anderer Regionen. Um die Bibel für ihre neu bekehrten Anhänger leichter übersetzen zu können, entwickelten sie eine eigene Sprache, das Kirchenslawisch, das in den orthodoxen Kirchen bis heute in Gebrauch ist. Sie werden in den Ostkirchen ebenso hoch verehrt wie die ursprünglichen Apostel. Im Jahr 868 sollen sie nach Rom gereist sein, wo sie vom Papst freundlich willkommen geheißen wurden. Die katholische Kirche nahm sie in ihren Heiligenkalender auf, und Papst Johannes Paul II. erklärte sie zu Patronen Europas.

sche Einzelheiten. Auch vor 1054 gab es schon viele Brüche, diese wurden aber stets gekittet, und auch dieses Mal hofften viele auf eine Überwindung der Kluft. Aber die Hoffnung auf eine Versöhnung schwand, nachdem Konstantinopel 1204 von Kreuzfahrern geplündert wurde, die der Papst ins Heilige Land geschickt hatte, während man gleichzeitig versuchte, in der Region einen lateinischen (römischen) Patriarchen einzusetzen. Weitere Einigungsversuche unternahm man 1274 und 1439 – letzterer fand auf dem Konzil von Florenz statt und war von einem gewissen Erfolg gekrönt, bevor 1453 mit der Eroberung Konstantinopels durch die osmanischen Angreifer auch diese Bemühungen obsolet wurden.

Die Trennung von Rom hatte zur Folge, dass sich die Unterschiede zwischen West- und Ostkirche verstärkten; das galt insbesondere nach 1453, als der Balkan und die griechischen Teile der orthodoxen Kirche sich für 400 Jahre mit der islamischen Oberherrschaft abfinden mussten. Die Reformation und die nachfolgenden Unruhen gingen an ihnen weitgehend vorbei. Mit dem Sturz Konstantinopels verlagerte sich das Machtzentrum der Ostkirche nach Moskau, das nun als „drittes Rom" bezeichnet wurde.

> **Seine Mitglieder sind in jeder Hinsicht Abbilder Gottes, klare, unbefleckte Spiegel, in denen sich der Schein des ursprünglichen Lichtes und sogar von Gott selbst widerspiegelt.**
> Pseudo-Dionysios Areopagita, **spätes 5. Jahrhundert**

1054
Spaltung von Ost- und Westkirche

1453
Konstantinopel wird von den Osmanen erobert

> *Jesus wurde zum Menschen, auf dass wir zu Gott werden können.*
>
> St. Athanasius von Alexandria, ca. 293–373

Mit der russischen Revolution von 1917 und mit der sowjetischen Machtergreifung in großen Teilen Osteuropas nach dem Zweiten Weltkrieg wurde die orthodoxe Kirche von den feindseligen kommunistischen Behörden in eine untergeordnete Rolle gedrängt (manchen Schätzungen zufolge kamen sechs Millionen russisch-orthodoxe Christen wegen ihres Glaubens ums Leben). Sie blieb nur dadurch funktionsfähig, dass sie sich ausschließlich auf Liturgie und Anbetung konzentrierte, sich aber an gesamtgesellschaftlichen Aufgaben nicht mehr beteiligte.

Dezentrale Autorität Die heutige orthodoxe Kirche hat keinen einzelnen Kirchenführer, der in seiner Stellung dem Papst vergleichbar wäre. Bei den Bischofsversammlungen der drei wichtigsten Kirchenzweige führt der Ökumenische Patriarch von Konstantinopel als Erster unter Gleichen den Vorsitz. Auch die Autorität ist in Übereinstimmung mit der Praxis frühchristlicher Gemeinden viel stärker dezentralisiert. Die örtlichen Bischöfe haben innerhalb ihres Amtsbezirkes die Hoheit und versammeln sich mit anderen Bischöfen aus ihrer Region, um Entscheidungen von weitreichenderer Bedeutung zu treffen.

Das Priesteramt der orthodoxen Kirche steht auch verheirateten Männern offen, Bischöfe müssen aber zölibatär leben und rekrutieren sich vorwiegend aus der mächtigen klösterlichen Tradition innerhalb der orthodoxen Kirche. In Bezug auf die Lehre wird großes Gewicht auf die „Heilige Tradition" der Kirche gelegt. Das wichtigste Ziel des Einzelnen ist in der orthodoxen Tradition die *Theosis*, eine mystische Vereinigung des Menschen mit Gott auf kollektiver und individueller Ebene.

Altertümliche Liturgie Der auffälligste Unterschied zwischen den orthodoxen und den westlichen Kirchen besteht in den prächtigen orthodoxen Gottesdiensten. Die Requisiten und Rituale haben sich in den orthodoxen Kirchen seit 1000 Jahren kaum verändert. Die Liturgie wird von Weihrauchwolken begleitet. Die Priester kleiden sich in reich verzierte Gewänder und tragen in Nachahmung der Apostel Bärte und lange Haare. In der Kirche werden Ikonen – religiöse Gemälde – aufgestellt und mit Kerzen eingerahmt. Die Gemeinde verneigt sich vor ihnen und küsst sie. Eine reich verzierte Trennwand, Ikonostatis genannt, trennt den Altar und damit die Geistlichen vom Hauptteil der Kirche und von den Laien ab. Die Liturgie wird zu einem großen Teil gesungen. Der ganze Gottesdienst, der einer charakteristischen Choreografie der Bewegungen und Gesten folgt, kann mehrere Stunden dauern. Die wenigen vorhandenen Kirchenbänke sind ausschließlich älteren und kran-

Ikonen

In der orthodoxen Kirche unterliegen Ikonen festgeschriebenen künstlerischen Konventionen, es gibt dabei allerdings innerhalb der Kirche unterschiedliche Traditionen. Nach allgemeiner Ansicht sollten Ikonen, im Gegensatz zur religiösen Kunst des Westens, nicht die menschliche Seite Jesu, seiner Mutter oder der Heiligen zeigen, sondern ihr göttliches Leben. In der russischen und griechischen Kirche sowie in den verschiedenen Balkankirchen gibt es für Ikonen allgemein anerkannte Symbolcodes. In der russischen Tradition steht beispielsweise die dunkelrote Kleidung der Jungfrau Maria für die Menschheit, die Erde, Blut und Opfer. Obwohl sie als Himmelskönigin gilt, wird sie nie mit einer Krone dargestellt, denn das wäre zu menschlich. Häufig symbolisieren drei Sterne auf ihrem Gewand die Zeit vor, während und nach der jungfräulichen Geburt. In den ersten Jahrhunderten des Christentums wurden Ikonen ausschließlich von Mönchen gemalt, und noch heute gilt die Ikonenmalerei traditionell als Form der Anbetung, bei der die künstlerische Tätigkeit sich mit Gebeten und Versenkung verbindet. Nach dem orthodoxen Glauben malte Lukas, einer der vier Evangelisten, als Erster die Mutter Jesu. In der westlichen Kirche waren Ikonen nach der Abspaltung vom Osten kaum noch in Gebrauch – manche religiösen Künstler, so Duccio in der italienischen Renaissance und El Greco im Spanien des 16. und 17. Jahrhunderts, malten sie aber weiterhin, wobei die strengen orthodoxen Regeln allerdings durch westliche Vorstellungen verwässert wurden.

ken Menschen vorbehalten. Die orthodoxen Kirchen haben sich standhaft geweigert, ihre liturgischen Rituale und Worte zu modernisieren: Man glaubt, sie spiegelten die frühen Jahrhunderte der Christenheit und die Zeitlosigkeit des Himmels wider.

Worum es geht
Die Geschichte des Christentums spielt nicht nur in Rom

15 Luther und seine Nachfolger

Das Wort „Protestant" wurde 1529 auf dem Reichstag zu Speyer erstmals auf diejenigen angewendet, die die Autorität Roms infrage stellten. Zwölf Jahre zuvor hatte Martin Luther mit seinem Aufbegehren gegen den Papst die Reformation in Gang gesetzt (siehe Kapitel 9). In den nachfolgenden Jahrhunderten bezeichnete der Begriff verschiedene Konfessionen, darunter Lutheraner, Reformierte, Baptisten und Anglikaner. Gemeinsam ist diesen Gruppen, dass das Schwergewicht auf dem individuellen Bibelstudium, einfachen Gottesdiensten und dem Glauben an die Bedeutung der Predigt liegt. Alle diese Aspekte lassen sich auf Luthers ursprüngliche Dispute mit Rom zurückführen.

Dass Luther den Würgegriff der römischen Kirche im westlichen Christentum aufbrechen konnte, lag an mehreren Faktoren. Einer davon war der Aufstieg des europäischen Nationalismus. Die Herrscher und, in geringerem Maße, auch die Völker waren nicht mehr bereit, sich vom Papst und seinem Verbündeten, dem Heiligen Römischen Kaiser, Vorschriften machen zu lassen. Diese politisch-nationalistische Dimension wurde zur ersten Triebkraft für die Ausbreitung von Luthers Ideen – und schließlich auch seiner neuen Kirche – in Deutschland und darüber hinaus, insbesondere in Skandinavien. Dort nahmen die dänische und die schwedische Königsfamilie, die über die gesamte Region herrschten, den neuen Glauben an.

Das Wachstum der Lutherischen Kirchen stellte jedoch die Beibehaltung einheitlicher Glaubensüberzeugungen infrage. Zu Beginn unterzeichneten die neuen Kirchen im Jahr 1530 gemeinsam das Augsburger Bekenntnis, und Luther stand zu seinen Lebzeiten im Mittelpunkt all dieser Strömungen, was den Einfluss einzelner Herrscher begrenzte. Seine rechte Hand war Philipp Melanchthon, der zwar nicht Luthers Begabung als Führungspersönlichkeit und Prediger besaß, der entstehenden

Kirche aber intellektuellen Rückhalt und theologische Ordnung vermittelte. „Ich musste mit Geschmeiß und Teufeln kämpfen, deshalb sind meine Bücher sehr kriegerisch", schrieb Luther im Vorwort zu einem von Melanchthons Büchern. „Ich bin der derbe Pionier, der den Weg frei machen muss; dann kommt Meister Philipp weich und sanft, sät und bewässert inbrünstig, denn Gott hat ihn reich mit Begabungen gesegnet."

Nach Luthers Tod im Jahr 1546 kam es zu Meinungsverschiedenheiten und Spaltungen. Diese Phase der Turbulenzen, welche durch die Anstrengungen der katholischen Gegenrevolution noch verstärkt wurden, mündete 1580 in einem Kompromiss: Jetzt unterzeichneten die meisten Lutheraner das Konkordienbuch mit einer eindeutigen Definition ihrer gemeinsamen Glaubensüberzeugungen.

Lutherische Prinzipien Das Konkordienbuch benennt die wichtigsten, dauerhaften Elemente von Luthers Reformvorstellungen. Bemerkenswert ist dabei insbesondere das Prinzip *sola scriptura:* Die Bibel genießt einen höheren Rang als alle überlieferten oder „von Menschen gemachten" Lehren der Kirche. Man war sich einig, dass die Bibel unter dem Einfluss des Heiligen Geistes geschrieben worden sei und dass sie – und nicht der Papst – im Christentum die höchste Autorität darstelle. Es war eine von Luthers größten Leistungen, dass er die Bibel aus dem Lateinischen ins Deutsche übersetzte, so dass sie nun leichter zugänglich war. Ein anderes wichtiges Prinzip hieß *sola fide* und wird manchmal auch „allein durch den Glauben" genannt: Danach wird ein Mensch durch den Glauben an Gott erlöst und kann dies – anders als die Katholiken glauben – nicht durch gute Taten verdienen oder beeinflussen.

Unter den protestantischen Kirchen, die aus der Reformation hervorgingen, ist die lutherische die älteste und die dem Katholizismus ähnlichste. Sie erkennt die Sakramente an – für die meisten Lutheraner sind es allerdings, anders als in der römischen Lehre, nicht sieben, sondern nur zwei –, weist ihnen aber in der Hierarchie

> **Woran du dein Herz hängst und worauf du dich verlässt,**
> **das ist auch dein Gott.**
> Martin Luther, 1529

der Wahrheiten einen Platz unterhalb der Predigt zu. Sie hat Bischöfe und Mönche, und der Gottesdienst ist zwar einfacher, schließt aber auch Musik mit ein (Johann Sebastian Bach komponierte für die Lutherische Kirche).

Das Konkordienbuch

Dieses historische, aus zehn Abschnitten bestehende Dokument ist das weltweit verbindende Element der lutherischen Kirchen. Man verabschiedete es 1580 in Dresden zum 50. Jahrestag des ursprünglichen Augsburger Bekenntnisses, bei dem Luther und seine Anhänger ihre Überzeugungen in einer Reihe von Thesen formuliert hatten. Das Konkordienbuch wurde von Jakob Andreae und Martin Chemnitz zusammengestellt; es war der Versuch, den Zusammenhalt zwischen den Teilen der damals schnell wachsenden Kirche zu festigen. Zu Beginn wird dort festgehalten, dass die lutherische Religion in direkter Linie auf die Prinzipien und Praktiken der frühchristlichen Kirche zurückgehe und dass sie – nicht Rom – die wahre Erbin des Geistes dieser Kirche sei. Wie das Augsburger Bekenntnis selbst, so enthält auch das Konkordienbuch Martin Luthers Großen und Kleinen Katechismus sowie einige seiner anderen Schriften und Predigten. Alle neuen lutherischen Geistlichen müssen sich bedingungslos auf das Konkordienbuch verpflichten.

Pietistische Lebensweise Im 18. Jahrhundert wurden die die Tradition wahrenden Einstellungen der lutherischen Hauptrichtung zum Anlass einer Opposition von innen. Die pietistische Bewegung forderte eine radikale Abkehr von den Verlockungen der „katholischen" Religion und ein stärkeres persönliches Engagement, mit dem die Lehren der Bibel im Alltagsleben praktiziert werden sollten. Die Pietisten sollen John Wesley dazu inspiriert haben, die Bewegung der Methodisten zu gründen (siehe Kapitel 17).

> **Glaube ist nichts anderes als das Vertrauen in die von Christus versprochene göttliche Gnade.**
>
> Philipp Melanchthon, 1497-1560

Pietismus

Die Tatsache, dass die Lutherische Kirche an den Sakramenten und den traditionellen Gottesdienstformen festhielt, wurde Ende des 17. und Anfang des 18. Jahrhunderts von den Pietisten zunehmend kritisiert. Wie der Name schon sagt, setzte sich diese Bewegung für eine ernstere, individuelle Form der Frömmigkeit ein. Im Mittelpunkt standen dabei die wiederholte Bibellektüre und eine einfache, gottgefällige Lebensweise, die weltliche Freuden ablehnte. Ihre Führungsgestalt war der lutherische Pastor Philipp Jakob Spener (1637–1705), der mit seinem Buch *Pia Desideria* viele andere geistliche Denker inspirierte, unter anderem August Francke (1663–1727). Francke war Professor an der Universität Halle, dem geistigen Zentrum des Pietismus, und ist heute vor allem als Gründer von Schulen für Arme in Erinnerung geblieben. Ein anderer Pietist, der Theologe Heinrich Müller (1631–1675), geißelte den Beichtstuhl, den Altar, das Taufbecken und die Kanzel der Lutherischen Kirchen als „vier törichte Symbole" und sprach sich stattdessen dafür aus, sich in „Frömmigkeitskollegien" zu versammeln und die Bibel zu studieren.

Weltweit gibt es schätzungsweise 64 Millionen Lutheraner. Ihre größte Dichte erreichen sie bis heute in Deutschland und Skandinavien; in Dänemark, Island und Norwegen ist der Lutheranismus Staatsreligion. Größere lutherische Bevölkerungsgruppen gibt es auch in den Vereinigten Staaten und in früheren deutschen Kolonien wie Namibia. Wie viele andere Konfessionen, so nimmt auch die Lutherische Kirche in Afrika und Asien viele neue Mitglieder auf, und die christliche Weltkarte nimmt eine neue Gestalt an.

Worum es geht
Mehr in der Bibel lesen

16 Die Anglikanische Kirche

In England nahm die Reformation eine eigene Form an. Dabei spielten die politischen Umstände eine wichtige Rolle: Der Papst lehnte es ab, Heinrich VIII. von seiner Frau zu scheiden, und der König wollte daraufhin eine nationale Kirche gründen, die ihm zu Willen war. Es gab aber auch religiöse Motive: Der Einfluss Luthers und Calvins machte sich in England ebenso bemerkbar wie im übrigen Europa. Die neue Kirche von England, die *Church of England*, positionierte sich schließlich zwischen Protestantismus und Katholizismus. Sie hat bis heute offizielle Verbindungen zum Staat und expandierte zusammen mit dem britischen Kolonialreich in die ganze Welt. Heute ist die anglikanische Kirche mit 80 Millionen Mitgliedern die drittgrößte christliche Gruppierung der Erde.

Die theologische Grundlage der Kirche von England wurde erstmals 1563 in 39 Artikeln, den *Thirty-Nine Articles of Faith*, formuliert. Sie bilden den Gipfelpunkt einer Reihe von Versuchen, die besonderen Glaubensüberzeugungen der nationalen Kirche festzuschreiben. Die Entwicklung begann 1536, als mit zehn Artikeln eine bescheidene Distanz zwischen der neuen Kirche und Rom geschaffen wurde. Die Kluft erweiterte sich 1552 mit 42 neuen Artikeln, die von Thomas Cranmer, Erzbischof von Canterbury und einer der am stärksten protestantisch geprägten Gestalten der englischen Revolution, festgeschrieben wurden. Die endgültige Fassung mit 39 Artikeln war das Ergebnis eines Kompromisses, zu dem man während der Regierungszeit von Elizabeth I. gelangte.

Ein Balanceakt Welch einen Balanceakt die anglikanische Konfession darstellte, zeigt sich sehr deutlich in Ton und Inhalt der 39 Artikel. Die ersten acht Artikel sind im Wesentlichen katholisch und blicken zurück auf die Apostel und auf die

Zeitleiste

1529
Heinrich VIII. ernennt sich selbst zum
Oberhaupt der Kirche von England

1563
Thirty-Nine Articles of Faith

Praxis der Urkirche. Die nächsten zehn handeln von den neueren Erkenntnissen der Reformation, übernehmen aber nicht vollständig Luthers Haltung, etwa in der Frage der Rechtfertigung allein durch den Glauben: Der anglikanische Glaube lässt noch Spielraum für gute Taten. Die restlichen Artikel behandeln die Lehre der Kirche und ihr Verhältnis zum Staat.

Auch die zweite Säule der Anglikanischen Kirche, das *Book of Common Prayer*, entwickelte sich während dieser turbulenten Phase. Auch hier hatte Thomas Cranmer seine Hände maßgeblich im Spiel: Seine Ziele waren die Auflösung der Klöster, die Verwendung der englischen Sprache anstelle des Lateinischen im Gottesdienst, das Ende der Heiligenverehrung und eine Einschränkung der üppigen religiösen Bilderwelt in den Kirchen. Als wichtigster Berater Heinrichs VIII., und nach dessen Tod 1547 seines Sohnes Edward VI., verband Cranmer Worte der Andacht aus der römischen Tradition mit einer Interpretation der Sakramente, die sich mehr an Luther und Calvin orientierte. Nach vielen Diskussionen und Überarbeitungen erschien 1662 ein endgültiger Text, der bis heute in Gebrauch ist, obwohl 1980 eine alternative Gottesdienstordnung eingeführt wurde.

Die Bruchlinie Die Bruchlinie zwischen katholischer und protestantischer (oder reformierter, wie die Anglikaner lieber sagen) Überzeugung besteht bis heute. Der „niedrige" oder „evangelikale" anglikanische Glaube *(Low Church)* geht mit seinen einfachen Zeremonien und den an der Bibel orientierten Lehren im Wesentlichen auf Luther, Zwingli und Calvin zurück.

Die „hohen" oder „anglokatholischen" Anglikaner *(High Church)* orientieren sich stattdessen im Zusammenhang mit Gottesdienst und Theologie am Katholizismus, die meisten von ihnen erkennen jedoch die oberste Autorität des Papstes nicht an. In jüngerer Zeit traten viele Hoch-Anglikaner zum katholischen oder orthodoxen Glauben über, weil sie empört waren, dass ihre Kirche auch Frauen im Priester-

❯ **Wenn man einen Anglikaner fragt: ‚Wo war deine Kirche vor der Reformation?', antwortet er am besten mit einer Gegenfrage: ‚Wo war dein Gesicht, bevor du es gewaschen hast?'** ❮
Michael Ramsey, Erzbischof von Canterbury, **1961–1974**

1662	**1867**	**2003**
Book of Common Prayer	erste Lambeth-Konferenz	erste Einsetzung eines offen homosexuellen Bischofs

Die Oxford-Bewegung

In den 1830er Jahren versuchte die Oxford-Bewegung (auch Traktarianer genannt, weil sie ihre Ansichten häufig in kleinen Büchern oder Traktaten verbreiteten), die Anglikanische Kirche näher an die Traditionen der Urkirche und – so die Kritiker – der römisch-katholischen Kirche anzunähern. Nach Ansicht ihrer führenden Köpfe John Henry Newman, Edward Pusey und John Keble, die alle der Universität Oxford angehörten, war der anglikanische Glaube zu einfach geworden. Sie sprachen sich für eine Rückkehr zu mittelalterlichen Gottesdienstformen und zum Mönchswesen aus. Nach ihrer Auffassung ließen sich die 39 Artikel mit den Lehren des katholischen Konzils von Trient vereinbaren. Beträchtlich geschwächt wurde die Bewegung 1845, als Newman zum römisch-katholischen Glauben übertrat.

amt aufnahm, was in ihren Augen eine Grenzüberschreitung darstellt. Im Jahr 2009 ließ der Papst zu, dass „katholische" Anglikaner in Form ganzer Gemeinden oder sogar Diözesen zum römischen Glauben konvertieren.

Die Kerngruppierung der Anglikanischen Kirche, deren Mitglieder in der Regel als Liberale bezeichnet wurden und die traditionell das Machtzentrum der Konfession darstellte, ist in den letzten Jahren geschrumpft: Sie bemühte sich darum, die Kirche weltweit auch in Streitfragen – wie die Aufnahme von Frauen ins Priesteramt (die in manchen Kirchenprovinzen begeistert angenommen und in anderen verboten wurde) und Homosexualität – zusammenzuhalten. Die Praxis, dass aus Gründen der Einigkeit keine einzelne Kirchenprovinz Reformen vollziehen darf, bevor nicht alle anderen überzeugt wurden, hat man aufgegeben. Nachdem 2003 in den Vereinigten Staaten mit Gene Robinson ein offen homosexueller Bischof in die anglikanische Episkopalkirche aufgenommen wurde, drohten einige afrikanische Kirchenprovinzen, sich von der Kirche abzuspalten.

Das Oberhaupt der *Anglican Communion*, des Anglikanischen Kirchenbundes, ist der Erzbischof von Canterbury, seine Befugnisse sind aber stark eingeschränkt. Er führt als Erster unter Gleichen den Vorsitz bei der Lambeth Conference, dem alle zehn Jahre stattfindenden Treffen sämtlicher anglikanischer Bischöfe; es wurde 1867 zum ersten Mal abgehalten. Seine Vorstellungen kann er aber nur mittels

> **Es war die Weisheit der Kirche von England,
> dass sie seit der Aufstellung ihrer ersten öffentlichen Liturgie
> einen Mittelweg zwischen den zwei Extremen –
> zwischen zu viel starrer Ablehnung
> und zu viel einfachem Zulassen von Abweichungen –
> eingehalten hat."**
>
> Book of Common Prayer, **1662**

Evelyn Underhill und die anglikanische Spiritualität

In der Anglikanischen Kirche bemühte man sich um die Entwicklung einer eigenen Spiritualität; dies geschah insbesondere in Kirchenprovinzen wie England, wo die Rolle als Staatsreligion es notwendig machte, eine möglichst breite Mitgliederschaft anzusprechen. Dennoch zog die in Wolverhampton geborene Dichterin und Romanschriftstellerin Evelyn Underhill (1875–1941) in den ersten Jahrzehnten des 20. Jahrhunderts mit ihren Schriften, Vorträgen und Andachten eine große Gefolgschaft an. Ihr erfolgreichstes, 1911 erschienenes Buch *Mysticism* (dt. *Mystik*) trug den Untertitel „Eine Studie über die Natur und Entwicklung des religiösen Bewusstseins im Menschen". Großes Gewicht legte sie auf die Rolle des Heiligen Geistes, auf kontemplative (anstelle öffentlicher) Gebete und auf das neu entstehende Fachgebiet der Psychologie.

Überzeugungskraft und Konsensfähigkeit durchsetzen. Nach ähnlich demokratischen Prinzipien funktionieren auch viele anglikanische Provinzen, darunter die Kirche von England selbst: Wichtige Entscheidungen werden auf regelmäßig abgehaltenen Treffen, den Synoden, von Bischöfen, Geistlichen und Laien durch Abstimmung getroffen.

Die Kirche von England ist bis heute eine Staatskirche, es gibt jedoch laute, hartnäckige Forderungen nach einer Loslösung vom Staat. Ihr Oberhaupt ist der britische Monarch, die Bischöfe werden vom Staat ernannt, und manche von ihnen sitzen im Oberhaus des Parlaments. Die anglikanische Lehre reagiert schneller auf weltliche Veränderungen als der römische Katholizismus. Die Anglikanische Kirche wendet sich beispielsweise nicht gegen die Empfängnisverhütung, und die Abtreibung wird zwar bedauert, man widersetzt sich aber nicht ihrer gesetzlichen Zulassung. Die Kirche von England betrachtet nicht nur die Anglikaner, sondern die gesamte englische Bevölkerung als ihre Gemeinde. Sie ist also für Nichtmitglieder ebenso da wie für ihre Mitglieder.

Worum es geht
Bemühungen um einen Mittelweg

17 Die Methodisten

John Wesley, der Begründer des Methodismus, wollte nie eine neue Kirche gründen. Er war während seines ganzen Lebens anglikanischer Geistlicher, aber er bemühte sich im 18. Jahrhundert darum, die Kirche von England zu reformieren, weil er sie für zu selbstgefällig und weltfremd hielt. Das Ergebnis war eine weltweite Bewegung, die heute 70 Millionen Anhänger hat.

Ähnlich wie der Pietismus, der aus einem Unbehagen gegenüber der bewahrenden Haltung der meisten Lutheraner erwuchs, so war auch der Methodismus ein Aufbegehren gegen einen, wie Wesley es sah, Mangel an Mitleid, Visionen und Engagement der Kirche von England, insbesondere wenn es um die Bedürftigen ging. Wesley meinte, die Anglikanische Kirche habe als Staatsreligion zu bereitwillig an dem wachsenden Wohlstand teilgehabt, der sich in England während der Industriellen Revolution breitmachte. Zu viele Kirchengemeinden nahmen die neuen Fabrikbesitzer mit größerem Wohlwollen auf als ihre Arbeiter.

Der „Heilige Club" Wesleys Vater und Großvater waren anglikanische Geistliche gewesen. Während seiner Priesterausbildung in Oxford trat er einer Gruppe gleichgesinnter, junger, evangelikaler Anglikaner bei, die als „Heiliger Club" (*Holy Club*) bekannt wurde. Die Kritiker bezeichneten sie wegen ihrer methodischen Annäherung an Leben und Glauben als „Methodisten". Die Gruppe fastete, studierte die Bibel und leistete gemeinnützige Arbeit bei Häftlingen und Armen.

Im Mai 1738 hörte Wesley bei einem pietistischen Gottesdienst, wie Worte von Martin Luther laut vorgelesen wurden. Dabei spürte er, wie sein Herz sich „seltsam erwärmte", und von nun an betrachtete er es als seinen Auftrag, einen ähnlichen Reformgeist auch in der Kirche von England zu wecken. Er wollte die anglikanische Lehre zu einer „Religion der Herzen" machen, wie er es formulierte.

Zeitleiste

1738	1791	1795
Wesleys Berufung	Wesley stirbt als Anglikaner	Gründung der Methodistischen Kirche

Im Jahr 1739 begab sich Wesley auf eine Missionsreise durch England. Er predigte, die Kirche müsse ihre soziale Tätigkeit verstärken. Seine Zusammenkünfte fanden als „Feldgottesdienste" vielfach unter freiem Himmel statt, weil die örtlichen Kirchengemeinden sowohl ihm als auch den Arbeitern, die zu seinen Gottesdiensten strömten, die kalte Schulter zeigten. Seine Predigten wurden von den Kirchenliedern seines Bruders Charles begleitet, der insgesamt 9000 solcher Gesänge schrieb, darunter „Love Divine, All Loves Excelling" und „Hark! The Herald Angels Sing".

> **Oh, dass ich tausend Zungen hätte!**
> **Charles Wesley, 1740**

Die „Four Alls" Obwohl Wesley von anglikanischen Kollegen kritisiert, in der Presse lächerlich gemacht und gelegentlich sogar mit dem Tode bedroht wurde, inspirierte er viele andere Wanderprediger, darunter auch Frauen, die in seine Fußstapfen traten. Aus ihren Botschaften kristallisierten sich die „vier Alle" heraus,

Methodismus in Amerika

Seit den 1760er Jahren schickte Wesley Prediger in die damaligen britischen Kolonien in Amerika. Mit Beginn des amerikanischen Unabhängigkeitskrieges (1775–1783) musste die Verbindung zwischen den methodistischen Predigern in den Vereinigten Staaten und der Kirche von England (deren Mitglied Wesley immer noch wahr) zwangsläufig aufgelöst werden. Wesleys Lösung: 1784 ernannte er Thomas Coke zum Oberhaupt einer eigenständigen methodistischen Episkopalkirche in den Vereinigten Staaten. Sie verbreitete sich von ihrem Zentrum in Baltimore aus schnell über das ganze Land.

Dabei gab es eine Reihe von Kirchenspaltungen, die erst 1968 überwunden wurden: In diesem Jahr schlossen sich die Methodistische Kirche und die Kirche der Vereinigten Brüder zur Vereinigten Methodistischen Kirche zusammen, die nun mit rund acht Millionen Mitgliedern die zweitgrößte protestantische Gruppierung der Vereinigten Staaten war. Sie verbindet Wesleys soziale Botschaften mit einem evangelikalen Predigtstil. Ihr Logo ist die Flamme, das Symbol des Heiligen Geistes. Sie wendet sich gegen Alkoholkonsum, Glücksspiel, Todesstrafe und Krieg.

1810
Abspaltung der Ursprünglichen Methodisten

1931
Vereinigung der Methodisten

1972
Abbruch der Vereinigungsgespräche mit der Kirche von England

wie sie im Methodismus genannt werden: Alle müssen gerettet werden, alle können gerettet werden, alle wissen, dass sie gerettet werden und alle können vollständig gerettet werden.

Die Elemente der Redekunst, der Erweckungsinbrunst und der mitreißenden Musik wurden von Wesley schließlich in einer methodistischen Gesellschaft zusammengeführt, die zwar noch anglikanisch war, aber eigene Kirchen und Verbindungen hatte. In den 1760er Jahren machten sich einige Prediger der Gesellschaft nach Amerika auf. Wesley bemühte sich immer wieder darum, Mitglied der Anglikanischen Kirche zu bleiben, und verfasste 1758 eine Denkschrift mit dem Titel *Reasons Against a Separation from the Church of England* („Gründe gegen eine Trennung von der Kirche von England"), er ordinierte aber auch eigene Geistliche. Die offizielle Spaltung ließ sich nun nicht mehr vermeiden und erfolgte 1795, vier Jahre nach seinem Tod.

Nonkonformismus Als Wesley starb, zählte seine methodistische Gesellschaft 57.000 Mitglieder. Fünfzig Jahre später war sie auf eine halbe Million Mitglieder in Großbritannien und eine Million in den Vereinigten Staaten angewachsen. Die neue Kirche wurde häufig als nonkonformistisch bezeichnet, weil sie nicht den Normen der Kirche von England entsprach, sondern Elemente aus der lutherischen Theologie mit dem hochanglikanischen Festhalten an den Sakramenten und energischer sozialer Tätigkeit verband. Ihre Gottesdienstordnung wurde im Book of Offices festgeschrieben, das auf dem 1662 erschienenen anglikanischen Book of Common Prayer basierte. In den 1960er Jahren handelten die Methodisten eine Wiedervereinigung mit der Kirche von England aus, die aber 1972 von den Anglikanern blockiert wurde.

Der Methodismus erfreute sich vor allem in Industrie- und Bergbaustädten sowie unter Kleinbauern und Landarbeitern großer Beliebtheit. In viktorianischer Zeit verkörperte er die „protestantische Arbeitsmoral" mit harter Arbeit und strengen moralischen Grundsätzen. Er lehrte die Tugenden der Ehrlichkeit, Sparsamkeit und Abstinenz. Glücksspiel war verpönt, und die Gemeindemitglieder wurden ständig aufgefordert, sich materiell und spirituell hochzuarbeiten.

> **Verdiene so viel du kannst. Spare so viel du kannst, gib so viel du kannst.**
> John Wesley, **1760**

Ursprüngliche Methodisten

Als die Methodistenkirche nach Wesleys Tod als eigene Konfession begründet wurde, verlor die Bewegung einen Teil ihrer radikalen Einstellungen. Sie wurde zwar als nonkonformistisch beschrieben, war aber nach dem Eindruck mancher Mitglieder zu konventionell geworden. Deshalb setzten sich die beiden Bauern Hugh Bourne und William Clowes – beide ohne Schulbildung – das Ziel, den ursprünglichen Eifer in einer Bewegung namens „Ursprüngliche Methodisten" wiederzubeleben. Sie spalteten sich 1810 von der Hauptrichtung ab und wurden als „Großmäuler" abgetan, weil sie den ganzen Tag über Freiluftgebete abhielten, Kirchenlieder zu den Melodien von Volksliedern sangen, Wunderheilungen vornahmen und auf einer einfa-

chen Sprache, einfacher Kleidung, einfachen Gottesdiensten und einem einfachen Leben beharrten. Die Ursprünglichen Methodisten rühmten sich, sie seien eine demokratische Kirche der Armen für die Armen. In vielen Industriestädten und ländlichen Dörfern bauten sie kleine Kapellen als Konkurrenz zur methodistischen Hauptkirche. Im weiteren Verlauf des Jahrhunderts gab es zunehmend Bemühungen, die Spaltung rückgängig zu machen, und 1931 vereinigten sich beide Bewegungen schließlich in der Methodistischen Union. In den Vereinigten Staaten gibt es bis heute eine eigene Kirche der Ursprünglichen Methodisten (die *Primitive Methodist Church*).

Mit der Expansion des britischen Kolonialreiches wurde auch die methodistische Religion mit ihrer typischen Energie und Entschlossenheit in die ganze Welt exportiert. Als demokratische, engagierte, internationale Kirche ist sie noch heute in Form von Distrikten und Kirchenkreisen organisiert. Ihre Oberhäupter werden in den meisten Ländern gewählt, haben das Amt nur für eine festgelegte Zeit inne und lehnen jeden Personenkult ab; in anderen gibt es aber auch methodistische Bischöfe. Eine eindeutige, gemeinsame Theologie und Praxis gibt es nicht, ein Mangel, der die Gemeinschaft im Vergleich zu anderen Konfessionen anfälliger für Spaltungen macht. In den Vereinigten Staaten gibt es derzeit bis zu 40 verschiedene Kirchen, die alle das Wort „methodistisch" im Namen führen.

Das Christentum verlangt einen radikalen sozialen Ansatz

18 Die Baptisten

Die Taufe (lat. *baptisma*) ist in allen christlichen Konfessionen der Augenblick, in dem ein Mensch in die Kirche aufgenommen wird. In einer Zeremonie, die auf die Taufe Jesu durch seinen Vetter Johannes zurückgeht, werden neue Mitglieder in der Kirche willkommen geheißen. Die Baptisten lehnen jedoch die traditionelle christliche Praxis ab, Säuglinge zu taufen. Nach ihrer Ansicht kann die Taufe – die häufig durch völliges Untertauchen in Wasser vollzogen wird – erst dann stattfinden, wenn der Einzelne erwachsen ist und sich bewusst dafür entscheiden kann, dem Vorbild Christi in seinem Leben zu folgen.

Weltweit gibt es rund 110 Millionen Baptisten, die sich auf viele selbstständige Kirchen verteilen. Allen gemeinsam ist ihre besondere Einstellung gegenüber der Taufe. In sämtlichen anderen Fragen der christlichen Lehre gibt es deutliche Unterschiede und in vielen Fällen sogar tiefe Risse. Im Jahr 2004 trat beispielsweise die US-amerikanische Southern Baptist Convention mit 16 Millionen Mitgliedern aus der weltweiten Dachorganisation der Baptist World Alliance aus, weil diese „zu liberal" sei.

Die Ursprünge der Baptisten lassen sich bis in die Zeit der Reformation zurückverfolgen. Damals nahmen Abweichler sich die Botschaft von Zwingli, Luther und Calvin zwar zu Herzen, gingen aber noch einen Schritt weiter: da Jesus in den Evangelien nirgendwo Kinder tauft, wollten sie es ebenfalls nicht tun. Die ursprünglichen Führungsgestalten der Reformation sprachen sich gegen diese Ansicht aus, aber die „Baptisten" blieben hartnäckig; gleichzeitig entwickelte sich bei ihnen eine tiefe Abneigung gegen Hierarchien und alle Versuche, ihnen Doktrinen und einheitliche Lehrmeinungen aufzuzwingen.

> **Ein Leck lässt ein Schiff sinken, und eine Sünde zerstört den Sünder.**
> John Bunyan, **1678**

1524
erste Kirche der Wiedertäufer

1609
John Smyth geht ins Exil

Wiedertäufer Die historischen Wurzeln der Baptistenbewegung liegen bei den Wiedertäufern, die den Puritanern nahestanden und Anfang des 17. Jahrhunderts unter Einfluss von John Smyth und Thomas Helwys die Kirche von England verließen. Diese radikale Gruppe, deren erste Kirche vermutlich 1524 in Augsburg gegründet wurde, lehnte nicht nur die Säuglingstaufe ab, sondern auch alle anderen Forderungen der weltlichen Behörden, wie den Beitritt zur Armee, die Teilnahme an Gerichtsverhandlungen, das Ablegen von Eiden und sogar die Anerkennung des Herrschaftsrechts von Prinzen oder Königen. Deshalb galten sie als Aufständische und Verräter, und sie mussten lange Phasen der Verfolgung erdulden.

In England machte sich der Einfluss der Wiedertäufer in der religiösen Bewegung der Separatisten bemerkbar; wie der Name schon sagt, lehnten sie jede Verbindung zwischen Religion und Staat ab, und damit wandten sie sich auch gegen die Ansprüche der Kirche von England. Zusammen mit den Separatisten wurden auch Smyth und Helwys festgenommen. Beide mussten 1609 in die Republik der Niederlande flüchten, die damals ein Zufluchtsort für die Nonkonformisten war; dort gründeten sie eine englischsprachige Gemeinde, die sich im Hinterzimmer einer Bäckerei traf. Smyth taufte sich zunächst selbst und entwickelte dann eine Reihe von Ansichten, derentwegen er als Begründer der Baptistenbewegung bezeichnet wird. Er lehnte jede Form der Liturgie ab, da sie einen Keil zwischen die Gläubigen und Gott treibe, und setzte sich für eine einfache, doppelte Führungsstruktur mit Pastoren und Deka-

John Bunyan

John Bunyan war ursprünglich ein fahrender Kaufmann, der Haushaltswaren in englischen Kleinstädten und Dörfern verkaufte. Im Jahr 1653 wurde er Baptist: Er wurde im Fluss Great Ouse getauft und erwarb sich anschließend landesweit den Ruf eines besonders überzeugten Wanderpredigers. Als 1660 nach dem Bürgerkrieg und Cromwells Commonwealth die Monarchie wiederhergestellt wurde, verringerte sich die Toleranz gegenüber den meisten Formen des protestantischen Glaubens. Bunyan verweigerte die Anpassung und setzte seine Predigertätigkeit fort. Deshalb saß er nach 1660 mehrmals im Gefängnis. Während einer Haft im Jahr 1676 schrieb er den ersten Entwurf zu seinem Werk *The Pilgrim's Progress* (dt. *Pilgerreise zur seligen Ewigkeit*); darin schilderte er in Umgangssprache die Zweifel, Versuchungen und Mühsale des Alltagslebens auf dem rituellen Weg zwischen der „Stadt der Zerstörung" und der „himmlischen Stadt". Es war bis ins 19. Jahrhundert das meistgelesene englischsprachige Buch nach der Bibel.

1634
erste Baptistengemeinde in den späteren Vereinigten Staaten

1676
Bunyan beginnt mit der Arbeit an *The Pilgrim's Progress*

1792
Gründung der Baptist Missionary Society

nen ein (während die anderen protestantischen Konfessionen ein dreistufiges Modell bevorzugten).

Recht auf Selbstständigkeit

Im Jahr 1612 kehrten die Baptisten nach England zurück und gründeten in Spitalfields im Osten von London ihre erste Gemeinde. Helwys vertrat in einem dem König James I. gewidmeten Buch die Ansicht, der Monarch habe kein Recht, über das Gewissen des Einzelnen zu bestimmen, „denn die Religion eines Menschen ist eine Sache zwischen diesem und Gott selbst". Deshalb wurde er verhaftet und starb als erster einer ganzen Reihe baptistischer Märtyrer im Gefängnis.

Im Jahr 1620 segelten Baptisten auf der *Mayflower* nach Massachusetts und gründeten in der neuen Kolonie erste Gemeinden. Diese waren demokratisch organisiert. Kein Geistlicher durfte anderen seine Ansichten aufzwingen. Alle Fragen mussten in der Gemeinde demokratisch entschieden werden. Der Glaube an die individuelle und lokale Selbstständigkeit hatte zur Folge, dass es nie eine einheitliche Baptistische Kirche gab, sondern immer nur eine Reihe miteinander verbundener Bewegungen, die sich alle als Baptistengemeinschaften bezeichneten.

> ❞ **Erwarte Großes von Gott; bemühe dich um Großes für Gott.** ❝
>
> William Carey, **1793**

Als die Bewegung der Baptisten sich auf die südlichen US-Bundesstaaten ausbreitete, musste sie sich mit der Sklaverei auseinandersetzen. Die Baptisten waren in ihrer Mehrzahl überzeugt, dass alle Menschen, ob schwarz oder weiß, vor Gott gleich seien; eine Minderheit jedoch, die Southern Baptist Convention, verteidigte die Sklaverei. Sie behauptete, es gebe dafür in der Bibel eine Rechtfertigung, und spaltete sich ab. In Großbritannien waren die Baptisten zur gleichen Zeit allgemein anerkannt und standen im Kampf für die Abschaffung der Sklaverei an vorderster Front. Sie erkannten in der Behandlung der Farbigen eine Parallele zu ihrer eigenen früheren Verfolgung als religiöse Abweichler.

Im Jahr 1792 gründete man in London die Baptist Missionary Society, um die Botschaft der Gemeinschaft nach Indien und in den Fernen Osten zu tragen. Zu ihren bekanntesten Mitgliedern gehörte William Carey (1761–1834), ein Schuster, der die letzten 40 Jahre seines Lebens in Indien verbrachte und dort die Bibel in 25 lokale Sprachen und Dialekte übersetzte.

Die Taufe der Gläubigen

Bis heute eint alle Baptisten das Prinzip der „Taufe der Gläubigen", das sie im Gegensatz zur Praxis der Säuglingstaufe vertreten. (In manchen Baptistenkirchen dürfen die Kinder überhaupt nicht am Gottesdienst teilnehmen, und sie werden erst als Teenager vollwertige Kirchenmitglieder.) Im Gegensatz zu anderen evangelikalen Gruppen gilt die Taufe nicht als Augenblick der

„Wiedergeburt", sondern als öffentlicher Ausdruck eines inneren Bekenntnisses zu Gott. Das Untertauchen im Wasser ist also ein dreifaches Symbol: für das Abwaschen des alten Lebens, für die Wiederauferstehung in einem neuen Leben mit Gott und für den tagtäglich gelebten Glauben.

Eine andere Gemeinsamkeit der Baptisten ist ihr Glaube an die vier Freiheiten, wie sie häufig genannt werden: die Freiheit der Seele des Einzelnen, der Kirche (Andacht ist an jedem Ort und in jeder Form möglich), der Bibel (die man interpretieren kann, wie man es für gut hält) und der Religion (der Weg zu Gott wird nicht vom lokalen Herrscher aufgezwungen, sondern man kann ihn sich selbst wählen). Aber auch diese übereinstimmenden Überzeugungen werden in den verschiedenen Baptistengemeinden unterschiedlich umgesetzt. Allein in den Vereinigten Staaten gibt es 50 verschiedene Baptistenkirchen, und in manchen Ländern bevorzugen die Baptisten eine „offene Mitgliedschaft": Auch die Angehörigen anderer Konfessionen dürfen mit ihnen beten, und manchmal wird nicht einmal die Taufe der Gläubigen vorausgesetzt. Damit setzen sie die Freiheiten, von denen sie so überzeugt sind, tatsächlich in die Tat um.

Was es heißt, Baptist zu sein

Baptisten nennen den Namen ihrer Konfession manchmal als Abkürzung für ihre wichtigsten Glaubensüberzeugungen: **B**iblische Autorität; **A**utonomie der lokalen Kirchengemeinde; **P**riestertum aller Gläubigen; zwei (engl. **t**wo) Sakramente (Taufe und Eucharistie); **I**ndividuelle Freiheit der Seele; **S**eparation (Trennung) von Kirche und Staat; und zwei (**t**wo) kirchliche Ämter (Pastor und Diakon).

Worum es geht
Nur Erwachsene können sich für Christus entscheiden

19 Reformierte Kirchen

Einige Kirchen, die aus der protestantischen Reformation hervorgingen, bezogen ihre Anregung nicht von Martin Luther, sondern von Johannes Calvin. Diese werden zusammenfassend als Presbyterianische oder Reformierte Kirchen bezeichnet. Calvin brach radikaler als Luther mit der früheren kirchlichen Organisation und Liturgie; unter anderem lehnte er die Ausschmückung von Kirchen, Zeremonien, nahezu sämtliche Musik im Gottesdienst und auch das Amt des Bischofs ab. Deshalb entwickelte sich in der Reformierten Kirche ein ernsthafter, einfacher und würdiger Gottesdienststil mit tiefer Spiritualität. Die Bewegung hat heute weltweit rund 24 Millionen Anhänger, die meisten von ihnen in Schottland, den Niederlanden, der Schweiz und den Vereinigten Staaten.

Zu Calvins Neuerungen gehörte der Älteste oder Presbyter, der kein Geistlicher war, aber an den demokratischen Entscheidungsprozessen in der Kirche und bei der Seelsorge mitwirkte. Er – ursprünglich waren die Ältesten ausschließlich Männer – war ein nicht ordinierter Priester. Das Wort Presbyter geht auf das griechische *presbyteros* („älter") zurück. Um seine Ansicht zu unterstreichen, zitierte Calvin die Apostelgeschichte, in der Älteste den geistlichen Bischöfen gleichgestellt sind: „In jeder dieser Kirchen wurden Älteste ernannt, die mit Gebeten und Fasten dem Herrn unterstellt wurden, an den sie nun glaubten."

Die Ausbreitung des Presbyterianismus Von Genf aus, wo Calvin zuhause war, breitete sich die Reformierte Kirche schnell aus. Großen Einfluss hatte sie unter anderem auf John Knox, der in die Schweiz reiste und bei Calvin arbeitete. Nach seiner Rückkehr in seine Heimat Schottland (das damals ein von England und Wales getrenntes Königreich war) spielte Knox eine wichtige Rolle in dem Aufstand, der 1558 ausbrach, als die junge schottische Königin Maria den katholischen französischen Thronerben heiratete. Knox konnte das schottische Parlament 1560

Zeitleiste

1559
Calvin vollendet sein Hauptwerk
Unterricht in der christlichen Religion

1560
Gründung der Kirk

überzeugen, den Calvinismus, der umgangssprachlich *Kirk* genannt wurde, zur schottischen Staatsreligion zu erklären. Auch nach dem Vereinigungsgesetz von 1707, mit dem das schottische Parlament zugunsten eines einzigen Gesetzgebers in London aufgelöst wurde, blieb die Presbyterian Church of Scotland nördlich der Grenze die beherrschende Kirche, während im Süden die anglikanische Konfession dominierte.

Auch in der Republik der Niederlande gedieh der Presbyterianismus. Die Niederländische Reformierte Kirche hielt 1571 in Emden ihre erste Synode ab und gab sich offiziell ein calvinistisches Programm. Eine Zeit lang mussten alle Staatsbeamten dieser Kirche angehören, sie wurde aber nie zur Staatsreligion.

John Knox

Hätte es John Knox (ca. 1510–1572) nicht gegeben, in Schottland hätte sich vielleicht wie in England die Anglikanische Kirche anstelle des Presbyterianismus durchgesetzt. Da die Reformierte Schottische Staatskirche für viele Gläubige – nicht zuletzt für die Puritaner, die in die Vereinigten Staaten reisten – zum Vorbild wurde, kann man Knox durchaus zusammen mit Calvin als Begründer des weltweiten reformierten Glaubens bezeichnen. Er war Kaplan bei dem protestantischen König Edward VI. von England, aber nachdem dieser 1553 gestorben war, verließ Knox bei Regierungsantritt der katholischen Maria I. das Land. In Genf schloss er sich Calvins religiöser Revolution an. Er entwickelte dort eine neue Gottesdienstordnung, die später von der Kirche von Schottland übernommen wurde. In die Heimat zurückgekehrt, erwies er sich als hartnäckiger Gegner der schottischen Königin Maria. Selbst als diese in Tränen ausbrach, wies er alle ihre Bemühungen zurück, ihn für eine religiöse Toleranz zu gewinnen, mit der sowohl ihr katholischer als auch sein reformierter Glaube anerkannt worden wäre. Der unbeugsame Mann starb 1572 als gefeierter, aber bettelarmer Nationalheld. Zu seinem Vermächtnis gehört die Überzeugung, dass Religionsfreiheit wichtiger ist als die Loyalität gegenüber einem Monarchen.

1571
erste Synode der Niederländischen Reformierten Kirche

1646
Bekenntnis von Westminster

1707
Im Vereinigungsgesetz (Act of Union) wird die schottische Staatskirche bestätigt

In England machte sich Calvins Einfluss ebenfalls bemerkbar. Das Bekenntnis von Westminster (Westminster Confession), auf das sich die Gegner des Königs Charles I. im englischen Bürgerkrieg 1646 einigten, war stark von der calvinistischen Theologie geprägt und ist in der angelsächsischen Welt bis heute einer der wichtigsten Texte der Presbyterianer. Im Jahr 1972 schloss sich die English Presbyterian Church mit der Congregationalist Church zur United Reform Church (URC) zusammen.

Die Gemeinschaft von Iona

Ende der 1930er Jahre gründete George McLeod, ein angesehener Geistlicher der Kirche von Schottland, auf einer einsamen Insel vor der Westküste Schottlands die Gemeinschaft von Iona. Im sechsten Jahrhundert hatte die Heilige Columba von dort aus der Bevölkerung Schottlands und Nordenglands eine unverkennbar keltische Form des Christentums nahegebracht. McLeod musste sich im Laufe der Jahre mit Anfeindungen der Generalversammlung seiner eigenen, konservativen Kirche auseinandersetzen, er war aber entschlossen, mit seiner Initiative weiterhin den Presbyterianismus zu erneuern. Das Ergebnis – eine ökumenische Gemeinschaft mit einem eigenen liturgischen Ansatz, der im Sinne Calvins einfach, würdig und zeitgemäß ist – wurde auf der ganzen Welt bewundert.

> **Ältester ist das Gleiche wie Bischof, und bevor die Parteien sich unter dem teuflischen Einfluss vermehrten, wurden die Kirchen von einem Ältestenrat geleitet.**
> St. Hieronymus, 347-420

> **Wer zu Gott dem Schöpfer gelangen will, muss die Schrift zur Leiterin und Lehrerin haben.**
> Johannes Calvin, 1559

Das Book of Order Die Reformierten Kirchen sind Bekenntniskirchen und halten an einer Reihe grundlegender Texte fest. Einer davon ist das *Book of Order*, das Praxis und Formen des Gottesdienstes festlegt. Seine Grundlage war *Die Form von Gebet und Anwendung der Sakramente*, ein Werk, das 1556 in Genf erstmals erschien und darüber berichtete, wie Calvins Lehre dort in den Gemeinden umgesetzt wurde. Einflussreich war auch Calvins Hauptwerk mit dem Titel *Unterricht in der christlichen Religion*, das er 1536 begann und 1559 vollendete.

Die meisten Reformierten Kirchen haben auch heute, in Übereinstimmung mit Calvins Prinzipien, die im 16. Jahrhundert in der fortschrittlichen politischen Kultur der Schweiz entwickelt wurden, eine demokratische Struktur. In Schottland genießen die lokalen Gruppen der Kirk eine beträchtliche Selbstständigkeit. Über ihnen stehen in der Hierarchie die regionalen „Presbyterien" und als oberste Autorität die Generalversammlung mit Laien und Geistlichen als Delegierte.

In der Reformierten Kirche ist jeder Einzelne aufgefordert, seine eigene, persönliche Beziehung zu Gott und Bibel zu entwickeln. Sie erklärt aber auch – im Gegensatz beispielsweise zu den Baptisten –, dass die Gruppe und die Kirche ebenso entscheidend dazu beitragen, den Glauben zu prägen.

Worum es geht
Religionsfreiheit ist das oberste Prinzip

20 Sekten und Kultgemeinschaften

Anfangs gab es nur eine christliche Kirche. Einigkeit war von überragender Wichtigkeit, und das reichte 1000 Jahre lang aus, um die Kirche zusammenzuhalten. Mit der Reformation begann ein Prozess der Zersplitterung, der bis heute anhält. Die Meinungsverschiedenheiten, die zur Gründung neuer oder abgespaltener Kirchen führten, galten zu ihrer Zeit als tiefgreifend und unüberwindlich, heute wirken sie aber oft geringfügig im Vergleich zu den Gemeinsamkeiten der Konfessionen. Seit dem 20. Jahrhundert gibt es starke ökumenische Bestrebungen, die eine Versöhnung und Wiedervereinigung der verschiedenen Kirchen zum Ziel haben. Andererseits entstand jedoch in der Geschichte des Christentums eine Reihe zahlenmäßig kleiner, aber sehr charakteristischer Gruppierungen.

Die Plymouth-Brüder Ursprünglich lehnten die Protestanten das römisch-katholische Christentum wegen seiner Verbindungen zu weltlicher Macht und Reichtum ab. Als die einzelnen aus der Reformation erwachsenen protestantischen Konfessionen sich durchsetzten, wandte sich eine neue Minderheit gegen den Verlust an Radikalität und Bibeltreue. Auf diese Weise formierten sich in den 1820er Jahren die Plymouth-Brüder. Ihre Mitglieder waren von der Weltlichkeit ihrer nonkonformistischen Kirchen enttäuscht und fühlten sich von einer Bewegung angezogen, die ihren Ausgangspunkt in Dublin hatte, ihre Hauptbasis aber in der englischen Hafenstadt Plymouth entwickelte. Sie hielten sich für eine geistliche Elite, forderten ein intensives Bibelstudium, lehnten jeden Schmuck ab und vermieden es sogar, in ihren Versammlungsräumen das Kreuz zu zeigen. Der Gesang durfte durch kein Instrument begleitet werden, und Frauen mussten sich den Kopf rasieren oder ihn bedecken. Die Brüder glaubten, sie würden den Geist einer heiligen, reinen Gefolgschaft wiederbeleben, wie er zwischen den ursprünglichen Aposteln geherrscht hat-

Zeitleiste

1652	1820er Jahre	1830
erste Versammlung der Quäker	Versammlung der Plymouth-Brüder	Veröffentlichung des Buches Mormon

❞ **Am besten drücken die drei ‚S' aus, wie die Armee den ‚Niederen und Ausgestoßenen' hilft: erstens mit Suppe, zweitens mit Seife und drittens mit Seelenheil.** ❝
William Booth, **1829–1912**

te. Die Bewegung erlebte seither viele Spaltungen, insbesondere wegen der Frage, wen man als Mitglied zulassen sollte. Heute hat die Brüderbewegung weltweit schätzungsweise 2,9 Millionen Mitglieder.

Die Quäker Die Gesellschaft der Freunde (besser als Quäker bekannt) wurde 1652 von dem Schuhmacherlehrling George Fox (1624–1691) aus Leicestershire gegründet. Zuvor war er in seiner Suche nach Gott an allen vorhandenen Konfessionen verzweifelt. Seine neue Bewegung war eigentlich keine Kirche, sondern eine Vereinigung, die eine innere Wahrheit oder ein inneres Licht aufdecken wollte. Die Gesellschaft hat keine Geistlichen und keine Sakramente. Die Treffen verlaufen weitgehend in schweigendem Gebet, wobei die Teilnehmer „auf Gott warten" und nur sprechen, wenn der Heilige Geist sie dazu veranlasst. Bekannt wurden die Quäker durch ihren Einsatz für soziale Gerechtigkeit insbesondere in Gefängnissen. Die Bewegung hat weltweit etwa 300.000 Mitglieder.

Die Heilsarmee Diese Vereinigung wurde 1878 von dem früheren Methodistengeistlichen William Booth und seiner Frau Catherine gegründet. Die Heilsarmee (Salvation Army) lehnt die Rituale der christlichen Hauptrichtung ab und bevorzugt stattdessen das einfache Ausleben des Glaubens in schwierigen Situationen. Im viktorianischen Großbritannien wurde sie regelmäßig als „Skelettarmee" lächerlich gemacht, heute jedoch genießt sie allgemeine Bewunderung wegen ihrer gemeinnützigen Arbeit, auch wenn die Zahl der Bekehrten gering ist. Ihre charakteristische Tätigkeit ist die Verkündung des Evangeliums im Freien mit Blaskapellen und einer quasi-militärischen Organisation und Kleiderordnung. Ihre Treffen finden nicht in Kirchen, sondern in Stadtburgen statt, und sie widmen sich der sozialen Tätigkeit in den bedürftigsten Gruppen der Gesellschaft – Drogensüchtige, Obdachlose und Prostituierte. Sakramente gibt es nicht, jede Mahlzeit wird als Wiederholung des letzten Abendmahls betrachtet. Die Heilsarmee hat weltweit 2,6 Millionen Mitglieder in 118 Ländern.

1875	**1878**	**1884**
Mary Baker Eddy, *Science and Health*	Einberufung der Heilsarmee	Gründung der Zeugen Jehovas

Ellen White

Ellen White (1827–1915) lehnte zu ihren Lebzeiten die Bezeichnung „Prophetin" ab. Ihre vielen Anhänger in der Kirche der Siebenten-Tags-Adventisten und darüber hinaus finden jedoch in den Berichten über ihre Visionen eine christliche Inspiration. Bei einem der bekanntesten derartigen Erlebnisse sah White ein „Volk der Wiederkunft", das durch das Licht Christi auf einem gefährlichen Weg in Richtung eines „Neuen Jerusalem" geführt wurde. Sie war eine produktive Schriftstellerin und Predigerin; mit ihren rund 40 religiösen Werken wurde sie zur am häufigsten übersetzten weiblichen Sachbuchautorin in der Literaturgeschichte. Zu ihren Themen gehörten ihre eigenen Überzeugungen, Mystik, Gesundheit und Lebensweise (sie war eine eifrige Fürsprecherin der vegetarischen Ernährung). Ursprünglich war sie Methodistin, ein aufgeschlossenes Publikum für ihre Schriften fand sie jedoch in den 1860er Jahren bei den Sabbat-Adventisten, jener Bewegung, aus der die Siebenten-Tages-Adventisten hervorgingen. Unter den Mitgliedern dieser Glaubensrichtung haben ihre Schriften heute die Stellung heiliger Bücher.

Christliche Wissenschaftler In ihrem 1875 erschienenen Buch *Science and Health* (dt. *Wissenschaft und Gesundheit mit Schlüssel zur heiligen Schrift*) beschrieb Mary Baker Eddy, wie sie ein halbes Jahrhundert lang an schlechter Gesundheit litt, bevor sie ihr Vertrauen ausschließlich auf Gott setzte und dadurch geheilt wurde. Ihre Anhänger bezeichnen sich als christliche Wissenschaftler und vertreten die Überzeugung, dass Menschen keine körperlichen, sondern geistige Wesen sind; deshalb, so glauben sie, sind Medizin und Ärzte kein Schlüssel zur Heilung von weltlichen Leiden. Baker Eddy gründete in Boston die Erste Kirche Christi, Wissenschaftler; die Bewegung hat heute weltweit rund 1800 Gemeinden.

Millenaristen Die christlichen Millenaristenbewegungen lehren, das Ende der Welt sei nahe. Ihre Anregung beziehen sie aus der Offenbarung des Johannes, dem letzten Buch der Bibel, in dem die Wiederkehr Jesu und seine tausendjährige Herrschaft über ein irdisches Paradies beschrieben werden. Nach Ansicht der Zeugen Jehovas, die 1884 gegründet wurden und eigenen Angaben zufolge weltweit sieben Millionen Mitglieder haben, steht dieses Ereignis unmittelbar bevor. Am bekanntesten wurden sie durch ihre Haustürmissionen, ansonsten aber halten sie sich von der übrigen Gesellschaft fern und bleiben unter sich. Die Siebenten-Tags-Adventisten, auch sie eine Millenaristenbewegung, entfalten dagegen insbesondere auf dem Gebiet der Gesundheitsfürsorge eine viel stärkere soziale Aktivität. Ihre Zahl liegt bei rund 14 Millionen, und sie halten sich insbesondere an die Prophezeiungen der amerikanischen Visionärin Ellen White; außerdem feiern sie den Tag des Herrn nicht am Sonntag, sondern am Samstag.

Die Offenbarung

Die Offenbarung des Johannes, auch Apokalypse genannt, erzählt die Geschichte eines ungewöhnlichen, lebhaften himmlischen Kampfes zwischen Gott und Satan. Sie leistete einen beträchtlichen Beitrag sowohl zur Angst vor dem Teufel als auch zu den Spekulationen der christlichen Millenaristen. Nach Ansicht mancher Fachleute wollten die Autoren des Buches um das Jahr 100 u. Z. eine Allegorie über das Leiden der Juden unter der „bösen" Oberhoheit des Römischen Reiches schaffen, viele Christen nahmen seine Bilder aber wörtlich: die „Zahl des Tieres" 666, Drachen, Schlangen, die vier apokalyptischen Reiter und Armageddon als das Ende. Die Offenbarung schließt mit dem Versprechen, Gott werde über das Böse triumphieren. Jesus werde wiederkehren, den Satan verbannen und eine tausendjährige messianische Herrschaft auf Erden antreten.

Die Mormonen Eine weitere Gruppe, die sich im 19. Jahrhundert von den christlichen Kirchen abspaltete, schloss sich in der von Joseph Smith gegründeten Kirche Jesu Christi der Heiligen der letzten Tage zusammen, die heute zwölf Millionen Mitglieder hat. Ihre Zentrale befindet sich in Salt Lake City. Besser bekannt sind diese Gläubigen als Mormonen: In ihren Lehren und Studien verwenden sie neben der Bibel das Buch Mormon. Dieses erzählt nach ihrer Überzeugung, wie Gott die Ureinwohner des amerikanischen Kontinents behandelte und wie sie von dem gen Himmel gefahrenen Jesus besucht wurden. Die Bewegung behauptet, Mormon sei ein amerikanischer Prophet gewesen, der die Geschichte der antiken Zivilisationen aus alten Aufzeichnungen zusammengetragen und auf goldenen Platten verewigt habe, die Smith 1823 im Bundesstaat New York ausgrub. Der Inhalt, den er 1830 veröffentlichte, ist für Mormonen das unveränderte Wort Gottes.

Worum es geht

Man kann Christus auf vielerlei Weise folgen

21 Entrückung

Die zweite Hälfte des 20. Jahrhunderts war insbesondere in den Vereinigten Staaten durch den Aufschwung eines neuartigen christlichen Fundamentalismus gekennzeichnet. Jetzt reichte es nicht mehr, sich einer Konfession anzuschließen. Als wahrer Gläubiger musste man in Christus „wiedergeboren" werden. Hand in Hand mit dieser Forderung gingen die Dienste von Heilern und Teufelsaustreibern, das Auftreten von Fernsehevangelisten, eine verwickelte Theorie des Dispensationalismus und die Vorstellung von der Entrückung: Danach werden Christen am Ende der Welt in den Himmel gebeamt wie die Gestalten in der beliebten Fernsehserie *Star Trek*.

Der Begriff „Wiedergeburt" stammt aus dem Johannesevangelium: Dort sagt Jesus, die Wiedergeborenen würden den Himmel sehen. Seit den 1960er Jahren wird er insbesondere in den Vereinigten Staaten im Rahmen einer evangelikalen Wiederbelebung weiter gefasst und bezeichnet insbesondere die spirituelle Wiedergeburt durch eine neue oder erneuerte Anerkennung Jesu im persönlichen Leben. Viele wiedergeborene Christen gehören zu unabhängigen oder halb unabhängigen Kirchen, darunter die „Hauskirchenbewegung", die in lockerer Verbindung zu den Baptisten steht; die Mitglieder dieser Bewegung lassen sich häufig durch vollständiges Untertauchen taufen.

Charismatischer Geist Die Freikirchen dieser neuen Gattung bevorzugen einen ungehemmten Stil der Anbetung. Sie greifen dabei auf die Pfingstbewegung und die charismatische Bewegung zurück, welche ebenfalls in den 1960er Jahren einen neuen Aufschwung nahmen und großes Gewicht auf die Aufgeschlossenheit gegenüber den Gaben des Heiligen Geistes legen. Weitere Kennzeichen der Gottesdienste von Wiedergeborenen sind Predigten über das Höllenfeuer, Teufelsaustreibungen und Wunderheilungen.

Zeitleiste

1820er Jahre

J. N. Darby zeichnet die „Haushaltungen" auf.

1950er Jahre

erste Fernsehevangelisten

Fernsehevangelismus

Im 20. Jahrhundert gewöhnte sich die Christenheit daran, ihre Botschaften mit modernen Kommunikationsmitteln einer großen Gemeinde zugänglich zu machen, wie man es früher von der Kanzel der Kirchen oder von den Bühnen der Wanderprediger herab getan hatte. Dazu nutzte man zunächst den Rundfunk und seit den 1950er Jahren das Fernsehen. Der amerikanische katholische Bischof Fulton Sheen lockte mit seiner hausbackenen theologischen Fernsehunterhaltung ein Publikum von bis zu 30 Millionen Menschen vor die Bildschirme (und erhielt dafür den Emmy Award). Vor allem aber bedienten sich protestantische Prediger des neuen Mediums; der bekannteste war sicherlich Billy Graham von der Southern Baptist Church. In den 1980er Jahren versank der Fernsehevangelismus in einer Reihe von Finanz- und Sexskandalen. Beliebte Moderatoren wie Jim und Tammy Faye Bakker oder Jimmy Swaggard wurden angeprangert, und ihre Sendungen wurden eingestellt.

Die Vorstellung von der Entrückung erwuchs bei diesen Evangelikalen und Fundamentalisten aus einer eigenartigen Lesart einer Voraussage, die Paulus im ersten Tessalonikerbrief trifft: Wenn Gott am Ende der Welt zum Gericht auf die Erde herabsteige, würden zuerst „die Toten, die in Christus gestorben sind, auferstehen. Danach werden wir, die wir leben und übrigbleiben, zugleich mit ihnen entrückt werden auf den Wolken in die Luft, dem Herrn entgegen". Dies deutete man als Versprechen für die Zeit, in der die übrige Welt die Trübsal des im Buch der Offenbarung prophezeiten Armaggedon durchlebt: Dann werden die wenigen Auserwählten oder „Wiedergeborenen" verschont, weil sie vom Schlachtfeld in den Himmel „entrückt" werden. Diese Rettung dauert eine bestimmte Zeit – manchmal wird sie auf sieben Jahre geschätzt –, und dann folgt die Rückkehr auf eine gereinigte Erde, auf der Jesus von Jerusalem aus für 1000 Jahre herrscht.

> ❞ Ich möchte mich einfach nur für Gott einsetzen. ❞
> **Billy Graham,** geb. 1918

Wiederbelebung der Vorstellung von der Wiedergeburt

Hal Lindsey veröffentlicht sein Buch *The Late, Great Planet Earth* (dt. *Alter Planet Erde wohin?*)

Diese Theorie widerspricht allen anderen christlichen Lehren, wurde aber erstaunlich populär. Ein führender Vertreter des Entrückungsgedankens ist Hal Lindsey, ein zum christlichen Fundamentalismus bekehrter früherer Mississippi-Frachtschiffskapitän. Sein Buch *The Late, Great Planet Earth* wurde seit seinem ersten Erscheinen 1970 weltweit 35 Millionen Mal verkauft.

Ein begeisterter Entrückungsprediger war auch der Reverend Jerry Falwell (1933–2007), ein bekannter christlicher Fundamentalist, der Verbindungen zur Southern Baptist Convention hatte. Er gründete die politische Lobbyorganisation Moral Majority, die mit der Partei der Republikaner verbunden ist. Er prophezeite: „Du wirst mit dem Auto fahren, und wenn die Trompete erklingt, wirst du und werden andere wiedergeborene Gläubige sofort aus diesem Auto weggeholt – du wirst verschwinden, und nur deine Kleidung wird zurückbleiben... nicht gerettete Menschen in dem Auto werden plötzlich verblüfft feststellen, dass der Wagen ohne Fahrer weiterrollt."

Dispensationalismus Der Entrückungsgedanke steht lose mit dem Dispensationalismus in Verbindung, einer evangelikalen Denkschule, die auf das 19. Jahrhundert und die Schriften des englisch-irischen Evangelikalen John Nelson Darby (1800–1882) zurückgeht. Darby war Mitbegründer der Plymouth-Brüder, wendete sich aber später von diesen ab und gründete die Exclusive Brethren.

Die Scientology-Kirche

Nach Ansicht mancher Kritiker enthält die Vorstellung von der Entrückung ein Element von Science-Fiction. Noch deutlicher tritt dieses Element in der Scientology-Kirche hervor, einer Organisation – manch einer würde sagen: einem Kult – mit acht Millionen Mitgliedern, die 1953 von dem Science-Fiction-Autor L. Ron Hubbard gegründet wurde. Sie steht außerhalb der christlichen Glaubensfamilie; ihre Glaubensüberzeugungen gehen auf die Dianetik zurück, Hubbards System der Selbsthilfe. Nach ihrer Lehre sind Menschen unsterbliche spirituelle Wesen oder Thetanen, die ihre Verbindung zu Gott und dem Ganzen des Kosmos verloren haben. Scientology verfolgt das Ziel, diese Verbindung wiederherzustellen. Die Gruppe wurde durch einige prominente Mitglieder bekannt, unter anderem durch die Schauspieler Tom Cruise und John Travolta.

> **» Ohne die Unterstützung der Wissenschaft, ohne Raumanzüge oder Weltraumraketen wird es jene geben, die an einen prächtigen Ort transportiert werden, welcher schöner und ehrfurchtgebietender ist, als wir es begreifen können. «**
> **Hal Lindsey**

Der Dispensationalismus unterteilt die Geschichte der Menschheit, wie sie in der Bibel erzählt wird, in eine Reihe von „Haushaltungen" oder „Dispensationen"; in jeder dieser Phasen wird Gott gegenüber der Menschheit auf eine charakteristische Weise tätig. Die Theorie gründet sich auf eine eigenartige, eng gefasste Lesart der Heiligen Schrift, die von der großen Mehrzahl der Christen und ihren Konfessionen abgelehnt wird. Sie wird häufig als wörtliche Bibelauslegung bezeichnet, erfordert aber in Wirklichkeit viel Fantasie. Die sieben Haushaltungen sind: 1. die Unschuld (vor Adams und Evas Fall im Garten Eden); 2. das Gewissen (von Adam bis Noah); 3. die Regierung (von Noah bis Abraham); 4. das Versprechen (von Abraham bis Moses); 5. das Gesetz (von Moses bis Jesus); 6. die Gnade (Gegenwart); und 7. das Königreich (das Ende der Zeiten, das bald beginnt).

Wiederbelebt und gefördert wurden Darbys ursprüngliche Spekulationen vor allem von dem derzeitigen geistigen Zentrum der Dispensationalisten, dem Dallas Theological Seminary in Texas. Zu den eher zeitgemäßen Lesarten der Theorie gehört die Annahme, die Gründung des Staates Israel 1948 sei das erste Stadium im Aufbau des Weltenendes, wie es im Buch der Offenbarung prophezeit wird. Die Dispensationalisten behaupten sogar, die gesamte neuere Geschichte des Nahen Ostens sei in der Offenbarung enthalten, und die Welt steuere langsam, aber unaufhaltsam auf einen dritten und letzten Weltkrieg zu, der in dieser Region beginnen werde.

Worum es geht

Die Wiederkehr Christi ist nahe

22 Das Jüdischsein

Das Judentum ist die älteste, mit 16 Millionen Anhängern aber auch die kleinste der drei monotheistischen Religionen. Kurz gesagt entspricht der jüdische Glaube der uralten Ansicht, dass es in der Religion weniger um Glauben als vielmehr um Tun gehe. Ein zentraler Begriff im Judentum ist *emunah* – Glaube –, der aber nicht nur den Gedanken, sein Vertrauen in Gott zu setzen, umfasst, sondern alles, was sich für eine Lebensführung nach ethischen, von Gott gegebenen Prinzipien daraus ergibt.

Für das „Judentum" gibt es im Hebräischen kein Wort. Manche Fachleute sind sogar der Ansicht, dass der Begriff erst seit dem 19. Jahrhundert gebräuchlich ist. Man kann Jude sein, ohne sich allen oder auch nur irgendwelchen Lehren des Judentums anzuschließen, wie sie in dem von Rabbinern festgeschriebenen jüdischen Gesetz vorgegeben sind. Man muss nur eine jüdische Mutter haben. „Säkulare" Juden machen sich vielleicht jüdische Werte und manche traditionellen Praktiken zu eigen, messen ihnen aber keine religiöse Bedeutung bei, sondern betrachten das Judentum als kulturelle und ethnische Identität. Durch diese Kombination von Religion und Rasse unterscheidet sich das Judentum von allen anderen Glaubensrichtungen.

Das auserwählte Volk Die heiligen Schriften des Judentums sind die jüdische Bibel, zu der die Bücher der Thora (Genesis, Exodus, Levitikus, Numeri und Deuteronomium) gehören, nicht aber die des Neuen Testaments; außerdem der Talmud (Schriften von Rabbinern) und der *Siddur* (Gebetbuch). Der Schlüssel für die Geschichte des jüdischen Volkes, wie sie in der Thora wiedergegeben wird, ist Gottes Versprechen im Buch Exodus, die Juden seien sein auserwähltes Volk: „Werdet ihr nun meiner Stimme gehorchen und meinen Bund halten, so sollt ihr mein Eigentum sein vor allen Völkern; denn die ganze Erde ist mein. Und ihr sollt mir ein Königreich von Priestern und ein heiliges Volk sein." Die Interpretation dieses Versprechens – und der übrigen Bibel – war vor allem die Aufgabe der Rabbiner (Lehrer). Ihre Kommentare (*Mischna*), die sie vielfach nur mündlich weitergaben, wurden um

Zeitleiste

ca. **1200** v. u. Z.	**586** v. u. Z.	**70** u. Z.	ca. **600**
Entstehung des jüdischen Königreiches	babylonische Gefangenschaft	Zerstörung des zweiten Tempels	Fertigstellung des Talmud

200 u. Z. zum ersten Mal aufgezeichnet. Später wurden sie mehrfach umgearbeitet und an neue Umstände angepasst; um 600 u. Z. entstand daraus der Talmud (von dem hebräischen Wort für „lernen").

> **Bin ich Jüdin von Religion, von Volk, von Stamm, von Nationalität, von Rasse?**
>
> Rabbi Julia Neuberger, **1995**

Das Erlebnis des Exils Die Geschichte des Judentums umfasst 3500 Jahre, mehr als drei Viertel der Geschichte der Zivilisation. Sie beginnt der Thora zufolge beim Stammvater Abraham. Die Juden wurden von Gott als besonderes Volk auserwählt und sollten ein Beispiel für Heiligkeit sein. Gott führte sie aus Ägypten und ermöglichte es ihnen, ihre Feinde zu besiegen und um 1200 v. u. Z. ein eigenes Reich zu gründen. Auf dem Berg Sinai gab er Moses, dem wichtigsten Propheten des Judentums, eine Reihe von Regeln für ein ethisch einwandfreies Leben: die Zehn Gebote.

Die 13 Artikel des Maimonides

Im 12. Jahrhundert gab es einen Versuch, das Wesen des Judentums zusammenzufassen, der stets populär geblieben ist. Der Gelehrte und Philosoph Maimonides (Rabbi Moses Ben Maimon) schrieb 13 Prinzipien fest: Gott existiert; Gott ist Eins; Gott hat keine körperliche Form; Gott ist ewig; Juden dürfen nur ihn allein anbeten; Gott hat durch die Propheten gesprochen; Moses ist der größte Prophet; die Thora ist göttlichen Ursprungs; die Thora ist in Ewigkeit gültig; Gott kennt die Taten der Menschen; Gott bestraft das Böse und belohnt das Gute; Gott wird einen Messias schicken; und Gott wird die Toten auferwecken.

> **Die Juden haben sich früher als fast alle anderen Völker, die sich bis heute erhalten haben, eine eigene, spezifische Identität geschaffen.**
>
> Paul Johnson, 1987

ca. **1800**	ca. **1900**	**1939**	**1948**
Spaltung von Orthodoxen und Reformierten	Liberale Bewegung	Holocaust durch die Nationalsozialisten	Gründung des Staates Israel

Das jüdische Königreich florierte. König Salomo baute 960 v. u. Z. in Jerusalem einen großen Tempel, der zum Mittelpunkt der Riten und Rituale wurde. Er wurde 586 v. u. Z. von den Babyloniern zerstört, die eine Spaltung zwischen den Juden ausnutzten, um sie zu unterwerfen. Viele Juden wurden ins Exil verschleppt, das erste von mehreren derartigen Ereignissen in der jüdischen Geschichte. Das wiederhergestellte neue Königreich existierte bis zum ersten Jahrhundert u. Z., in der Spätzeit unter römischer Oberhoheit. Ein Aufstand führte im Jahre 70 u. Z. zur Zerstörung des zweiten Tempels. Von nun an war man stets bestrebt, die jüdische Tradition schriftlich festzuhalten.

Als die Juden quer durch Europa wanderten, nahm ihre Verfolgung zu. Zuflucht fanden sie aber um 1000 u. Z. unter den islamischen Herrschern in Spanien. Danach erlebten sie im christlichen Europa noch größere Beschränkungen, bis ein neues liberales Bewusstsein ihnen zu Beginn des 19. Jahrhunderts im Westen und in Übersee (1648 kamen die ersten Juden nach Amerika) größere Freiheiten verschaffte; im Osten setzte sich die Verfolgung jedoch fort. Hitlers Versuch, das ganze Volk im Rahmen des Holocaust auszulöschen, forderte unter den Juden Anfang der 1940er Jahre sechs Millionen Todesopfer. Im Jahr 1948 erhielten die Juden mit der Gründung Israels ihren eigenen Heimatstaat.

Orthodox, reformiert und liberal Vom siebten bis zum 19. Jahrhundert vermied das jüdische Volk jede Einteilung in verschiedene Kategorien. Stattdessen betonte man das Gemeinsame: die Vertreibung (*Galut*) aus dem gelobten Land. Als sich aber im 19. Jahrhundert die Gleichberechtigung in der Gesellschaft immer stärker durchsetzte, entstanden im jüdischen Glauben jene Kategorien, die uns noch heute vertraut sind. Diejenigen, die den größten Wert auf Traditionen und Gesetze legten, bezeichneten sich selbst als gehorsam, wurden aber von anderen als orthodoxe Juden eingeordnet. Sie stellen heute einen Anteil von zehn bis 15 Prozent aller Juden. Das reformierte Judentum entstand durch eine Neubewertung der traditionellen Religion vor dem Hintergrund der veränderten Verhältnisse im Europa des 19. Jahrhunderts. Fast 2000 Jahre alte Regeln (beispielsweise im Zusammenhang mit den Privilegien einer Priesterkaste aus Familien und mit den Vorschriften für rituelle Reinheit) wurden aufgegeben. Zur Reformbewegung gehört heute der größte Teil der gläubigen Juden. Die liberale Bewegung war zu Beginn des 20. Jahrhunderts ursprünglich eine Untergruppe der Reformierten, modernisierte aber weitere Glaubensaspekte: Sie betrachtet beispielsweise jeden, der einen jüdischen Elternteil hat (und nicht nur die Kinder jüdischer Mütter), als Juden und lässt auch Frauen als Rabbiner zu. Ihr Ziel ist es, das traditionelle Judentum mit der modernen Welt in Einklang zu bringen.

Ultraorthodoxe

Der bekannteste Flügel des modernen ultraorthodoxen Judentums ist der Chassidismus (von hebräisch *chassid* = fromm). Der Begriff wurde erstmals im zweiten Jahrhundert v. u. Z. für besonders fromme Juden benutzt und im 18. Jahrhundert in Osteuropa wiederbelebt, insbesondere bei den unterdrückten jüdischen Bauern in Polen, Litauen und anderen Regionen. Ziel der Bewegung ist eine Vertiefung der Frömmigkeit – häufig durch Musik und Mystik – und eine verstärkte Spiritualität anstelle der Gelehrsamkeit. Durch Auswanderungswellen gelangte sie nach Westeuropa und darüber hinaus. Die modernen chassidischen Gemeinden halten eng zusammen und erlegen sich strenge Bescheidenheitsregeln auf. Die Männer tragen unter den Ohren lange Haarlocken, weil es im Buch Levitikus die Vorschrift gibt, den Rand des Bartes nicht zu schneiden.

Worum es geht

Die Juden sind Gottes auserwähltes Volk

23 Jüdische Übergangsriten

Bis heute prägt eine charakteristische, im Laufe von 3500 Jahren entstandene Sammlung jüdischer Riten und Rituale das Leben der Juden. Ihre Ursprünge gehen wie die gesamte Glaubensrichtung auf die hebräische Bibel und den darin beschriebenen Bund zwischen Gott und seinem auserwählten Volk zurück. Dass diese Rituale so lange erhalten blieben, liegt zu einem großen Teil an dem Wunsch des jüdischen Volkes, seine Identität auch während langer Phasen des Exils und der Verfolgung nicht zu verlieren. Sie sind zu einem Teil des modernen jüdischen Lebens geworden; in welchem Umfang sie allerdings praktiziert werden, hängt häufig davon ab, welche Form des Judentums der Einzelne sich zu eigen gemacht hat.

Die erste Verpflichtung, die den Juden in der Thora auferlegt wird, die *Mitzwa*, steht im Kapitel eins des Buches Genesis: „Seid fruchtbar und mehret euch." Kinder zu haben ist für die Juden eine religiöse Forderung, die der zentralen Beziehung zu Gott neues Leben einhaucht und damit seine Herrschaft auf Erden stärkt. Außerdem dient es dem praktischen Zweck, die Mitgliederzahl der bei weitem kleinsten der drei monotheistischen Religionen aufrechtzuerhalten. Insbesondere die chassidischen Juden nehmen diese Verpflichtung sehr ernst.

Menschliches Leben gilt dem Judentum als heilig; deshalb werden alle Formen der Empfängnisverhütung abgelehnt. Es gibt allerdings Abstufungen: Am wenigsten ist gegen orale Verhütungsmittel wie die Pille einzuwenden, deren älteste Formen schon in der rabbinischen Literatur beschrieben werden, am meisten gegen Kondome oder Coitus interruptus. Grundlage solcher Bewertungen ist das Verbot im Buch Genesis, „den Samen zu verschütten". Die Abtreibung ist im Judentum nicht mit

Zeitleiste

1200 v. u. Z.

Jüdische Lebensregeln werden
in der Thora festgeschrieben.

19. Jahrhundert

Reformierte Juden stellen die Regeln
des koscheren Essens infrage.

dem gleichen strengen Verbot belegt wie in der katholischen Kirche, und wenn das Leben der Mutter in Gefahr ist, wird sie sogar befürwortet.

Zeremonien Wie es Gottes in der Thora niedergelegten Wünschen entspricht, schließen alle jüdischen Jungen im Alter von acht Tagen einen „Bund im Fleisch", indem sie sich der Beschneidung unterziehen – die Vorhaut wird entfernt. Nach jüdischer Überzeugung ist dies das körperliche Zeichen für die Verpflichtung gegenüber Gott. Nach der Thora sollte die Operation vom Vater des Säuglings durchgeführt werden, meist wird jedoch ein *Mohel* – ein speziell ausgebildeter Rabbiner und/oder Arzt – damit beauftragt. Früher fand sie in der Synagoge statt, heute verlegt man sie meist in die Wohnung der Familie. Männliche und weibliche Neugeborene erhalten in Ritualen in der Synagoge ihren Namen und werden gesegnet.

Auch von Männern, die zum Judentum konvertieren, wird die Beschneidung verlangt.

Was ist koscher?

Die jüdischen Ernährungsvorschriften haben ihren Ursprung in der hebräischen Bibel und werden als *Kaschrut* bezeichnet; davon leitet sich das Wort *koscher* für Lebensmittel ab, die man essen darf. Die Regeln werden manchmal mit Gesundheit und Hygiene in Verbindung gebracht, grundsätzlich haben sie jedoch eher mit dem Befolgen biblischer Vorschriften zu tun, so unvernünftig sie dem modernen Geist auch erscheinen mögen. Maimonides schrieb über die Ernährungsvorschriften: „Sie lehren uns, unseren Appetit zu beherrschen, uns an die Beschränkung unserer Wünsche zu gewöhnen und es zu vermeiden, die Freude am Essen und Trinken als Daseinsziel des Menschen zu betrachten". Orthodoxe Juden befolgen die Gesetze peinlich genau: Sie trennen Fleisch und Milch, lehnen Fische ab, wenn sie nicht Flossen und Schuppen haben, und schlachten Tiere auf genau vorgeschriebene Weise. Manche halten sich sogar an die Vorschrift im Buch Levitikus, wonach man keine Früchte von einem Baum essen soll, der noch keine drei Jahre alt ist. Diese strikte Einhaltung der Regeln ist ein weiterer Faktor, durch den sich orthodoxe Juden von anderen unterscheiden. Die reformierten Juden vertraten im 19. Jahrhundert die Ansicht, *Kaschrut* sei zum Selbstzweck geworden und diene nur noch dazu, eine Distanz zwischen Juden und Nichtjuden zu schaffen. Heute halten sich viele reformierte und liberale Juden je nach ihren eigenen Vorlieben an die Regeln oder auch nicht.

ca. **1900**	**1917**	**1948**
Zahl der Eheschließungen mit Nichtjuden nimmt zu.	Balfour-Deklaration	Gründung des Staates Israel

> ❯ **Gott sprach zu Abraham... Alles, was männlich ist unter euch, soll beschnitten werden. Ihr sollt aber die Vorhaut an eurem Fleisch beschneiden. Das soll ein Zeichen sein des Bundes zwischen mir und euch.** ❮
>
> Genesis 17, 10-11

Nach dem Talmud ist man mit 13 Jahren erwachsen. In diesem Alter hält man junge Juden für fähig, die Gebote einzuhalten. Jungen werden Bar Mitzwa, Mädchen Bat Mitzwa – „Sohn und Tochter der Pflicht". In der reformierten Tradition werden beide Anlässe gefeiert, Männer und Frauen gelten vor Gott als gleichberechtigt.

Das traditionelle Verbot im Judentum, Nichtjuden zu heiraten, widerspricht zwar den modernen Vorstellungen von individueller Freiheit und religiöser Toleranz, unter historischen Gesichtspunkten ist es aber verständlich: Es diente dem Ziel, auch im Exil und bei Verfolgung eine einheitliche Gemeinschaft aufrechtzuerhalten. In orthodoxen und ultraorthodoxen Kreisen wird das Verbot noch heute weitgehend beachtet – hier würde schon das strenge Festhalten an Ernährungsvorschriften und rituellen Reinheitsgesetzen die Führung eines „gemischten" Haushalts erschweren. Unter reformierten und liberalen Juden wird die Eheschließung mit Andersgläubigen geduldet, bleibt aber für viele Eltern ein Grund zur Verärgerung. Sie wünschen sich zwar die Integration ihrer jüdischen Kinder in die Gesamtgesellschaft und erkennen an, dass Mischehen dem Antisemitismus entgegenwirken, dennoch bedauern sie die Verwässerung der jüdischen Identität. In den Vereinigten Staaten heiraten über 50 Prozent der Juden Angehörige anderer Religionen.

Im Gegensatz zum Christentum betreiben Juden keine Mission. Man versucht nicht aktiv, andere zu bekehren. Möchte jemand von sich aus Jude werden, wird der Wunsch nach Übertritt sorgfältig geprüft und vielfach auch abgelehnt.

Der jüdische Kalender Der jüdische Kalender ist kompliziert und verworren. Als sehr alte Glaubensrichtung hat das Judentum ein starkes Gespür für das Verstreichen der Zeit; dies erkennt man an den täglichen Gebetszeiten und der Trennung des *Sabbat* (Ruhetag am Samstag) von der übrigen Woche. Mit Ausnahme des Versöhnungstages (Jom Kippur) erinnern alle Feiertage im Kalender an Gottes Gegenwart in Natur und Geschichte – insbesondere in der Geschichte des jüdischen Volkes.

Zionismus

Zwischen Judentum und Zionismus besteht ein enger Zusammenhang, man sollte aber beides nicht gleichsetzen. Zionismus ist zumindest in seiner modernen Form eine politische, nationalistische Bewegung, die seit den 1880er Jahren für das Recht der Juden auf einen eigenen Staat in Palästina eintrat, der Region, in der Gott seinen ursprünglichen Bund mit ihren Vorfahren geschlossen hatte. Der Druck der Zionisten führte 1917 zur Balfour-Deklaration: Darin befürworteten die Briten, die damals in Palästina herrschten, den Gedanken an einen jüdischen Staat. Als die Region in der Folgezeit zum Brennpunkt für jüdische Einwanderungsbewegungen aus der ganzen Welt wurde, wuchsen die Bedenken wegen des Schicksals der dort bereits ansässigen, nichtjüdischen Bevölkerung. Nach dem Holocaust durch die Nationalsozialisten und einem Terroristenfeldzug gegen die britischen Streitkräfte in Palästina wurde 1948 der Staat Israel gegründet. Dort leben heute rund 40 Prozent aller Juden, aber viele Menschen aus allen Zweigen des Judentums stellen die Errungenschaften des Zionismus infrage. Den ultraorthodoxen Juden beispielsweise ist das moderne Israel zu säkular – also nicht jüdisch genug –, viele liberale Juden dagegen lehnen das Verhalten der israelischen Regierung und die Siedlungen in den besetzten Gebieten ab.

Pessach im Frühjahr ist ein Zeitraum von 49 Tagen, der an den Auszug des jüdischen Volkes aus der ägyptischen Sklaverei erinnert. Sein Höhepunkt ist das Fest Schawuot (Wochenfest) zu Ehren der Verkündung der Thora und der Zehn Gebote auf dem Berg Sinai. Das Gegengewicht im Herbst bildet Rosch Haschana, das „Neujahrsfest", auf das zehn Tage später der „Versöhnungstag" Jom Kippur folgt; außerdem findet im Herbst das „Laubhüttenfest" Sukkot statt, das an die Wanderung durch die Wildnis in das Gelobte Land und an Gottes Schutz erinnern soll.

Worum es geht
Es gibt eine charakteristische jüdische Lebensweise

24 Die Kabbala

In allen drei monotheistischen Religionen gibt es die Vertreter eines mystischen, von Fantasie und Intuition geprägten Glaubens. Im Judentum wird diese Richtung als Kabbala bezeichnet. Ihr wichtigster Text, das Sefer ha Zohar („Buch des Glanzes"), erschien erstmals in den 1280er Jahren in Spanien; nach den Behauptungen seiner Anhänger repräsentiert es aber eine verborgene, erotisch-spirituelle Tradition im Judentum, die bis ins erste Jahrhundert u. Z. oder noch weiter zurückreicht. Es verlieh den Gebeten und dem geistlichen Leben vieler Juden neue Energie und trug dazu bei, dass sie in ihrem Glauben einen Sinn erkennen konnten, der über Regeln, Riten und Rituale hinausgeht. Andere Vertreter der jüdischen Hauptrichtung halten aber die verschiedenen Ausprägungsformen der Kabbala für Aberglauben, der Visionen und bösen Geistern eine zu große Bedeutung beimisst.

Das Zohar wurde 1280 von dem spanischen Rabbiner Moses de Leon (ca. 1250–1305) verfasst oder zusammengestellt. Seinen eigenen Aussagen zufolge bearbeitete er einen wesentlich älteren Text von Rabbi Shimon bar Yochai, der um 70 u. Z., als der zweite Tempel in Jerusalem zerstört wurde, ein bekannter Lehrer war. Wie er aber an diesen Text gelangt war, wurde nie ganz klar. Das antike Dokument, eine Sammlung der mündlichen Kommentare von Shimon bar Yochai über die Thora, war nach de Leons Angaben später aus dem Talmud weggelassen worden und verloren gegangen oder in Vergessenheit geraten.

Im Zusammenhang mit den Behauptungen Moses de Leons über das Zohar gab es viele Diskussionen. Der Text enthält Bezüge zu Ereignissen, die sich lange nach dem Jahr 70 abspielten. Nach Ansicht der Gläubigen ist das ein Beweis, dass Shimon bar Yochai ein Prophet war. Manche behaupten sogar, er habe vorausgesagt, dass seine Schriften 1200 Jahre lang im Verborgenen bleiben würden, bevor sie auf wundersame Weise wieder auftauchen und den Juden als Richtschnur dienen würden.

Zeitleiste

ca. **70** u. z.	**1280**
Shimon bar Yochai schreibt seine Lehren nieder	Moses de Leon schreibt das Zohar

Allgemein wird aber berichtet, nach de Leons Tod habe seine mittellose Witwe ein Kaufangebot für den ursprünglichen Text erhalten und darauf geantwortet, einen solchen Text gebe es nicht. Ihr Mann habe ihn einfach neu erfunden. Dennoch blieben die Anhänger des Zohar bei ihrer Ansicht, die Worte des Buches seien unter göttlichem Einfluss geschrieben worden.

Innere Bedeutung In seiner Untersuchung der Thora beschreibt das Zohar vier Bedeutungsebenen: die buchstäbliche, die allegorische, die von den Lehren der Rabbiner geleitete und schließlich die innere Antwort oder *Sod*. Die Anfangsbuchstaben dieser vier Ebenen im Aramäischen (der antiken Sprache, derer sich Moses de Leon bediente) ergeben ein Wort, das „Obstgarten" oder „Paradies" bedeutet. Auf der Suche nach der inneren Bedeutung, so das Zohar, müssen sich Juden der Liebe Gottes in Gehorsam und Gebet hingeben; dann beginnt ein spiritueller Weg, der durch heilige Visionen gekennzeichnet ist und in sieben mit Farben markierten Stadien der Ekstase gemessen wird. Das letzte Stadium ist farblos, und der Gläubige betrachtet das undurchschaubare Mysterium Gottes.

Insgesamt haben die Beschreibungen der Beziehung zwischen den Menschen, Gott und der Thora im Zohar einen erotischen Unterton; dieser ist so stark, dass es im 17. Jahrhundert Bestrebungen gab, nur Männern über 40 Jahren die Lektüre des Zohar zu gestatten.

Die Sefirot

Die *Sefirot* sind in der Kabbala die zehn „Emanationen" Gottes, die er im Universum erschafft. Sie entsprechen verschiedenen Schöpfungsebenen oder Zweigen am Baum des Lebens und sind das Mittel, mit dem Gott sich selbst und seine ethischen Grundsätze seinem Volk offenbart. Das sind *Kether* (Wille), *Chochma* (Weisheit), *Bina* (Einsicht), *Chessed* (Gnade), *Gewura* (Gerechtigkeit), *Tiferet* (Harmonie), *Netzach* (Sieg), *Hod* (Glanz), *Yesod* (Macht) und *Malchut* (Königreich).

> *[Die Kabbala] macht den Menschen Angst,*
> **deshalb bemühen sie sich, sie zu leugnen oder kleinzureden,**
> **damit sie sinnvoller erscheint.** *
>
> Madonna, **2005**

1480er Jahre

Vertreibung der Juden aus Spanien

ca. **1500**

Isaac Luria verfeinert die Kabbala

Der Gott, den man nicht kennen kann Die wichtigsten religiösen Lehren des Zohar sprechen den Menschen viel Macht zu. Gute Männer und Frauen, so heißt es dort, können das Universum durch ihre Taten verbessern und so einen Strom der göttlichen Gnade in Gang setzen. Dies ist insgesamt einer der wichtigsten Grundsätze der Kabbala-Bewegung: Sie ist bestrebt, zwischen einem unendlichen, ewigen Schöpfergott und den Individuen, die seine endliche Schöpfung bevölkern, einen Zusammenhang herzustellen.

Die Kabbala setzt sich aus Wegen zur spirituellen Selbstverwirklichung zusammen. Dazu gehören Gebete, Reflexion und die Bereitschaft zu einer mystischen Reise, in der sich die äußere religiöse Praxis (jüdische Riten und Rituale) mit ihrer inneren Bedeutung versöhnt. Sie ist aber im Vergleich zum Zohar ein umfassenderes theologisches und mystisches System. Ihre Anhänger behaupten, sie gehe auf das 10. Jahrhundert v. u. Z. zurück und sei damals für die jüdische Bevölkerung im antiken Israel das Normale gewesen. Erst während der späteren Aufstände, Kriege, Vertreibungen und anderen Leiden, so die Behauptung, wurde sie begraben oder vergessen.

Im Talmud bedeutet das Wort *Kabbala* einfach „empfangenes Wissen", aber im Laufe der Jahrhunderte, die auf die weite Verbreitung des Zohar im Judentum des Mittelalters folgten, fanden die darin skizzierten mystischen Grundsätze ihren Weg in die Hauptrichtung des jüdisch-theologischen Denkens. Beschleunigt wurde diese Entwicklung durch die Zerstörung und Zerstreuung der jüdischen Gemeinschaft, die in Spanien seit 1490 einsetzte. Parallel zu diesem Prozess wurde die Lektüre der Kaballa, die bisher fast ausschließlich der jüdischen Oberschicht vorbehalten war, nun zu einer volkstümlichen Bewegung; kabbalistische Werke kursierten in der jüdischen Diaspora und beschrieben einen esoterischen Weg zur unmittelbaren Vereinigung mit Gott.

> **Wertvoller als das Gewand ist der Körper, welcher es trägt, und noch wertvoller als er ist die Seele, welche den Körper belebt. Toren sehen nur das Gewand der Thora, die Klügeren sehen den Körper, die Weisen sehen die Seele, ihr eigentliches Sein; und in messianischer Zeit wird sich die ‚höhere Seele' der Thora offenbaren.**
>
> *Zohar*

Madonna und die Kabbala

Die Sängerin Madonna wurde zwar katholisch erzogen, entwickelte sich aber zu einer prominenten Anhängerin der Kabbala, nachdem sie 1997 von ihrer Freundin, der Schauspielerin und Komikerin Sandra Bernhard, mit der Lehre bekanntgemacht worden war. Eigenen Angaben zufolge verdankt sie der Kabbala ein größeres Selbstwertgefühl und spirituelle Orientierung. Vor dem Hintergrund dieser Verbindung nahm sie den hebräischen Namen Esther an und trug in der Öffentlichkeit am Handgelenk ein rotes, siebenmal geknotetes Band, das böse Geister abwehren soll. Sie hat sich einer besonderen Form der Kabbala angeschlossen, die von dem Rabbiner Philip Berg vertreten wird; dieser gründete 1969 in Jerusalem das erste Kabbala-Zentrum und später weltweit 50 weitere. In ihrem 1998 erschienenen Album *Ray of Light* dankt Madonna dem Kabbala-Zentrum für die „kreative Richtschnur", und in einem Kinderbuch, das sie 2003 herausbrachte, äußert sie Gedanken über die ethische Ablehnung von Habgier und Neid durch die Bewegung.

Die Kabbala wurde zum Gegenstand vieler Diskussionen und Neubewertungen, insbesondere durch Isaac Luria (1534–1572) und seine Schule für kabbalistische Studien in Safed im Norden Galiläas. Die Lurianische Kabbala legt besonderes Gewicht auf den Kosmos, die Meditation und die Wiederkehr eines jüdischen Messias. Sie unterscheidet deutlich zwischen *Ein Sof* – dem Aspekt Gottes, den man nie kennen kann, weil er endlos und unpersönlich ist – und den *Sefirot*, jenen zehn offenbarten Aspekten, die das Leben der Juden, das Schicksal Israels und die Menschheitsgeschichte prägen.

Worum es geht

Das Mysterium Gottes
lässt sich teilweise enträtseln

25 Antisemitismus

Alle Religionen und Gläubigen mussten sich irgendwann einmal in ihrer Geschichte mit Vorurteilen weltlicher Herrscher, anderer Bürger oder der Anhänger anderer Glaubensrichtungen auseinandersetzen. Die Juden erlebten dies aber länger und in extremerer Form als alle anderen. Von den judenfeindlichen Unruhen in Alexandria im dritten Jahrhundert v. u. Z. bis zum Holocaust durch die Nationalsozialisten zwischen 1939 und 1945, bei dem sechs Millionen Juden ums Leben kamen, hat der Schatten des Antisemitismus die jüdische Identität geprägt.

Feindseligkeit gegen Juden gab es schon lange vor der Entstehung des Christentums. Griechen und Römer griffen die unter ihnen lebenden Juden an und warfen ihnen übermäßigen Einfluss, übertriebene finanzielle Macht und seltsame Geheimpraktiken vor – ein Vorgeschmack auf die Vorwürfe, die später im christlichen Europa erhoben wurden. Aber die Abspaltung der christlichen Kirche vom Judentum im ersten Jahrhundert u. Z. hinterließ ein besonderes Erbe von Hass und Misstrauen zwischen den beiden Religionen, das erst 1965 aus dem Weg geräumt wurde: In diesem Jahr sprach der Vatikan die Juden offiziell vom Verbrechen des Gottesmordes frei.

Die Zuflucht des Teufels Die frühen Kirchenführer waren darauf bedacht, sich eindeutig von ihren jüdischen Wurzeln abzugrenzen, und verurteilten deshalb hemmungslos das Judentum. Der heilige Johannes Chrysostomos (ca. 344–407) stellte 387 in einer Reihe von acht Predigten vor der Bevölkerung von Antiochia alle Waffen bereit, die auch von späteren Generationen benutzt wurden: Er bezeichnete die Juden als fleischlich, wollüstig, geizig, verflucht und teuflisch. Sie hätten alle Propheten ermordet, anschließend Christus gekreuzigt, und jetzt beteten sie den Teufel an. Der heilige Hieronymus (ca. 340–420)) nannte die Synagoge „ein Bordell, einen Wohnort des Lasters, die Zuflucht des Teufels, die Festung des Satans, einen Ort zur Verderbnis der Seele, einen Abgrund aller nur vorstellbaren Übel und

Zeitleiste
3. Jahrhundert v. u. z.
judenfeindliche Ausschreitungen in Alexandria
1. Jahrhundert u. z.
erste „Blutbeschuldigung"

was man sonst noch will". Der älteste Bericht über eine von Christen in Brand gesteckte Synagoge stammt aus dem Jahr 338, aus der Stadt Callicnicul am Euphrat.

Auf besonders heimtückische Weise wurden die Juden von Christen verteufelt. Man setzte sie ohne Weiteres mit dem Satan selbst gleich, dem Feind Jesu im Neuen Testament. Sie wurden beschuldigt, seine Kennzeichen zu tragen und seine Werke zu tun. Ein beliebter Begriff im christlichen Mittelalter war der des *foetor judaicus*; er bezeichnete einen fauligen Schwefelgeruch, den Juden angeblich ausdünsteten und der auch ein Zeichen des Teufels war. Ein anderer Vorwurf lautete, die Juden entführten christliche Kinder, um ihr Blut dem Teufel zu opfern. In der christlichen Kunst des Mittelalters wurde der Teufel häufig mit langer Hakennase dargestellt, einem körperlichen Merkmal, das er angeblich mit den Juden gemeinsam hatte.

Die Blutbeschuldigung

Blutbeschuldigungen – falsche Vorwürfe, eine bestimmte (meist religiöse) Gruppe verwende im Rahmen ihrer Rituale das Blut ihrer Opfer – sind seit dem ersten Jahrhundert u. Z. dokumentiert. Damals warf der griechische Chronist Apion den Juden vor, sie hätten während ihrer Zeremonien im Tempel von Jerusalem gefangene Griechen geopfert. Der gleichen Anklage sahen sich die Christen ein Jahrhundert später ausgesetzt, als ihre römischen Verfolger sich die Symbolik von Jesu Leib und Blut im Brot und Wein der Eucharistie zunutze machten: Sie behaupteten, die Mitglieder der neuen Kirche würden während ihrer Gottesdienste Blut trinken. Die erste christliche Blutbeschuldigung gegen Juden gab es 1144: Damals wurden die Juden von Norwich beschuldigt, sie hätten einen Botenjungen gefangen genommen, getötet und geopfert. Die Anklage wurde durch einen Gerichtshof zurückgewiesen, aber die angeklagten Juden mussten vor der wütenden Volksmenge fliehen. Der Junge hieß William von Norwich und wurde von der Kirche später heiliggesprochen.

338
erster Bericht über eine von Christen niedergebrannte Synagoge

1144
Mord an William von Norwich

1939–1945
Holocaust durch die Nationalsozialisten

1965
Der Vatikan spricht die Juden vom Gottesmord frei

Sündenböcke Der angebliche Grund für die Feindseligkeit der Christen gegen-über den Juden war der Gottesmord – die Tötung Jesu. In Wirklichkeit steckten aber oftmals eher pragmatische Gründe dahinter. Im Europa des Mittelalters war die winzige Minderheit der Juden (nicht mehr als 1,5 Millionen Menschen auf dem ge-samten Kontinent) in juristischen, medizinischen und Finanzberufen häufig überre-präsentiert. Wegen ihres unverhältnismäßig großen Erfolges wurden sie zum Gegen-stand des Neides, und man machte sie zu Sündenböcken. Brauchte ein Herrscher je-manden, den er für Missstände in seinem Reich verantwortlich machen konnte, wa-ren die Juden ein bequemes Ziel. Als die Kaiserin Maria Theresia von Österreich, eine gläubige Christin, im Jahr 1750 zusätzliche Steuereinnahmen brauchte, vertrieb sie die Juden zunächst von ihren weitläufigen Besitzungen in Böhmen und ließ sie dann wieder zurückkehren, wenn sie für dieses Privileg alle zehn Jahre eine Sonder-steuer zahlten.

Papst Pius XII. und die Juden

Pius XII. wurde 1939, wenige Monate vor Ausbruch des Zweiten Weltkriegs, zum Papst gewählt. Jüdische Historiker werfen ihm Antisemitismus vor, weil er sich ent-schloss, während der Kriegsjahre zum Holocaust durch die Nationalsozialisten zu schweigen, obwohl er darüber Bescheid wusste. Nach Ansicht der Kritiker war er gegenüber den Gräueltaten der Nazis blind, weil er glaubte, Hitler könne als ein-ziger verhindern, dass ein Kommunismus sowjetischer Prägung ganz Europa er-oberte und die Kirche zerstörte. Weiter wird der Vorwurf erhoben, die Diplomaten des Vatikan hätten den Juden keine Visa für die Reise nach Palästina erteilt und ih-nen damit die Hilfe bei ihrer Flucht vor der Verfolgung versagt, weil der Papst ein Gegner des jüdischen Heimatstaates war. In der unmittelbaren Nachkriegszeit zeigte Pius, so wurde behauptet, sein wahres Gesicht, indem er zuließ, dass der Vatikan den nationalsozialistischen Kriegsverbre-chern als Zwischenstation für die Flucht nach Afrika und Lateinamerika diente. Darauf entgegnen seine Verteidiger, er sei kein Antisemit gewesen, habe über den wahren Schrecken des Holocaust nicht Bescheid gewusst und habe (fälsch-lich) geglaubt, er müsse einen streng neu-tralen Standpunkt bewahren, um so die Unabhängigkeit der Kirche zu erhalten und letztlich an einem Friedensabkommen mit-wirken zu können. Im Jahr 1999 stimmte der Vatikan der Einsetzung einer gemein-samen Kommission mit jüdischen Histori-kern zu, die in seinen Archiven recherchie-ren und ein vollständigeres Bild der Rolle von Papst Pius zeichnen sollte. Zwei Jahre später legten die jüdischen Mitglieder der Kommission unter Protest ihre Ämter nie-der, weil Rom sich weigerte, die Archive gänzlich zu öffnen.

> **Die Verteufelung der Juden durch die Christen geht unmittelbar auf die jüdische Ablehnung Jesu zurück, also auf die alte Frage, ob Juden Jesus ermordet haben. So entstand das Bild von den Juden als Dämonen.**
> Rabbi Norman Solomon, geb. 1933

Die Christen waren nicht die Einzigen, die die Juden angriffen. Im 18. Jahrhundert wurden sie von Voltaire und anderen großen Denkern der Aufklärung, die ansonsten in jeder Hinsicht das Gewissen und die Freiheit verteidigten, als habgierig und neidisch verunglimpft und sogar wegen ihrer Sabbatgebräuche verteufelt. Im 19. Jahrhundert verfassten deutsche Wissenschaftler pseudogelehrte Abhandlungen, mit denen sie die vermeintliche Minderwertigkeit des jüdischen Volkes belegen wollten.

Toleranz im Islam Der Islam stand den Juden traditionell toleranter gegenüber als das Christentum – vielleicht, weil die beiden Religionen trotz ihres gemeinsamen monotheistischen Ansatzes nicht so eng miteinander verwandt sind wie das Juden- und das Christentum. Vom neunten bis zum 19. Jahrhundert genossen die Juden in muslimischen Ländern häufig eine größere Religionsfreiheit als im Einflussgebiet des Christentums; im 11. Jahrhundert kam es jedoch in Spanien, das bis dahin ein Hort der Toleranz und des gegenseitigen Respekts zwischen islamischen Herrschern und jüdischen Untertanen gewesen war, zu Pogromen, und viele Juden mussten sich im christlichen Europa ein neues Exil suchen. Im 20. Jahrhundert nahm die Toleranz gegenüber dem Judentum im Islam teilweise ab, insbesondere nachdem 1948 in einem Gebiet, das zuvor den vorwiegend muslimischen Palästinensern gehört hatte, der Staat Israel gegründet worden war.

Worum es geht
Antisemitismus ist das älteste Vorurteil.

26 Die Geburt des Islam

Die Geschichte vom Wachstum des Islam ist bemerkenswert. Im Jahr 610 u. Z. empfing der Prophet Mohammed auf einem einsamen Berggipfel in der Nähe der heiligen Stadt Mekka im heutigen Saudi-Arabien das Wort Gottes. Er starb 632; 100 Jahre später hatte sich der Glaube an seine Botschaft im Westen entlang der nordafrikanischen Küste bis nach Spanien und in der entgegengesetzten Richtung bis in den Himalaja ausgebreitet. Anfangs wurden Allahs Offenbarungen an Mohammed mündlich überliefert, nach seinem Tod jedoch schrieb man sie unter dem Namen *Koran* nieder – das Wort bedeutet „Lesung".

Mohammed war von Beruf Kaufmann und arbeitete in Mekka. Die Stadt war zu einem größeren Handelszentrum herangewachsen, und dieser Wandel hatte auch soziale Spannungen mit sich gebracht. Außerdem war sie ein religiöses Zentrum, ein Ziel für Pilgerfahrten oder *Haddsch*, in das die Araber kamen, um ihre verschiedenen Stammesgötter anzubeten. Sie kannten zwar die jüdische und christliche Tradition mit nur einem Gott und waren ihr gegenüber nicht feindselig eingestellt, sie selbst bevorzugten aber unbestimmtere spirituelle Grundsätze, die der Stammessolidarität oder *Muruwa* einen heiligen Wert beimaßen.

Mohammed glaubte, eine Vereinigung der Religionen werde größeren Frieden und mehr Gerechtigkeit mit sich bringen. Einmal im Jahr zog er sich in eine Höhle außerhalb Mekkas zurück und betete um Anleitung; auch verteilte er Almosen an die wachsende Zahl der Armen und abseits Stehenden in der Stadt. Im Jahr 610, mit 40 Jahren, war er wieder einmal allein in der Höhle und wurde dabei nach seinem eigenen Bericht von einer überwältigenden Macht ergriffen. Anfangs glaubte er, ein *Dschinn* – ein böser Geist – habe ihn angegriffen, aber in Wirklichkeit war es der

Engel Gabriel, der von Gott oder Allah die Worte einer neuen, arabischen Heiligen Schrift überbrachte.

Mohammeds Familie

Mohammeds erste Ehefrau Chadidscha war älter als er und bei ihrer Heirat eine finanziell unabhängige Witwe. Obwohl Polygamie zu jener Zeit in Arabien die Regel war, nahm Mohammed sich keine weitere Ehefrau, solange sie lebte. Die beiden hatten mindestens sechs Kinder: Zwei Söhne namens Qasim und Abdullah starben im Säuglingsalter; die vier Töchter hießen Zainab, Ruqayya, Umm Kulthum und Fatima. Chadidscha starb 619, im „Jahr der Traurigkeit", wie Mohammeds frühe Biografen es nannten. Danach heiratete er noch mindestens neunmal, häufig aus politischen oder humanitären Gründen. Die häusliche Sawda zum Beispiel, auch sie eine Witwe, war die Cousine eines lokalen Stammesführers. Seine Lieblingsfrau war nach Ansicht der sunnitischen Muslime Aischa, die erst sechs Jahre alt war, als sie getraut wurden. Nach Mohammeds Tod wirkte sie daran mit, seine Lehren in den Hadithen zu sammeln. Zajnab bint Jahsh, eine weitere Ehefrau, war zunächst mit einem seiner Adoptivsöhne verheiratet, aber die beiden wurden geschieden, so dass Mohammed sie heiraten konnte. Der islamischen Lehre zufolge war der Prophet ein hilfsbereiter Ehemann, der im Haushalt mitarbeitete und seinen Ehefrauen, betrachtet man die Gepflogenheiten seiner Zeit, ein ungewöhnliches Maß an Freiheit zugestand. In seinen letzten Lebensjahren jedoch begrüßten seine Ehefrauen die Besucher von einem Platz hinter einem Wandschirm aus, und sie durften nicht wieder heiraten, falls er vor ihnen sterben sollte. Dies wurde später als Grund genannt, warum alle muslimischen Frauen einen Schleier tragen sollen.

Nach jener ersten „Nacht des Schicksals" erlebte Mohammed viele ähnliche Offenbarungen, was häufig ein schmerzvoller Prozess war. Sein Verhalten zeigt jedoch exemplarisch die völlige Hingabe (arabisch *Islam*), wie sie jeder Mensch gegenüber dem Göttlichen zeigen sollte.

622
Hidschra

630
Verteidigung Mekkas

632
Tod Mohammeds

Tag der Abrechnung Anfangs sprach Mohammed in der Öffentlichkeit nur vorsichtig über seine Erlebnisse, aber als die Nachricht sich verbreitete, fanden Allahs Worte über inneren Wandel, soziale Gleichberechtigung, Einheit, gegenseitigen Respekt und Frieden viele Anhänger. Zu jener Zeit tobte ein Krieg zwischen Persien und Byzanz sowie zwischen den Stämmen der Region, und viele Menschen in Arabien fürchteten um die Zukunft der Menschheit.

Mohammeds Anhänger lernten jede neue Offenbarung, die er ihnen brachte, auswendig. Wer lesen und schreiben konnte, schrieb sie nieder. Eine zentrale Botschaft lautete: Es gibt nur einen Gott, nämlich Allah, und die Menschen müssen eines Tages vor ihm Rechenschaft für ihre Taten ablegen. Es werde einen Tag der Abrechnung geben (der arabische Begriff *Yawn ad-din* bedeutet auch „Augenblick der Wahrheit").

Hidschra Mohammeds Lehren erwiesen sich als unpopulär, und obwohl er Konfrontationen um jeden Preis zu vermeiden versuchte, wurden er und seine Anhänger in Mekka angegriffen. Man befürchtete, jemand werde ihn ermorden. Manchmal verzweifelte er fast, aber er bezog Kraft aus seinem Glauben an Allah und aus den immer wiederkehrenden Offenbarungen, darunter vor allem eine traumähnliche nächtliche Reise, auf der Gabriel ihn nach Jerusalem entführte. Um den Spannungen in Mekka zu entgehen, zog er 622 mit rund 70 Anhängern und ihren Familien in einer *Hidschra* (Wanderung, Pilgerreise) nach Medina.

> Ich habe nie eine Offenbarung empfangen,
> ohne dabei zu glauben, mir sei die Seele entrissen worden...
> Manchmal erscheint es mir wie das Läuten einer Glocke,
> und das ist für mich am schwersten; das Läuten hört auf,
> wenn ich mir ihrer Botschaft bewusst werde.
>
> Mohammed, 570–632

> An diesem Tag treten die Menschen getrennt heraus,
> damit ihnen ihre Taten gezeigt werden, Und wer das Gewicht eines
> Sonnenstäubchens an Gutem tut, er sieht es, Und wer das Gewicht
> eines Sonnenstäubchens an Schlechtem tut, er sieht es.
>
> Koran, 99:6–8

Die letzte Predigt

Mohammed starb am 8. Juni 632 in den Armen seiner Ehefrau Aischa. Seine „letzte Predigt" hielt er kurz vor seinem Tod vor einer Versammlung von 120.000 Pilgern auf dem Berg Arafat. Eine Kurzfassung dieser Predigt findet sich in den Moscheen auf der ganzen Welt. Er weist darin seine Zuhörer an, Fehden und Kämpfe zu beenden, und predigt Toleranz. „Ein Araber hat keine Überlegenheit über einen Nicht-Araber; ein Weißer hat keine Überlegenheit über einen Schwarzen, auch nicht der Schwarze über den Weißen, außer durch Frömmigkeit und gute Taten."

Die Feindseligkeiten zwischen Mohammed und der Bevölkerung Mekkas eskalierten schließlich zu einem richtigen Krieg. Mohammed war zwar kein Pazifist, er hielt Gewalt aber für das letzte Mittel. Eine Offenbarung befahl ihm, die Gefangenen, die seine Anhänger gemacht hatten, im Gegensatz zur üblichen Sitte nicht zu töten, sondern mit oder ohne Lösegeld freizulassen. Im Jahr 627 konnte er eine Belagerung Medinas durch die Armee von Mekka durchbrechen. Dieses Ereignis wurde zum Wendepunkt. Er kehrte 630 im Triumph nach Mekka zurück. Sein Sieg hatte die Stämme Arabiens vereinigt und auf der Halbinsel sowie darüber hinaus eine Welle von Bekehrungen ausgelöst.

Worum es geht
Mohammed war Gottes letzter Prophet

27 Die Säulen des Islam

Nach islamischer Lehre steht der Glaube an erster Stelle, und man kann ihn nicht durch Kompromisse an das weltliche Leben anpassen. Das Kernstück seiner Gebote sind die „Säulen des Islam", die allen Spielarten dieser Religion gemeinsam sind. Die Säulen – ihre Zahl ist in den einzelnen islamischen Traditionen unterschiedlich – repräsentieren die Pflichten, die jeder Muslim erfüllen muss, wenn er im Einklang mit Allahs Lehren ein gutes, verantwortungsbewusstes Leben führen will. Sie prägen weltweit das Alltagsleben der weit mehr als eine Milliarde Muslime auf der ganzen Welt.

In der Lehre der Sunniten – das sind rund 60 Prozent aller Muslime – gibt es fünf Säulen. Diese sind: 1. Schahada – das ehrliche Aussprechen des muslimischen Glaubensbekenntnisses: „Es gibt keinen Gott außer Allah, und Mohammed ist sein Prophet"; 2. Salat – das rituelle Gebet, das mit nach Mekka gewandtem Gesicht fünfmal am Tag (Morgendämmerung, Mittag, später Nachmittag, Sonnenuntergang, Nacht) zu vollziehen ist; 3. Zakat – das Zahlen einer Almosensteuer zum Nutzen der Armen und Bedürftigen; 4. Saum – Verzicht auf Essen, Trinken, Zigaretten und Sex bei Tageslicht während des Monats Ramadan; und 5. Haddsch – die Pilgerreise nach Mekka, die einmal im Leben zu unternehmen ist.

Das Hadith Während der Koran für Muslime das Wort Allahs ist, können sie mithilfe des Hadith – einer Sammlung der Aussprüche und Lehren Mohammeds – dessen Leben und Vorbild verstehen und nachahmen; beides zusammen wird im Islam als *Sunna* bezeichnet. Der Koran entspricht in seiner Länge ungefähr dem christlichen Neuen Testament, die Hadithe dagegen umfassen viele Bände und sind Gegenstand heftiger Diskussionen. Als ungefähr 100 Jahre nach dem Tod des Pro-

Zeitleiste

ca. 635	ca. 730
Aufzeichnung des Koran nach Mohammeds Tod	erste schriftliche Versionen der Hadith

pheten ihre ersten schriftlichen Versionen im Umlauf waren, erschienen auch viele nicht autorisierte Texte, die angeblich Mohammeds Leben wiedergaben. Später stellte man strenge Regeln auf, nach denen entschieden wurde, welche Fassungen authentisch waren. Am stärksten verehrt wird die Sammlung, die Ismail al-Bukhari (gest. 870 u. Z.) zusammenstellte.

Koran, Hadith und Sunna bilden zusammen die Grundlage der Scharia, des islamischen Gesetzes. Bis zum 11. Jahrhundert diskutierten die Gelehrten, was man als Scharia betrachten sollte, später ging diese Flexibilität aber verloren; noch heute lässt der Islam jedoch *Istihsan* zu, eine Interpretation nicht der Worte, sondern des Geistes der Gesetze.

> ❯ **Was der Gesandte euch nun gibt, das nehmt an! Aber verzichtet auf das, was er euch verwehrt!** ❮
>
> **Koran 59:7**

Die Hadd-Strafen

Die Scharia sieht so genannte Hadd-Strafen für bestimmte Vergehen vor: für Alkoholkonsum, Diebstahl, Mord, Ehebruch, Verleumdung und Abfall vom Glauben. Nach Ansicht mancher Muslime kommen diese Gesetze unmittelbar aus dem Koran und sind demnach von Gott eingesetzt. Andere halten sie für Interpretationen und für die extremsten Strafen, die ein Richter verhängen kann. Die eigentliche Bestrafung für den Übeltäter ist das Wissen, dass er Allah enttäuscht hat. Der Genuss von Alkohol kann mit Auspeitschen bestraft werden, Dieben können Gliedmaßen amputiert werden. Mord wird von manchen Scharia-Gelehrten nach dem Grundsatz „Menschenleben für Menschenleben" behandelt. Ebenso ist Auspeitschen für Ehebruch und jede Form sexueller Ausschwei-

fungen vorgesehen, und der Koran empfiehlt es auch für jeden, der eine Frau beschuldigt und seine Behauptung nicht mithilfe von vier Zeugen belegen kann (ein Ergebnis dessen, so heißt es, dass Mohammeds Ehefrau Aischa fälschlich beschuldigt wurde). In manchen islamischen Gesellschaften wurde dieses Gesetz umgekehrt: Dort kann eine Frau ausgepeitscht werden, wenn sie einen Mann der Vergewaltigung beschuldigt und keine vier Zeugen für das Verbrechen benennen kann. Was schließlich den Abfall vom Glauben angeht, so lehnte der Prophet in religiösen Fragen jeden Zwang ab; nach dem Koran werden aber diejenigen, die dem Islam abschwören, mit einem Fluch belegt.

> Die Muslime hängen bis auf den heutigen Tag zutiefst der Scharia an. Diese hat dazu geführt, dass sie die archetypische Figur Mohammeds auf einer sehr tiefen Ebene verinnerlicht haben, und indem er aus dem siebten Jahrhundert befreit wurde, ist er zu einer lebendigen Gegenwart in ihrem Leben und zu einem Teil ihrer selbst geworden.
>
> Karen Armstrong, 2000

Übergangsriten Ein Neugeborenes wird in einer muslimischen Familie kurz nach der Geburt begrüßt, indem man ihm den Gebetsruf, mit dem die Gläubigen fünfmal am Tag zur Moschee gerufen werden, in das rechte Ohr und die Aufforderung, aufzustehen und zu beten, ins linke flüstert. Die Beschneidung männlicher Babys findet in Übereinstimmung mit der Aufforderung, die auch Juden in der Genesis und Muslime im Koran finden, im Alter von sieben Tagen statt, wenn das Kind gesund ist. Sobald Kinder dazu in der Lage sind, lernen sie Verse aus dem Koran, und mit zehn Jahren können sie bereits am Fasten teilnehmen.

Ehen werden nach einer jahrhundertealten Sitte häufig von den Familien arrangiert, nach Angaben von Mohammeds Frau Aischa bestand der Prophet aber darauf, stets auch das Mädchen zu fragen. Niemand sollte gezwungen werden. Die Hochzeitszeremonie (*Nika*) ist oftmals eine einfache Angelegenheit, die vom Imam in der Moschee vollzogen wird; die darauf folgende Hochzeitsfeier (*Walima*) jedoch stellt das öffentliche Bekenntnis zu der Verbindung dar. Mischehen zwischen muslimischen Männern und nichtmuslimischen Frauen werden in den meisten Gesellschaften akzeptiert, der umgekehrten Kombination begegnet man jedoch mit weniger Toleranz.

Ein Muslim darf bis zu vier Ehefrauen haben, der Koran legt aber Wert darauf, dass die erste Frau sich darüber nicht ärgert und dass die späteren Ehefrauen sie nicht verletzen. Außerdem muss der Mann in der Lage sein, materiell und emotional für seine Ehefrauen zu sorgen. Eine Frau kann die schriftliche Zusicherung verlangen, dass sie sich scheiden lassen darf, wenn ihr Mann später weitere Ehefrauen nimmt. Die Ehescheidung ist im Islam zulässig, gilt aber als sehr trauriges Ereignis. Dem Koran zufolge gibt es auf Erden nichts, was Allah stärker verhasst ist.

Im Koran gibt es einen Vers (4:34), der es scheinbar erlaubt, die Ehefrau zu schlagen; die Gelehrten betonen aber, er stehe im Zusammenhang mit dem Ablauf einer Ehescheidung, bei der die Frau sich geweigert hat, auf die Vernunft zu hören. Weiter wird darauf verwiesen, dass der Prophet selbst dieses Mittel bei keiner seiner Ehefrauen jemals einsetzte.

Der islamische Kalender Im islamischen Kalender gibt es zwei wichtige Feiertage: Eid-ul-Fitr, das Fest des Fastenbrechens am Ende des Ramadan, und Eid-ul-Adha, das Opferfest während der Haddsch. *Ramadan* bedeutet einfach „der neunte Monat" und war in der arabischen Kultur schon lange vor Mohammed bekannt. Im Islam ist er die Zeit, in der man Sünden sühnt, sich von der Welt zurückzieht, sich auf die Religion konzentriert und Geduld zeigt.

Kreuzzüge und Islamfeindlichkeit

Die Stadt Jerusalem hat in allen drei monotheistischen Religionen eine einzigartige Stellung. Für Muslime ist sie die drittheiligste Stadt nach Mekka und Medina. Christliche Kreuzfahrer, die vom Papst zur Bekämpfung der muslimischen „Ungläubigen" ausgeschickt wurden, griffen 1099 Jerusalem an, ermordeten 30.000 vorwiegend muslimische Bewohner und errichteten ein christliches Königreich. Erst 1187 wurden die Kreuzfahrer von Saladin wieder aus der Stadt gedrängt, und erst Ende des 13. Jahrhunderts hatte man sie völlig aus der Region vertrieben. Das Bild der Muslime, das von Päpsten und Kreuzfahrern in jener Zeit gezeichnet wurde – ungebildete Wilde, die kriegslüstern und von ihrem Wesen her gewalttätig und intolerant seien – stand im Widerspruch zur tatsächlichen islamischen Lebensweise, prägte sich aber im christlichen Abendland ein und ist noch heute spürbar.

Worum es geht
Der Glaube steht für Muslime an oberster Stelle

28 Sunniten und Schiiten

In allen Religionen gibt es verschiedene Traditionen, Sekten und Gruppen, zwischen denen häufig jahrhundertealte Meinungsverschiedenheiten bestehen. Im Islam kam es 50 Jahre nach dem Tod des Propheten zu einer Spaltung zwischen der Mehrheit, den Sunniten, und der radikalen Minderheit der Schiiten, die von sich behaupteten, sie stünden dem Leben und Vorbild des Propheten näher. Gerade zu der Zeit, als der Islam sich schnell nach Westen und Osten ausbreitete, fand in seinem Zentrum ein grundlegender Bruch statt. Das Erbe dieser Spaltung, die vor 1300 Jahren stattfand, ist bis heute ein Teil der muslimischen Welt.

Als Mohammed 632 starb, gab es zwei potenzielle Nachfolger: seinen Vetter und Schwiegersohn Ali ibn Abi-Talib und den ersten bekehrten Mann Abu Bakr. Wen Mohammed selbst bevorzugte, ist nicht klar. Ali war im Haushalt des Propheten aufgewachsen, hatte dessen Tochter Fatima geheiratet und wurde offenbar von Mohammed auf seiner letzten Haddsch gesalbt. Abu Bakr war der Vater von Mohammeds Ehefrau Aischa und wurde vom Propheten dazu bestimmt, während dessen letzter Krankheit die Gebete zu leiten.

Schließlich fiel die Entscheidung, und Abu Bakr wurde zum Kalifen (Führer) ernannt. Als er zwei Jahre später starb, ernannte er seinen eigenen Nachfolger Umar ibn al-Khattab, der zehn Jahre lang Kalif blieb und 638 für die Ausbreitung des Islam nach Jerusalem sorgte. Während dieser Zeit trat das islamische Kalifat in der Region an die Stelle des persischen und byzantinischen Reiches, und mit ihm kam die religiöse Toleranz. Die unterworfenen Völker hatten die Wahl, ob sie den Islam übernehmen und von Steuern befreit werden wollten oder bei ihrem eigenen Glauben blieben und für dieses Privileg bezahlten.

Zeitleiste

632	638	656
Tod des Propheten	Jerusalem kommt unter islamische Herrschaft	Ali ibn Abi-Talib stellt das Kalifat infrage

> 🟊 **Kein einziger Vers des Koran ist auf den Botschafter Gottes herabgekommen, den er nicht mir diktierte und mich vorlesen ließ.** 🟊
>
> Ali ibn Abi-Talib, ca. 11. Jahrhundert

Als Umar von einem christlichen Sklaven ermordet wurde, wählten sechs seiner engsten Berater Uthman ibn Affan, den Ehemann von zwei Töchtern des Propheten, zum nächsten Kalifen. Uthman stand zwölf Jahre an der Spitze des Islam, der sich nun im Westen nach Nordafrika und in östlicher Richtung im Industal sowie nach China ausbreitete. Man warf ihm aber Vetternwirtschaft vor, und er wurde in Ägypten ermordet.

Der Kampf um die Führung Jetzt endlich war Alis Augenblick gekommen. Er verlegte den Mittelpunkt des Kalifats nach Kufa im Irak. Dort zog Aischa, die Witwe des Propheten, mit einer Armee gegen ihn zu Felde und behauptete, er sei an Uthmans Tod beteiligt gewesen. Als Aischa 656 in der Kamelschlacht bei Basra geschlagen und für den Rest ihrer Tage nach Mekka geschickt wurde, setzte sich Muawiya, der Gouverneur von Damaskus und ein Verwandter von Uthman, an die Spitze des Kampfes gegen Ali. Die beiden Armeen trafen in der Schlacht von Siffin aufeinander. Muawiyas Soldaten spießten sich Seiten des Koran auf ihre Speerspitzen, aber Ali weigerte sich, den Befehl zum Angriff zu geben, und schließlich gelangte man zu einem Kompromiss. Ali wurde 661 von Extremisten aus seinem eigenen Lager umgebracht; die Nachkommen dieser so genannten Charidschiten, die Bevölkerungsgruppe der Ibaditen mit rund 500.000 Mitgliedern, leben heute in Nordafrika, Oman und Sansibar.

Ali hatte zwei Söhne. Diese Enkel des Propheten erklärten, sie würden Muawiya als Kalifen anerkennen, wenn er ihnen jeweils den Titel eines Imam verliehe. Für kurze Zeit herrschte Frieden, und Muawiya, der von Damaskus aus regierte, erwies sich als kompetenter Herrscher. Als er starb, ging das Kalifat an seinen Sohn Yazid über. Alis Söhne wandten sich aber dagegen, dass das Herrscheramt als erblicher Besitz behandelt wurde, und einer von ihnen, Hussein, setzte sich als Anführer der Schiat Ali – der „Partei Alis" – an die Spitze des Protestes.

661	**680**	**1744**
Ali wird ermordet	sunnitische Mehrheit besiegt in der Schlacht die Schiiten	Al-Wahhab schließt einen Pakt mit dem Haus Saud

Ismailiten

Die Ismailiten sind eine Gruppierung der Schiiten; ihre Zahl liegt heute bei rund 17 Millionen. Nach Ansicht der Nizaris, ihrer bei weitem größten Untergruppe, ist ihr Oberhaupt, der 49. Aga Khan, ein unmittelbarer Nachkomme des Propheten. (Andere Schiitengruppen erklären, die Abstammungslinie sei beendet.) Die Ismailiten haben eine eigene, weltabgewandte Spiritualität; Grundlage ist die Suche nach einer verborgenen Bedeutung in den Schriften. In der ersten Hälfte des 10. Jahrhunderts gelang es ihnen aber auch, die Kontrolle über Tunesien und später über Ägypten zu übernehmen. Damals errichteten sie in Kairo ein eigenes Kalifat, das ungefähr 200 Jahre Bestand hatte. Während die schiitische Hauptrichtung die Schriften wörtlich nimmt, vertreten die Ismailiten einen eher mystischen Ansatz. Auch die Drusen im Libanon und in Syrien stehen mit den Ismailiten in Verbindung.

Die endgültige Spaltung Im Jahr 680 fand am Ufer des Flusses Euphrat die Schlacht von Kerbela statt. Sie endete für die unmittelbaren Nachkommen des Propheten mit einer katastrophalen Niederlage. Hussein wurde ausgehungert, und schließlich wurden er und ein großer Teil seiner Familie umgebracht. Zwei seiner Söhne überlebten allerdings und übernahmen in der schiitischen Bewegung die Rolle von Imamen. Die Schiiten hielten die sunnitische Mehrheit (der Begriff Sunniten bezieht sich auf ihre Loyalität gegenüber der Sunna, den Aussprüchen und Taten des Propheten) für zu weltlich und bevorzugten die religiöse Reinheit Alis und seiner Familie.

Für die Schiiten – das heißt für bis zu 20 Prozent der weltweiten muslimischen Bevölkerung – ist die Imam-Hussein-Moschee in Kerbela bis heute ein heiliger Ort, der auf einer Stufe mit Mekka steht und ein Symbol für Märtyrertod und Ungerechtigkeit im menschlichen Leben darstellt. Jedes Jahr am Aschuratag, an dem an die Niederlage Husseins erinnert wird, versammeln sich in der Moschee schiitische Männer, um sich mit Messern zu ritzen und sich mit Ketten auf den eigenen Rücken zu schlagen, womit sie an die Brutalität der Soldaten von Yazid gemahnen.

> 》 **Das Schiitentum entstand nicht nur durch die Frage nach der politischen Nachfolge Mohammeds, auch wenn diese Frage natürlich von großer Bedeutung war... Es ging weniger darum, wer Mohammeds Nachfolger werden sollte, als vielmehr um die Frage, welche Funktionen und Qualitäten eine solche Person haben müsste. 《**
>
> Hossein Nasr, 1979

Eine Frage der Führung Die Trennlinien, die durch diese Schlachten der Frühzeit entstanden, prägen den Islam bis heute. Wer soll die Gläubigen anführen? Der frömmste Muslim, wie die Charidschiten fordern? Oder ein unmittelbarer Nachkomme des Propheten, wie es die Schiiten verfechten? Oder ein qualifizierter Herrscher, der den vom Propheten angestrebten Frieden und die Einigkeit voranbringt, wie die Sunniten glauben?

Die Wunden der Sunniten/Schiiten-Spaltung sind nie geheilt. Neben den historischen gibt es auch andere Unterschiede. Die Schiiten haben ihren eigenen Gebetsruf (dem sie nicht fünf-, sondern dreimal täglich folgen). Sie verehren die Gräber ihrer verstorbenen Imame, darunter auch die Begräbnisstätte Alis im irakischen Nadschaf; dies wiederum ist für die Wahhabiten, die zur sunnitischen Tradition gehören, Ketzerei.

Andere Unterschiede beziehen sich eher auf die Lehre. Schiiten legen größeren Wert auf die Hadithe, weil diese ihre Verbindung zum Propheten stärken. Sunniten und Schiiten glauben, dass Allah über alle Taten der Menschen im Voraus Bescheid weiß, aber nach sunnitischer Lehre legt er sie auch fest, was die Schiiten verneinen. Außerdem herrscht in der Hauptrichtung des Schiitentums die Ansicht, dass die Nachkommen des Propheten ausgestorben seien, und deshalb billigt man den heutigen Religionsgelehrten – den Ayatollahs – eine größere Bestimmungsgewalt über islamische Gesetze und Lebensführung zu. Sunniten dagegen greifen stärker auf die meist eher gemäßigte Weisheit früherer Zeiten zurück.

> ## Wahhabiten
>
> Es gab in der Geschichte viele Aufstände gegen die Exzesse der sunnitischen Herrscherelite im Kalifat und später im osmanischen Reich. Ein bekannter Rebell war Muhammad ibn Abd al-Wahhab (1703–1792): Er setzte sich an die Spitze einer anti-intellektuellen, anti-mystischen und gegen das Establishment gerichteten Bewegung, die sich für eine Rückkehr zu Koran und Sunna einsetzte. Beide, so sagte er, seien zeitlos und müssten weder aktualisiert noch in einen Zusammenhang gestellt werden. Er teilte jedoch nicht Mohammeds Toleranz gegenüber anderen Glaubensrichtungen und auch nicht dessen (für das siebte Jahrhundert) fortschrittliche Einstellung gegenüber Frauen. Diese Ansichten zeigen sich in seinen Lehren, die als Wahhabiya bezeichnet werden. Nachdem er 1744 einen Pakt mit dem Herrscherhaus Saud geschlossen hatte, konnte er einen Hort des reinen Glaubens prägen, der bis heute in Form des Staates Saudi-Arabien Bestand hat. Dort ist das Wahhabitentum die beherrschende Form des Islam.

Es gibt im Islam viele verschiedene Richtungen

29 Das Herz des Islam

Der Ausdruck „Herz des Islam" verweist auf die mystische Tradition des Sufismus. Als der Islam sich im neunten und 10. Jahrhundert immer weiter ausbreitete, erreichte er zunehmend auch die Juristen: Diese fassten die Weisheiten des Koran, des Hadith und der Sunna in den Gesetzen der Scharia zusammen, einem System, das der Gesellschaft eine Struktur geben sollte. Die Gegenreaktion auf diese trocken-juristische Denkweise war der Sufismus, der die Liebe höher einstuft als das Recht. Mit seinen oftmals hemmungslosen Zeremonien, die auch Lieder und Tänze umfassen, ist er in den Augen vieler orthodoxer Muslime verdächtig, er bleibt aber bis heute eine wichtige Kraft innerhalb der islamischen Tradition.

Die Wurzeln des Sufismus reichen ins achte Jahrhundert zurück, als Größe, Macht und weltliche Orientierung des islamischen Reiches zunahmen. Manche Muslime fühlten sich vom Luxus und vom Reichtum der Herrscherelite, die sich mit der Expansion herausgebildet hatte, abgestoßen. Diese Abweichler, die Sufis, hatten die Befürchtung, ihr Glaube könne als „Staatsreligion" nach außen verlagert werden, und dabei könne Allahs Botschaft an den Propheten und jeden einzelnen Muslim in Vergessenheit geraten.

Die Sufis setzten sich für eine einfache Lebensweise ein, bei der alle Muslime gleichberechtigt sein sollten und Unterschiede nicht vom Gesetz verboten, sondern toleriert werden sollten. Die Anhänger der asketischen sufistischen Lebensweise erkannte man an ihrer groben Wollkleidung; nach Ansicht mancher Fachleute stammt sogar der Name von *suf*, dem arabischen Wort für Wolle.

Frauen in der sufistischen Tradition

Frauen genossen im Sufismus traditionell als Führungspersönlichkeiten und Intellektuelle eine größere Freiheit als in anderen Richtungen des Islam. Rabia al-Adawiyya (717–801) war eine von mehreren Lehrerinnen, die in der Frühzeit des Sufismus die Ansicht vertraten, man solle Allah aus freien Stücken lieben, und nicht weil Regeln und Gesetze den Menschen Angst einjagen. Als sie ein Kind war, soll Mohammed ihrem Vater in einem Traum erschienen sein und sie als Auserwählte benannt haben; aber ihre Heimatstadt Basra wurde von einer Hungersnot heimgesucht, und sie wurde als Sklavin verkauft. Als ihr Besitzer jedoch ihre entrückten Gebete hörte, ließ er sie frei und erklärte, er sei nun ihr Sklave. Den größten Teil ihres Lebens verbrachte sie ohne jeden Besitz in der irakischen Wüste; sie lehnte alle Heiratsanträge ab, lockte aber zahlreiche Schüler an. Diesen brachte sie bei, dass Aufrichtigkeit und Selbstkritik wichtig seien. Manchmal wird sie als Begründerin der sufistischen „Liebesmystik" bezeichnet, die den Zustand der spirituellen Ekstase mit der Verliebtheit in Gott gleichsetzt.

Inneres Leben Sufisten haben eine kontemplative, mönchsähnliche Einstellung zum Glauben. Dazu gehört, dass man sich praktisch und/oder mental von den irdischen Angelegenheiten zurückzieht und sich auf die Notwendigkeit konzentriert, Ehrgeiz und Egoismus abzulegen; dadurch, so die Lehre, entdeckt man ein inneres spirituelles Leben, das jeden Gläubigen in die Lage versetzt, sein Herz zu reinigen und eins mit Allah zu werden.

Die Sufis sind in „Orden" mit Meister und Schülern organisiert, wobei der Meister die Führung vor seinem Tod an einen auserwählten Anhänger überträgt. Die meisten Meister nehmen für sich eine Verbindung oder Blutsverwandtschaft mit dem Propheten Mohammed in Anspruch, die häufig über seinen Schwiegersohn Ali verläuft. Eine der größten Sufi-Gruppen, die Naqschibandi, hält sich jedoch für Nachfolger des ersten Kalifen Abu Bakr.

> ❯ **Askese bedeutet nicht, dass du nichts besitzen sollst, sondern dass nichts dich besitzen soll.** ❮
> **Ali ibn Abi-Talib,**
> **ca. 11. Jahrhundert**

> **Du gehörst zur Welt der Dimension,**
> **aber du kommst aus der Welt der Nicht-Dimension.**
> **Schließe den ersten Laden und eröffne den zweiten.**
>
> Mevlana von Konya, **1207–1273**

Sufis versammeln sich an *Zawiya*, Orten der Gelehrsamkeit und Konzentration, wo sie beten und meditieren. Dazu gehören rhythmisches Atmen, Fasten, Nachtwachen und Gesänge, die das Bewusstsein für Gott stärken sollen. Solche Rituale und Praktiken zogen schon bald die Kritik anderer Muslime auf sich. Musik, Dichtung und Tänze zur spirituellen Erbauung oder sogar zum Erreichen eines tranceähnlichen Zustandes zu verwenden, galt als unislamisch. Berichte über Wunder und Magie wurden angegriffen. Als der Sufi-Meister Husain ibn Mansur im Jahr 922 erklärte, ein guter Muslim könne die Haddsch auch im Geiste vollziehen und mit seinem Körper zuhause bleiben, wurde er wegen Gotteslästerung hingerichtet. Aber obwohl die Sufi so viel Misstrauen provozierten, gehörten sie immer zur Hauptrichtung des Islam; ihre Denkweisen und Erkenntnisse werden auch heute noch geschätzt.

Neo-Sufismus

Der Neo-Sufismus, auch er eine islamische Reformbewegung, entstand im 19. Jahrhundert und gedieh insbesondere unter nordafrikanischen Muslimen. Autoritäten wie der Marokkaner Ahmad ibn Idris (1760–1836) wollten die Menschen zu besseren Muslimen machen, aber die traditionelle Lehre war nach ihrer Ansicht zu trocken und vom Alltagsleben in der Region zu weit entfernt. Ibn Idris sprach allen muslimischen Denkern seit dem Propheten die Autorität ab und forderte seine Zuhörer auf, über Leben und Vorbild Mohammeds nachzudenken und zu meditieren, nicht aber über die Traditionen der Vergangenheit. Auf dieser Grundlage sollten sie entscheiden, wie sie in ihrer eigenen Gesellschaft ein moralisches, gerechtes Leben führen konnten. In Libyen ist die Sanusiya-Bewegung, die zum Neo-Sufismus gehört, die vorherrschende Form des Islam, und neo-sufistische Führungsgestalten wie der Algerier Amir Abdel Kader standen im 19. Jahrhundert an vorderster Front im Widerstand gegen die Kolonialmächte.

Der spirituelle Hintergrund Abu Hamid al-Ghazzali (1058–1111), der manchmal als Thomas von Aquin des Islam bezeichnet wird, war ein islamischer Rechtsgelehrter. Er erlitt 1095 einen Zusammenbruch, den er später so erklärte: Er habe erkannt, dass er zwar viel *über* Gott wisse, aber Gott selbst nicht kenne. Seine Lösung bestand darin, dass er sich die sufistische Lebensweise zu eigen machte und sie später in seinem Werk *Die Wiederbelebung der religiösen Wissenschaften* zusammenfasste, dem nach Koran und Hadith am häufigsten zitierten islamischen Buch.

Al-Ghazzali wollte inneres und äußeres Leben im Islam vereinbaren und stellte dazu das Gesetz der Scharia in einen ethischen und spirituellen Zusammenhang. Die Leser seines Buches sollten spirituelle Übungen ausführen und unter anderem durch *Dhikr* (das Singen göttlicher Namen) das Bewusstsein für Gott stärken. Manche Sufis lehnen aber den Gedanken, man könne mystische Erkenntnisse zu Papier bringen, grundsätzlich ab und erklären, dies sei, als wolle man sie nach außen verlagern.

Die Blütezeit Seine Blütezeit erlebte der Sufismus zwischen dem 13. und 16. Jahrhundert, als er zu einer echten Volksbewegung wurde. Viele neue Orden entstanden. Dschalaleddin Rumi, auch Mevlana von Konya genannt, gründete die Gruppe der tanzenden Derwische: Er lehrte, Drehungen des Körpers und Musik könnten den Menschen in himmlische Sphären erheben. Das, so sagte er, sei die reinste Form des Islam, das heißt der Hingabe an Allah.

In jüngerer Zeit wurde die sufistische Tradition vielfach unterdrückt. Besonders misstrauisch standen ihr die europäischen Kolonialmächte gegenüber, die muslimische Regionen einnahmen. Ein anderer, der sie – allerdings nicht mit dauerhaftem Erfolg – unterdrückte, war Kemal Atatürk, der Gründer der modernen Türkei im 20. Jahrhundert. Die meisten sunnitischen Herrschereliten unterhalten heute enge Verbindungen zu Orden der Sufi, und die großen sufistischen Tempel in Bagdad, Ajmer (Indien), Sylhet (Bangladesh) und Konya (Türkei) sind nach wie vor Pilgerzentren.

Der Islam hat auch eine mystische Seite

30 Der militante Islam

Im 20. Jahrhundert lehnten viele Herrscher muslimischer Länder die in ihren Augen mittelalterliche Vergangenheit ab und versuchten, Religion und Politik zu trennen. Atatürk in der Türkei, Nasser in Ägypten, Jinnah in Pakistan und der Schah im Iran wurden von den westlichen Regierungen in ihren Bemühungen unterstützt, mit der Zeit zu gehen: Sie kleideten sich modern, ersetzten die Scharia durch eine bürgerliche Gesetzgebung und drängten Geistliche an den Rand oder vertrieben sie. Solche gewaltigen Veränderungen provozierten aber zwangsläufig eine Gegenbewegung: In den letzten Jahrzehnten des 20. und den ersten Jahren des 21. Jahrhunderts gewann eine neue Form des militanten Islam an Boden.

Im 19. und 20. Jahrhundert wurden die westlichen Vorstellungen von säkularen Nationalstaaten, Demokratie und Industrialisierung vorherrschend. Gesellschaften, die das Vorbild nicht übernahmen, galten als rückständig, und im Kampf um Märkte und weltpolitischen Einfluss wurden sie häufig als Kolonien von europäischen Staaten geschluckt. Dieses Schicksal erlitten die nordafrikanischen Staaten im 19. Jahrhundert durch Frankreich und Italien, und nachdem das Osmanische Reich – „der kranke Mann Europas" – zusammen mit Deutschland im Ersten Weltkrieg besiegt war, teilten Großbritannien und Frankreich seine Ländereien im Nahen Osten als Protektorate unter sich auf. Ein letztes Symbol für die westliche Eroberung von Gebieten, die Muslime jahrhundertelang als die ihren betrachtet hatten, war 1948 die Gründung des Staates Israel auf dem Gebiet des vorwiegend muslimischen Palästina.

Religiös und säkular Manche muslimischen Herrscher versuchten angesichts des Wandels in der Welt, das westliche Vorbild an ihre Länder anzupassen. Andere, insbesondere die Bath-Bewegungen im Irak und Syrien, verbanden Sozialismus mit arabischem Nationalismus. Alle bemühten sich bis zu einem gewissen Grade, Reli-

Zeitleiste

1915	1948	1966
Sturz des osmanischen Reiches	Gründung des Staates Israel	Hinrichtung von Sayyid Qutb

gion und Staat zu trennen – und wenn es Widerstand gab, reagierten sie häufig mit Gewalt. In Ägypten ließ der säkulare Nationalistenführer Gamal Abdel Nasser (1918–1970) Sayyid Qutb, den er als Ungläubigen gebrandmarkt hatte, im Jahre 1966 hinrichten. Im Iran trieb die westlich orientierte Regierung des Schahs Mohammad Reza Pahlevi (1944–1979) den geistlichen Schiitenführer Ajatollah Ruhollah Khomeini (1902–1989) ins Exil. Dieser kehrte aber später zurück und kam durch eine Revolution an die Macht.

Die Fatah

Fatah ist eine islamisch-juristische Meinung, die von Juristen oder geistlichen Führern abgegeben wird und die Gesetzeslage klarstellen soll, wenn neue Umstände oder Fragen auftauchen, für die es im Koran und in der Sunna keine klaren Anweisungen gibt. International berüchtigt wurde das Wort 1989, als der Ajatollah Khomeini eine *Fatah* gegen den britischen Romanautor Salman Rushdie aussprach, weil dieser in seinem Roman *Die satanischen Verse* angeblich ein gotteslästerliches Bild von Mohammed gezeichnet hatte. Gotteslästerung wird mit dem Tod bestraft. Khomeinis *Fatah* wurde einen Monat nach ihrem Erlass von 48 der 49 Mitgliedsstaaten der Islamkonferenz missbilligt, aufgehoben wurde sie aber erst neun Jahre später.

Khomeini bemühte die Geschichte, um seinen Kampf gegen den Staat zu charakterisieren: Er verglich ihn mit dem Kampf zwischen Yazid und Hussein 680 in Kerbela und behauptete, der Schah sei in jeder Hinsicht ein ebenso großer muslimischer Hochstapler wie Yazid. Er betonte, man könne den Islam nicht so modernisieren, dass er zu den wirtschaftlichen oder politischen Umständen passe. Anschließend bediente er sich aber der ersten Ansätze des modernen militanten Islam, um ein Regierungssystem zu schaffen, das seinen eigenen historischen Ansichten entsprach. Im heutigen iranischen Gottesstaat besteht eine instabile Verbindung zwischen demokratischen Wahlen nach westlichem Muster und einem „geistlichen Führer", der aus der klerikalen Elite stammt.

1979	**1994**	**2001**
Sturz des Schahs im Iran	Machtübernahme durch die Taliban in Afghanistan	Zerstörung des World Trade Center durch die Al-Qaida

Besuch in der Vergangenheit Sehr schnell vereinnahmte der neue militante Islam auch andere uralte Glaubensüberzeugungen für seine Zwecke. Abul Ala Maududi (1903–1979), der Gründer der Partei Jamaat-i-Islami in Pakistan, dem vielfach ein wichtiger Einfluss auf den militanten Islam zugeschrieben wird, berief sich als einer der Ersten auf den Begriff des *Dschihad* aus dem Koran – das Wort bedeutet ursprünglich einfach „Kampf" – und unterstützte einen heiligen Krieg gegen westliche Einflüsse und alle, die sie übernehmen wollten. Zur gleichen Zeit verglich der fundamentalistische Gelehrte Sayyid Qutb sich selbst und seine Anhänger in Ägypten gern mit der Gruppe, die den Propheten begleitet hatte, als er von korrupten Stadtvätern aus Mekka nach Medina vertrieben wurde.

Qutbs bekanntestes Werk mit dem Titel *Zeichen auf dem Weg* erschien 1964. Darin spricht er vom Segen des Koran für Gewalt und Mord an „Ungläubigen" (einschließlich aller Muslime, die sich säkulare Werte zu eigen machen). Es findet noch heute große Anerkennung bei extremistischen Gruppen wie dem islamischen Dschihad, der Hisbollah im Libanon und der Dissidentenbewegung in Saudi-Arabien. Das Regierungssystem Saudi-Arabiens orientiert sich zwar nach wie vor an den puritanisch-wahhabitischen Idealen aus dem 18. Jahrhundert, der spektakuläre Reichtum, der sich dort in jüngerer Zeit durch die Ölreserven angesammelt hat, und die langjährige Verbindung zu den Vereinigten Staaten waren aber für viele seiner Einwohner, auch für den Al-Qaida-Begründer Osama bin Laden, der Anlass zu militanten Aktionen und zu Morden.

Bin Laden plante seinen weltweiten Terrorfeldzug aus dem Exil in Afghanistan, wo seit 1994 die militant-islamische Bewegung der Taliban herrschte. Zu den „Neuerungen" dieser Regierung gehörte es, Frauen sowohl Schulbildung als auch Berufstätigkeit zu verbieten und ihnen eine vollständige Verhüllung des Körpers in der Öffentlichkeit vorzuschreiben. Nach Ansicht aller Gelehrten aus der Hauptrichtung des Islam widerspricht eine solche Politik der Praxis des Propheten.

> **Ja, wir sind reaktionär, und ihr seid aufgeklärte Intellektuelle: Ihr Intellektuellen wollt nicht, dass wir 1400 Jahre weiter zurückgehen. Ihr, die ihr Freiheit wollt, Freiheit für alles, die Freiheit von Parteien, ihr, die ihr alle Freiheiten wollt, ihr Intellektuellen: Freiheit, die eure Jugend verderben wird, Freiheit, die den Weg für den Unterdrücker ebnen wird, Freiheit, die unsere Nation zu Boden ziehen wird.**
> Ayatollah Khomeini, **1979**

Sayyid Qutb

Der ägyptische Lehrer, Schriftsteller und Dichter Sayyid Qutb war nach Angaben eines Studienkollegen des Al-Qaida-Führers Osama bin Laden „derjenige, der unsere Generation am stärksten beeinflusst hat". Über Qutb sind die Muslime geteilter Meinung. Für seine Bewunderer war er ein Märtyrer des wahren Islam. Seine Gegner sehen in ihm einen gewalttätigen Extremisten. Er begrüßte es, dass Nasser 1952 die westlich orientierte ägyptische Regierung stürzte, wurde aber durch den säkularen Nationalismus des neuen Herrschers schon bald desillusioniert. Im Jahr 1954 kam er nach einem Mordversuch an Nasser ins Gefängnis, und, von wenigen Monaten abgesehen, verbrachte er sein ganzes weiteres Leben hinter Gittern. Die Zeit nutzte er, um sein Werk *Zeichen der Zeit* fertigzustellen, ein bis heute einflussreiches Manifest des politischen Islam. Außerdem schrieb er einen 30-bändigen Kommentar zum Koran: Darin bekannte er sich zum gewalttätigen *Dschihad*, und er behauptete, die muslimische Welt brauche keine Regierungen – der einzelne Muslim müsse nur dem Koran und dem Hadith gehorchen. Er wurde 1966 auf Befehl Nassers hingerichtet.

Selbstmordattentäter In seinem Bestreben, auf eine sich wandelnde, vom Westen beherrschte Welt zu reagieren, predigt der militante Islam die Rückkehr zu traditionellen muslimischen Werten. Er selbst hat diese Werte jedoch verzerrt und verletzt, und in den nichtmuslimischen Staaten entstand der Eindruck, die Praktiken von Taliban und Al-Qaida seien im Koran und im Hadith beschrieben. Das stimmt nicht. Für Selbstmordattentate beispielsweise, eine beliebte Taktik der militanten Extremistengruppen, findet sich im Koran keine Begründung. Selbstmord ist im Islam verboten, und die Tötung unschuldiger Unbeteiligter wird als Mord verurteilt. „Wer die Rechtschaffenen zusammen mit den Übeltätern tötet", schrieb der Prophet, „hat nichts mit mir zu tun, und ich habe nichts mit ihm zu tun."

Worum es geht
Der militante Islam ist eine Minderheit

31 Die vielen Gesichter des Hinduismus

Der Hinduismus nimmt für sich in Anspruch, die älteste Religion der Welt zu sein. Er hat eine Milliarde Anhänger, davon 90 Prozent in Indien. Der moderne Hinduismus ist das Ergebnis einer komplizierten Entwicklung und vereinigt viele verschiedene Richtungen in sich. Deshalb wird er oft weniger als Religion denn als Lebensweise bezeichnet. Eigentlich handelt es sich um eine Familie von Religionen, eine Ansammlung kultureller und philosophischer Systeme, die weder einen einzelnen Begründer noch eine einzige Heilige Schrift oder auch nur eine allgemeine Lehre gemeinsam haben.

Die ältesten Wurzeln des heutigen Hinduismus liegen in der Hochkultur, die zwischen 2500 und 2000 v. u. Z. im und am Industal gedieh – im „Land der sieben Flüsse" oder Sapta-Sindhu (daher das Wort „Hindu"). Dieses altindische Reich war damals größer als Ägypten oder Mesopotamien. Als es durch die Arier aus den nördlichen Steppen neu belebt wurde, entwickelte sich eine Reihe heiliger Texte auf Sanskrit, die gemeinsam als die Veden (von veda = „Wissen") bezeichnet werden. Vier Veden sind bei allen Hindus anerkannt; am bekanntesten ist der Rigveda.

Zu Beginn handelte es sich bei den Anhängern der vedischen Religion um Reisende, Kaufleute und manchmal auch Aggressoren. Seit dem siebten Jahrhundert v. u. Z. setzte sich dann eine Gruppe von Mystikern innerhalb der Tradition für eine veränderte Einstellung ein, die Wert auf Frieden und innere Spiritualität legte. Ihre Lehren findet man in den Upanischaden, die stark von den Veden beeinflusst wurden und wie diese im modernen Hinduismus als heilige Texte gelten.

Aus dieser vedischen Religion der Achsenzeit entstand der Hinduismus: Zu der bisher sehr ernsten, eingeschränkten Tradition kam eine verwirrende Fülle farbenprächtiger Gottheiten, Statuen und Tempel hinzu. Der Begriff „Hindu" selbst setzte

Zeitleiste

ca. 2500–2000 v. u. Z.	ca. 1500 v. u. Z.
älteste Hochkultur im Industal	Entstehung der Veden

sich ungefähr im 13. Jahrhundert u. Z. durch, aber als eigenständige Religion gab es den Hinduismus erst seit dem 18. oder 19. Jahrhundert, als Indien mit seinen europäischen Kolonialherren zu leben lernte. Dieser neue Hinduismus lehrte, das Göttliche sei unendlich und man könne es deshalb nicht auf einen einzigen Ausdruck beschränken, weder auf Brahman (die transzendente, unpersönliche Macht hinter dem Universum) noch auf Bhagavan oder Ishvara, die Sanskrit-Worte für „Herr" und „Gott", die eine höhere, kreative oder destruktive Macht bezeichnen. Stattdessen betete man eine Vielzahl von Gottheiten an, in denen jeweils ein anderer Aspekt des Ganzen zum Ausdruck kam. Am beliebtesten waren Shiva und Vishnu.

Brahma

Im Hinduismus gibt es eine Dreiheit (*Trimurti*) von Göttern, die gemeinsam das Leben in der Welt umschließen. Neben Vishnu und Shiva gibt es noch Brahma (nicht zu verwechseln mit Brahman), der die Welt und alle ihre Geschöpfe erschafft (die meisten Hindus sind aus Respekt vor allen erschaffenen Lebewesen Vegetarier, und wer Fleisch isst, meidet das Fleisch der Kühe). In bildlichen Darstellungen hat Brahma eine rote Hautfarbe, vier Köpfe – von denen jeder einen der grundlegenden Vedentexte liest –, vier Arme und einen Bart. Er wird zwar als erster der drei Götter bezeichnet und in allen hinduistischen Riten zusammen mit Vishnu und Shiva erwähnt, ihm sind aber nur sehr wenige Tempel geweiht. In der hinduistischen Mythologie gibt es dafür viele Erklärungen; die meisten sind Variationen einer Geschichte, wonach Shiva einen Fluch über Brahma aussprach, weil dieser seine göttlichen Pflichten vernachlässigte, um einer Frau namens Shatarupa nachzustellen.

Vishnu und Shiva Es gibt im Hinduismus viele Schulen, die unterschiedliche Philosophien vertreten und das Göttliche in unterschiedlicher Form anbeten. Vereinfacht kann man sie in vier Gruppen einteilen: Vaishnavas, Shaivas, Shaktis und Smartas.

Die größte Gruppe, die Vaishnavas, stellen Vishnu und seine Fähigkeit, sich als Mensch zu manifestieren, in den Mittelpunkt. Neunmal, meist in Zeiten tiefer Kri-

sen, stieg Vishnu demnach vom Himmel herab und rettete die Erde. Seine nächste Wiederkehr wird nach Ansicht vieler Anhänger das Ende der Welt bedeuten. Die bekanntesten dieser Manifestationen waren Krishna und Rama. Beide sind Gegenstand epischer Erzählungen, welche schildern, wie sie mit heldenhaften Taten die moralische Ordnung und das Gleichgewicht in der Welt wiederherstellten. Vishnu wird meist in Menschengestalt, mit blauer Hautfarbe und vier Armen, dargestellt. Begleitet ist er in der Regel von Licht und Sonne.

Die Shaivas bevorzugen Shiva, einen widersprüchlichen Charakter, der manchmal asketisch, manchmal auch hedonistisch ist und nur zerstört, um etwas noch Reineres zu schaffen. Auch Shiva hat in den Darstellungen die Gestalt eines Menschen, aber er hat ein drittes Auge, das Weisheit symbolisiert. Die Shaktis betonen das Weibliche und die göttliche Mutter; diese hat meist die Form von Lakshmi, einer sehr populären Göttin, die als schöne, vierarmige Frau in einer Lotusblüte dargestellt wird. Ihre Vorzüge sind harte Arbeit, Wohlstand, Tugend und Tapferkeit. Die Smartas schließlich beten fünf oder manchmal auch sechs Gottheiten an, die in ihrer Gesamtheit das Göttliche charakterisieren.

Bhagavad Gita

Das Bhagavad Gita („Lied des Herrn") ist einer der einflussreichsten Texte des Hinduismus und stellt eine weitere Verbindung zwischen den verschiedenen Richtungen dieser Religionsfamilie dar. Es entstand nach Ansicht der meisten Fachleute im dritten Jahrhundert v. u. Z. und ist vordergründig eine Diskussion über den Zweck von Kriegen. Es besteht aus einem Dialog zwischen dem Krieger Arjuna und seinem Freund Krishna, der sich als der Gott Vishnu in Menschengestalt zu erkennen gibt. Arjuna ist nahe davor, Kämpfe als nutzlos abzulehnen, aber Krishna überzeugt ihn davon, dass sie unter manchen Voraussetzungen notwendig seien, um das *Dharma* in einer ansonsten zerstörerischen Welt wiederherzustellen. Das Bhagavad Gita gewann mit seinen Postulaten großen Einfluss: Es fordert von allen Menschen, sich von weltlichen Vorteilen loszusagen und ihnen gleichgültig gegenüberzustehen. Außerdem verspricht es, dass diesen Zustand nicht nur wenige Auserwählte erreichen könnten, sondern alle Menschen. „Wenn sie sich auf mich verlassen", sagt Krishna zu Arjuna, „erreichen selbst jene, die im Mutterleib des Bösen geboren wurden, das höchste Ziel."

> ❞ Jene, die sich in Mir von allen Taten lossagen und Mich
> als Höchstes betrachten, Mich anbeten... Für jene, deren Gedanken
> in Mich eingegangen sind, bin Ich schon bald der Retter
> aus dem Ozean des Todes und der Seelenwanderung...
> Richtet euren Geist allein auf Mich, euren Verstand auf Mich.
> So sollt ihr danach in Mir wohnen. ❝
>
> Bhagavad Gita, ca. 300 v. u. Z.

Indischer Nationalismus Zwischen dem Hinduismus auf der einen Seite und der indischen Kultur und nationalen Identität auf der anderen Seite besteht ein enger Zusammenhang. Dieser wurde im 19. und 20. Jahrhundert durch indische Nationalisten verstärkt, die sich von der Kolonialherrschaft befreien wollten. Weitere Gemeinsamkeiten aller Hindus sind die Veden, bestimmte rituelle Praktiken sowie philosophische Begriffe wie *Samsara* und *Dharma*. *Samsara*, der vom *Karma* gelenkte Kreislauf von Geburt, Tod und Wiedergeburt, gehört zu den wichtigsten Lehren des Hinduismus und findet sich auch in anderen Religionen wieder.

Dharma ist im Hinduismus eine übergeordnete Ethik, die über den Umgang mit anderen Menschen bestimmt. Zu ihr gehört die Vorschrift, anderen und Gott durch tugendhaftes, ethisches Verhalten zu dienen. Jeder Einzelne hat sein *Dharma*, das *Svadharma*. Der Moralkodex des *Dharma* nimmt im Hinduismus eine solch zentrale Stellung ein, dass die Religion häufig auch von Hindus selbst als Sanatana Dharma (Sanskrit für „ewiges Gesetz") bezeichnet wird.

Worum es geht
Der Hinduismus ist eine ganze Religionsfamilie

32 Anbetung im Hinduismus

Die Anbetung oder *Puja* kann im Hinduismus vielfältigen Gesetzmäßigkeiten folgen und ist eng mit dem sozialen und kulturellen Alltagsleben Indiens verflochten. *Puja* kann in einer großen Menschenmenge im Tempel stattfinden, gilt aber vorwiegend als individuelles Bestreben und ist ebenso wertvoll, wenn es allein zuhause an einem privaten Altar oder einfach durch Meditation vollzogen wird.

Hinduistische Riten und Rituale sind bewusst so gestaltet, dass die Gläubigen stets an die Allgegenwart des Göttlichen erinnert werden. Ihr oberstes Ziel ist *Mokscha*, die Befreiung aus dem *Samsara*-Kreislauf von Geburt, Tod und Wiedergeburt – die im Jenseits der endgültigen Vereinigung mit Brahman vorausgeht.

Hindus sind nicht verpflichtet, überhaupt in den Tempel zu gehen. Viele tun dies nur an hohen religiösen Feiertagen. Wichtigster Gegenstand der Verehrung sind die Götterbilder, die man zuhause hat. Diese werden nicht nur als Bilder betrachtet, sondern als Verkörperungen des Göttlichen (eine Vorstellung, die allerdings im hinduistischen Pluralismus von manchen Sekten, beispielsweise von den Arya Samaj, abgelehnt wird). Gebete haben häufig die Form von Gesängen, oder man liest aus heiligen Schriften vor.

Samskaras Die *Samskaras* oder Sakramente sind Rituale, die häufig mit Reinigung zu tun haben und alle Lebensstadien begleiten. Werdende Mütter unterziehen sich im dritten Schwangerschaftsmonat einer Zeremonie zur Punsavara (Schutz des Fetus), und im siebten Monat wird im Rahmen von Simantonnyaria darum gebetet, dass das Kind geistig und körperlich gesund ist. Bei der Geburt folgt Jalakarma: Man streicht Honig in den Mund des Babys und flüstert ihm den Namen Gottes ins

Zeitleiste

ca. 300 v. u. Z.	1858
Das Bhagavat Gita nennt die Ebenen des Kastensystems	Beginn der britischen Kolonialherrschaft

> **Wie wunderbar ist doch die Kraft eines Glaubens, welcher Alte und Schwache, Junge und Leidende treibt, ohne Zaudern und ohne Klage die unerhörten Anstrengungen einer solchen Reise, samt allen Entbehrungen, die sie mit sich bringt, geduldig auf sich zu nehmen! Ob es aus Furcht geschieht oder aus Liebe, weiß ich nicht, aber was auch immer der Beweggrund sein mag, die Sache selbst ist für uns kühle Verstandesmenschen vollkommen unbegreiflich.**
>
> **Mark Twain über den Hinduismus, 1895**

Ohr (ein ganz ähnliches Ritual wie im Islam). Die Zeremonie Upanayana („heiliger Faden") wird abgehalten, wenn ein Kind in die Schule kommt.

Die Eheschließung ist ein kompliziertes, formelles Ritual mit vielen genau ausgearbeiteten Stadien. Es beginnt damit, dass die Eltern der Braut den Bräutigam bei der Hochzeitsfeier willkommen heißen und auf seiner Stirn einen roten Fleck – den *Kumkum* – anbringen. Das *Dharma* legt großen Wert darauf, dass die Partner zueinander passen. Traditionell glaubte man in Indien, dies sei am besten gewährleistet, wenn Eltern die Ehe für ihre Kinder arrangieren. Ehescheidung ist möglich, kommt aber nur sehr selten vor.

Frauen im Hinduismus
Die verschiedenen Schulen des Hinduismus sind sich, was die Stellung der Frau angeht, nicht einig. Die Ansichten hängen vom sozialen, kulturellen und wirtschaftlichen Umfeld der Gläubigen häufig ebenso stark ab wie von den heiligen Texten, die zu dem Thema keine klare Richtung vorgeben. In einem vedischen Hochzeitslied heißt es beispielsweise, die Frau „sollte sich als Befehlshaberin an die Versammlung wenden". Andererseits war das indische Parlament noch 1987 damit beschäftigt, die alte Tradition des *Sati* oder *Suttee* zu verbieten, bei der die Frau sich bei der Einäscherung ihres Mannes mit ins Feuer wirft. Manche heiligen Schriften loben Frauen, die dieses Opfer auf sich nehmen. In traditionellen Hindugruppen müssen Witwen noch heute einen besonderen weißen Sari tragen, sich den Kopf kahl scheren und sich weitgehend aus der Öffentlichkeit fern-

1947	**1950**	**1987**
Ende der britischen Kolonialherrschaft	Verbot der Diskriminierung wegen Kastenzugehörigkeit	Verbot des *Sati*

halten, nachdem sie alle weltlichen Besitztümer ihres Mannes den Kindern überge-
ben haben. Manche verdienen sich ihren Lebensunterhalt dann durch Betteln.

Das Kastensystem

Angesichts der engen Verflechtung von Religion und gesellschaftlichem Leben wird die Tatsache, dass das Kastensystem in Indien immer noch existiert, häufig auf den Hinduismus zurückgeführt. Diese Methode zur Einstufung von Menschen geht auf religiöse Ansichten über Reinheit und eine natürliche, von Gott gegebene Hierarchie zurück. Das Wort „Kaste" wurde erstmals von portugiesischen Siedlern benutzt. Hindus kennen das System eher als die vier *Varnas*. In absteigender Reihenfolge sind das: die Brahmanen oder Priester, die der Überlieferung zufolge aus Brahmas Mund hervorgegangen sind; die Kshatriyas (Herrscher/Krieger), entstanden aus Brahmas Armen; die Vaishyas (Kaufleute/Handwerker), hervorgegangen aus Brahmas Hüften; und die Shudras (ungelernte Arbeiter/Diener) aus Brahmas Füßen. Hinzu kam eine fünfte Kategorie, die „Unberührbaren", welche unterhalb des ganzen Systems standen. Diese grundlegenden Kategorien überspannte ein kompliziertes System der Schichten oder *Jatis*, die durch Geburt, Eheschließung und Beruf definiert wurden. Die Kasten prägen bis heute die indische Gesellschaft; dies gilt insbesondere in ländlichen Gebieten, wo Eheschließungen zwischen verschiedenen *Jatis* zwar gestattet sind, aber mit Unmut betrachtet werden. Die „Unberührbarkeit" hingegen wurde gesetzlich abgeschafft.

Yoga Das Leben eines Hindu gliedert sich in vier Stadien oder *Ashramas*:
1. Brahmacharya, das Stadium des Schülers, in dem rituelles Grundwissen im Zölibat mit kontrollierter Meditation unter Leitung eines Guru erlangt wird; 2. Grihastha, das Stadium des Haushälters mit Eheschließung, Elternschaft und der Einrichtung eines Zuhauses; 3. Vanaprastha, das Stadium des Ruhestandes, in dem man materielle Wünsche aufgibt und mehr Zeit für Gebet und Meditation aufwendet; und 4. Sannyasa, das Stadium der Vorbereitung auf den Tod.

Der Tradition zufolge gibt es mehrere Wege oder Yogas zur Orientierung in diesen vier Stadien. Im Westen bringt man den Begriff mit körperlichen Übungen in Verbindung, im Hinduismus bezeichnet er jedoch eine Fülle körperlicher, mentaler und spiritueller Disziplinen, die in verschiedenen heiligen Texten beschrieben werden. Man kennt bis zu 18 verschiedene Yogas, von denen vier besonders wichtig

Pilgerreisen

Hindus werden insbesondere in ihrem dritten Lebensstadium (Vanaprashta) aufgefordert, Pilgerreisen zu unternehmen, um so *Mokscha* zu erreichen. Neben verschiedenen heiligen Städten und Tempeln gibt es das große Pilgerfest Kumbha Mela, das alle vier Jahre abwechselnd in den Städten Allahabad, Haridwar, Nashik und Ujjain stattfindet. Alle vier liegen an den Ufern heiliger Flüsse. Die Entstehung des Festes lässt sich auf die vedischen Texte zurückführen, in denen die Götter ihre Kraft zurückgewinnen, indem sie einen Ozean aus Milch auffüllen. Die Pilger vollziehen im Rahmen des Festes ein rituelles Bad. Bekanntermaßen reisen bis zu 70 Millionen Menschen in einem einzigen Jahr zur Kumbha Mela.

sind: *Bhakti* Yoga – der Weg der Liebe und Hingabe; *Karma* Yoga – der Weg des richtigen Handelns; *Raja* Yoga – der Weg der Meditation; und *Jnana* Yoga – der Weg von Weisheit und Wissen. Alle vier überschneiden sich, und wenn man einen Weg einschlägt, muss man die anderen nicht verlassen.

Feste Der wichtigste hinduistische Feiertag ist das Lichterfest Diwali, das je nach dem Datum des Neumondes Ende Oktober oder Anfang November gefeiert wird. Wie alle hinduistischen Zeremonien ist es ein farbenprächtiges Fest, mit Feuerwerk und Straßenfesten. Alle Wohnungen werden mit *Diyas* erleuchtet, kleinen Tontöpfen voller Senföl, in denen ein Baumwollfaden als Docht angebracht ist. Die Lichter sollen der Göttin Lakshmi den Weg in die Wohnungen weisen, wo sie ihren Segen verteilt. Durch ihre Gegenwart angeregt, gründen manche Hindus gerade zu dieser Jahreszeit neue Unternehmen. Andere nutzen eine weitere alte, ehrwürdige religiöse Tradition, die zu Diwali das Glücksspiel gestattet.

Worum es geht
In der hinduistischen Praxis vermischen sich Religion und Kultur

33 *Samsara*

Der Kreislauf aus Geburt, Tod und Wiedergeburt, der im Hinduismus als *Samsara* und an anderen Orten auch als Reinkarnation bezeichnet wird, steht in ausgeprägtem Gegensatz zu den Vorstellungen der monotheistischen Religionen über den endgültigen Tod und das Jenseits. In der hinduistischen Lehre findet eine ständige, fortschreitende Beurteilung statt, manchmal über viele Lebenszeiten hinweg; sie unterliegt dem *Karma*. Dieser Begriff bezeichnet in ungefährer Übersetzung die Taten des Einzelnen während seines Lebens, umfasst aber auch die Vorstellung von einem Erbe, das von einem Leben zum nächsten mitgenommen wird.

Das Wort *Karma* kommt aus dem Sanskrit und bedeutet wörtlich „Tat". Es geht auf die Upanischaden zurück, insbesondere jene von Yajnavalkya, dem Hofphilosophen des Königs Janaka von Videha. Dieser war ein führender Unterstützer einer friedlichen, inneren Spiritualität, die dem vedischen Glauben seit 800 v. u. Z. ein neues Gesicht gab.

Zuvor hatte man im Tod ein Vorspiel zum Aufenthalt im Land der Götter gesehen, welcher den Menschen zuteil wurde, wenn sie die Rituale befolgten. Yajnavalkya und andere Weise seiner Zeit formulierten eine neue Idee: Danach zählten die Taten, und nur wenn ein Gläubiger mit Taten bewies, dass er sich vom Streben nach allem Irdischem losgesagt hatte, wurde er in einem Leben nach dem anderen von der Last der Krankheit, des Alters und der Sterblichkeit befreit, ohne dass aber Hoffnung auf eine endgültige Erlösung bestand.

Diesen Kreislauf des Leidens bezeichnete man als *Samsara*. Er konnte nur durch vollständige Selbsterkenntnis durchbrochen werden, die dann zur *Mokscha* führte, der endgültigen Befreiung und ewigen Vereinigung mit dem höchsten Gott in einem unklar definierten Himmel. Die neuen Ideen von *Karma* und *Samsara* waren anfangs umstritten, aber im fünften Jahrhundert v. u. Z. hatten sie sich in der Hauptrichtung des Hinduismus durchgesetzt.

Zeitleiste

ca. **800** v. u. Z.

In den Upanischaden werden *Karma* und *Samsara* definiert

Yajnavalkya

Der Weise und Astronom Yajnavalkya gilt als Autor der Brihadaranyaka-Upanischade und anderer heiliger Schriften. Er ist im Hinduismus eine hochverehrte Sagengestalt. Als junger Schüler soll er seinen Guru geärgert haben, weil er allzu stolz auf seinen eigenen Geist war. Ihm wurde befohlen, sein Wissen als Nahrung zu erbrechen, und dann wurde es von seinen Mitschülern, die die Gestalt von Rebhühnern annahmen, aufgefressen. Er hatte zwei Ehefrauen. Die eine, Maitreyi, fragte ihn, ob sie durch Erwerb großer Reichtümer die Unsterblichkeit erlangen könne. Er schalt sie und erklärte, sie müsse sich während ihres ganzen Lebens darum bemühen, das „absolute Ich" zu begreifen. Nur so werde sie den Weg zu unendlichem Wissen und damit auch zur Unsterblichkeit finden. Yajnavalkya warnte davor, den Begriff des *Atman* zu definieren, der gewöhnlich mit „Seele" oder „Ich" übersetzt wird. „Über diesen *Atman* kann man nur sagen: 'Nicht, nicht'... Er ist unbegreiflich, denn man kann ihn nicht begreifen. Er ist unverweslich, denn er unterliegt nicht der Verwesung. An ihm bleibt nichts hängen, denn er hängt an nichts. Er ist nicht gebunden; und doch zittert er weder vor Angst noch erleidet er Verletzungen."

Ursache und Wirkung *Karma* macht deutlich, wie stark im Hinduismus die konkrete Lebensweise im Kontrast zu abstrakten Prinzipien von „richtig" und „falsch" im Mittelpunkt steht. Nach dem Glauben der Hindus hat jede Tat, ob gut oder schlecht, entweder unmittelbar oder in einem zukünftigen Leben ihre Auswirkungen. Schlechte, gegen das *Dharma* gerichtete Taten – Hindus sprechen von *Paap* – bringen ein schlechtes *Karma* mit sich, gute Taten (*Punya*) führen zu einem guten *Karma*. Dennoch handelt es sich nicht nur um eine einfache Beziehung von Ursache und Wirkung, bei der jeder Einzelne sein Schicksal in der Hand hat. Hindus glauben auch, dass die Götter unmittelbar eingreifen und das *Karma* eines Menschen verändern können.

Eine Geschichte – im Hinduismus sind solche Geschichten ebenso beliebt wie Gleichnisse im Christentum – handelt von Sandipani, einem Guru Krishnas, der irdischen Verkörperung des Gottes Vishnu. Sandipani hat seinen Sohn an einen Mee-

resdämon verloren, der ihn nach Yama gebracht hat, den Bereich des Herrschers der Toten. Dies soll am schlechten *Karma* des Sohnes gelegen haben. Aus Achtung vor seinem früheren Lehrer setzt Krishna/Vishnu seine Autorität ein, um den Sohn von Yama zurückzuholen und seinem Vater wiederzugeben. Er macht das schlechte *Karma* zu einem guten. Genau diese Machtausübung, die über die persönlichen Bemühungen des Einzelnen hinausgeht, beweist für manche Hindus die Existenz Gottes.

Prayopavesa

Prayopavesa, das Fasten bis zum Tod, ist im Hinduismus eine anerkannte Übung, man sollte es aber nicht unmittelbar mit Selbstmord gleichsetzen. Der Vorgang unterliegt strengen Vorschriften. Es muss ohne Anwendung von Gewalt und mit natürlichen Mitteln stattfinden. Man darf nur darauf zurückgreifen, wenn der Körper erschöpft ist und nicht mehr funktioniert. Aus einem Impuls heraus kann man es nicht unternehmen: Es bedarf einer Vorbereitungszeit, in der man Freunden und Verwandten erklärt, was geschehen wird.

Außerdem muss man es mit ernster Gesinnung antreten, nicht aber, wenn man sich in einem Höhenflug der Gefühle befindet. Im November 2001 nahm sich Satguru Sivaya Subramuniyaswami, ein angesehenes Oberhaupt der hinduistischen Gemeinschaft in den Vereinigten Staaten, durch *Prayopavesa* das Leben. Er hatte Darmkrebs im Endstadium. Nachdem er eine Zeit lang meditiert hatte, nahm er keine Nahrung mehr zu sich und trank nur noch Wasser. Er starb nach 32 Tagen.

❞ Unser Schicksal wurde geformt, lange bevor der Körper ins Dasein trat. ❝

Tulsidas, hinduistischer Schriftgelehrter, **1532–1623**

Varianten des *Karma* Im Hinduismus kann das *Karma* mehrere Formen haben. *Sanchita karma* ist die Gesamtheit des *Karma* aus allen früheren Leben – eine Art Summe der Schulden. Den Teil der Schuld, den der Einzelne in seinem jetzigen Leben tilgen kann, nennt man *Prarabdha karma*; das *Agami karma* dagegen wird am Ende des jetzigen Lebens zur Gesamtschuld jeder Seele (*Atman*) hinzugefügt oder von ihr abgezogen. Flüchtiger ist das *Kriyamana karma*, manchmal auch „*Karma* des Augenblicks" genannt: Es entsteht durch Alltagsvorgänge im Leben und hat keine langfristigen Auswirkungen.

Unter Hindus gibt es Diskussionen darüber, wie das *Karma* in einzelnen Gruppen funktioniert. Manche vertreten die Ansicht, man könne Kinder und Tiere nicht für ihre Taten verantwortlich machen, und deshalb seien sie vom *Agami karma* ausgenommen. Sie tragen aber das *Sanchita karma*. Der Schlüssel zur Befreiung vom *Samsara* liegt für alle Hindus darin, dass man das *Sanchita karma* zur Neige gehen lässt, und das schafft man nur durch ein moralisch einwandfreies Leben und die Hilfe der Götter.

Worum es geht

Wir alle leben viele Male

34 Der Jainismus

Seit 2600 Jahren teilen die Jainisten mit den Hindus sowohl den indischen Subkontinent als auch viele Glaubensüberzeugungen. Dennoch unterscheidet sich diese uralte, friedliebende Religion, die rund vier Millionen Anhänger hat, in mehrfacher Hinsicht vom Hinduismus: durch ihre übergeordnete Sorge für das Universum, durch ihren Glauben an die spirituelle Gleichberechtigung von Menschen, Tieren und Pflanzen, und durch ihre extreme Askese. Alle Jain sind Vegetarier; sie lehnen weltliche Besitztümer, Sexualität und Gewalt ab und folgen einem Weg, der im sechsten Jahrhundert v. u. Z. von dem indischen Prinzen und Einsiedler Mahavira vorgezeichnet wurde.

Jain glauben nicht an einen Gott oder an Götter, sie sind jedoch überzeugt, dass es *Jinas* (reine Seelen) und *Tirthankaras* (inspirierte Lehrer) gibt. Manch einer würde sie als Atheisten bezeichnen. Sie glauben aber an die unsterbliche Seele. Ihre spirituellen Praktiken, ähnlich denen von Mönchen, gründen sich auf eine tiefgreifende Sorge um das Wohl aller Lebewesen im Universum – Menschen, Tiere und Pflanzen – und um die Gesundheit des Universums selbst. Wie Hindus und Buddhisten glauben sie an den Kreislauf des *Samsara*, den sie aber ausschließlich unter dem Gesichtspunkt der Selbsthilfe interpretieren. Götter, die helfen könnten, gibt es nicht.

Drei Rechte Jeder Jain ist selbst für seine Bestrebungen verantwortlich, dem obersten Prinzip seines Glaubens – der Gewaltlosigkeit – und den „Drei Juwelen" treu zu bleiben: richtiger Glaube, richtiges Wissen und richtiges Verhalten. Um nach diesen Prinzipien zu leben, legen Jain fünf Gelübde oder *Mahavratas* ab: Sie verpflichten sich dazu, keine Gewalt auszuüben, keine Besitztümer zu haben, stets die Wahrheit zu sagen, nie zu stehlen und sexuelle Mäßigung zu üben. Der Zölibat gilt als Idealzustand. Die Gelübde der vielen zölibatär lebenden jainistischen Mönche

und Nonnen werden als auf einer höheren Ebene stehend betrachtet als die der Laien, die heiraten und Kinder haben, sich aber dazu verpflichten, dem Partner lebenslang treu zu bleiben und Sex nicht zum Vergnügen zu betreiben.

Nach der jainistischen Lehre wurden die ersten vier Gelübde von *Parsva* formuliert, dem 23. *Tirthankara* ihrer Religion in diesem Zeitalter. Es gab auch andere Zeitalter und viele weitere *Tirthankaras*, darunter auch Frauen. Historischen Belegen zufolge lebte Parsva im neunten Jahrhundert v. u. Z. und war königlicher Herkunft. Das fünfte Gelübde kam auf Geheiß von Mahavira – wörtlich „großer Held" – hinzu, der nach der jainistischen Überlieferung von 599 bis 527 v. u. Z. lebte.

Nach dem Tod seiner Eltern, König Siddharta und Königin Trishala, verließ Mahavira (der damalige Prinz Vardhamana) im Alter von 30 Jahren den Königspalast und lebte die nächsten zwölfeinhalb Jahre ohne Besitztümer, um nach Erleuchtung zu streben. Als er sie schließlich gefunden hatte, lehrte er den Rest seines Lebens andere, wie man sie erlangt; seine Weisheiten sammelte er in einem heiligen Buch mit dem Titel *Agamas*. Bei seinem Tod hatte Mahavira die *Mokscha* erlangt – eine weitere gemeinsame Vorstellung von Jainismus und Hinduismus.

Fasten

Das Fasten spielt in der jainistischen Spiritualität eine größere Rolle als in anderen Religionen und wird von Frauen häufiger vollzogen als von Männern. Nach ihrer Überzeugung reinigt Fasten den Körper und den Geist; das Vorbild ist Mahavira mit seinem von Verzicht und Askese geprägten Leben. Einmal soll er angeblich ein halbes Jahr lang keine Nahrung zu sich genommen haben, eine Übung, die Mönche noch heute nachahmen. Manche gehen noch einen Schritt weiter und fasten ein ganzes Jahr. Dabei reicht es nicht aus, einfach nichts zu essen. Man muss auch den Wunsch zu essen überwinden. Wenn man sich weiterhin nach Nahrung sehnt, gilt das Fasten als sinnlos.

527 u. u. Z.
Tod Mahaviras

350 v. u. Z.
Bei einer Hungersnot sterben viele jainistische Mönche

19. Jahrhundert u. Z.
Zahl der Jain erreicht ihren Tiefpunkt

> 〝 Ich verbeuge mich vor jenen, die Allwissenheit im Fleisch
> erreicht haben und im befreiten Zustand den Weg
> zum immerwährenden Leben lehren. Ich verbeuge mich vor jenen,
> die das vollkommene Wissen erlangt und ihre Seele von allem
> Karma befreit haben. Ich verbeuge mich vor jenen, die durch
> Selbstkontrolle und Selbstaufopferung die Selbstverwirklichung
> ihrer Seelen erlangt haben. Ich verbeuge mich vor jenen,
> die das wahre Wesen der Seele kennen und die Bedeutung
> des Spirituellen gegenüber dem Materiellen lehren. Ich verbeuge
> mich vor jenen, die streng die fünf großen Verhaltensgelübde
> befolgen und uns zu einem tugendhaften Leben anregen. 〞
>
> Namaskara Sutra: **tägliches Gebet der Jain**

Mit ihrer Besorgnis für das Universum haben die Jain genauere Vorstellungen vom Jenseits entwickelt als die Hindus. Beschrieben werden mehrere Schichten. Im Zentrum steht die „Mittlere Welt", in der die Menschen nach Erleuchtung streben müssen. Darüber befinden sich zwei Schichten: In der einen leben befreite Wesen wie Mahavira in Ewigkeit in einer Welt ohne Anfang (daher gibt es auch keinen Schöpfergott) und Ende, die zweite ist eine Art Station auf der ewigen Reise zur endgültigen Erleuchtung. Darunter gibt es zwei weitere Schichten: eine Reihe von sieben Höllen, in denen die Lebewesen von Dämonen und von ihresgleichen gequält werden, aus der sie aber entkommen können, und schließlich einen Kerker, in dem die niedrigsten Lebensformen für immer festgehalten werden.

Jainistischer Einfluss In der Geschichte hatte es der Jainismus im Schatten des Hinduismus immer schwer. Wenn der Hinduismus stark war – beispielsweise im 19. Jahrhundert im Zusammenhang mit dem Widerstand gegen die Kolonialmacht –, wurde der Jainismus geschwächt. Heute gibt es zwei Richtungen: die Digambara- und die Swetambara-Jain. Die ersteren sind ernster. Ihre Mönche tragen niemals Kleidung. Außerdem vertreten sie eine eher traditionelle Haltung, beispielsweise im Hinblick auf die Rolle der Frauen: Diese können nach ihrer Auffassung nur dann die höchste Erleuchtung erlangen, wenn sie zuvor als Männer wiedergeboren wurden.

Im Jainismus gedieh und gedeiht eine einflussreiche literarische Kultur. Einige der ältesten Bibliotheken Indiens wurden von Jain gegründet. In überproportionaler Zahl findet man sie auch in der wohlhabenden Elite des Landes. Obwohl sie nur

Jainistisches Vegetariertum

Jain sind Vegetarier, aber da sie Gewalt gegen alle Lebewesen (auch Pflanzen) verabscheuen, verzehren sie auch kein Wurzelgemüse wie Kartoffeln, Knoblauch, Zwiebeln, Möhren und Rüben. Dagegen essen sie Wurzeln wie Kurkuma, Ingwer und Erdnüsse. Auberginen werden gemieden, weil sie viele Samen enthalten, und Samen gelten als Träger zukünftigen Lebens. Strenge Jain essen keine Lebensmittel, die über Nacht stehengeblieben sind, wie beispielsweise Joghurt, und nehmen ihre Mahlzeiten vor Sonnenuntergang ein. Die strengen jainistischen Ernährungsvorschriften spiegeln sich am stärksten in der Küche von Gujarat wider.

0,2 Prozent der Bevölkerung ausmachen, zahlen sie mehr als 20 Prozent des Steueraufkommens. Einer von denen, die sich durch die jainistischen Vorstellungen von Gewaltlosigkeit beeinflussen ließen, war der Führer der Unabhängigkeitsbewegung Mahatma Gandhi.

Orte der Anbetung Für Jain war Mahavira nicht der Begründer ihrer Religion, aber an den letzten Tag, an dem er lehrte, wird jedes Jahr mit der jainistischen Version des hinduistischen Diwali-Festes erinnert. Das zweite große Fest, zu dem Jain ihre Tempel aufsuchen, ist Paryushana, der Geburtstag Mahaviras; er bildet den Höhepunkt einer achttägigen Periode des Fastens, der Buße und der Rituale.

Da Jain keine Götter haben und die Vorstellung, Mahavira sei ihr Begründer, ablehnen, muss man sich fragen, warum sie überhaupt etwas verehren. Teilweise liegt das am allgemeinen Einfluss des hinduistischen kulturellen Umfeldes, auch wenn die jainistischen Rituale in der Regel strenger und ernster sind. Allerdings beten die Jain das Ideal jener Vollkommenheit an, die Mahavira, Parsva und alle anderen (historisch nicht belegten) *Tirthankaras* erlangten. Alle Teilnehmer streben danach, zu reinen Seelen zu werden.

Die Welt steht der Erleuchtung im Weg

35 Sikhismus

Der Sikhismus wurde Ende des 15. Jahrhunderts vom Guru Nanak begründet, einem Hindu, der auch den Islam studiert hatte. Die heutigen 20 Millionen Sikhs (von dem Sanskrit-Wort für „Lernender" oder „Schüler") sind allerdings der Ansicht, dass das von ihm überlieferte Glaubenssystem viel mehr ist als nur eine Synthese aus Hinduismus und Islam. Es ist seine eigene, charakteristische Schöpfung. Gestärkt wurde sie durch die neun Gurus, die auf Nanak folgten, und später durch das Guru Granth Sahib, das heilige Buch der Sikhs, dem heute der gleiche Status beigemessen wird wie einem lebenden Guru.

In Indien wurde in den letzten Jahrzehnten wiederholt der Vorwurf erhoben, der Sikhismus sei nur eine Sekte des Hinduismus. Diese Ansicht geht zum Teil auf hinduistische Nationalisten zurück, die damit auf den Konflikt zwischen dem indischen Staat und der großen Zahl der Sikhs im Punjab reagierten. Im Juni 1984 stürmten indische Truppen den Goldenen Tempel von Amritsar, das höchste Heiligtum der Sikhs. Vier Monate später wurde die indische Premierministerin Indira Gandhi von zweien ihrer Leibwächter, beide Sikhs, ermordet. Ihr Tod gab den Anlass zu blutigen Auseinandersetzungen zwischen den Glaubensgemeinschaften, bei denen schätzungsweise 10.000, nach anderen Schätzungen sogar 17.000 Menschen ums Leben kamen.

Eine Religion des Dienens Zwischen Hinduismus und Sikhismus gibt es viele Gemeinsamkeiten, insbesondere den Glauben an *Samsara*, den Kreislauf von Geburt, Tod und Wiedergeburt. Sowohl der Islam als auch der Sikhismus sind monotheistische Religionen. Dennoch hat der Sikhismus seinen eigenen Charakter, dessen Grundlage die Pflicht zum Dienen bildet – zum Dienst an Gott und an der Gemeinschaft. Im Vergleich zum Hinduismus legt er also größeres Gewicht auf die Unterordnung des Einzelnen unter die Gesellschaft.

Zeitleiste

1469	1699
Geburt des Guru Nanak	Guru Gobind Singh erklärt die Khalsa

Wenn sich ethische Fragen stellen, auf die es im Guru Granth Sahib oder im Gurmat (den gesammelten Weisheiten der Gurus) keine klare Antwort gibt, sollen sie nach der Lehre des Sikhismus von der gesamten Gemeinschaft der Gläubigen oder *Khalsa* gemeinsam gelöst werden. Taten sind wichtiger als Rituale; die Gläubigen sollen ihr *Haumain* – den selbstbezogenen Stolz, durch den sie sich an weltliche Dinge binden – ablegen und stattdessen in ihrem Inneren nach Erleuchtung suchen.

Die fünf K Das charakteristische äußere Erscheinungsbild der Sikhs geht auf die Zeit des neunten und letzten Guru, der auf Guru Nanak folgte, zurück. Im Jahr 1699 schrieb der Guru Gobind Singh die „fünf K" vor, wie sie von den Sikhs genannt werden. Sie sollten für die Khalsa als Erkennungszeichen dienen und eine Bindung zwischen ihnen schaffen: Kes (ungeschnittene Haare); Karra (eiserner Armreif); Kangha (Holzkamm); Kaschaira (Baumwollunterwäsche); und Kirpan (ein kleiner Dolch). Sikh-Männer tragen außerdem einen Turban.

Rituale der Sikhs

Einem neugeborenen Kind flüstern Sikhs das Mul Mantar (ein von Guru Nanak verfasstes Gebet) ins Ohr und streichen ihm Honig in den Mund. Innerhalb der ersten 40 Tage wird das Kind in den Gurdwara (Tempel) gebracht und dort mit heiligem Wasser getauft. Die Hochzeitszeremonie der Sikhs, Anand Karaj genannt, gründet sich auf Richtlinien der Gurus und wird nur vollzogen, wenn beide Partner Sikhs sind. Trotz der Lehre des Guru Nanak, wonach Rituale eine untergeordnete Rolle spielen, sind Sikhs erpicht auf Prozessionen; Götterbilder lehnen sie jedoch ab. Sie feiern Diwali, allerdings als Erinnerung an die Freilassung des sechsten Guru Hargobind Singh, der 1619 aus dem Gefängnis kam. Ihr höchster Feiertag ist Vaisakhi, das Neujahrsfest, mit dem die Geburt des Sikh-Volkes als Khalsa im Jahr 1699 gefeiert wird.

1799	1919	1984
Gründung eines unabhängigen Sikh-Staates	Briten richten in Amritsar ein Blutbad an	Erstürmung des Goldenen Tempels durch indische Truppen

> 〝 Die Erkenntnis der Wahrheit steht höher als alles andere.
> Noch höher aber steht ein wahrhaftiges Leben. 〞
>
> Guru Nanak, 1469–1539

Jedes der fünf K hat seinen eigenen Symbolgehalt. Haare sind für Sikhs ein Zeichen für Heiligkeit und Stärke. Sie ungeschnitten zu lassen, bedeutet, dass man Gottes Geschenk so annimmt, wie es beabsichtigt war. Die Ursprünge von Kaschaira und Kirpan liegen in der oftmals gewalttätigen Geschichte des Sikhismus, der seine eigene Identität im Schatten der größeren hinduistischen und muslimischen Gruppen rund um seine Heimat an der indisch-pakistanischen Grenze sichern musste. Die Kaschaira war im 18. Jahrhundert die bevorzugte Kleidung der Sikh-Krieger, und der Kirpan erinnert an die „heiligen Soldaten", die der Guru Gobind Singh zur Verteidigung des Sikhismus rekrutierte.

Guru Nanak Der Guru Nanak legte mit einer Reihe höchst poetischer Schriften das Fundament der sikhistischen Lehre und Religion. Die historische Forschung lieferte kaum Anhaltspunkte für sein Leben, aber seine Anhänger haben rund um ihn eine Fülle von Geschichten gestrickt. Eine davon erzählt, wie er sich mit elf Jahren weigerte, die „heilige Schnur" zu tragen, wie es bei hinduistischen Jungen seines Alters und seiner Kaste in seiner Heimat Punjab Sitte war. Er erklärte, Menschen sollten sich durch ihre Taten unterscheiden und nicht durch ihre Kleidung.

Der wichtigste Kritikpunkt des Guru Nanak an Hinduismus und Islam lautete: Beide legen zu viel Wert auf Äußerlichkeiten – auf Pilgerreisen, Selbstkasteiung und Armut –, während ihnen die inneren Veränderungen, die in der Seele jedes Gläubigen stattfinden müssen, weniger wichtig sind. Er lehrte, es gebe nur einen Gott, dieser habe weder Form noch Geschlecht und behandle alle gleich, unabhängig davon, ob sie Männer oder Frauen seien, zu einer hohen Kaste oder zu den „Unberührbaren" gehörten. Außerdem behauptete er, man könne eine Beziehung zu Gott haben, ohne dass es dazu irgendwelcher Priester oder Rituale bedürfe.

Kampf ums Überleben Unter Guru Arjan Dev (1563–1606), dem fünften Nachfolger des Guru Nanak, begann für die Sikhs ein langer Überlebenskampf. Der Mogulkaiser Janaghir (Regierungszeit 1605–1627) war durch die Erfolge des Guru Arjan in der wachsenden Sikh-Hauptstadt Amritsar beunruhigt und wollte die Gruppe gefügig machen. Im Jahr 1606 ließ er den Guru hinrichten, aber der Kampf setzte sich unter Arjans Nachfolger fort, und die Moguln versuchten, die Sikhs mit Gewalt zum Islam zu bekehren.

Pflichten und Flüche

Nach dem Glauben der Sikhs ist die Befreiung vom *Samsara* nur durch die Gnade Gottes möglich. Vor diesem Hintergrund benennen sie drei Pflichten zum Dienst an Gott und fünf Flüche, welche die Gläubigen von ihm trennen. Die Pflichten sind Nam Japna – behalte Gott immer in deinem Gedächtnis, Krlt Karna – führe ein aufrichtiges Leben, und Vand Chakna – sei mildtätig und sorge für andere. Die fünf Flüche sind: Wollust, Habgier, die Hochschätzung weltlicher Dinge, Jähzorn und Überheblichkeit.

Der Guru Gobind Singh (1666–1708) machte aus den Sikhs sowohl eine Religionsgemeinschaft als auch eine Streitmacht, die sich verteidigen konnte. Der Dichter, Philosoph und Krieger folgte mit neun Jahren seinem Vater als Guru nach. Im Jahr 1699 erklärte er alle Sikhs zu Mitgliedern der Khalsa, legte ihre Kleiderordnung fest und rekrutierte die „heiligen Soldaten". Kurz vor seinem Tod befahl er, es solle keine weiteren menschlichen Gurus mehr geben, sondern nur das heilige Buch.

Den auf Guru Gobind folgenden Militärführern gelang es gegen Ende des 18. Jahrhunderts, im Punjab einen unabhängigen Sikh-Staat zu gründen, aber sogar dort waren die Sikhs in der Minderheit. Anfangs widersetzten sie sich der britischen Herrschaft in Indien, später wurden sie aber zu engen Verbündeten des Raja, bis im Jahr 1919 ein Massaker an Sikhs in Amritsar die Beziehungen vergiftete. Als der Punjab 1947 zwischen den neu geschaffenen Staaten Indien und Pakistan aufgeteilt wurde, fühlten sich die Sikhs übergangen, und ihre Verbitterung führte in gerader Linie zu den Gewalttaten der 1980er Jahre.

Diene anderen, dann dienst du Gott

Worum es geht

36 Buddha und der Bodhi-Baum

Im Buddhismus gibt es, im Unterschied zu den meisten anderen Religionen, keine Vorstellung von einem persönlichen Gott. Er konzentriert sich vielmehr auf die individuelle spirituelle Entwicklung und die Suche nach Erleuchtung; Grundlagen sind dabei die Lehren und Erfahrungen des Prinzen Siddharta Gautama, der im sechsten Jahrhundert v. u. Z. zum Wandermönch wurde und sich mit dem Problem des menschlichen Leidens auseinandersetzte.

Siddharta Gautama verließ seine Frau, sein neugeborenes Kind und seine Eltern – diese weinten, als er seine edlen Kleider gegen den einfachen gelben Umhang eines Mönchs tauschte und sich mit einem Schwert die Haare abschnitt. Sechs Jahre lang streifte er durch Nordindien und bemühte sich darum, den Schmerz, den er um sich herum sah, mit den Aussagen der vedischen Religion Indiens in Einklang zu bringen. Er lebte asketisch, lehnte alle Bequemlichkeiten und jeden Luxus ab, und disziplinierte sich in einem Leben des Gebets und der Meditation. Aber vergeblich: Ein Teil von ihm – er sprach von seinem „Schatten-Ich" – blieb in der Welt verwurzelt und verwehrte ihm die Erleuchtung.

In seiner Verzweiflung ließ er von seiner strengen Lebensweise ab und setzte sich für drei Tage und drei Nächte unter einen großen Feigenbaum. An seinem tiefsten Punkt angelangt, konnte Gautama schließlich das Schatten-Ich zur Ruhe betten und das *Dharma* verstehen – das gleiche Wort gebrauchen auch die Hindus, er aber bezeichnete damit das Gesetz (oder die Wahrheit), in dem sich die Grundprinzipien des Daseins widerspiegeln. Der wahre Grund für das Leiden in der Welt, so begriff er, war die Unkenntnis über das eigentliche Wesen der Menschen.

❞ Mit einer einzigen Kerze kann man Tausende von Kerzen anzünden, und das Leben der Kerze verkürzt sich nicht. Glück nimmt niemals ab, wenn man es teilt. ❜

Buddha, **sechstes Jahrhundert v. u. Z.**

Mit dieser Erkenntnis erlangte er die spirituelle Erleuchtung und sah die Welt mit neuen Augen. Der Baum wird als Bodhi-Baum oder Baum der Erleuchtung bezeichnet, und Gautama wurde zu Buddha, dem „Erleuchteten". Er verbrachte sein restliches irdisches Leben damit, anderen dabei zu helfen, den gleichen Bewusstseinszustand zu erlangen; er beharrte darauf, dass jeder diesen Weg gehen könne.

Buddhistische Schriften Die Geschichte Buddhas ist in den buddhistischen Schriften enthalten, einer vielbändigen Sammlung unterschiedlichen Ursprungs. Anfangs wurde der Bericht von Buddhas ersten Schülern – einer als *Sangha* bezeichneten Mönchsgemeinschaft – mündlich überliefert. Erst im dritten Jahrhundert v. u. Z. wurde er niedergeschrieben. Die Echtheit der verschiedenen Texte wurden vielfach diskutiert, es gab aber kaum einmal echte Konflikte. Viele Gelehrte bevorzugen eine Version aus dem ersten Jahrhundert v. u. Z., die im nordindischen Pali-Dialekt verfasst ist – dieser ist eng mit der Sprache verwandt, die Buddha selbst sprach.

Der Mahabodhi-Tempel

An der Stelle, an der Buddha seinen spirituellen Durchbruch erlebte, steht heute der Mahabodhi-Tempel – der Name bedeutet „großes Erwachen". Er ist rund 100 Kilometer von Patna im ostindischen Bundesstaat Bihar entfernt und wurde zum UNESCO-Weltkulturerbe erklärt. Im Jahr 250 v. u. Z. gründete der Kaiser Asoko an dieser Stelle ein buddhistisches Kloster. Das heutige Bauwerk, mit vier kleineren Türmen und einem 60 Meter hohen Zentralturm, wurde im fünften Jahrhundert u. Z. vollendet. Buddhisten sehen in diesem Ort den „Nabel der Welt" der am Ende der Zeiten als Letzter zerstört werden wird.

483 v. u. Z.
Buddha stirbt

3. Jahrhundert v. u. Z.
Die buddhistischen Lehren werden in Schriftform gebracht

250 v. u. Z.
Bau des Mahabodhi-Tempels

Ungewöhnlich ist an den buddhistischen Schriften, dass wir aus ihnen sehr wenig über das Leben Buddhas selbst erfahren. Sie sind keine Biografie und konzentrieren sich ganz bewusst nicht auf seine Person. Einzelheiten über sein Leben sind nur aus den Anekdoten zu erschließen, die er in seine Predigten einfließen ließ.

Die buddhistischen Schriften bestehen aus drei Hauptteilen oder „Körben" (*Tripitaka*): dies sind erstens die Abhandlungen oder Predigten; zweitens die Disziplinen, ein praktisches Regelwerk für jene, die Buddha nachfolgen und in seinen Mönchsorden eintreten wollen; und drittens eine vielgestaltige Sammlung weiterer philosophischer Schriften.

Die vier edlen Wahrheiten Das Kernstück von Buddhas Lehre ist in einer Rede enthalten, die er im Wildpark von Samath vor seinen ersten Schülern hielt. Sie wird als „Lehrrede über die vier edlen Wahrheiten" bezeichnet. Diese Wahrheiten sind: Dukkha, die Wahrheit des Leidens; Samudaya, die Wahrheit der Ursache des Leidens; Nirodha, die Wahrheit des Erlöschens des Leidens; und Magga, die Wahrheit des Weges zum Erlöschen des Leidens. Buddhisten vergleichen Buddha manchmal mit einem Arzt. In den ersten beiden Wahrheiten erkannte und diagnostizierte er die Ursachen des Leidens. In der dritten erkannte er, dass das Leiden geheilt werden kann. Und in der vierten verschreibt er die Therapie gegen das Leiden.

Siddharta Gautamas Jugend

Aus den buddhistischen Schriften erfahren wir zwar nur wenig über Buddhas Jugend, doch berichtet uns die traditionelle Lehre, dass er ungefähr 563 v. u. Z. in dem kleinen Königreich Kapilvastu im heutigen Nepal geboren wurde. Sein Vater war König Suddhodana, seine Mutter die Königin Maha Maya. Manchen Berichten zufolge starb sie bei seiner Geburt. Andere schildern, ein Einsiedler und Seher habe das Baby gesehen und prophezeit, es werde ein Heiliger werden. Als junger Mann lebte Gautama im Luxus – allein drei Paläste wurden für ihn gebaut. Mit 16 Jahren heiratete er seine Cousine Yasodhara; die beiden hatten einen Sohn namens Rahula. Manche Texte erzählen, dass Siddharta Gautama diesem Leben mit 29 Jahren den Rücken kehrte. Sein Tod wird traditionell auf das Jahr 483 v. u. Z. datiert, heutige Wissenschaftler vermuten jedoch eher, dass er um 400 v. u. Z. starb.

Buddha machte die Begierde (*Tanha*) für das Leiden verantwortlich. Er räumte ein, Begierde könne etwas Positives sein, nannte aber auch drei negative Formen: Habgier, Unwissenheit und Hass. Alle drei führten zu destruktiven Bestrebungen. In einer seiner bekanntesten Lehrreden, der „Feuerpredigt", beschrieb er die Menschheit als „brennend vom Feuer der Wollust, vom Feuer des Hasses, vom Feuer des Wahns. Ich sage, sie brennt bei der Geburt, im Alter und im Tod, mit Kummer, mit Klagen, mit Schmerz, mit Trauer, mit Verzweiflung."

Die dritte edle Wahrheit jedoch böte die Möglichkeit, dem Brennen zu entkommen, sich zu befreien und ins Nirvana zu gelangen: in den Zustand der Erleuchtung, in dem das Feuer gelöscht sei und durch eine spirituelle Freude ohne Angst und emotionales Übermaß ersetzt werde.

> **Wer mich sieht, sieht das *Dharma*, und wer das *Dharma* sieht, sieht mich.**
> **Buddha,**
> **sechstes Jahrhundert v. u. Z.**

Der achtfache Pfad Um das *Nirvana* zu erlangen, müssen Buddhisten dem achtfachen Pfad folgen, der zur vierten edlen Wahrheit gehört. „Ich sah einen uralten Pfad, eine alte Straße, auf der die rechtmäßig zum Selbst Erwachten aus früheren Zeiten wandelten", sagt Buddha in den Schriften. „Und was ist dieser uralte Pfad, diese alte Straße, auf der die rechtmäßig zum Selbst Erwachten aus früheren Zeiten wandeln? Eben dies ist der edle achtfache Pfad: richtige Erkenntnis, richtige Gesinnung, richtige Rede, richtiges Handeln, richtiger Lebenserwerb, richtiges Streben, richtige Achtsamkeit, richtige Sammlung... Diesem Pfad bin ich gefolgt." Er ließ sich dabei vor allem von der Praxis der Meditation leiten, die ein Kernstück der buddhistischen Tradition bildet.

Worum es geht
Die Menschen müssen nach dem *Dharma* streben

37 Schulen des Buddhismus

Weltweit gibt es heute schätzungsweise 350 Millionen Buddhisten. Sie gehören verschiedenen Schulen an. Im Mittelpunkt steht immer der Buddha, das Schwergewicht wird aber auf unterschiedliche Aspekte seiner Lehre gelegt. Die ursprüngliche buddhistische Mönchsgemeinschaft *Sangha* entwickelte sich zu einer Vielfalt an Gläubigengemeinschaften weiter. Diese umfassen sowohl die traditionelle, von Mönchen dominierte Theravada-Schule als auch die weiter ausgelegte, in ganz Asien verbreitete Mahayana-Schule.

Erste Meinungsverschiedenheiten darüber, wie man im Einzelnen den Lehren Buddhas folgen solle, traten rund 100 Jahre nach seinem Tod auf einem großen Konzil zutage. Das Herzstück der Theravada („Schule der Älteren") ist bis heute die Mönchsgemeinschaft der *Sangha*, die auf Buddhas erste Schüler zurückgeht. Sie ist am stärksten in der Gemeinschaft der Singhalesen in Sri Lanka und Südostasien vertreten.

Der Mahayana-Buddhismus (Mahayana bedeutet „großes Fahrzeug") ist vor allem in Ostasien verbreitet und kennt verschiedene Ausprägungsformen, wie den Amitabha-Buddhismus, den Zen-Buddhismus und den Tibetanischen Buddhismus. Er hat eigene Kategorien gebildet – die drei *Yanas* oder Fahrzeuge. Das größte ist das zentrale, alltägliche Mahayana. Dann gibt es das stärker traditionelle Hinayana, oft als „schmaler Weg" bezeichnet; Vertreter dieser Gruppe legen den Schwerpunkt auf Meditation, einfaches Leben sowie persönliche und spirituelle Disziplin. Vajrayana schließlich (wörtlich „Diamantfahrzeug" oder „unzerstörbares Fahrzeug") hat insbesondere in Tibet großen Einfluss. Zu dieser farbenprächtigsten der drei Gruppen gehört auch die Tradition des Tantra.

Zeitleiste

5. Jahrhundert u. Z.

Bodhidharma bringt den Buddhismus nach China

7. Jahrhundert u. Z.

Hui Neng lehrt den Zen-Buddhismus

Mahayana-Buddhisten beschreiben die Beziehung zwischen den drei *Yanas* mit einer Metapher. Hinayana ist demnach das Fundament des Palastes der Erleuchtung. Das Mahayana liefert die Wände und den Dachstuhl, und Vajrayana ist sein goldenes Dach. Alle drei sind notwendig, damit das Gebäude seinen Zweck erfüllt, aber das eine zieht den Blick vielleicht stärker auf sich als die anderen.

Das Buddha-Prinzip Zwischen Theravada- und Mahayana-Buddhismus gibt es einen wesentlichen Unterschied, der die Frage von Buddhas Menschsein betrifft. Nach der Lehre des Theravada war Buddha ein weiser Mensch, der anderen zeigte, wie man das Nirvana erlangen kann. Alles, was Buddhisten brauchen, ist sein Vorbild. Mahayana-Buddhisten unterscheiden zwischen dem historischen Buddha und einem „Buddha-Prinzip", wie man es nennen könnte, einer ewigen Gegenwart, die für alle Menschen offen und Teil aller Menschen ist. Dies entspricht dem Brahman im vedisch-hinduistischen Denken, das den Buddhismus im Laufe seiner Entwicklung stark beeinflusste; es lässt viel stärker zu, dass der Mensch allein durch seine Bemühungen dem Kreislauf des *Samsara* entkommt und das Nirvana erlangt.

Bodhidharma

Über Bodhidharma gibt es nur wenig gesichertes Wissen, aber es ranken sich viele Legenden um ihn. Er soll im südindischen Staat Kerala geboren und königlicher Herkunft sein, wandte sich aber von seinen Ursprüngen ab und zog als buddhistischer Mönch durch Malaysia, Thailand und Vietnam, bevor er schließlich nach China kam. Er beherrschte die Kampfkunst und hatte eine gespannte Beziehung zu dem Kaiser Wu aus der Liang-Dynastie; es gelang ihm aber, den Buddhismus auf chinesischem Boden heimisch zu machen. Bodhidharma lehrte die Methode der Wandbetrachtung – wenn man eine Wand oder ein kahles Objekt betrachte, konzentriere sich der Geist in der Meditation. Angeblich sah er neun Jahre lang ununterbrochen eine Wand an. Im Buddhismus ist er der 28. Patriarch in einer Linie, die unmittelbar auf Buddha zurückgeht, und der erste Patriarch der buddhistischen Zen-Schule in China.

8. Jahrhundert u. Z.	9. Jahrhundert u. Z.	13. Jahrhundert u. Z.
Padmasambhava kommt nach Tibet	Buddhismus gerät in Indien unter Druck	Buddhismus stirbt in Indien aus

Die Ausbreitung des Buddhismus Im dritten Jahrhundert v. u. Z. verbreitete sich der Buddhismus unter der Schirmherrschaft des Kaisers Ashoka über ganz Indien und wurde vom Kult einer Elite zur Volksreligion. Jahrhundertelang existierte er neben Hinduismus und Jainismus, aber seit dem 9. Jahrhundert erlebte er parallel zu einer Wiederbelebung des Hinduismus, durch die sich die Grenze zwischen den beiden Religionen verwischte, einen Rückgang. Unter zusätzlichen Druck geriet er im 11. Jahrhundert durch aggressive muslimische Herrscher, und im 13. Jahrhundert war er in seinem Mutterland so gut wie verschwunden. In anderen Regionen Asiens dagegen gediehen seine verschiedenen Schulen nach wie vor.

Seit dem ersten Jahrhundert u. Z. hatte sich der Buddhismus entlang der Seidenstraße verbreitet. Der indische Mönch Bodhidharma soll ihn im fünften Jahrhundert in China durchgesetzt haben, wo er sich mit der lokalen Religion des Taoismus vermischte. Dort bildeten sich eigene Mahayana-Schulen, insbesondere der Amitabha- und der Zen-Buddhismus. Eine Blütezeit erlebte der Zen-Buddhismus im 17. Jahrhundert, als der angesehene Lehrer Hui-Neng ihm einen eigenen chinesischen Charakter verlieh.

Zen-Praxis Grundlage des Zen sind zwei Praktiken: die Meditation und das Lernen. Er lehrt, dass Erleuchtung vor allem im gegenwärtigen Augenblick zu finden ist und lehnt mit einem Nachdruck, wie man ihn sonst nirgendwo im Buddhismus findet, Rituale und Intellekt ab, zugunsten einer instinktiven spirituellen Erleuchtung, welche unmittelbar vom Meister auf den Schüler übergeht.

> Wenn man lebt, sitzt man, ohne sich hinzulegen.
> Wenn man tot ist, liegt man, ohne zu sitzen.
> In beiden Fällen ist man ein Haufen stinkender Knochen!
> Was hat das mit der großen Lehre des Lebens zu tun?
> Lasst uns mit denen, die mitfühlend sind,
> ein Gespräch über den Buddhismus führen.
> Was diejenigen angeht, deren Ansichten von unseren
> abweichen, so wollen wir sie höflich behandeln und
> dadurch glücklich machen. (Aber) Diskussionen sind
> unserer Schule fremd, denn sie vertragen sich
> nicht mit ihrer Lehre.
>
> **Hui-Neng, 7. Jahrhundert u. Z.**

> **」 Jene, die vom Wahn zur Realität zurückkehren,
> die an Wänden meditieren über die Abwesenheit
> vom Selbst und von anderem, über die Einheit von Sterblichem
> und Weisem und die sogar von den heiligen Schriften
> nicht bewegt werden, sind in vollständigem,
> unausgesprochenem Einvernehmen mit der Vernunft. 「**
>
> Bodhidharma, 5. Jahrhundert u. Z.

In Tibet scheiterten alle Versuche, die lokale Bon-Religion zu verdrängen, bis der König Trisong Detsen im achten Jahrhundert einen indischen Meister in das Land einlud. Padmasambhava, der „aus dem Lotus Geborene", gehörte zu einer Vajrayana-Schule, die auf das erste Jahrhundert u. Z. zurückging. Nach seiner Lehre, die auch Tantra genannt wird, kann man über alles im Leben zur Erleuchtung gelangen. Entscheidend ist, dass man sich bei der Suche nach spiritueller Erweckung auf die natürlichen Gesetzmäßigkeiten, Wünsche und Energien des Körpers einstellt und ihnen folgt. In einer der vielleicht am häufigsten genannten tantrischen Lehren wird deshalb der Sexualität ein spiritueller Zweck beigemessen, wenn der Einzelne genug Zeit darauf verwendet, sie zu praktizieren.

Das tibetanische Totenbuch

Zu den im Westen bekanntesten buddhistischen Texten gehört das *Tibetanische Totenbuch*, richtiger „Befreiung durch Hören im Zwischenzustand" genannt. Der Überlieferung zufolge wurde es von Padmasambhava geschrieben; es beschreibt einen Zustand namens *Bardo*, der vom Einsetzen des Todes bis zur Wiedergeburt in der nächsten Inkarnation reicht. Das Buch enthält Meditationen, Gebete, Mantras und Hinweise auf die Anzeichen von Tod und Wiedergeburt. Es beschreibt sechs Stadien, darunter eine Zwischenphase, in der man Visionen von Buddha sieht.

In China blühte der Buddhismus auf

38 Das buddhistische Lebensrad

Buddhisten befolgen je nach ihren verschiedenen Traditionen bestimmte tägliche Übungen, es bleibt aber ein Kernbestand gemeinsamer Überzeugungen und Bestrebungen, insbesondere die Befreiung vom Schmerz des *Samsara* durch die Erlangung des ewigen Nirvana. Ganz oben auf der Liste der typisch buddhistischen Rituale und Übungen stehen die Meditation und eine Reihe farbenprächtiger Feste rund um den Tempel, mit denen die Weisheit Buddhas gefeiert wird.

Das wichtigste gemeinsame Fest aller Buddhisten ist Vesakh oder Vaisakha, das jedes Jahr im Mai gefeiert und häufig als Buddhas Geburtstag bezeichnet wird. Es erinnert nicht nur an seine Geburt, sondern auch an sein Leben und seine Erleuchtung. An diesem Tag gehen Buddhisten mit Blumen in ihren Tempel. Sie beten, meditieren und zünden Kerzen und Räucherstäbchen an. Manche beteiligen sich an einer Zeremonie, in der eine Statue des Buddha als Baby gewaschen wird. Die daran teilnehmen, sind von ihrem eigenen schlechten *Karma* gereinigt.

Andere wichtige Daten im buddhistischen Kalender sind der Tag des Dharma, an dem die Gläubigen sich für die Weisheit Buddhas und der späteren erleuchteten Lehrer (Bodhisattvas) bedanken. Theravada-Buddhisten messen dem Kathina-Fest, das an die Verteilung von Almosen durch Buddha erinnert, besondere Bedeutung bei. Im tibetanischen Buddhismus ist der Neujahrstag (Losar) ein großes Ereignis, und in manchen Traditionen feiert man mit Parinivana (auch Nirvanatag genannt) Buddhas Tod, was eine Gelegenheit darstellt, über den Kreislauf von Leben, Tod und Wiedergeburt nachzudenken.

Zeitleiste

Anfang Februar	Ende Februar
Nirvanatag	Losar

Nirvana

Die Vorstellung vom Nirvana – im ursprünglichen Pali-Dialekt der buddhistischen Schriften heißt es Nibbana – gibt es nicht nur im Buddhismus. Buddha bezeichnete es als „das höchste Glück". Es ist nicht unbedingt ein Ort, sondern ein Zustand ohne Sehnsüchte, Ärger und Habgier, aber voller Frieden und Mitgefühl.

Wer das Nirvana erlangt hat, ist vom *Samsara* befreit, hat kein neues *Karma* mehr und verbleibt ewig in diesem Idealzustand. Eine Beschreibung des Nirvana wird im Buddhismus abgelehnt. Buddha sagte, es sei einfach ein „Bewusstsein ohne Eigenschaften, ohne Ende und voller Leuchten."

Buddhistische Rituale kann man allein zuhause, aber auch in einem Kloster oder Tempel vollziehen. Jede dieser Formen hat den gleichen Stellenwert. Dennoch spielen die Tempel im Buddhismus eine große Rolle für die Gemeinschaft und als Symbole. Ihre Gestalt muss fünf Elemente in sich vereinen: Feuer, Luft, Erde, Wasser und Weisheit. Die Erde ist in der Regel durch ein viereckiges Fundament gekennzeichnet, die Weisheit durch eine Spitze ganz oben auf dem Bauwerk.

Bei der Andacht sitzt man traditionell barfuß auf dem Fußboden, betrachtet ein Bild des Buddha und singt. Manche Mönche tragen auch Gesänge aus den Schriften und gelegentlich auch Musik vor. Ein weiteres Merkmal der Anbetung ist das Mantra, ein Wort oder Satz, der immer wieder wiederholt wird. Das Mantra soll den spirituellen Zustand des Menschen und seine Fähigkeit, sich auf sein Inneres zu konzentrieren, positiv beeinflussen. Manchmal werden Mantras auch auf Fahnen geschrieben, mit denen der Tempel verziert wird. Außerdem benutzten Buddhisten bei ihren Gesängen in der Regel Gebetsperlen.

❜ Alles, was wir sind, ist das Ergebnis dessen, was wir gedacht haben: Es gründet sich auf unsere Gedanken, es besteht aus unseren Gedanken. ❛

Dhammapada (buddhistische Schrift)

April	Mai	Dezember
Theravada (Neujahr)	Vesakh („Tag des Buddha")	Bodhi-Tag

> **❥ Alle Lebewesen fürchten sich davor, mit Knüppeln geschlagen zu werden. Alle Lebewesen fürchten sich davor, getötet zu werden. Versetze dich in die Lage des anderen. Töte niemanden und lasse niemand anderes töten. ❧**
>
> Dhammapada (buddhistische Schrift)

Meditation Nach buddhistischer Überzeugung muss die Meditation mit Körper und Geist vollzogen werden, um eine „Dualität" zu vermeiden. Man strebt danach, sich durch Meditation von der Welt, ihren Tätigkeiten und Besorgnissen abzuwenden und die Verbindung zu einem inneren Leben aus Gedanken, Gefühlen und Wahrnehmungen herzustellen. Meditation gilt als Mittel zur Erlangung zentraler mentaler Zustände wie Ruhe, Konzentration und Zielgerichtetheit. Dieser letzte Zustand besteht aus sechs verschiedenen Kräften: Hören, Überlegen, Nachdenklichkeit, Wahrnehmung, Anstrengung und Intimität.

Auch die Körperhaltung ist für eine erfolgreiche Meditation in allen Spielarten des Buddhismus wichtig, besonderes Gewicht wird darauf aber im Zen gelegt. Zu den entscheidenden Praktiken des Zen gehört das Zazen: Man nimmt bei der Meditation eine von mehreren empfohlenen Haltungen ein. Die klassische Position ist der Lotussitz: Man sitzt mit gekreuzten Beinen, wobei der linke Fuß auf dem rechten Oberschenkel und der rechte Fuß auf dem linken Oberschenkel liegt.

Das Bhavachakra Zu den am weitesten verbreiteten buddhistischen Bildern gehört das Bhavachakra oder Lebensrad. Dieses ist ein Mandala, ein kompliziertes Diagramm mit spiritueller und ritueller Bedeutung. Mandalas stammen ursprünglich aus dem Hinduismus, wurden aber von den Buddhisten, insbesondere in der tibetanischen Tradition, übernommen. Sie werden dort aus farbigem Sand hergestellt, womit die Flüchtigkeit des Lebens symbolisiert werden soll.

Im Bhavachakra fließen die buddhistischen Visionen vom Universum und vom Kreislauf aus Geburt, Tod und Wiedergeburt zusammen. In der Regel wird es in fünf oder sechs Bereiche unterteilt: den Bereich der Götter (der sich seinerseits häufig in bis zu 26 Ebenen gliedert), in dem die Götter in einer angenehmen Umgebung ein langes Leben führen, sich aber immer noch um die letzte Erleuchtung und das Nirvana bemühen; den Bereich der Menschen; den Bereich der hungrigen Geister mit jenen, die von weltlichem Besitz eingenommen, aber auch enttäuscht sind – symbolisiert wird er manchmal durch Gestalten mit dickem Bauch und kleinem Mund, die sich nach Nahrung sehnen, sich aber nicht satt essen können; den

Bereich der Tiere, die nicht zur Erleuchtung fähig sind, aber freundlich behandelt werden sollen; und schließlich den Bereich der Hölle mit ihren Qualen, der aber nur ein Übergangszustand ist.

Das ethische Leben Von Buddhisten wird erwartet, dass sie für alle Taten und die daraus erwachsenden Folgen persönlich die Verantwortung übernehmen. Zur ethischen Lebensführung nehmen sie einige charakteristische Standpunkte ein. Einer davon ist die Überzeugung, dass es falsch sei, Tiere zu verletzen oder zu töten: Man sieht zwischen Menschen und Tieren eine sehr enge Verbindung, nicht zuletzt durch das *Samsara* – Menschen können im Bereich der Tiere wiedergeboren werden.

Buddhisten predigen und praktizieren auch Gewaltlosigkeit. Buddha warnte: „Selbst wenn Diebe euch ein Glied nach dem anderen mit einer zweihändigen Säge vom Leib schneiden, folgt ihr meiner Lehre nicht, wenn ihr euren Geist feindselig macht." Deshalb sind viele Buddhisten Pazifisten. Mönche dürfen sich zwar verteidigen, aber auch dabei keinen anderen Menschen töten. Andererseits waren buddhistische Mönche aber die Pioniere der Kampfkunst. Vielleicht am bekanntesten ist der Mönchsorden der Shaolin, der für seine kämpferischen Fähigkeiten berühmt ist.

Shaolinmönche und Kungfu

Der Orden der Shaolin ist eine buddhistische Sekte, die im fünften Jahrhundert u. Z. gegründet wurde; ihr Zentrum ist der Zen-Tempel von Dengfeng in China. Im Westen wurde sie vor allem bekannt, weil sie die Kampfkunst des Kungfu entwickelte. Der Tempel hat eine wechselvolle Geschichte: Er wurde viele Male angegriffen, zerstört und wieder aufgebaut. Die kriegerische Vergangenheit war für die Mönche der Anlass, Kungfu zur Selbstverteidigung zu erlernen. Die Lehre der Shaolin verbietet es aber den Mönchen, selbst zum Angreifer zu werden; außerdem dürfen sie nur so viel Kraft anwenden, wie zur Selbstverteidigung unbedingt notwendig ist.

Worum es geht

Nirvana ist ein Seinszustand

39 Konfuzianismus

**Der chinesische Philosoph Konfuzius (551–449 v. u. Z.) hielt sich selbst
weder für einen kreativen Denker noch für den Gründer einer Religion.
Vielmehr bezeichnete er sich als „Überbringer" vorhandener Gedanken,
die er gesammelt hatte, indem er die Weisheiten der Vergangenheit
studierte und auf die Gegenwart anwandte. Konfuzius' Moralsystem,
Li genannt, wollte ethische Verhaltensweisen für Herrscher und
Beherrschte gleichermaßen definieren; die Grundlage bildeten dabei
Gerechtigkeit und Ehrlichkeit. Dieses System hat bis heute großen
Einfluss auf das Leben mehrerer Milliarden Menschen in Ländern wie
China, Korea und Vietnam, wo sich immer noch rund 350 Millionen
Einwohner als Konfuzianer bezeichnen.**

Nach Ansicht der Fachleute kann man Berichte über das Leben des Konfuzius nicht
für bare Münze nehmen. Glaubt man jedoch dem großen chinesischen Geschichts-
werk „Aufzeichnungen des Historikers", das vier Jahrhunderte nach seinem Tod
entstand, wurde er in der Stadt Qufu im Staat Lu geboren, der heute zur chinesi-
schen Provinz Shandong gehört. Auf Chinesisch heißt er Kong Fuzi; im Englischen
wurde er jedoch zu „Confucius" (eingedeutscht „Konfuzius").

Konfuzius entstammte der Mittelschicht, wie man sie mit dem modernen Begriff
nennen könnte. Sein Vater war ein betagter Adliger, dessen Eheschließung mit einer
viel jüngeren Frau zu einem Skandal geführt hatte, so dass er seinen privilegierten
Platz in der Gesellschaft räumen musste. Konfuzius musste seinen Lebensunterhalt
mit Arbeit verdienen und war zu verschiedenen Zeiten als Schreiber und Buchhalter
tätig.

Die fünf Klassiker Mit Fleiß, Kompetenz und Einsatz stieg Konfuzius auf der
Karriereleiter auf und wurde mit 53 Jahren Justizminister in Lu. Er war jedoch von
der moralischen Laxheit seines Herrschers enttäuscht, trat zurück und reiste 15 Jah-

Zeitleiste

551 v. u. Z.	**532** v. u. Z.	**498** v. u. Z.
Geburt des Konfuzius	Konfuzius heiratet	Ernennung zum Justizminister von Lu

re lang durch Nordost- und Zentralchina. Dabei sprach er mit anderen von seinen Gedanken über gute Regierungsarbeit und ethische Lebensführung. Die letzten vier Jahre seines Lebens verbrachte er zuhause und unterrichtete seine Anhänger, die gemeinsam mit seinem Enkel Zisi seine Gedanken überall verbreiteten.

Nach Ansicht seiner Anhänger fasste Konfuzius seine Lehren in den „fünf Klassikern" zusammen. Diese waren das Buch der Wandlungen (auch bekannt als I Ging oder Yijing), das Buch der Lieder, das Buch der Riten, das Buch der Urkunden und die Frühlings- und Herbstannalen. Die Konfuzianer halten diese Werke bis heute in Ehren; nach heutiger Kenntnis stammen sie aber vermutlich nicht von Konfuzius selbst, sondern von späteren Generationen seiner Schüler, die seine Weisheiten verbreiten wollten.

Die Analekten

Der eigentliche klassische Text des Konfuzianismus sind die Analekten, eine Sammlung von Aussprüchen und Gesprächen des Konfuzius, die von seinen Schülern seit der Zeit rund 50 Jahre nach seinem Tod gesammelt wurden. Sie wollten damit aus seinen Lehren ein Glaubens- und Handlungssystem destillieren. Dies erwies sich als so erfolgreich, dass der Konfuzianismus unter der Hang-Dynastie, die das kurz zuvor vereinigte China regierte, zur offiziellen kaiserlichen Philosophie wurde; er blieb bis ins 19. Jahrhundert hinein die Grundlage des chinesischen Amtsapparates.

Konfuzius bezog seine Gedanken aus verschiedenen Quellen, unter anderem von indischen Weisen und aus traditionellen chinesischen Glaubensüberzeugungen. Neben Buddha ist er eine der Schlüsselfiguren der Achsenzeit (800–300 v. u. Z.), der Phase, in der das religiöse Verständnis auf der ganzen Welt in einem tiefgreifenden Wandel begriffen war.

Matteo Ricci

Dem italienischen Jesuitenpriester Matteo Ricci (1552–1610) wurde es als erstem Europäer gestattet, die Verbotene Stadt in Peking, Sitz der chinesischen Kaiser, zu betreten. Er übersetzte auch als Erster Konfuzius' Schriften ins Lateinische; zuvor hatte er bereits das erste Chinesisch-Portugiesische Wörterbuch verfasst. Ricci war über die portugiesische Kolonie im indischen Goa nach China gelangt und lebte dort von 1582 bis zu seinem Tod. Zu diesem Zeitpunkt schaffte der Kaiser die Regel ab, wonach Ausländer in der portugiesischen Enklave Macao bestattet werden mussten, und er bestimmte für diesen Zweck stattdessen einen buddhistischen Tempel in Peking.

483 v. u. Z.
Rückkehr von den Reisen,
Tätigkeit als Lehrer

479 v. u. Z.
Tod des Konfuzius

ca. **430** v. u. Z.
Entstehung der Analekten

> ❝ Grober Reis zum Essen, Wasser zum Trinken, mein gebeugter Arm als Kissen – kann man darin nicht Freude finden? Reichtümer und Ehren, die durch Unaufrichtigkeit angehäuft wurden, sind für mich wie die schwebenden Wolken. ❞
>
> Konfuzius

Persönliche Vollkommenheit Die politische Philosophie des Konfuzianismus befürwortet die Herrschaft der Fähigsten, welche aber nicht unbedingt von hoher Abstammung sein müssen. Die Unterscheidung zwischen dem politischen und dem sozialen, ethischen und moralischen Bereich verschwimmt aber schnell: Konfuzius setzte sich für ein hierarchisches Regierungssystem ein und forderte, die Herrscher (wie auch die Beherrschten) sollten nach persönlicher Vollkommenheit streben. Sie sollten lernen, Lehren aus der Vergangenheit schöpfen und ihr Urteilsvermögen zum Wohle aller einsetzen. Kurz gesagt, sie sollten ein Vorbild sein – genau wie auch Konfuzius selbst es war.

Konfuzius ist also keine Gottheit, sondern ein Vorbild. Sein ethischer Kodex gründet sich nicht auf eine abstrakte Theorie über das Verhalten der Menschen, sondern auf seine eigenen Reaktionen. Man sollte aber darauf hinweisen, dass er kein Skeptiker war. Er befolgte getreulich die traditionellen Rituale der Ahnenverehrung und verbrachte lange Perioden in tiefem Schweigen – wir würden von Gebet sprechen. Sein Interesse galt aber nicht den esoterischen, sondern den irdischen Dingen. Seinen Schülern sagte er: Lernt zuerst, den Menschen zu dienen, dann kümmert euch um die Götter.

Hier und Jetzt Über das Jenseits machte Konfuzius keine Aussagen. Nichts in seinen Lehren spricht dafür, dass er sich für Fragen nach Geist und Seele interessiert hätte, wie sie für andere Religionen typisch sind. Seine Vision schöpfte vielmehr in großem Umfang aus den bestehenden chinesischen Traditionen wie Ahnenverehrung, Priorität der Familie (*Hsiao*), Respekt vor den Älteren und Loyalität. Dieser ethische Ansatz, den er Li nannte, hat drei wichtige Säulen.

Die erste Säule betrifft die Riten und Rituale. Ihre Grundlage sind Zeremonien, in denen den Vorfahren und alten Gottheiten Opfer dargebracht werden. Konfuzius glaubte, diese seien der Grundstein für das ethische Verhalten des Einzelnen und den gesellschaftlichen Zusammenhalt. „Respekt wird ohne Riten zu mühseliger Geschäftigkeit", stellt er in den Analekten fest. „Besorgnis wird ohne Riten zu Ängstlichkeit; Kühnheit wird ohne Riten zu Ungehorsam, und Ehrlichkeit wird ohne Riten zu Unhöflichkeit."

Die zweite Säule wird durch die gesellschaftlichen und politischen Institutionen gebildet. Konfuzius war kein Revolutionär, aber er wollte, dass das vorhandene System dem Nutzen aller besser diente. Ein einziger Kaiser, der über ganz China herrschte, war ihm lieber als eine Reihe kleinerer Staaten, die ständig Krieg führten. Der Kaiser, so erklärte er, solle eine herausragende Ehrlichkeit und Aufrichtigkeit besitzen. Mit diesen Eigenschaften werde er sich den Respekt seiner Untertanen erwerben. Ein Kaiser, der diese Eigenschaften nicht hatte, verdiente es nach Konfuzius' Ansicht nicht, das Land zu beherrschen.

Die dritte Säule schließlich bezieht sich auf die Regeln des alltäglichen Verhaltens. Als Richtschnur für Einzelne und die Gesellschaft befürwortete Konfuzius dabei das Prinzip des *Yi* – der Rechtschaffenheit oder des ethisch Richtigen. *Yi* ist das Gegenteil von Eigeninteresse: Es lehrt, das Wohl des Ganzen müsse stets Vorzug vor dem Nutzen für den Einzelnen haben.

Ren

Ren bildet ein Kernstück in Konfuzius' ethischer Lehre. Das Wort lässt sich nicht ohne Weiteres übersetzen. Seine Bedeutung liegt irgendwo zwischen Wohlwollen, Menschlichkeit und Selbstlosigkeit. „Wenn die Menschen von Gesetzen geleitet werden und man ihnen durch Strafen die Einheitlichkeit geben will, werden sie sich bemühen, die Strafe zu vermeiden, aber sie haben kein Gespür für Scham", sagt Konfuzius in den Analekten. „Wenn sie sich aber von Tugend leiten lassen und man ihnen Einheitlichkeit durch die Regeln des Anstandes gibt, werden sie ein Schamgefühl haben und darüber hinaus gut werden."

> **Es ist uns erlaubt, die Ansichten unseres Meisters über Kultur und die kulturellen Kennzeichen des Guten zu hören, aber über die Wege des Himmels wird er uns überhaupt nichts sagen.**
> **Zigong,** einer von Konfuzius' ersten Schülern

Worum es geht
Der andere kommt zuerst

40 Konfuzius und die Kommunisten

Konfuzius hinterließ seinen Anhängern einen umfangreichen Fundus philosophischer Gedanken. Spätere Generationen seiner Jünger vollbrachten die Leistung, daraus eine Religion zu machen, die in China zu einem Teil des gesellschaftlichen und politischen Systems wurde. Eine solche Partnerschaft mit den weltlichen Autoritäten brachte zwangsläufig Konflikte und Schwierigkeiten mit sich, insbesondere, nachdem sich 1949 die kommunistische Volksrepublik China gebildet hatte. Während der „Kulturrevolution" zwischen Mitte der 1960er und Mitte der 1970er Jahre wurde der Konfuzianismus angegriffen und verfolgt, in jüngerer Zeit hat er jedoch wieder an Einfluss gewonnen.

Einen Anteil daran, dass Konfuzius' Gedanken zu einem System wurden, hatte auch seine Familie. Sein Enkel Zisi führte die philosophische Schule nach dem Tod des Großvaters weiter, und noch heute wird einer seiner direkten Nachkommen, der Kung Tsui-chang heißt und in Taiwan lebt, als 79. Nachfahre in einer Reihe verehrt, die bis zu Konfuzius zurückreicht. Vor allem aber sorgten seine Schüler – insbesondere Mencius (372–289 v. u. Z.) und Xun Zi (312–230 v. u. Z.) – dafür, dass Konfuzius dauerhafte Spuren in der chinesischen Kultur hinterließ. Sie ordneten seine Lehren und machten daraus eine religiöse und gesellschaftliche Kraft. Als der König von Qin 221 v. u. Z. die Nachbarstaaten eroberte und sich zum Kaiser Shi Huang Di von China ausrief, war der Konfuzianismus bereits eine einflussreiche Bewegung. Sie war sogar so stark, dass Huang Di darin eine Bedrohung für seine Herrschaft sah: Er befahl, alle Bücher von Konfuzius zu verbrennen und dessen Anhänger lebendig zu begraben.

Mencius

Mencius wird häufig als berühmtester Konfuzianer nach Konfuzius bezeichnet. Traditionell gilt er als Schüler von Zisi, dem Enkel des Meisters. Eine Legende berichtet, wie Mencius als Kind dreimal umzog, weil seine Mutter das richtige Umfeld suchte, indem er studieren konnte. Der Konfuzianismus räumt der Bildung einen hohen Stellenwert ein. Nach Konfuzius' Vorbild reiste Mencius mehr als 40 Jahre lang durch China, lehrte und erteilte den Herrschern Ratschläge, wenn sie wissen wollten, wie sie sich gegenüber ihren Untertanen moralisch verhalten sollten.

Mencius hielt wie Konfuzius am Glauben an die Hierarchie von Herrschern und Beherrschten fest, fügte aber einen neuen Gedanken hinzu: Wenn die Verantwortlichen nicht moralisch handelten und ihren Untertanen nicht mit Respekt begegneten, hätten diese das Recht, den Herrscher zu stürzen. Mencius' Gespräche mit Herrschern wurden in den Vier Büchern festgehalten, die später großen Einfluss auf den Neokonfuzianismus gewannen. Insbesondere mit der Vorstellung, dass die Menschheit von Natur aus gut sei, von der Gesellschaft aber zu falschem Verhalten verführt werde, ging Mencius wiederum über die Gedanken des Meisters hinaus.

Huang Di machte sich in seiner Staatsphilosophie die damals herrschende Ideologie des Legalismus zu eigen. Diese beinhaltete eine Reihe pragmatischer Prinzipien, welche den Herrschern das Recht zubilligten, das für sie Nützliche zu tun, statt im Interesse ihrer Untertanen zu handeln, wie Konfuzius es befürwortet hatte. Die neue Lehre erwies sich aber als unpopulär, und als der Kaiser zwei Jahrzehnte später durch die Han-Dynastie gestürzt wurde, erlebten die konfuzianischen Prinzipien einen Aufschwung.

> **Welch ein Glück ist es,
> Freunde von weither willkommen zu heißen.**
>
> Konfuzius (zitiert bei der Eröffnung der Olympischen Spiele in Peking 2008)

ca. **200** v. u. Z.	ca. **1200** u. Z.	**1960**er Jahre	**2008**
die Han-Dynastie fördert den Konfuzianismus	Zhu Xi und der Neo-Konfuzianismus	Kulturrevolution	Ausspruch des Konfuzius wird bei den Olympischen Spielen in Peking zitiert

> ❞ Wer seinen Staat nach moralischen Grundsätzen führt,
> wird vom Volk unterstützt, genau wie der Polarstern
> von allen anderen Sternen umringt ist. ❝
>
> Konfuzius

Die Han-Dynastie blieb bis ins Jahr 220 u. Z. bestehen und bestätigte den Konfuzianismus als Religion: Sie erhob Konfuzius in den Status eines vollkommenen Denkers, dessen unbestreitbare Lehre man lernen, studieren und letztlich anbeten sollte.

Neo-Konfuzianismus Diese herausgehobene Stellung blieb noch lange nach dem Sturz der Han-Dynastie bestehen, aber der Konfuzianismus machte während dieser Zeit einen Wandel durch. Insbesondere Zhu Xi (1130–1200) interpretierte Konfuzius' Fünf Klassiker radikal neu und legte damit die Grundlage für den Neo-Konfuzianismus, wie er heute genannt wird. Er öffnete den Konfuzianismus für buddhistische und taoistische Einflüsse, so dass diese drei Strömungen sich insbesondere im Hinblick auf Rituale und die Sorge um die Seele teilweise vermischten; die buddhistischen Vorstellungen von *Karma* und Wiedergeburt machte er sich allerdings nicht zu eigen. Das Magazin *Life* stufte Zhu Xi in einer Liste der wichtigsten Menschen des letzten Jahrtausends an 45. Stelle ein.

Konfuzianische Tempel

Der älteste und größte konfuzianische Tempel befindet sich in Qufu, wo Konfuzius geboren wurde und starb. Das Bauwerk wurde 478 v. u. Z. errichtet, ein Jahr nach Konfuzius' Tod, und hatte neun Innenhöfe. Bei den meisten anderen konfuzianischen Tempeln sind es nur zwei oder drei. Wie es der ursprünglichen Vorstellung des Meisters entsprach, geht es in diesen Tempeln nicht nur um Anbetung, sondern ebenso stark auch um Bildung – in der Regel ist eine Schule angeschlossen. Anders als der Buddhismus vermeidet der Konfuzianismus bildliche Darstellungen; deshalb gibt es in den Tempeln kaum einmal Bilder des Meisters. Als wichtig und anbetungswürdig gilt nicht der Mann selbst, sondern seine Idee. An seinem Geburtstag ruft die staatlich finanzierte Kultgemeinschaft in China zu Opfern auf und inszeniert öffentliche Feiern. Bei diesen Gelegenheiten wird auch der alte Achtreihentanz aufgeführt, an dem acht Reihen von jeweils acht Tänzern mitwirken. Er geht auf Zeremonien zurück, mit denen früher die chinesischen Kaiser geehrt wurden.

Da das konfuzianische Denken in China fast zwei Jahrtausende lang die Grundlage für eine autokratische Herrschaft gebildet hatte, wurde es natürlich zum Angriffspunkt für die chinesischen Kommunisten, die 1949 an die Macht kamen. Man warf Konfuzius eine „feudale Mentalität" vor. Das „Kleine Rote Buch" – auch als „Mao-Bibel" bekannt – des Vorsitzenden Mao Tsetung trat als Kernstück der nationalen Philosophie an die Stelle von Konfuzius' Schriften und sollte mit der gleichen bedingungslosen Hingabe behandelt werden. Wer ein Exemplar bei sich trug und den Inhalt laut vortrug, konnte damit rechnen, in der Parteihierarchie voranzukommen.

Rehabilitation In Wirklichkeit war Konfuzius nicht zwangsläufig der Gegenpol zu den kommunistischen Grundsätzen. Seine Überzeugung, dass das Wohl der Gruppe oder Gemeinschaft höher einzustufen sei als die Rechte des Einzelnen, passte gut zur kommunistischen Gedankenwelt, und in den 1980er Jahren wurde er in China rehabilitiert. Sein Geburtstag wird heute im ganzen Land gefeiert, und die chinesischen Kommunistenführer zitieren ihn regelmäßig in ihren Reden. Von einer populären Version seiner Schriften, die der chinesische Wissenschaftler Yu Dan 2008 herausbrachte, wurden mehr als zehn Millionen Exemplare verkauft, und auf dem Gelände der angesehenen Tsinghua-Universität in Peking, wo früher eine Statue des Vorsitzenden Mao stand, befindet sich heute ein Standbild des Konfuzius. Für moderne Chinesen ist er ein *Junzi* – ein Heiliger, Gelehrter und „vollkommener Gentleman".

Die Statue symbolisiert die Bedeutung des Konfuzianismus als ein unverzichtbarer Bestandteil des politischen, wissenschaftlichen, gesellschaftlichen und religiösen Lebens im heutigen China. Chinesen betrachten Konfuzius' Gedanken noch heute mit religiösen Gefühlen, obwohl er – was die Wissenschaftler immer wieder betonen – nicht vorhatte, eine Religion zu gründen.

Worum es geht
Der Konfuzianismus prägt noch heute die chinesische Gedankenwelt

41 Der Taoismus

Der Taoismus hat weder einen Gründer noch einen Gründungszeitpunkt, und seine Anhänger verehren weder einen Gott noch mehrere Götter, sondern das Tao, ein universelles Prinzip, das sich nicht mit Worten beschreiben lässt. Seine Philosophie, die im Kern auf sehr alte chinesische Glaubensüberzeugungen zurückgeht, wurde stark vom Buddhismus beeinflusst und stand ursprünglich in deutlichem Gegensatz zum Konfuzianismus; bis heute ist sie kaum zu definieren. Manche der zentralen Begriffe des Taoismus wurden – häufig aus dem Zusammenhang gerissen – im Westen allgemein bekannt. Die wichtigsten sind Feng Shui, Tai Chi und Yin und Yang.

Seinen Ursprung hat der Taoismus in der Zeit vor rund 2500 Jahren, der Achsenzeit, in der auch der Konfuzianismus entstand. Der Taoismus erwuchs aus den Naturreligionen und dem Schamanismus – der Kommunikation mit der Welt der Geister –, die damals in und um China verbreitet waren.

Der erste Anarchist Zwei Schlüsselgestalten für die Entstehung des Taoismus waren der Einsiedlermönch Zhuangzi (ca. 370–311 v. u. Z.) und im sechsten Jahrhundert v. u. Z. der Weise Lao Zi (auch Laotse genannt). Zhuangzi beschäftigte sich im Gegensatz zu Konfuzius nicht mit Staatsführung und der Beziehung zwischen Herrschern und Beherrschten, im Gegenteil: Er wurde als der erste Anarchist der Welt bezeichnet. „Ordnung stellt sich von selbst ein, wenn man den Dingen ihren Lauf lässt", schrieb er in dem heiligen Text, der unter seinem Namen bekannt wurde. In Wirklichkeit aber ist das Zhuangzi eine Anthologie von Texten, welche zwischen dem vierten und dem Ende des dritten Jahrhunderts verfasst wurden. Nur die ersten sieben Kapitel – die „inneren Kapitel" stammen möglicherweise wirklich von Zhuangzi.

Laotse wird als Autor des Tao Te King („Über den Weg und seine Kraft") verehrt, des wichtigsten heiligen Buches im Taoismus. Über ihn selbst ist aber nur wenig bekannt. Der Name bedeutet einfach „Alter Meister", und der Text scheint ebenfalls nicht das Werk eines Einzelnen, sondern eine Sammlung zu sein. In seinen 81 kurzen Kapiteln, in häufig undurchsichtigen Versen geschrieben, preist es die Vorzüge der Selbstlosigkeit und der persönlichen Suche; für die Legalisten – die Gegner des Konfuzius – war es aber vor allem deshalb reizvoll, weil es die Ansicht vertrat, Herrscher sollten so wenig wie möglich in das Leben ihrer Untertanen eingreifen.

Tai Chi

Der Zusammenhang zwischen Taoismus und den altchinesischen Kampfkünsten wird sowohl im Zhuangzi als auch im Tao Te King angesprochen. Beide Texte untersuchen die Psychologie, Praxis und Ethik der Kampfkünste im Rahmen der chinesischen Tradition. Tai Chi wurde nach heutiger Kenntnis als System spiritueller Übungen von dem chinesischen Taoistenpriester Zhang Sanfeng entwickelt. Er soll von 1127 bis 1279 gelebt haben, manche Fachleute halten aber auch ihn für eine Sagengestalt. Die modernen Formen des Tai Chi, die man auch im Westen findet, ähneln körperlichen Übungen mehr als einer taoistischen Praxis.

Der Meister des Himmels Ein dritter möglicher Zeitpunkt für die Entstehung des Taoismus ist das Jahr 142 u. Z.: Damals soll der erste Himmelsmeister Zhang Daoling eine Offenbarung von Laotse empfangen haben, der nun die gottähnliche Personifizierung des Tao selbst war. Zhang lebte als Einsiedlermönch auf dem Berg Heming. Laotse erschien ihm und erklärte, die Welt werde enden, und dann werde ein „großer Friede" folgen. Um anderen beim Erreichen dieses unklar definierten Zustandes zu helfen, so erklärte Laotse, müsse Zhang als Vermittler zwischen den Menschen und den himmlischen Kräften fungieren: Er müsse einen neuen Bund durchsetzen, welcher radikale Verhaltensänderungen verlangen würde, und als Symbol dafür müssten die vorhandenen Rituale aufgegeben werden.

Wenn man aber darauf beharrt, die Entstehung des Taoismus mit einem bestimmten historischen Zeitpunkt zu verknüpfen, wird man seinem Wesen nicht gerecht. Wichtig ist nicht, wer das Tao offenbart, sondern das Tao selbst. Dies kann man mit einfachen Worten als „der Weg" oder sogar als „der Weg des Himmels" übersetzen, es ist aber viel mehr. Im Tao ist alles im Universum vereinigt und verbunden.

> 〃 Es gab etwas Unbestimmtes und doch Vollkommenes,
> welches früher da war als Himmel und Erde.
> Tonlos und formlos hängt es von nichts ab und ändert sich nicht.
> Es wirkt über alle und ist frei von Gefahr.
> Man kann es als die Mutter des Universums betrachten.
> Seinen Namen kenne ich nicht; ich nenne es Tao. 〃
>
> Tao Te King, **sechstes Jahrhundert v. u. Z.**

Tao ist kein Gott, aber der Taoismus hat seine Gottheiten. Sie sind wie alles ande-re ein Teil des Universums und demnach vom Tao abhängig. Tao hat kein Dasein und ist unsichtbar, aber seine Wirkungen kann man erkennen. Es wird häufig als un-beschreibbar bezeichnet – Worte sind nicht in der Lage, es auszudrücken –, aber der Taoismus lehrt ohnehin, dass Spekulationen darüber, was es ist oder nicht ist, Ener-gieverschwendung sind; entscheidend ist, dass man es lebt.

Persönlichkeitsentwicklung Der Taoismus hat mehrere zentrale Themen: die Herstellung eines Zustandes der Harmonie oder Vereinigung mit der Natur, das Streben nach spiritueller Unsterblichkeit, tugendhaftes, aber unauffälliges Handeln und vor allem die Persönlichkeitsentwicklung. Auf dieses letzte Ziel sind die beson-deren Praktiken des Taoismus ausgerichtet. Wie es den buddhistischen Einflüssen

Feng Shui

Das Feng Shui lässt sich über den Taois-mus hinaus auf die alte chinesische Kos-mologie und Astrologie zurückführen. Die enge Verbindung zum Taoismus ergab sich durch das gemeinsame Prinzip des Yin und Yang und das beiderseitige Inte-resse am *Chi* – an den Energien, die das Universum formen. Feng Shui gehört zu den Aspekten des Taoismus, die insbeson-dere in den 1960er Jahren durch die Hip-pie-Gegenkultur in den Westen exportiert worden ist. In jüngerer Zeit wurde es auf eine Methode zur – der kosmischen Energie entsprechenden – Ausrichtung und Ein-richtung von Zimmern, Büros, Gebäuden und sogar ganzen Stadtlandschaften reduziert.

entspricht, wird Meditation befürwortet. In taoistischen Tempeln werden zahlreiche Götter und Göttinnen angebetet, die meisten aus traditionellen chinesischen Religionen. In der Liturgie geht es aber vor allem darum, dass die Teilnehmer sich stärker mit dem Tao in Einklang bringen, wobei ihnen häufig Priester und Mönche zur Seite stehen.

Yin und Yang Der Taoismus betrachtet Körper und Geist als Einheit. „Das Eine" ist nach seiner Lehre das Wesentliche am Tao und die Energie des Lebens. Die Beziehung zwischen „Dem Einen" und Tao wird mit der zwischen Sohn und Mutter verglichen. Dieses Wesen zeigt sich in Begriffen wie Wu und Yu (Sein und Nichtsein), Te (Tugend oder Aufrichtigkeit), Tzu Jan (Natürlichkeit oder Spontanität) und Wu Wei (ungekünsteltes Handeln oder Nicht-Handeln). „Wenn nichts getan wird, bleibt auch nichts ungetan", sagt das Tao Te King.

Zu diesen Prinzipien gehört auch die Lehre von Yin und Yang, die eine weitere Schlüsselidee des Taoismus ausdrückt: Wenn entgegengesetzte Kräfte aufeinandertreffen, entsteht kein Chaos wie in anderen Religionen, sondern eine grundlegende Harmonie. Wie andere Teile des komplizierten, eng verflochtenen taoistischen Glaubenssystems, so wird auch die Lehre von Yin und Yang im Westen häufig ohne Zusammenhang mit einer Religion weitergegeben oder mit anderen New-Age-Begriffen kombiniert, die man aus der ganzen Welt zusammengesucht hat.

Verfolgung und Flucht Im Hinblick auf seine Beziehung zu staatlichen Autoritäten hat der Taoismus eine wechselvolle Geschichte. Großen Einfluss und halboffiziellen Status erlangte er unter der Tang-Dynastie (618–907 u. Z.) und der Song-Dynastie (960–1279). Sein Einfluss nahm aber ab, als Zhu Xi einen Teil seiner Praktiken in den Neo-Konfuzianismus übernahm (siehe Kapitel 40). Als Führer des Taoismus gelten traditionell die Himmelsmeister, die Nachfolger von Zhang Daoling, die in jüngerer Zeit in Taiwan im Exil leben. Vom chinesischen Festland wurden sie 1949 nach der Machtergreifung des Parteivorsitzenden Mao Tsetung vertrieben. Maos kommunistische Regierung verbot den Taoismus und löschte ihn nahezu völlig aus; derzeit lebt er jedoch wieder auf, und weltweit gibt es heute schätzungsweise 20 bis 50 Millionen Taoisten.

Worum es geht
Spekuliere nicht über „den Weg", sondern lebe ihn

42 Der Schintoismus

Der Glaubensrichtung des Schintoismus gehört der größte Teil der japanischen Bevölkerung an. Er steht zum Buddhismus in einer komplizierten Beziehung. Manche Japaner bezeichnen sich sowohl als Buddhisten als auch als Schintoisten und sehen darin keinen Widerspruch. Für andere ist Schinto das Produkt einer Vermischung zwischen dem Buddhismus, der ungefähr im sechsten Jahrhundert u. Z. aus China nach Japan kam, und einer älteren, ursprünglich japanischen Religion. Der Schintoismus hat viele Formen und war in verschiedenen historischen Phasen eng mit dem japanischen Nationalismus verknüpft; heute sehen seine 119 Millionen Anhänger darin jedoch im Wesentlichen einen persönlichen Glauben.

Als der Buddhismus sich von Indien bis nach Japan ausbreitete, wurde er durch verschiedene chinesische Religionen beeinflusst. In die Mischung, die zum Schintoismus wurde, flossen also Buddhismus, Konfuzianismus und eine Spur Taoismus sowie der ursprüngliche Glaube der Japaner ein. Dieser lehrte, dass es eine entfernte Gottheit gebe; sie wurde von der Gemeinschaft insbesondere zu wichtigen Zeitpunkten wie der Ernte angebetet. Er umfasste aber auch Elemente der Kosmologie und eine alte Mythologie mit kunstvollen moralischen Fabeln.

Kami Kernstück des Schintoismus ist der Begriff *Kami*, den man mit „ein Gott", „Götter", „ein Geist" oder „spirituelles Wesen" übersetzen kann. Im Westen wurde das Wort vor allem durch die Kamikaze-Piloten der japanischen Luftwaffe im Zweiten Weltkrieg bekannt, die mit ihren Flugzeugen in ein Ziel flogen und dabei ihr eigenes Leben opferten. *Kaze* bedeutet „Wind", *Kamikaze* ist also der „göttliche Wind".

Der Schintoismus ist nicht in erster Linie eine Glaubensrichtung oder ein Versuch, die Welt und ihr Leiden zu erklären. Eher ist er die spirituelle Ahnung, dass *Kami* überall um uns ist – in uns selbst, in den Tieren, in den Jahreszeiten, in den Vorfahren, in Flüssen und Gebirgen. Letztlich ist es ein heiliges Element oder eine Energie hier auf Erden. Wegen der Verehrung des *Kami* ist der Schintoismus ausschließlich auf diese Welt konzentriert, nicht aber auf ein Jenseits oder die Ewigkeit. Das Übernatürliche kann man im Hier und Jetzt entdecken.

Die gesellschaftliche und kulturelle Seite des Schintoismus ist häufig nicht von seinen spirituellen und rituellen Aspekten zu trennen. Manchmal hört man, er sei überhaupt keine eigenständige Religion, sondern ein Aspekt der japanischen Lebensweise, mit dem Prinzipien für ethisches Verhalten festgelegt werden. So gehört es zu den schintoistischen Ritualen, stets Respekt zu zeigen – häufig durch Verbeugungen.

Heilige Texte Der Schintoismus hält sich viel darauf zugute, sich um Taten und Rituale zu kümmern, nicht aber um Worte und komplizierte Theorien. Deshalb wird auch kein großer Wert auf heilige Bücher gelegt. Ein erster Versuch, seine Geschichte und gesammelten Erkenntnisse aufzuzeichnen, stellte im Jahr 712 das Kojiki („Aufzeichnung alter Geschehnisse") dar: Es beschreibt die Beziehungen zwischen Geistern, Natur und Menschen und enthält auch einen Schöpfungsmythos, nach dem die Götter als erste Tat auf Erden die japanische Inselgruppe als Paradies erschaffen haben.

> ❟ **Vollständig lebendig zu sein, heißt eine ästhetische Wahrnehmung des Lebens zu haben, denn ein wichtiger Teil des Guten in der Welt liegt in ihrer oft unaussprechlichen Schönheit. ❟**
>
> Yukitaka Yamamoto, **führender Schinto-Priester und Autor**

720	1638	1860er Jahre
Nihon Shoki	Vertreibung christlicher Missionare	Meiji-Restauration

Missionare in Japan

Der Schintoismus ist zwar anderen Religionen gegenüber tolerant, aber die christlichen Missionsversuche in Japan, die Mitte des 16. Jahrhunderts unter Führung des berühmten Jesuitenpaters Francis Xavier stattfanden, scheiterten. Anfangs wurden die Missionare von den Japanern freundlich aufgenommen, weil sie zusammen mit westlichen Kaufleuten eintrafen, aber bis 1597 war der Vorrat an Toleranz aufgebraucht, und 26 Franziskanerpater wurden in Nagasaki hingerichtet. Bis 1638 hatte man alle christlichen Missionare vertrieben. Sie wurden erst Ende des 19. Jahrhunderts wieder ins Land gelassen. Das wahre Motiv für ihre Vertreibung scheint aber die Furcht der japanischen Herrscherelite gewesen zu sein, das Christentum könne ihre Macht über die Bevölkerung schwächen.

Ein weiteres heiliges Buch, das Nihon Shoki („Chronik Japans"), entstand um 720 u. Z. und stellte eine Verbindung zwischen dem Schintoismus und den japanischen Herrschern her. Der Kaiser galt nun als Nachfahre der Sonnengöttin Amaterasu. Dieses nationalistische Element gewann in den 1860er Jahren mit der Meiji-Restauration an Gewicht: Der Kaiser wurde nun als „Hohepriester des Schinto" bezeichnet. Nach der Niederlage im Zweiten Weltkrieg verzichtete das japanische Kaiserhaus auf jeden Anspruch auf göttliche Herkunft.

Jinja-Schinto Die wichtigste Form des Schintoismus wird als Jinja- oder „Schrein"-Schinto bezeichnet. In dessen Mittelpunkt stehen die rund 80.000 öffentlichen Schreine in Japan sowie die unzähligen häuslichen Schreine oder *Kamidana*. Andere Spielarten beschäftigen sich mit verschiedenen Quellen der *Kami*. Der Volks- oder Minzoku-Schinto beispielsweise hat Geschichten und Legenden über Geister zum Thema.

Bei den öffentlichen Schreinen kann es sich um große Tempel handeln, aber auch um kleine Wälder mit heiligen Bäumen, um Berggipfel oder Wasserfälle. Das verbindende Element ist ihre Stellung als heiliger Boden, als Ort der *Kami*. Einen

> **Die Japaner gehen für lebensbejahende Tätigkeiten zum Schinto-Schrein und für Sterberiten in den buddhistischen Tempel.**
>
> Mary Pat Fisher: Living Religions **(2008)**

Schrein betritt man traditionell durch ein Tor, der ihn von der übrigen Welt trennt. Diese Schinto-Tore (die *Torii*) mit zwei senkrechten Säulen und zwei überstehenden, orange oder schwarz gestrichenen Querbalken sind zu einem der charakteristischen Symbole Japans geworden. Der berühmteste *Torii* steht am Itsukushima-Schrein in Miyajima und geht vermutlich auf das sechste Jahrhundert zurück; seine Fundamente liegen bei Flut unter Wasser.

Andernorts ist der heilige Ort mit *Shimenawa*-Seilen, die traditionell aus geflochtenem Stroh hergestellt werden, gegen böse äußere Einflüsse abgrenzt. Im Heiligtum dienen verschiedene Bereiche oder Gebäude zum Beten und zum Hinterlassen von Opfern. Außerdem gibt es die *Shintai*, einen oder mehrere Gegenstände, die als Symbole für die Gegenwart des *Kami* dienen. Dabei kann es sich um Objekte aus der Natur wie Bäume oder große Felsbrocken handeln, aber auch um Produkte der Menschen, beispielsweise um einen Spiegel.

Ein zentraler Begriff des Schintoismus ist wie im Buddhismus jener der Reinigung. Wer einen Schrein besucht, unterzieht sich zu Beginn dem Reinigungsritual des *Harae*. Reinheit ist im Schintoismus mehr als nur Sauberkeit. Man wäscht sich das ab, was die Christen als Sünde bezeichnen – den Schmutz der Welt jenseits der *Kami*.

Rituale im Schrein

Wendepunkte des Lebens werden im Schintoismus durch einen Besuch des örtlichen Schreins gekennzeichnet. Beim Hatsumiyamairi wird ein Neugeborenes unter den Schutz des *Kami* gestellt. Bei Jungen findet das Ritual am 32. Tag nach der Geburt statt, bei Mädchen am 33. Das Fest Schichigosan ist nach dem Alter der Kinder benannt, die daran teilnehmen: sieben (*schichi*), fünf (*go*) und drei (*san*). Dabei danken die Gläubigen den Göttern für das bisherige Leben der Kinder und beten für eine sichere, erfolgreiche Zukunft. Am Seijin Shiki, dem Tag der Erwachsenen, kann jeder, der im vergangenen Jahr seinen 20. Geburtstag gefeiert hat und damit nach japanischem Gesetz volljährig geworden ist, im Schrein den Göttern danken. Die traditionelle Schinto-Hochzeit dagegen hat in jüngster Zeit an Beliebtheit verloren: Nur ein Viertel der Bevölkerung gelobt sich noch im Schrein lebenslange Treue.

Worum es geht
Geister sind überall

43 Moderne Glaubens-richtungen

Die meisten großen Weltreligionen entwickelten sich in der Achsenzeit zwischen 800 und 300 v. u. Z.. Christentum und Islam entstanden später, griffen aber in großem Umfang auf die Erkenntnisse dieser früheren Zeit zurück. Zwar haben sich alle auf die Veränderungen in der säkularen Welt und im Leben ihrer Anhänger eingestellt, aber über keine kann man sagen, sie habe einen modernen Ursprung. In den letzten beiden Jahrhunderten entwickelten sich jedoch eine Reihe neuer religiöser Traditionen, von denen einige den Anlass zu heftigen Kontroversen gaben. Bevor wir uns ansehen, welchen Herausforderungen die Religion in der modernen Zeit gegenübersteht, wollen wir diese Neuentwicklungen kurz betrachten.

Bahai Nach der Lehre des Islam war Mohammed Gottes letzter Prophet. Der schiitische Islam wartet jedoch noch auf die Offenbarungen eines neuen Imam, der zu Mohammeds Nachkommen gehört und eine Führungslinie fortsetzt, die im 10. Jahrhundert u. Z. unter umstrittenen Umständen zu Ende gegangen ist. Im Iran, der Hochburg des schiitischen Islam, erklärte sich Sayyid Ali Muhammad, ein Nachkomme des Propheten, im Mai 1844 zu diesem neuen Imam. Der Bab, wie er genannt wurde, behauptete, er sei ein Botschafter Gottes, der die bevorstehende Ankunft eines neuen Propheten ankündigen sollte. Er wurde 1850 von den iranischen Behörden hingerichtet.

Im Jahr 1852 berichtete der 35-jährige Adlige Mirza Husain Ali, einer von Babs inhaftierten Gefolgsleuten, er habe in seiner Zelle eine Vision gehabt, und darin habe Gott ihn zu seinem neuen Propheten erklärt. Von nun an nannte er sich Bahaullah – „Herrlichkeit Gottes". Ein Jahr später wurde er aus der Haft entlassen und ins Exil geschickt. Eine Zeit lang lebte er als Einsiedler, aber durch sein Vorbild und seine

Bahaullah erklärt sich zu Gottes Propheten

Schriften zog er eine immer größere Zahl von Bekehrten an. Manche von ihnen waren Muslime, in ihrer Mehrzahl entstammten sie jedoch den christlichen und jüdischen Gemeinden im Nahen Osten, wo Bahaullah im Exil lebte.

In seinem Buch *Sieben Täler* griff er in großem Umfang auf die mystisch-islamische Tradition des Sufismus zurück, an anderen Stellen jedoch pries er die Werte von Toleranz, Respekt gegenüber allen Religionen, sozialen Reformen und internationalem Recht – eine Botschaft, die höchst modern klingt. Seine einflussreichste Schriftensammlung mit dem Titel *Kitab-i-Aqdas* vollendete er 1892, kurz vor seinem Tod.

Die Führungsposition des Bahai-Glaubens ging zunächst auf Bahaullahs Nachkommen über, in jüngerer Zeit dann an ein Gremium, das Haus der Gerechtigkeit. Shoghi Effendi, der die Bahai-Gemeinde von 1921 bis 1957 leitete, fasste Bahaullahs Botschaft an die Welt so zusammen: Anzustreben seien „die selbstständige Suche nach Wahrheit, unbeeinträchtigt durch Aberglauben oder Traditionen; die Einheit des ganzen Menschengeschlechts – das Grundprinzip und die grundlegende Lehre des Glaubens; die grundlegende Einheit aller Religionen; die Ablehnung jeglicher Vorurteile, ob religiöser, rassischer, sozialer oder nationaler Natur; die Harmonie, die zwischen Religion und Wissenschaft herrschen muss; die Gleichberechtigung von Männern und Frauen, der beiden Flügel, auf denen der Vogel der Menschheit fliegen kann."

" Stolz zu sein, ist nicht an dem, welcher sein eigenes Land liebt, sondern an jenem, welcher die ganze Welt liebt. Die Erde ist nur ein Land, und die Menschen sind seine Bürger. "

Bahaullah, **1817–1892**

" Ich kann verstehen, warum die Christen uns als Ketzer bezeichnen. Aber was am wichtigsten ist: Wen wird Gott einen Ketzer nennen? Aus Gottes Sicht ist meine Offenbarung zutiefst orthodox. "

San Myung Mun, **1977**

1930er Jahre

Entstehung der Rastafari-Gemeinschaft in Jamaika

1950er Jahre

Entstehung der Vereinigungskirche

Die Bahai sind begeisterte Missionare und haben die Lehre von Bahaullah über die ganze Welt verbreitet. Die Gemeinschaft hat heute sechs Millionen Anhänger, wird aber im Iran verfolgt: Dort gilt die Vorstellung, Mohammed sei nicht der letzte Prophet gewesen, als Gotteslästerung.

Haile Selassie

Der äthiopische Kaiser Haile Selassie (1892–1975) äußerte sich öffentlich nie zu dem Glauben der Rastafari, dass er die Inkarnation Gottes sei. Er stellte aber in Shashamane, gut 300 Kilometer südlich der Hauptstadt Addis Abeba, Land für die Umsiedlung von Rastafaris aus Übersee bereit, und als er im April 1966 Jamaika besuchte, wurde er von einer riesigen Menschenmenge begrüßt. Seitdem feiern die Rastafari jedes Jahr am 26. April den „Grounation Day". Haile Selassie war aber auch offizielles Oberhaupt der alten Äthiopisch-Orthodoxen Kirche und betete regelmäßig in deren Gotteshäusern. Seine Politik bestand darin, Bündnisse mit dem Westen zu schließen, was den Rastafari ein Dorn im Auge war. Er wurde 1974 durch einen Staatsstreich gestürzt und starb im folgenden Jahr in der Haft unter rätselhaften Umständen. Manche Rastafari glauben, er sei noch am Leben und halte sich versteckt.

Rastafari Die Religionsgemeinschaft der Rastafari entstand in den 1930er Jahren in Jamaika und hat heute weltweit schätzungsweise eine Million Anhänger. Sie halten Haile Selassie, von 1930 bis 1975 Kaiser von Äthiopien, für eine Inkarnation Gottes. Er werde seine göttlichen Kräfte nutzen, um die Mitglieder der afro-karibischen Gemeinschaft, die heute aufgrund von Kolonialherrschaft und Sklavenhandel im „Land Babylon" im Westen lebten, nach Afrika in das „Land Zion" zurückzubringen. Nach dem Glauben der Rastafari sind die schwarzen Afrikaner Gottes auserwählte Rasse.

Die Wurzeln der Rastafari-Bewegung liegen in der Arbeit des politischen Aktivisten Marcus Garvey, der in den 1930er Jahren in Jamaika tätig war und bei den Rastafari als Prophet gilt. Grundlage der heute eigenständigen spirituellen Bewegung ist das Alte Testament, aus dem auch die Wiedergeburt, der rituelle Gebrauch von Marihuana zur Verstärkung der Spiritualität abgeleitet werden sowie die Praxis, die Haare zu den charakteristischen Locken zu drehen.

San Myung Mun

San Myung Mun wurde 1920 in dem damals von Japan besetzten Korea geboren. Anfangs wurde er in der konfuzianischen Tradition erzogen, aber mit zehn Jahren trat er zum Christentum und zur Reformierten Kirche über. Eigenen Behauptungen zufolge bekam er mit 16 Jahren Besuch von Jesus, der ihm die Anweisung gab, sein unfertiges Werk zu vollenden und das Reich Gottes auf Erden zu errichten. In seinen ersten Jahren als Prediger wurde Mun im heutigen Nordkorea inhaftiert. Er wurde 1950 von UN-Truppen befreit und gründete 1954 die Vereinigungskirche. Dies alles fand vor dem Hintergrund des Koreakrieges (1950–1953) statt, eines Konflikts zwischen dem kommunistischen Norden und dem vom Westen unterstützten Süden des Landes. Im Jahr 1958 schickte Mun erste Missionare nach Japan und ein Jahr später nach Amerika. 1975 war seine Kirche bereits in 120 Ländern aktiv.

Die Moonies Die Vereinigungskirche, besser als Moonies (oder Moon-Sekte, abgeleitet von der englischen Schreibweise des Namens Sun Myung Moon) bekannt, wurde in den 1950er Jahren in Korea von San Myung Mun gegründet und hat weltweit rund eine Million Mitglieder. Mun behauptet, er repräsentiere die Wiederkehr Christi und stehe in Kontakt mit Konfuzius, Buddha und Jesus. Die Lehre seiner Kirche greift sowohl auf christliche als auch auf östliche Glaubensüberzeugungen zurück und setzt sich für die Einheit aller Religionen ein, um damit den Himmel auf Erden zu schaffen. Christen werden aufgefordert, das Kruzifix als Symbol aufzugeben, weil es die Menschen an Schmerzen erinnere, und es durch die Krone zu ersetzen. Ihre „Segnungszeremonien" – manche bezeichnen sie als Massenhochzeiten von Paaren, die durch Mun zusammengestellt wurden – sind nach wie vor ebenso umstritten wie der Gründer selbst. Im Jahr 1982 wurde er in den Vereinigten Staaten wegen Steuerhinterziehung verurteilt.

Es gibt immer neue Wege zu Gott

44 Religion und Naturwissenschaft

Zwischen der Religion und den Naturwissenschaften herrscht seit langem ein angespanntes Verhältnis. In der Religion geht es um Glauben, in der Wissenschaft um Beweise. Keine der großen Religionen behauptet, sie könne nach den empirischen Maßstäben der Naturwissenschaften „beweisen", dass es eine Gottheit gibt, aber ihre Anhänger glauben dennoch daran. Manche Wissenschaftler – insbesondere der Evolutionsbiologe Richard Dawkins – behaupten deshalb, der Glaube sei nicht serlös oder rational begründet und habe in der modernen Welt keinen Platz.

Früher hatten Religion und Wissenschaft viel mehr Gemeinsamkeiten, und in manchen Glaubensrichtungen ist das noch heute so. Der Buddhismus beispielsweise lehnt jede Wissenschaftsfeindlichkeit ab und befürwortet die unvoreingenommene Erforschung der Schöpfung einschließlich der Menschheit selbst. Bei den Bahai ist es ein zentraler Grundsatz, dass eine Harmonie zwischen Wissenschaft und Religion bestehen muss: Religion ohne Wissenschaft ist Aberglaube, Wissenschaft ohne Religion ist Materialismus.

Glaube und Vernunft In der Geschichte der Religion gab es immer wieder Phasen, in denen keine Abgrenzung zwischen Glauben und Vernunft zu erkennen war. Thomas von Aquin pries im 13. Jahrhundert in seiner *Summa Theologica* die Erforschung der Natur. Zwischen dem achten und 14. Jahrhundert erlebte die naturwissenschaftliche Forschung unter dem Islam eine Blütezeit. Zu jener Zeit wurden die Algebra, Algorithmen und Alkalimetalle entdeckt, die bis heute Kernstücke von Mathematik, Physik, Informatik und Chemie bilden. Auch im Hinduismus wurde die Mathematik gefördert: Operationen mit Quadraten, Kuben und Wurzeln finden sich in heiligen vedischen Texten, die bis ins Jahr 1000 v. u. Z. zurückreichen.

Zeitleiste

ca. **1000** v. u. Z.	**8.** bis **14. Jahrhundert**
vedische Arithmetik	Goldenes Zeitalter des Islam

Islam und Naturwissenschaft

Die Zeit vom achten bis 14. Jahrhundert wird häufig als „Goldenes Zeitalter des Islam" bezeichnet. Damals leisteten Gelehrte aus islamischen Ländern einen großen Beitrag zu den wissenschaftlichen Kenntnissen der Welt. Ihre Inspiration bezogen sie vermutlich aus einem Vers im Koran: „Er hat euch gelehrt, was ihr nicht wisst."

Das interpretierte man als Aufforderung, Wissen zu erwerben. Auf den Gebieten der Astrologie, Geographie und Mathematik machte man wichtige Fortschritte; unter anderem wurde die Algebra entwickelt, die dazu geführt haben soll, dass man die islamischen Erbgesetze verstand.

Im Christentum galt die Naturwissenschaft bis weit ins Mittelalter hinein als Unterdisziplin der Religion, und man bemühte sich, ihre Entdeckungen mit den Lehren der Kirche in Einklang zu bringen. Dies wurde jedoch immer schwieriger und warf das Thema auf, das bis heute im Mittelpunkt der Meinungsverschiedenheiten zwischen Religion und Wissenschaft steht: Sie bedienen sich ganz unterschiedlicher Methoden. Auf der einen Seite steht das, was den Gläubigen offenbart wird, auf der anderen das, was der Wissenschaftler beobachten kann.

Galileo Galilei Das prominenteste Opfer der Spaltung zwischen Religion und Wissenschaft war der toskanische Physiker, Mathematiker und Astronom Galileo Galilei (1564–1642), der heute häufig als „Vater der modernen Naturwissenschaft" bezeichnet wird. Galilei war Christ und mit Päpsten befreundet; er wurde aber angegriffen, als er öffentlich erklärte, die Erde kreise um eine unbewegte Sonne. Die Kirche orientierte sich am Alten Testament und lehnte seine Haltung offiziell ab, viele Führungspersönlichkeiten räumten aber insgeheim ein, dass Galilei Recht hatte.

1633
Galilei ist mit der Inquisition konfrontiert

1859
Darwin: *Die Entstehung der Arten*

2006
Dawkins: *Der Gotteswahn*

> **Wie sich die Federn eines Pfaus und das Juwel einer Schlange an der höchsten Stelle des Körpers befinden, so hat auch die Mathematik die höchste Stellung unter allen Zweigen der Veden und Shastren.** ❝
>
> Jyotish-Vedanga (vedischer Text), **ca. 1000 v. u. Z.**

Im Jahr 1633 wurde er vor die Inquisition zitiert, zum Widerruf seiner Ansichten gezwungen und für den Rest seines Lebens unter Hausarrest gestellt. Seine Schriften waren bis 1718 verboten und blieben bis 1835 auf dem kirchlichen Index der verbotenen Bücher. Papst Johannes Paul II. jedoch, der die Beziehung zwischen Religion und Wissenschaft auf eine neue Grundlage stellen wollte, sprach 1992 öffentlich sein Bedauern darüber aus, wie die Kirche Galilei behandelt hatte.

Aufklärung Noch größer wurde die Kluft zwischen Religion und Wissenschaft mit der Aufklärung im 18. Jahrhundert. In seinem 1859 erschienenen Werk *Origin of Species* (dt. *Die Entstehung der Arten*) wies Charles Darwin nach, dass alle Lebewesen der Erde im Laufe der Zeit durch Evolution und natürliche Selektion – das heißt durch das Überleben des Geeignetsten – aus gemeinsamen Vorfahren hervorgegangen sind. Damit setzte er sich in direkten Widerspruch zum Schöpfungsbericht im Buch Genesis, was ihm die lautstarke Feindseligkeit der Christen einbrachte.

Einer der wortgewaltigsten Kritiker Darwins war Samuel Wilberforce, der anglikanische Bischof von Oxford. In einer berühmt gewordenen Diskussion, die 1860 in Oxford vor über 1000 Zuhörern stattfand, geriet Wilberforce mit dem Biologen Thomas Huxley aneinander, einem engen Vertrauten Darwins. Wilberforce wollte von Huxley wissen, ob er von Seiten seines Großvaters oder seiner Großmutter von einem Affen abstamme? Darauf erwiderte Huxley, er schäme sich nicht, einen Affen als Vorfahren zu haben, aber er schäme sich für seine Verwandtschaft mit einem Mann wie Wilberforce, der seine geistigen Gaben dazu benutze, die Wahrheit zu verschleiern.

Darwin selbst war nicht der Typ, der die Religion abgelehnt hätte, und vermied deshalb solche unmittelbaren Konfrontationen. Er meinte: „Mir scheint es (zu Recht oder zu Unrecht), dass direkte Argumente gegen Christentum und Gottesglauben kaum Wirkung auf die Öffentlichkeit haben; die Freiheit des Denkens fördert man am besten durch die allmähliche Erhellung des Geistes der Menschen, welche aus dem Fortschritt der Wissenschaft erwächst."

Integration oder Unabhängigkeit? Im 20. Jahrhundert kam es zu einer Wiederannäherung. Der französische Jesuit und Paläontologe Pierre Teilhard de Chardin (1881–1955) bemühte sich, die Evolutionstheorie mit dem biblischen Bericht über die Erschaffung der Welt durch Gott in Einklang zu bringen. Er glaubte, man könne Religion und Wissenschaft zusammenführen.

Es gibt mindestens drei Arten der Annäherung an die Frage nach dem Verhältnis von Religion und Wissenschaft: unter dem Aspekt des Dialoges, der Unabhängigkeit und des Konflikts. Im Dialog setzen sich Geistliche, Theologen und Wissenschaftler an einen Tisch und sondieren ihre Meinungsverschiedenheiten. Schätzungsweise 40 Prozent der Naturwissenschaftler hängen irgendeiner Form religiösen Glaubens an.

Wer an die Unabhängigkeit glaubt, erkennt an, dass Religion und Wissenschaft in „nicht überlappenden Bereichen" existieren, wie der amerikanische Evolutionsbiologe Stephen Jay Gould (1941–2002) es formulierte. Mit anderen Worten: Sie beschäftigen sich mit völlig verschiedenen Aspekten des menschlichen Daseins.

Ein Musterbeispiel für den Konflikt ist der 2006 erschienene Bestseller *The God Delusion (*dt. *Der Gotteswahn)*, in dem der Wissenschaftler Richard Dawkins aus Oxford einen Frontalangriff auf die Religion unternimmt. Der Glaube an einen persönlichen Gott ist in seinen Augen eine Art geistige Störung, ein Wahn, der sich trotz aller Belege für das Gegenteil hartnäckig hält. Er erläutert diese Belege und wirft der organisierten Religion vor, sie beeinträchtige den Fortschritt der Naturwissenschaften.

Untersuchungen zur Wirksamkeit von Gebeten

Wenn es einen Gott gibt, so eine Überlegung von Wissenschaftlern, müssten Gebete zu diesem Gott einen messbaren Effekt haben. Die Frage wurde mehrfach untersucht, klare Befunde gibt es aber kaum. Einer der ersten, der solche Forschungen vornahm, war der viktorianische Intellektuelle Sir Francis Galton. Er äußerte folgenden Gedanken: Da die britische Königsfamilie regelmäßig in die Gebete ihrer treuen Untertanen eingeschlossen werde, müssten ihre Mitglieder eigentlich länger leben als der Rest der Gesellschaft. Da das nicht der Fall war, zog er den Schluss, Gebete seien unwirksam. Spätere Forschungsprojekte mit „Gebeten Dritter" – man betete für Kranke – zeigten, was die Folgen für die Patienten anging, ganz unterschiedliche Ergebnisse. Die wissenschaftlichen Untersuchungen über die Auswirkungen der Aktivitäten von Geistheilern ergaben keinen Beweis, dass diese ihre erklärten Ziele erreichten, aber die Untersuchung von Bernardi, über die im Jahr 2001 vielfach berichtet wurde, legte den Verdacht nahe, dass herzkranke Gläubige durch Gebete oder das Aufsagen von Yoga-Matras ihren Blutdruck senken können.

Worum es geht
Religion und Naturwissenschaft bleiben Gegenpole

45 Atheismus

Traditionell versteht man unter Atheismus einfach die Ablehnung jeder Religion, aber einhergehend mit dem Vormarsch säkularer, naturwissenschaftlicher Philosophien insbesondere in der abendländischen Gesellschaft wird er heute manchmal als eigenständige Religion angesehen, mit gottesfreien Ritualen bei Geburt, Eheschließung und Tod. Rund 2,3 Prozent der Weltbevölkerung bezeichnen sich selbst als Atheisten.

Schon so lange es Menschen gibt, die eine Gottheit anbeten, lehnen andere diese Vorstellung ab. Dennoch kann man die schnelle Ausbreitung des Atheismus bis zu ihrem jetzigen Höhepunkt auf das 19. Jahrhundert und Philosophen wie Friedrich Nietzsche (1844–1900) zurückführen. Sie verkündeten unzweideutig: „Gott ist tot". Diese Bemerkung machte Nietzsche erstmals in seinem 1882 erschienenen Band *Die fröhliche Wissenschaft*, bekannt wurde sie aber durch sein vierteiliges philosophisches Prosawerk *Also sprach Zarathustra* (1883–1885).

Das Wort „Atheismus" kommt aus dem Griechischen; seine beiden Teile bedeuten: *a* – „ohne" und *theismus* – der „Glaube an Götter". Je nach Definition kann man also Atheist und gleichzeitig religiös sein. Buddhisten beispielsweise lehnen jede Vorstellung von einem persönlichen Gott ab, und viele Juden haben keinen religiösen Glauben. Der berühmte Schriftsteller Graham Greene (1904–1991) bezeichnete sich selbst gern als Katholiken, der nicht an Gott glaubt.

Weg mit der Götterwelt Bei der Suche nach den Anfängen des Atheismus gelangt man meist zu den griechischen und römischen Philosophen: Sie lehnten die gesellschaftliche Bindung an Götter zwar nicht völlig ab, vertraten aber leidenschaftlich die Ansicht, diese Götterwelt sei für den Zustand und das Wohlergehen der Menschheit völlig bedeutungslos. Insbesondere drei Philosophen werden häufig als Begründer des Atheismus genannt: Epikur, Diagoras und Lucretius.

Epikur (341–270 v. u. Z.) lebte in Athen und lehrte, das Universum sei zwar unendlich und ewig, Gut und Böse in der Welt solle man aber ausschließlich danach definieren, ob es dem Einzelnen Vergnügen oder Schmerzen bereitete. Der Tod, so erklärte er, sei für Körper und Seele das Ende. Diagoras, der im 5. Jahrhundert v. u. Z. ebenfalls in Athen lebte, wandte sich gegen die Bindung der Griechen an ihre Götter und wurde aus der Stadt vertrieben. Er wird manchmal als „Vater des Atheismus" bezeichnet. Der römische Dichter und Philosoph Lucretius (99–55 v. u. Z.) schließlich lehnte alle Ausprägungsformen des Übernatürlichen als sinnlosen Aberglauben ab.

Die Verfolgung von Atheisten

Diagoras war vermutlich der erste Atheist, der verfolgt wurde: Da er die Götter ablehnte, vertrieb man ihn aus Athen. Bis ins 17. Jahrhundert war „Atheist" ausschließlich ein Schimpfwort, und niemand hätte sich selbst so bezeichnet. Im 18. Jahrhundert jedoch wurde der Begriff zu einer Art Ehrennamen für Radikale. Der Dichter Percy Bysshe Shelley (1792–1822) wurde aus der Universität Oxford ausgeschlossen, nachdem er eine Kampfschrift mit dem Titel „Die Notwendigkeit des Atheismus" verfasst hatte, und Charles Bradlaugh (1833–1890) durfte trotz mehrfacher Wahlsiege seinen Sitz im Unterhaus nicht einnehmen, weil er sich weigerte, einen Eid auf Gott zu schwören. Erst 1886, nach sechs Jahren, durfte er den parlamentarischen Eid ablegen, ohne auf eine Bibel zu schwören.

Hinduistische und muslimische Atheisten
Die erste organisierte Atheistengruppe in einer großen Religionsgemeinschaft war vermutlich die Carvaka-Schule im vedischen Indien im sechsten Jahrhundert v. u. Z. Den Begriff benutzte sie aber natürlich nicht. Sie hatte nur begrenzten Einfluss und zählt nicht zu den sechs großen Schulen der hinduistischen Philosophie, aber nach heutiger Kenntnis hatte sie Auswirkungen auf die buddhistische Vorstellung, wonach es keinen persönlichen Gott gibt. Die Carvaka-Lehren – der Tod ist das Ende, sinnliches Vergnügen ist für Menschen ein legitimes Ziel, Religion ist eine Erfindung – zeigen bereits deutliche Anklänge an den modernen Atheismus.

❞ Die Religion ist der Seufzer der bedrängten Kreatur, das Gemüt einer herzlosen Welt, wie sie der Geist geistloser Zustände ist. Sie ist das Opium des Volkes. ❝

Karl Marx, 1843

Im Islam gilt Atheismus als Ablehnung Allahs und damit als Hinwendung zu einer anderen Religion. Der Koran betrachtet dies mit Missfallen: „Ja, diejenigen, die glauben, dann den Glauben verweigern, dann glauben, dann den Glauben verweigern, dann an Glaubensverweigerung zunehmen, es ist bestimmt nicht an Allah, dass Er ihnen verzeiht und nicht, dass Er sie einen Weg rechtleitet." An anderer Stelle heißt es aber auch: „Kein Zwang in der Religion". Die Hadithe sagen es unverblümter: „Tötet jeden, der seine Religion wechselt." Dem Islam abzuschwören (um eine andere Religion anzunehmen oder Atheist zu werden), gilt in zahlreichen muslimischen Ländern, darunter Saudi-Arabien, Afghanistan, Iran und Jemen, nach wie vor als Abtrünnigkeit und wird mit dem Tode bestraft.

Der historische Jesus Im späten 18. und gesamten 19. Jahrhundert wurde der Atheismus in Europa, angeregt durch die Aufklärung und den Fortschritt der Naturwissenschaften, zu einer eigenständigen Bewegung in unserer Zeit. Zu den ersten Gelehrten, die in der Bibel keine Heilige Schrift mehr sahen, sondern eine historische Quelle, gehörte der deutsche Theologe D. F. Strauss. Er löste 1835 im christlichen Europa mit seiner Biografie eines streng „historischen Jesus", dessen göttliche Natur er leugnete, einen Skandal aus. Die Wunderberichte in den Evangelien, so seine Behauptung, ließen sich mit natürlichen Phänomenen erklären.

Der erste atheistische Staat der Welt

Im Jahr 1967 erklärte Enver Hoxha (1908–1985), der marxistische Staatschef Albaniens, sein Land zum ersten atheistischen Staat der Welt. Kirchen und Moscheen wurden geschlossen, Geistliche inhaftiert und gefoltert, Gläubige verfolgt. Sein Regime wurde vom kommunistischen China unterstützt, von den meisten anderen Staaten jedoch abgelehnt. Nach dem Zusammenbruch des Kommunismus nahmen zahlreiche Einwohner Albaniens die religiöse Betätigung wieder auf.

> ❞ Ich werde kein Wesen gut nennen, welches nicht das ist, was ich meine, wenn ich dieses Attribut meinen Mitgeschöpfen beilege, und wenn ein solches Wesen mich zur Höllenstrafe verurteilen kann, weil ich es nicht so nenne, dann fahre ich eben zur Hölle. ❝
>
> John Stuart Mill, 1872

Den dauerhaftesten Einfluss hatte jedoch Nietzsche. Seine Behauptung „Gott ist tot" ging seiner Beschreibung einer Zeit des „Nihilismus" voraus, in der es die Begriffe von Wahrheit nicht mehr gebe, Gesetzessysteme auf Grundlage der jüdisch-christlichen Ideale, welche die europäische Gesellschaft prägten, zusammenbrechen würden, und nichts noch irgendeine Bedeutung habe.

Während Nietzsche sein philosophisches Gerüst des Atheismus aufbaute, arbeitete Darwin fleißig an einer Widerlegung der Behauptung, man könne Gott oder Götter erkennen, weil sie die Natur erschaffen hätten oder sogar ein Teil davon seien. „Darwin ermöglichte es dem Atheisten, auch intellektuell zufrieden zu sein", schrieb Richard Dawkins. Darwins Evolutionstheorie ließ keinen Platz mehr für einen Schöpfergott. Sie zeigte, wie genetische Variation und Selektion im Laufe vieler Jahrtausende zu immer neuen Lebensformen führen, während andere aussterben.

Zur gleichen Zeit steuerte Sigmund Freud (1856–1939) eine psychologische Sichtweise bei, die den Atheismus unterstützte. Er bezeichnete die Religion als Massenwahn, der die Realität neu gestalte und so ein sicheres Gefühl des Glücks und des Schutzes vor Leiden erzeuge.

Auf der Grundlage einer derart umfassenden wissenschaftlichen Untermauerung konnte Karl Marx eine religionsfeindliche politische Philosophie entwickeln und behaupten, Religion diene dazu, die Menschen am unteren Ende der wirtschaftlichen und sozialen Leiter von den echten Problemen abzulenken, die sie bedrückten.

Worum es geht
Atheismus ist eine Glaubensrichtung

46 Verwalter der Schöpfung

Religion hat ihre Ursprünge in den Schöpfungsmythen und der Anbetung von Naturgottheiten. Deshalb beschäftigen sich die Weltreligionen in jüngerer Zeit umfassend mit der Bedrohung, die der Klimawandel für unseren Planeten darstellt. Mit ihrer Vernetzung, ihrem internationalen Zuschnitt und ihren ethischen Grundsätzen eignen sich die Religionen gut als Bewahrer der Schöpfung. Viele ihrer Überzeugungen beinhalten teils unausgesprochen, teils explizit eine Forderung nach jener radikalen Umstellung der Lebensweise, die nach Ansicht der Wissenschaftler notwendig ist, wenn wir die Umweltkatastrophe abwenden wollen.

Ein Kernstück der meisten Religionen bilden Geschichten darüber, wie die Erde entstanden ist. Viele davon sind eindimensional, wie jener Bericht, der den Christen und Juden gleichermaßen heilig ist: Danach hat Gott die Welt in sechs Tagen erschaffen und Mann und Frau als Bewohner eines Paradiesgartens gestaltet. Im Buddhismus ist die Schöpfung ein Kreislauf, und diese Überzeugung beeinflusst auch die Einstellungen gegenüber dem Klimawandel. Für einen Schöpfergott, mit dem der Ursprung des Universums zu erklären wäre, ist dabei kein Platz. Stattdessen, so die Lehre, hängt alles von allem ab. Was jetzt geschieht, wurde zum Teil durch frühere Ereignisse verursacht und übt seinerseits Einfluss auf zukünftige Ereignisse aus.

Wie andere Religionen, die aus der vedischen Tradition erwuchsen und die Wiedergeburt beinhalten, so lehrt auch der Buddhismus, dass es mehrere Epochen gibt, in denen die Welt ins Dasein tritt, eine gewisse Zeit überlebt, sich selbst zerstört und wiedergeboren wird. Insbesondere im Buddhismus geschieht das alles natürlich, ohne göttliche Eingriffe, aber häufig als Folge des Verhaltens der Menschen.

Zeitleiste

ca. **1500** v. u. Z.	**1990**
Schöpfungsbericht im Rigveda	Weltkirchenrat beschäftigt sich mit dem Klimawandel

> ❯ Damals war weder Nicht-Existenz noch Existenz:
> Es gab keinen Bereich der Lüfte, keinen Himmel dahinter.
> Der Tod war damals nicht, und es war da auch nichts Unsterbliches,
> kein Zeichen, welches Tag und Nacht trennte. Dunkelheit war da:
> anfangs in Dunkelheit verborgen, war dieses Alles ein unter-
> schiedsloses Chaos. Alles, was existierte, war leer und formlos:
> durch die große Macht der Wärme wurde dieses Eine geboren. ❮
>
> Rigveda, ca. 1500 v. u. Z.

Schöpfungsmythen Die Schöpfungsmythen lassen sich in zwei Gruppen ein-
teilen: In der einen wurde der Planet durch eine göttliche Kraft zum Nutzen der
Menschheit erschaffen, in der anderen entstand er zum gegenseitigen Nutzen aller
Lebewesen. Am krassesten zeigt sich dieser Unterschied bei der Betrachtung von äl-
teren animistischen Traditionen wie dem Schintoismus, dessen Anhänger Geister in
Bäumen, Gebirgen und Quellen sehen, und der jüngeren christlichen und islami-
schen Religion, in denen der gesamte Rest der Schöpfung traditionell dazu da ist,
das Leben der Menschen zu sichern.

Solche Glaubensüberzeugungen bilden den Hintergrund für die unterschiedlichen
Einstellungen der Religionsgemeinschaften zu Tieren. Nach Ansicht der Jain sind
Tiere und Pflanzen den Menschen gleichberechtigt, weil alle eine lebende Seele ent-
halten und deshalb mit Respekt und Mitgefühl behandelt werden sollten. Jain sind
strenge Vegetarier und ernähren sich schon seit Jahrhunderten so, dass die Ressour-
cen der Welt möglichst wenig belastet werden. Der Koran dagegen erklärt, Tiere
seien zum Nutzen der Menschen erschaffen worden. Man soll sie zwar freundlich
behandeln, kann sie aber auch ausbeuten: „Allah ist es, der für euch das Weidevieh
gemacht hat, dass ihr auf manchen davon reitet und von manchen esst. Und ihr habt
davon Nutzen, indem ihr mit ihnen ein Herzensbedürfnis befriedigt. Und auf ihnen,
wie auf Schiffen, macht ihr eure Reise" (40:79/80).

2007
Vatikankonferenz über
globale Erwärmung

2009
Ökumenischer Patriarch macht
sich grüne Ziele zu Eigen

Mohammed und die Tiere

In den Berichten über Mohammeds Leben finden sich auch Beispiele dafür, wie er sich um Tiere kümmerte. Als einer seiner Mitreisenden ein paar Eier aus einem Vogelnest nimmt, tadelt ihn der Prophet und besteht darauf, dass er sie zurücklegt. Auf die Frage, ob Allah freundliches Verhalten gegenüber Tieren belohne, erwidert er: „Ja, es gibt eine Belohnung für Akte der Nächstenliebe gegenüber jedem lebenden Wesen." An anderer Stelle sagt er: „Wer einen Spatz oder irgendetwas Größeres ohne gerechten Grund tötet, wird von Allah am Tag des Gerichts dafür zur Verantwortung gezogen." Ein gerechter Grund ist es allerdings auch, wenn man das Tier essen will.

Eine neue Herausforderung Die Aufgabe, neue Wege zur Förderung der ökologischen Vielfalt und zur Erhaltung unseres Planeten zu finden, hat diese unterschiedlichen Einstellungen gegenüber der Schöpfung wieder stark ins Bewusstsein gerückt. Alle Religionen lehnen den Materialismus, die Anhäufung von Reichtum und übermäßigen Konsum ab. Damit haben sie das gleiche Anliegen wie Umweltschützer, die sich für ein verändertes Verhalten der Menschen gegenüber dem Planeten einsetzen.

> Das Bild, das wir von uns selbst haben,
> spiegelt sich in unserem Umgang mit der Schöpfung wider.
> Wenn wir uns nur für Verbraucher halten, werden wir
> die Erfüllung darin suchen, die ganze Erde zu verbrauchen;
> wenn wir aber glauben, dass wir nach dem Bilde Gottes gemacht
> sind, werden wir mit Vorsicht und Mitgefühl handeln und danach
> streben, zu dem zu werden, als das wir erschaffen sind.
>
> Bartholomäus, Ökumenischer Patriarch von Konstantinopel, 2009

Religionsführer spielten in dem Feldzug gegen den Klimawandel eine wichtige Rolle. Der protestantische Weltkirchenrat in Genf richtete 1990 als eines der ersten Kirchengremien eine Abteilung ein, die sich mit dem Klimawandel beschäftigen sollte. Im Sommer 2007 versammelten sich internationale Führungspersönlichkeiten aus der muslimischen, jüdischen, buddhistischen und christlichen Tradition

Papst Benedikt und die grünen Ziele

Im April 2007 hielt Papst Benedikt XVI. vor der vatikanischen Konferenz eine Rede zum Klimawandel. Er erklärte, die Misshandlung der Umwelt widerspreche Gottes Willen, und drängte Bischöfe, Wissenschaftler und Politiker, eine „nachhaltige Entwicklung" zu fördern. Umweltschutz und die Ernährung der Armen in der Welt – welche seit langem ein besonderes Anliegen vieler Religionen ist – galten manchmal als einander widerstreitende Ziele. Insbesondere dem Christentum wurde vorgeworfen, es kümmere sich nicht um die drohende ökologische Katastrophe, weil es sich für wirtschaftliche Entwicklung einsetze und eine Kontrolle der Geburtenrate durch allgemein verfügbare Verhütungsmittel ablehnt. Papst Benedikt widersprach dem Gedanken, es gebe hier einen Konflikt; er drängte auf „Forschung und die Förderung von Lebensweisen sowie von Produktions- und Konsummodellen, welche die Schöpfung und die wahren Erfordernisse eines nachhaltigen Fortschritts der Völker respektieren". Außerdem forderte er eine neue, verantwortungsbewusste Einstellung gegenüber dem Schicksal unseres Planeten: „Statt Umwelt... kann man Schöpfung sagen. Die Herrschaft des Menschen über die Schöpfung darf nicht despotisch oder gefühllos sein. Der Mensch muss Gottes Schöpfung kultivieren und schützen."

neben einem schrumpfenden Gletscher in Grönland zu einem schweigenden „Gebet für den Planeten", und 2008 kamen 1000 führende Persönlichkeiten vieler Glaubensrichtungen als Delegierte im schwedischen Uppsala zusammen, um ein Manifest zu unterzeichnen: Darin verpflichteten sich ihre Religionsgemeinschaften, Druck auf die politischen Führer auszuüben, damit diese bis 2020 eine 40-prozentige Verringerung der Kohlendioxidemissionen durchsetzten – wobei die Verantwortung vorwiegend bei den reichen Industrieländern liegen sollte. „Die Tradition unseres Glaubens bietet eine Grundlage für Hoffnung", stellten sie fest, „und auch Gründe dafür, trotz aller Schwächen nicht aufzugeben."

Wir haben die Schöpfung missachtet

47 Der gerechte Krieg

Häufig wird behauptet, Religion stehe im Mittelpunkt aller Konflikte auf der Welt. Dies ist ein wichtiger Grund dafür, dass Menschen sich von den religiösen Institutionen abwenden. Die Wurzel des Problems liegt aber oftmals im Verhalten von Eiferern, die an den Rändern der Glaubensgemeinschaften stehen. Die Gläubigen erklären in ihrer Mehrzahl, Konflikte würden von „schlechter Religion" verursacht. „Gute Religion", das machen die heiligen Schriften sehr deutlich, lehnt den Krieg ab. Und unter den Glaubensrichtungen, die Kriege unter bestimmten Umständen für gerechtfertigt halten, ist die Liste der Situationen, für die dies gilt, mit der Entwicklung der modernen Kampfmittel und Massenvernichtungswaffen immer kürzer geworden.

Manche Glaubensrichtungen machen sich die völlige Gewaltlosigkeit zu eigen. In den buddhistischen Schriften findet sich der Rat: „Lass in Kriegszeiten in dir den Geist des Mitgefühls wachsen, welcher den Lebewesen hilft, den Willen zu kämpfen aufzugeben." Der Dalai Lama, das Oberhaupt der Tibeter (der im Exil lebt, seit die Chinesen seine Heimat besetzten, und der auch den Friedensnobelpreis erhielt), demonstriert durch seinen gewaltlosen Umgang mit den Chinesen in Wort und Tat ständig Buddhas Friedenswillen.

Ahimsa In anderen Religionen ist die Sache nicht so eindeutig. Der Hinduismus verurteilt kriegerische Gewalt in einem Lehrsatz, der auf Sanskrit *Ahimsa* genannt wird: „Übe keine Gewalt aus." (Den gleichen Begriff gibt es auch im Buddhismus und im Jainismus, er hat dort aber eine etwas andere Bedeutung.) Andererseits rangieren aber die Kshatriyas (Krieger) im hinduistischen Kastensystem weit oben. Auch der Guru Nanak setzte sich für den Frieden ein, und viele Sikhs sind heute Pazifisten; dennoch reagierte der Sikhismus im Laufe der Jahrhunderte immer wieder mit dem Einsatz gut ausgebildeter Soldaten auf die Aggression anderer, die ihm die Religionsfreiheit streitig machen wollten.

Zeitleiste

ca. **1500** v. u. Z.	**426**
Der Rigveda beschreibt die Moral von Soldaten	Augustinus schreibt über den gerechten Krieg

Das Recht auf Selbstverteidigung

Viele Buddhisten nehmen selbst dann keine Waffen in die Hand, wenn sie damit ihr eigenes Leben verteidigen könnten. Mönche verteidigen sich unter Umständen durch Kampfkunst, können aber nie einen anderen Menschen töten. Im Buddhismus erzählt man sich eine Geschichte aus dem Vietnamkrieg (1959–1975). Der berühmte vietnamesische Mönch Thich Nhat Hanh, ein Zen-Buddhist, der 1967 von Martin Luther King für den Friedensnobelpreis vorgeschlagen wurde, erlebte immer wieder, dass sein Bekenntnis zur Gewaltlosigkeit während des Konflikts infrage gestellt wurde. „Angenommen, irgendjemand hätte alle Buddhisten auf der Welt getötet, und Sie wären der Einzige, der noch übrig ist. Würden Sie nicht versuchen, die Person zu töten, die Sie töten will, um so den Buddhismus zu retten?" Darauf erwiderte Thich Nhat Hanh: „Es wäre besser, wenn er mich tötet. Wenn im Buddhismus und im *Dharma* eine Wahrheit steckt, wird sie nicht vom Antlitz der Erde verschwinden, sondern sie wird wieder auftauchen, wenn jene, die nach der Wahrheit suchen, bereit zur Wiederentdeckung sind. Wenn ich töte, würde ich gerade jene Lehren verraten und aufgeben, die ich zu erhalten strebe. Es wäre also besser, wenn er mich tötet und ich dem Geist des *Dharma* treu bleibe."

In dem Versuch, die Quadratur des Kreises zu schaffen und die Friedensliebe mit der Fähigkeit zur Abwehr von Aggressoren zu verbinden, stellte der Sikhismus eine Reihe von Prinzipien, Dharam Yudh genannt, für einen „gerechten Krieg" auf. Ein Konflikt ist legitim, wenn vier Voraussetzungen erfüllt sind: 1. Alle anderen Mittel haben versagt; 2. das Motiv ist weder Rache noch Feindseligkeit; 3. er wird mit geringstmöglicher Gewalt und ohne Schädigung von Zivilisten ausgetragen; und 4. an seinem Ende wird das gesamte eroberte Eigentum einschließlich besetzter Territorien zurückgegeben.

> **Niemand ist mein Feind. Niemand ist ein Fremder. Ich bin mit allen im Frieden. Der Gott in uns macht uns unfähig zu Hass und Vorurteil.**

Guru Nanak

Der gerechte Krieg Solche Kriteriensammlungen gibt es häufig. Im Rigveda werden die Kriterien des Hinduismus für das ethische Verhalten von Soldaten im Kampf festgeschrieben. Sie dürfen die Spitze ihrer Pfeile nicht vergiften, nicht auf Kranke, Alte, Frauen und Kinder zielen und nicht von hinten angreifen. Auch im Christentum gibt es Regeln für einen „gerechten Krieg".

Im Neuen Testament macht Jesus unterschiedliche Aussagen zu der Frage, ob man zur Lösung von Konflikten auf Gewalt zurückgreifen darf. Im Matthäusevangelium (5, 39) erklärt er: „Ich aber sage euch, dass ihr nicht widerstreben sollt dem Übel, sondern: wenn dir jemand einen Streich gibt auf deine rechte Backe, dem biete die andere auch dar." Später jedoch wird dieser pazifistische Impuls eingeschränkt; jetzt erklärt er seinen Jüngern (Lukas 22,36): „Aber nun, wer einen Geldbeutel hat, der nehme ihn, desgleichen auch die Tasche, und wer's nicht hat, verkaufe seinen Mantel und kaufe ein Schwert."

Die christliche Vorstellung vom gerechten Krieg formulierte Augustinus in seinem Werk *Vom Gottesstaat* (426 u. Z.). Demnach muss die Aggression, der man begegnet, „dauerhaft, schwerwiegend und sicher" sein. Alle anderen Mittel müssen versagt haben. Es muss ernsthafte Erfolgsaussichten geben, und schließlich darf der Waffengebrauch keine Übel und Beeinträchtigungen verursachen, die schwerer sind als das Übel, das man beseitigen will.

Der gerechte Krieg im Islam

Viele Muslime widersprechen der heutigen Annahme, der Islam sei grundsätzlich kriegslüstern und schere sich nicht um die Folgen der Konflikte für Unschuldige. Ein solches Bild ist weit verbreitet, seit islamische Fanatiker 2001 die Zwillingstürme des World Trade Centers zerstörten und fast 3000 Menschen töteten. Die Muslime der Hauptrichtung bestreiten, dass hemmungslose Gewalt ein Teil ihrer Geschichte sei. Sie weisen auf eine viel ältere Tradition im Islam hin, in der man nur widerwillig in den Krieg zieht und sich möglichst menschlich verhält. Als Saladin 1187 Jerusalem von den christlichen Kreuzfahrern zurückeroberte, stellte er fest, dass eine Reihe heiliger Stätten des Islam geschändet waren. Dennoch verbot er Racheakte. Die Stadtbewohner, die während der Schlacht in Gefangenschaft gerieten, wurden später gegen Zahlung eines symbolischen Lösegeldes wieder freigelassen.

> **❜ Gewalt und Waffen können die Probleme der Welt niemals lösen. ❛**
>
> Papst Johannes Paul II., 2003

In der Vergangenheit wurden mit diesen Kriterien aggressive Feldzüge zur Eroberung von Land und – beispielsweise bei den Kreuzzügen – zur Zwangsbekehrung gerechtfertigt. Die moderne katholische Kirche lehnt Krieg jedoch ab. Nach Ansicht mancher Theologen machen es die Kernwaffenarsenale mit ihrer ungeheuren Zerstörungskraft unmöglich, das vierte Kriterium zu erfüllen. Papst Paul VI. appellierte 1965 in einer historischen Rede an die Vereinten Nationen: „Kein Krieg mehr, nie wieder Krieg!", und Papst Johannes Paul II. verurteilte 1991 den ersten Golfkrieg bei nicht weniger als 56 Gelegenheiten; 2003 bezeichnete er den Einmarsch in den Irak als „Niederlage für die Menschheit".

Der Islam Die Religion, die in jüngster Zeit im Zusammenhang mit Krieg vielleicht am stärksten in die Kritik geriet, war der Islam. Dies lag an terroristischen Gräueltaten, die von islamischen Extremisten verübt wurden. Tatsächlich erlaubt der Islam den Krieg aus „edlen" Beweggründen, das heißt zur Selbstverteidigung und zum Schutz unterdrückter Muslime in anderen Ländern. Dabei dürfen aber Unbeteiligte nicht geschädigt werden, und es ist stets möglichst wenig Gewalt anzuwenden; Kriegsgefangene müssen human behandelt werden. Alle diese Lehren ergeben sich aus Abschnitten des Koran und aus Mohammeds eigenem Verhalten.

Meinungsverschiedenheiten bestehen allerdings im Zusammenhang mit den so genannten „Schwertversen" des Koran, die Krieg nur zur Selbstverteidigung, aber nicht als Mittel zur Verbreitung des Islam gestatten. Manche radikalen Denker vertreten die Ansicht, die vermeintliche Feindseligkeit der modernen Welt gegenüber dem Islam, die insbesondere aus dem Westen komme, erfordere die Selbstverteidigung. Wie dem auch sei: Nach der Lehre des Koran kann es für Krieg auf Erden keine Belohnung geben. Wurde er aus den richtigen Gründen geführt, wird Allah richten, und die Belohnung wird es im Himmel geben.

Worum es geht

Krieg ist heute so gut wie nie zu rechtfertigen

48 Der Missionsdrang

Das Bedürfnis zu missionieren gibt es in vielen Religionen als tief verwurzelten Auftrag, möglichst vielen Menschen die eigenen Überzeugungen nahezubringen. Die Missionierung gehörte aber in Vergangenheit und Gegenwart auch häufig zu den umstrittensten Tätigkeiten religiöser Gemeinschaften. Im mittleren und südlichen Afrika beispielsweise wurden die Spannungen zwischen christlichen und muslimischen Gemeinschaften verschärft, weil beide Seiten sich bemühten, andere zu bekehren – manchmal auch mit Gewalt.

Die biblische Aufforderung „geht hin und lehret alle Völker" war dem Christentum von Anfang an ein zentrales Anliegen. Auch der Islam wurde in den ersten Jahren nach Mohammeds Tod sehr schnell nach Nordafrika und Spanien verbreitet, und die buddhistischen Wandermönche brachten ihren Glauben nach China, Tibet und Japan.

Alle wandten friedliche Mittel an und lehnten Zwangsbekehrungen ab. Wenn aber Religion untrennbar mit politischer Macht verbunden war wie im christlichen Europa, im islamischen Kalifat und in China, wo die Herrscherdynastien den Konfuzianismus und Taoismus übernahmen, hatte die Entscheidung, ob man sich bekehren lässt, zwangsläufig Auswirkungen auf das tägliche Leben.

Wer auf dem Territorium des Kalifats den Islam ablehnte, musste Steuern zahlen, ansonsten herrschte aber Toleranz. Heiden und Juden, die sich außerhalb des Christentums stellten, während die Allianz von Kaiser des Heiligen Römischen Reiches und Papst in Europa herrschte, hatten Verfolgung und die Inquisition zu fürchten. Und wenn der Kaiser in China den Taoismus bevorzugte, wurden Konfuzianer zur Zielscheibe, und umgekehrt.

Zeitleiste

1. Jahrhundert n. Z.

Die Apostel Jesu verbreiten die „Frohe Botschaft"

5. Jahrhundert n. Z.

Buddhistische Mönche missionieren in China

Die Neue Welt Nach der Entdeckung der „Neuen Welt" durch Christoph Kolumbus 1492 kamen mit den Konquistadoren spanische katholische Priester und Nonnen dorthin. Sie standen vor einem Problem, mit dem Missionare sich seither immer auseinandersetzen müssen. Sie waren aufrichtig bemüht, den Einheimischen ihren Gott nahezubringen, wobei sie häufig vorhandene Religionen hinwegfegten, aber für die eroberten Völker waren sie gleichzeitig ein Teil der Unterdrückung. Manche wie der spanische Priester Bartolomé de las Casas – der als „Verteidiger der Indianer" bezeichnet wurde, weil er sich dagegen wandte, dass die ersten spanischen Kolonialbehörden die Einheimischen wie Sklaven behandelten – vertraten die Ansicht, Religion könne Eroberer und Eroberte nicht mit zweierlei Maß messen, aber viele andere hatten solche Skrupel nicht. Die Bekehrung zum Christentum diente als Mittel, um die einheimische Bevölkerung – und die aus Afrika importierten Sklaven – gefügig zu machen.

Dennoch fasste die katholische Kirche im spanischen Kolonialreich – dem heutigen Mittel- und Südamerika – Fuß, sie konnte jedoch die vorhandenen Religionen nicht völlig verdrängen. Das Ergebnis war ein Synkretismus – die Vermischung verschiedener Religionen –, was die Missionsbestrebungen in vielen Regionen der Welt bis heute erschwert. In Brasilien zum Beispiel, das von den Portugiesen im Wesentlichen nach den gleichen Prinzipien erobert wurde wie andere Länder von den Spaniern, gedeiht die Religion des Candomblé heute neben dem Katholizismus, und beide haben dieselben Anhänger.

Zu dieser Mischung aus von Sklaven mitgebrachten altafrikanischen Ritualen und katholischen Elementen bekennen sich heute rund zwei Millionen Menschen; ihr Zentrum liegt in der Stadt Salvador da Bahia im Nordosten des Landes.

> **Wenn eine Weisung von einem irdischen König als Ehre gilt,
> wie kann man dann die Weisung eines Himmelskönigs
> als Opfer betrachten?**
> David Livingstone, 1813–1873

7. Jahrhundert u. z.	1492	19. Jahrhundert
Mohammeds Schüler verbreiten den Islam	„Entdeckung" Amerikas	Höhepunkt der europäischen Missionstätigkeit

Santería

Die Santería ist ebenfalls eine synkretistische Religion, die sich während der europäischen Kolonisierung Amerikas entwickelte. Ihr Schwerpunkt liegt heute in Kuba, sie hat aber auch in den Vereinigten Staaten eine beträchtliche Zahl von Anhängern. In der Santería vermischen sich religiöse Überzeugungen von Katholiken, Afrikanern und amerikanischen Ureinwohnern. Sie lehrt, dass ein Gott namens Obatala über allen anderen Gottheiten, den *Orishas*, steht. Zur ihren Ritualen gehören Exorzismus und Tieropfer, und sie wurde mit dem Voodoo in Verbindung gebracht. Früher bemühten sich die katholische Kirche und die Kolonialbehörden, sie auszurotten; deshalb entwickelte sich in der Santería ein System, mittels dessen die *Orishas* nach christlichen Heiligen benannt wurden, so dass man ihre wahre Identität geheimhalten konnte. Beispielsweise ist Babalu-Aye, der Santería-Gott der Kranken, auch als heiliger Lazarus bekannt.

In den meisten modernen Gesellschaften ist die Religionsfreiheit als grundlegendes Menschenrecht anerkannt, aber das hat der Missionsarbeit keineswegs ein Ende bereitet. Die großen Religionsgemeinschaften bemühen sich heute in der Öffentlichkeit und im privaten Umfeld um die Förderung von Verständnis und Respekt, aber sie streben nach wie vor auch Bekehrungen an.

Friedliche Koexistenz Nicht alle Religionen folgen solchen Prinzipien. Im Judentum gibt es zwar einen offiziellen Bekehrungsprozess, ihm fehlt aber die eifrige Massenmission, die es in manchen Zweigen der beiden anderen monotheistischen Religionen, des Christentums und des Islam, gibt. Die Ursache hierfür liegt in den früheren Versuchen anderer Glaubensrichtungen, Juden mit Gewalt zu bekehren.

Gleichzeitig fordern manche Religionen von ihren Anhängern kein exklusives Bekenntnis, sondern diese können auch mehreren Glaubensrichtungen angehören. Im Christentum akzeptieren die Baptisten, dass die Teilnehmer ihrer Gottesdienste Verbindungen zu anderen Konfessionen haben. Die Bahai, die in jüngerer Zeit zu den erfolgreichsten Missionaren gehören, erkennen im Rahmen ihres absoluten Respekts gegenüber allen Religionen an, dass Bekehrte auch Verbindungen zu anderen Glaubensrichtungen beibehalten. Und der japanische Schintoismus existiert im Leben vieler Menschen friedlich neben dem Buddhismus: Manche Japaner entscheiden sich beispielsweise bei der Taufe für eine schintoistische und beim Begräbnis für eine buddhistische Zeremonie.

Der Geist der Selbstaufopferung

Wie man auch ethisch zu den Bestrebungen stehen mag, Menschen zu bekehren: Die Missionare, welche die europäischen Kolonialherren begleiteten, hatten zweifellos Mut und waren bereit, für ihren Glauben zu sterben. Manche führten ihre persönlichen Habseligkeiten sowie eine große Zahl von Bibeln und Gesangbüchern in sargförmigen Reisekoffern mit sich. Sie rechneten damit, in Erfüllung ihrer Aufgabe ums Leben zu kommen, und in vielen Fällen geschah das auch – entweder durch Krankheit oder, in einigen unglücklichen Fällen, als Märtyrer von der Hand derer, die sie erretten wollten. Ein solches Schicksal galt in der militant-missionarischen Geisteswelt als „Erfüllung von Gottes Ziel", wie es in einem klassischen Missionslied von 1894 heißt.

Unruheherde Missionsbestrebungen können auch heute noch zu Konflikten führen. In Indien hegen viele Hindus einen starken Widerwillen gegen christliche Missionare, denn deren Tätigkeit zerstört nach ihrer Auffassung das Gefüge der indischen Gesellschaft. In jüngerer Zeit führten solche Ressentiments zu Gewalttaten: Hinduistische Religionsführer warfen den christlichen Missionaren vor, sie würden ihre Götter verunglimpfen. Große öffentliche Aufmerksamkeit erregte ein Zwischenfall im Januar 1999. Damals verbrannten der christliche Missionar Graham Staines aus Australien und seine beiden kleinen Söhne im Bundesstaat Orissa bei lebendigem Leibe, als sie in ihrem Wohnmobil schliefen. Vorher hatte man dem Missionar Bekehrungsbestrebungen vorgeworfen.

Besondere Unruhe stiften einige neue Kirchen und Gruppen, die an den fundamentalistischen Rändern der großen Religionen angesiedelt sind – auch hier insbesondere Christentum und Islam – und ganz offen zur Massenbekehrung aufrufen. Manche islamische Gruppen verfolgen beispielsweise in europäischen Staaten ausdrücklich das Ziel, die muslimische Bevölkerung zu vergrößern und die Möglichkeit zur Gründung islamischer Staaten zu schaffen, die nach den Gesetzen der Scharia regiert werden sollen. Die Muslime der Hauptrichtung lehnen solche Ziele ab und bemühen sich stattdessen darum, Toleranz und Verständnis zwischen den Religionen zu fördern.

Worum es geht
Ich will, dass alle das Gleiche glauben wie ich

49 Spiritualität

Der weltweite Wirtschaftsabschwung der Jahre 2008/2009 dürfte zu einer Vertrauenskrise gegenüber dem Kapitalismus und seinem Konsumdenken geführt haben, manchen Berichten zufolge ließ er aber insbesondere in der abendländischen Gesellschaft das Interesse an Religion neu erwachen. Dies zeigte sich nicht an zunehmenden Besucherzahlen in Kirchen, Moscheen und Tempeln, sondern an der verstärkten Nachfrage nach Besinnungstagen, Meditationskursen und Workshops zum Erlernen jener Hilfsmittel, mit denen die Angehörigen der verschiedenen Glaubensrichtungen traditionell den Zugang zu dem finden, was umfassend, aber auch ungenau als Spiritualität bezeichnet wird.

Die Begriffe Spiritualität und Religion werden häufig synonym verwendet, sie bedeuten aber nicht das Gleiche. Religion ist eher ein Weg, um Zugang zur Spiritualität zu finden. Sie ist aber auch eine äußere, gemeinschaftsbetonte Form der Spiritualität im Gegensatz zu jener eher inneren, individuellen Ausdrucksform, zu der man am besten durch innere Einkehr gelangt – durch Meditation, Betrachtung der Natur oder durch einen höheren Bewusstseinszustand, der durch Fasten oder andere körperliche Übungen hergestellt wird.

Christentum, Islam und Judentum haben jeweils eigene spirituelle Traditionen, die in den vorangegangenen Kapiteln erläutert wurden. Alle bemühen sich um eine intime, persönliche, mystische Beziehung zum Göttlichen, die man in den üblichen Riten und Ritualen nicht findet. Solche Bemühungen stehen in manchen Glaubenstraditionen stärker im Mittelpunkt als in anderen. Der Sufismus ist beispielsweise für Muslime der Hauptrichtung wahrscheinlich eher akzeptabel als die Kabbala für die Mehrzahl der Juden. Im Christentum dagegen betrachtet man diejenigen, die der spirituellen Seite ihres Glaubens mehr Gewicht beimessen als den üblichen liturgischen Formen, Regeln und Strukturen, seit jeher -zumindest zu deren Lebzeiten – mit Misstrauen.

Zeitleiste

3. Jahrhundert	1515
christliche Einsiedlermönche ziehen in die Wüste	Geburt der Heiligen Teresa von Ávila

Teresa von Ávila Ein gutes Beispiel ist die spanische Karmcliterin und Heilige Teresa von Ávila (1515–1582). Als junge Nonne widmete sie sich in ihrem abgeschlossenen Kloster der Einkehr und den kontemplativen Gebeten. Glaubt man ihrer spirituellen Autobiografie *Gott hat mich überwältigt*, so erreichte sie damit schließlich einen Zustand der religiösen Ekstase, in dem sie sich mit Gott eins fühlte. Sie empfahl einen vierfachen spirituellen Weg, auf dem auch andere es ihr gleichtun konnten. Er begann mit einem „mentalen Gebet", das die Welt ausschloss, dann folgte das „Gebet der Stille", in dem sie sich in Gott verlor und das sich in der „Hingabe der Vereinigung" fortsetzte; jetzt erreichte sie einen Zustand der Ekstase, und schließlich gelangte sie zur „Hingabe der Ekstase", einem tranceähnlichen Zustand, in dem die Sinnesorgane nicht mehr funktionierten und der Körper sich anfühlte, als ob er schwebte.

Zu Teresas Lebzeiten hielt man ihre Trance jedoch vielfach für ein Anzeichen dafür, dass sie vom Teufel besessen war. Die anderen Nonnen ihres Klosters kritisierten sie häufig und drängten sie ins Abseits, und als sie ihrem Orden mit einer Reform zu einem mehr weltabgewandten, spirituelleren Leben verhelfen wollte, warf man ihr bei jedem Schritt Knüppel zwischen die Beine. Wie viele überragende spirituelle Gestalten im Christentum, so fand auch sie nach ihrem Tod mehr Anerkennung als zu Lebzeiten: Heute gehört sie zu den wenigen „Kirchenlehrerinnen".

Stille

In jüngerer Zeit berichten Klöster der monotheistischen und fernöstlichen Religionen im Westen über eine zunehmende Zahl von Anfragen spiritualitätshungriger Besucher, die es mit einem Leben der Kontemplation und Stille versuchen wollen. Auch Kirchenführer preisen die Vorteile der Stille als Heilmittel gegen wirtschaftliche und ökologische Unsicherheiten. Rowan Williams, der mönchsähnliche Erzbischof von Canterbury und Oberhaupt der anglikanischen Gemeinde, bezeichnete den „Bereich der Stille" als „entscheidenden Teil der täglichen Disziplin". Die uralte Lebensweise der Einsiedler, welche in der frühchristlichen Kirche eine zentrale Stellung einnahmen und noch heute Bestandteil der östlichen Traditionen sind, findet heute wieder zunehmend Interesse. Die Stille wird geschätzt, weil sie ideale Voraussetzungen für Spiritualität und Einkehr schafft. Die meisten Religionen betrachten sie als eine Gegenwart und nicht als das Fehlen von etwas. Wenn die Menschen nicht sprechen, können sie sich selbst auf einer tieferen spirituellen Ebene finden.

> ❯ Kontemplatives Gebet ist nach meiner Meinung nichts anderes als ein enger Austausch zwischen Freunden; es bedeutet, dass man sich die Zeit nimmt, um häufig mit dem allein zu sein, von dem wir wissen, dass er uns liebt. ❰
>
> Hl. Teresa von Ávila

Körper und Geist In den fernöstlichen Religionen dagegen findet man kaum einmal eine Trennung zwischen Religion und Spiritualität. Nach den Überzeugungen mancher Traditionen, beispielsweise des Jainismus, erlangen Mönche und Nonnen durch ihre Selbstaufopferung eine höhere spirituelle Bewusstseinsebene als die Mehrzahl der Gläubigen, die sich mit den alltäglichen Ansprüchen von Familie und Arbeit zufriedengeben müssen. Im Buddhismus jedoch werden alle – ob Mönch oder nicht – zum Meditieren aufgefordert; dieses gilt als geistige und körperliche Übung, mit der man sich von Gedanken und Gefühlen trennen und so einen höheren Bewusstseinszustand erreichen kann. Im Buddhismus ist Meditation nicht vom Alltagsleben oder der rituellen Praxis getrennt, sondern sie ist das Kernstück der Religion.

Bede Griffiths

Der in Großbritannien geborene Benediktinermönch Bede Griffiths (1906–1993) verbrachte sein Erwachsenenleben zum größten Teil in den Ashrams Südindiens. Dort versuchte er, zu einer Synthese zwischen abendländischem Christentum und östlicher Spiritualität zu gelangen. Er blieb zwar katholischer Mönch, übernahm aber die äußeren Gepflogenheiten des hinduistischen Klosterlebens und trat in einen Dialog mit dem Hinduismus ein, den er in zwölf populären Büchern festhielt. Ein Schlüsselbegriff war für ihn das „integrale Denken" – das Bemühen, spirituelle und wissenschaftliche Weltanschauung miteinander in Einklang zu bringen. Im Jahr 1983 schrieb er: „Wir stehen jetzt vor der Herausforderung, eine Theologie zu schaffen, die sich der so vielfach übereinstimmenden Befunde der modernen Wissenschaft und der östlichen Mystik bedient, um daraus eine neue Theologie zu entwickeln, die viel angemessener wäre."

❞ Schweigen ist unsere erste menschliche Sprache. Im Leben jedes Menschen sollte es Einsamkeit geben – nicht als äußeren Dauerzustand, sondern als Kloster in unserem Inneren. Dann können wir in ruhiger Harmonie in der Welt leben. ❞

Revd. Cynthia Bourgeault, 2009

Auch im Taoismus gibt es das Bestreben, die Trennung von Körper und Geist zu überwinden. Er lehrt, dass körperliche Tätigkeiten spirituelle Wirkungen haben; deshalb betreiben seine Anhänger Übungen wie Tai Chi, um geistigen Freiraum zu schaffen und das Tao unmittelbar kennenzulernen. Körperliche Reinheit (beispielsweise durch strenge Diät) ist untrennbar mit geistiger Gesundheit verbunden.

Austausch zwischen Ost und West Die östlichen Vorstellungen von einer gesteigerten Spiritualität haben im Westen schon seit langem großen Einfluss. Im 19. Jahrhundert wurde die Bewegung des Transzendentalismus in den Vereinigten Staaten und Europa stark von vedischen und hinduistischen Gedanken geprägt. Sie legte Wert darauf, Zugang zu einem inneren Kern des spirituellen Denkens zu finden und eine Beziehung zum Göttlichen herzustellen, die kaum etwas mit den religiösen Institutionen zu tun hatte.

In jüngerer Zeit haben verschiedene spirituelle Bewegungen unter dem Oberbegriff „New Age" fernöstliche Rituale und Praktiken übernommen, diese wurden allerdings manchmal aus ihrem ursprünglichen Zusammenhang gerissen. Die taoistischen Lehren des Yin und Yang und des Feng Shui wurden beispielsweise im Westen zu Formen des Lifestyle, die ihrer religiösen Bedeutung fast völlig beraubt sind und nicht mehr zu einer Glaubenstradition gehören.

Worum es geht
Körper und Geist können eine Einheit sein

50 Die Zukunft der Religion

Die lautstarke Vorhersage, die Religion habe nun ihre beste Zeit hinter sich, ist seit dem 19. Jahrhundert immer deutlicher zu vernehmen; sie hat sich aber als verfrüht erwiesen. Selbst wenn man sich nur auf Europa konzentriert, wo die Zahl der Gläubigen zweifellos gesunken ist, ist Gott nicht tot. Zu Beginn des 21. Jahrhunderts mag sich die Religion im Wandel befinden, aber nichts spricht dafür, dass sie im Sande verläuft. Betrachtet man die ganze Welt, so nimmt die Zahl derer, die nach eigenen Angaben eine religiöse Bindung haben, in Afrika, Asien und Lateinamerika sogar zu.

Negativ betrachtet ist die Zugehörigkeit zu einer Religion nur mit dem Gefühl der Sicherheit zu erklären, die sie angeblich bietet, wenn man sich vor dem eigenen Ende und letztlich dem Ende der Welt fürchtet. Die Anhänger dieser Ansicht sind überzeugt, dass Religion nur deshalb überlebt und gedeiht, weil die Welt ein solches Chaos ist. Wissenschaftler erklären uns, dass der Planet einer Umweltkatastrophe entgegengeht. Die Kluft zwischen armen und reichen Ländern wird trotz aller Bemühungen, sie zu schließen, immer größer. Und trotz aller wissenschaftlichen Bestrebungen verwirrt uns weiterhin die Zufälligkeit des Leides, das uns trifft.

Das gottförmige Vakuum Einer der größten Einwände gegen die organisierte abendländische Religion betraf lange die politische und gesellschaftliche Macht, die sich mit ihr verbindet. Der französische Philosoph Jean-Paul Sartre (1905–1980) verwendete die Formulierung „gottförmiges Vakuum", um den Platz, den Gott im Bewusstsein der Menschen immer eingenommen habe, zu beschreiben. Dennoch war er der Ansicht, wir müssten Gott ablehnen und das Vakuum leerlassen, weil Religion die persönliche Freiheit verneine. Kurz gesagt, disqualifiziert sie sich

Zeitleiste

1882	2006
Nietzsche erklärt, Gott sei tot	Die Zahl der Katholiken steigt weltweit auf 1,2 Milliarden

durch ihre Bestrebungen – die oft Hand in Hand mit politischer Macht gehen –, uns ihrem Willen zu unterwerfen.

Aber die Ära, in der Kirche und Staat gemeinsam und mit Gottes Segen das Leben nach ihrem eigenen Bilde prägten, scheint mit Sicherheit in Europa und zunehmend auch in den Vereinigten Staaten vorüber zu sein. Die christliche Lehre mit ihren von Kirchenführern häufig wütend vorgetragenen Einwänden gegen homosexuelle Beziehungen, Empfängnisverhütung, außerehelichen Sex und vor allem die Abtreibung, für viele Gläubige die Prüfsteine für Moral und Ethik, wurden von der Gesetzgebung und zunehmend auch in der öffentlichen Meinung über den Haufen geworfen.

Fundamentalismus
Was bleibt dann, insbesondere im Westen, noch für die Religion? Materielles und Spirituelles, Gott und Mammon überschneiden sich weiterhin, allerdings nicht mehr im gleichen Ausmaß wie früher. Viele Gläubige sehen in einer solchen Entwicklung etwas Positives, eine Gelegenheit für die Religion, den Menschen wieder zu dienen, statt Zwang auf sie auszuüben. Aber bisher ist das nur ein Trend, und sicher gibt es auch Strömungen in die entgegengesetzte Richtung. So gibt es beispielsweise sowohl im Christentum als auch im Islam eine Minderheit, die sich von der modernen Welt, von ihren säkularen Werten und sogar von ihren Freiheiten bedroht, übersehen oder schlecht behandelt fühlt. Solche Menschen greifen zunehmend auf ihre heiligen Schriften zurück, suchen dort Sicherheit und lesen sie immer stärker im wörtlichen Sinn – mit katastrophalen Folgen.

Paul Tillich

Der aus Deutschland stammende amerikanische Theologe und Philosoph Paul Tillich (1886–1965) vertrat die Ansicht, Religion sei für die Menschheit notwendig, weil wir eine tief verwurzelte Angst in uns trügen, die Teil des Menschseins sei und nicht als neurotisch bezeichnet werden sollte. Die Furcht vor Verlust und der Schrecken der Auslöschung, so schrieb er, seien ein natürlicher Teil unseres Alterungsprozesses, der auf Therapien nicht anspreche. Die Vorstellung von einem persönlichen Gott – in der abendländischen Religion eine alte Tradition – lehnte er ebenso ab wie einen Gott, der ständig in das Getriebe des Universums eingreift, wie es sowohl die westlichen als auch die östlichen Traditionen behaupten. Stattdessen lehrte er, man solle auf dem Weg über die Religion einen Gott suchen, der über dem persönlichen Gott stehe. Er behauptete, dies sei ein Teil unseres emotionalen oder intellektuellen Erlebens, weil der „Gott über Gott" der Ursprung aller Gefühle von Mut, Angst, Hoffnung und Verzweiflung sei.

> **❯ In Zukunft werden wir in unserer Religion
> keine Lehre des Übernatürlichen mehr sehen,
> sondern ein Selbsterfahrungsexperiment. ❮**
> Don Cupitt, 1997

Neue Perspektiven Die wachsende Intoleranz sollte die Aufmerksamkeit
nicht von der eigentlichen Geschichte der Religion ablenken, wie sie von der Mehr-
heit gelebt wird. In jüngerer Zeit haben sich innerhalb der Religionen und zwischen
ihnen neue, positive Perspektiven entwickelt. Das bahnbrechende Zweite Vatikani-
sche Konzil der katholischen Kirche, das von 1962 bis 1965 abgehalten wurde, war
nach den Worten seines Initiators, Papst Johannes XXIII. bestrebt, „ein Fenster zur
Welt" zu öffnen. Aus dem Dialog zwischen Kirchen und Traditionen erwuchs ge-
genseitige Toleranz, wo es früher nur Ablehnung, Misstrauen und Feindseligkeit
gab. Die Kluft zwischen den vorwiegend östlichen Religionen und denen des Wes-
tens wurde mit dem Ende der Kolonialzeit kleiner. Größerer Respekt, mehr Kennt-
nisse und bessere Kommunikation führten zu einem Austausch von Ideen. Westliche
Christen integrieren heute buddhistische Erkenntnisse in ihr spirituelles Leben –
und umgekehrt.

Gleichzeitig ist der politische Druck, mit dem die Religion ausgelöscht werden
sollte, geschwunden. Viele der meist marxistischen Regime, die aus der Religion
nur noch ein weiteres Instrument der staatlichen Kontrolle machen wollten, wurden
gestürzt oder haben ihren Kurs geändert. Die kommunistischen Behörden Chinas
ziehen Konfuzius heute heran, um historische Ereignisse wie die Olympischen
Spiele 2008 in Peking zu bewerben. Wenn die Religion in den letzten 100 Jahren
überhaupt etwas bewiesen hat, dann dieses: Jeder Versuch, sie mit Gewalt zu besei-
tigen, sichert ihr das Überleben.

Unsere Zeit wird häufig als Ära des religiösen Extremismus bezeichnet, sie ist
aber auch die Epoche der Ökumene und der religionsübergreifenden Initiativen.
Über das Erste wird häufiger berichtet als über das Zweite, aber gerade die Ent-
wicklung von Dialog, Toleranz und Verständnis wird die Extremisten letztlich an
den Rand drängen. Die Taten islamischer, christlicher und hinduistischer Funda-
mentalisten, die anderen ihre Ansichten aufzwingen wollen, haben überall da, wo es
sie gab, Reaktionen jener Mehrheit ausgelöst, die ihren Glauben zurückerobern und
die wahren Prinzipien der Religion wiederherstellen will.

Zahlen

Die Zahl der Anhänger verschiedener Religionen genau anzugeben ist schwierig, weil in jedem Einzelfall andere Definitionen und Berechnungsmethoden angewandt werden. Laut Forschungsergebnissen, die das Pew Forum on Religion and Public Life in Washington 2009 veröffentlichte, beläuft sich die Zahl der Muslime auf der Welt auf schätzungsweise 1,57 Milliarden oder 22,9 Prozent der Weltbevölkerung; 60 Prozent dieser Gruppe leben demnach nicht im traditionellen Kernland des Islam im Nahen Osten und Nordafrika, sondern in Asien. Die Zahlen des Pew Forum lassen darauf schließen, dass die Größe der weltweiten muslimischen Bevölkerung in früheren Umfragen unterschätzt wurde. Fasst man die Ergebnisse dieser früheren Umfragen zusammen, machen Christen 30 bis 33 Prozent der Weltbevölkerung aus, Muslime 18 bis 21 Prozent, Hindus 12 bis 15 Prozent und Buddhisten fünf bis sieben Prozent. Alle anderen Religionen haben einen Anteil von unter einem Prozent.

Die Suche nach Gott Die Suche nach Gott, nach Göttern, nach Erleuchtung, nach *Theosis*, nach *Dharma* oder Nirvana setzt sich für Milliarden Menschen auf der ganzen Welt fort. In ihrer überwältigenden Mehrheit gehört die Weltbevölkerung noch heute institutionalisierten Religionen an. Viele andere suchen außerhalb des konventionellen Umfeldes nach Spiritualität, lassen sich dabei aber von den besten religiösen Traditionen leiten. Die Suche kann viele Formen haben und viele Namen annehmen, aber letztlich geht es immer um das Gleiche: Der Einzelne bemüht sich darum, durch religiöse Systeme einen Sinn und Wert in seinem Leben zu finden.

Die Religion ist bei robuster Gesundheit
Worum es geht

Glossar

Achsenzeit Begriff aus der Geschichtsforschung für die Zeit von 800 bis 300 v. u. Z. In dieser Übergangsphase entstanden viele Weltreligionen.

Ahura Name der Götter, die im Zoroastrismus angebetet werden

Atman im Hinduismus die heilige Kraft des → Brahman, die jeder Einzelne in sich selbst erlebt.

Brahman im Hinduismus die heilige Kraft, die alle Lebewesen am Leben hält; der innere Sinn des Daseins

Brahmane Angehöriger der hinduistischen Priesterkaste

Chassidismus im 18. Jahrhundert gegründete mystische Bewegung im Judentum

Chi in den chinesischen Religionen die grundlegende Energie und der Geist des Lebens

Dharma im Buddhismus die Wahrheit und der Weg zur Erlösung

Diaspora die verstreuten Judengemeinden außerhalb Palästinas

Dschihad innerliche Anstrengung zum Ablegen schlechter Gewohnheiten; in letzter Zeit Begriff für einen Krieg im Namen der Religion

Entrückung Lehre christlicher Fundamentalisten, wonach den Auserwählten die „letzten Tage" der Erde erspart werden, weil sie in den Himmel aufgenommen werden, um dort das → Millennium zu erwarten

Eschatologie Lehre über das Ende der Geschichte mit der Wiederkunft des Messias, dem Jüngsten Gericht und dem endgültigen Triumph der Gläubigen

Fatah offizielle juristische Meinung oder Entscheidung eines Religionsgelehrten in einer Frage des islamischen Rechts

Gathas Schriften des Zoroastrismus

Haddsch die muslimische Pilgerreise nach Mekka

Hadith Überlieferungen oder gesammelte Lehren des Propheten Mohammed

Heiliger Geist im Christentum die dritte Person in der Dreifaltigkeit aus Vater, Sohn und Heiligem Geist.

Hidschra die Wanderung der ersten Muslime von Mekka nach Medina im Jahr 622, ein Ereignis, mit dem die Entstehung des Islam verbunden wird

Himmelsgott höchste Gottheit, die von vielen Menschen als Schöpfer der Welt angebetet wurde; wurde später durch näherliegende Götter und Göttinnen verdrängt

Imam in der Hauptrichtung des Islam der Leiter der Gebete in der muslimischen Versammlung; im Schiitentum ein Nachfahre des Propheten, der göttliche Weisheit besitzen soll

Inkarnation die Verkörperung Gottes in Menschengestalt

Jina im Jainismus ein menschlicher Geist, der die Erleuchtung erlangt hat

Junzi im Konfuzianismus eine vollständig entwickelte, weise Persönlichkeit

Kaaba der würfelförmige, Allah gewidmete Granitschrein in Mekka

Kabbala mystische Tradition im Judentum

Karma im Buddhismus ein Vorgang, der alle Taten, Ängste, Wünsche und Abneigungen umfasst

Kenosis griechischer Begriff, bezeichnet im Christentum die Selbstentleerung

Li Glaubensüberzeugungen eines →*Junzi*

Mandala im Buddhismus eine symbolische, bildliche Darstellung des Universums

Mantra kurze Prosaformel oder Gesang, ursprünglich aus den vedischen Religionen

Millennium die tausendjährige Phase von Frieden und Gerechtigkeit, die nach Ansicht mancher Christen auf das Ende der Menschheitsgeschichte folgen wird und mit dem Jüngsten Gericht zu Ende geht

Mokscha Befreiung aus dem → *Samsara*, dem Kreislauf von Geburt, Tod und Wiedergeburt

Nirvana im Buddhismus die letzte Realität, das Ziel und die Erfüllung des menschlichen Lebens und das Ende aller Schmerzen

Offenbarung (Apokalypse) das letzte Buch des Neuen Testaments; enthält eine Beschreibung des Weltenendes

Orthodox wörtlich „richtige Lehre", für die osteuropäischen Christen der Begriff zur Unterscheidung von den westlichen Christen

Patriarchen ursprünglich die Bezeichnung für Abraham, Isaak und Jakob, die Stammväter der Israeliten; später insbesondere in der orthodoxen Tradition der Titel christlicher Religionsführer

Prophet Mensch, der im Namen Gottes spricht

Ren im Konfuzianismus die wichtigste Tugend, sie umfasst Menschlichkeit, Mitgefühl und Wohlwollen

Rigveda wörtlich „Wissen in Versen"; die heiligste der vedischen Schriften, bestehend aus über 1000 Hymnen

Samsara der Kreislauf aus Geburt, Tod und Wiedergeburt

Schahada das muslimische Glaubensbekenntnis: „Ich bezeuge, dass es keinen Gott gibt außer Allah und dass Mohammed sein Botschafter ist."

Scharia wörtlich: „der Weg zur Wasserstelle"; das heilige Gesetz des Islam

Shu im Konfuzianismus die Tugend der Rücksicht; steht in enger Verbindung mit der Goldenen Regel

Sufismus mystische Spiritualität im Islam

Sunna islamische Gebräuche, die durch Tradition bestätigt wurden und das Verhalten sowie die Praxis des Propheten Mohammed nachahmen sollen

Tao im Taoismus der Weg der richtigen Lebensführung

Talmud klassische Auslegung des uralten jüdischen Gesetzeskodex durch Rabbiner

Thora in der Regel Bezeichnung für die ersten fünf Bücher der jüdischen Heiligen Schrift, aber auch für die Gesetze, die Moses auf dem Berg Sinai offenbart wurden

Yoga Meditationsmethode zur Befreiung von Selbstsucht und zum Erlangen der Erleuchtung

Index

Danksagung des Autors
Mein Dank gilt meinem Lektor bei Quercus, Slav Todorov, und seinen Kollegen, meinem Agenten Derek Johns und meiner Familie – Siobhan, Kit und Orla – die geduldig und mit überzeugend engagierter Miene zugehört haben, wenn ich mich mit ihnen über die Details dieser großen (aber hoffentlich nicht großspurigen) Tour ausgetauscht habe. Alle Bibelzitate in der englischen Ausgabe sind aus der New Jerusalem Bible (Darton, Longman and Todd, 1974).

Titel der Originalausgabe:
50 ideas you really need to know – religion

Bibliografische Information der Deutschen Nationalbibliothek
Die Deutsche Nationalbibliothek verzeichnet diese Publikation in der Deutschen Nationalbibliografie; detaillierte bibliografische Daten sind im Internet über http://dnb.d-nb.de abrufbar.

Springer ist ein Unternehmen von Springer Science+Business Media
springer.de

© Spektrum Akademischer Verlag Heidelberg 2011
Spektrum Akademischer Verlag ist ein Imprint von Springer

11 12 13 14 15 5 4 3 2 1

Planung und Lektorat: Frank Wigger, Dr. Christoph Iven
Umschlaggestaltung: wsp design Werbeagentur GmbH, Heidelberg
Titelbild: „Die Erschaffung des Adam" von Michelangelo Buonarotti (1475 – 1564), Fresko (Detail) in der Sixtinischen Kapelle, Vatikanische Museen, Vatikanstadt/Alimari/The Bridgman Art Library
Redaktion: Mag. Uta Scholl
Satz: TypoDesign Hecker, Leimen

ISBN 978-3-8274-2638-3

Printed in the United States
By Bookmasters